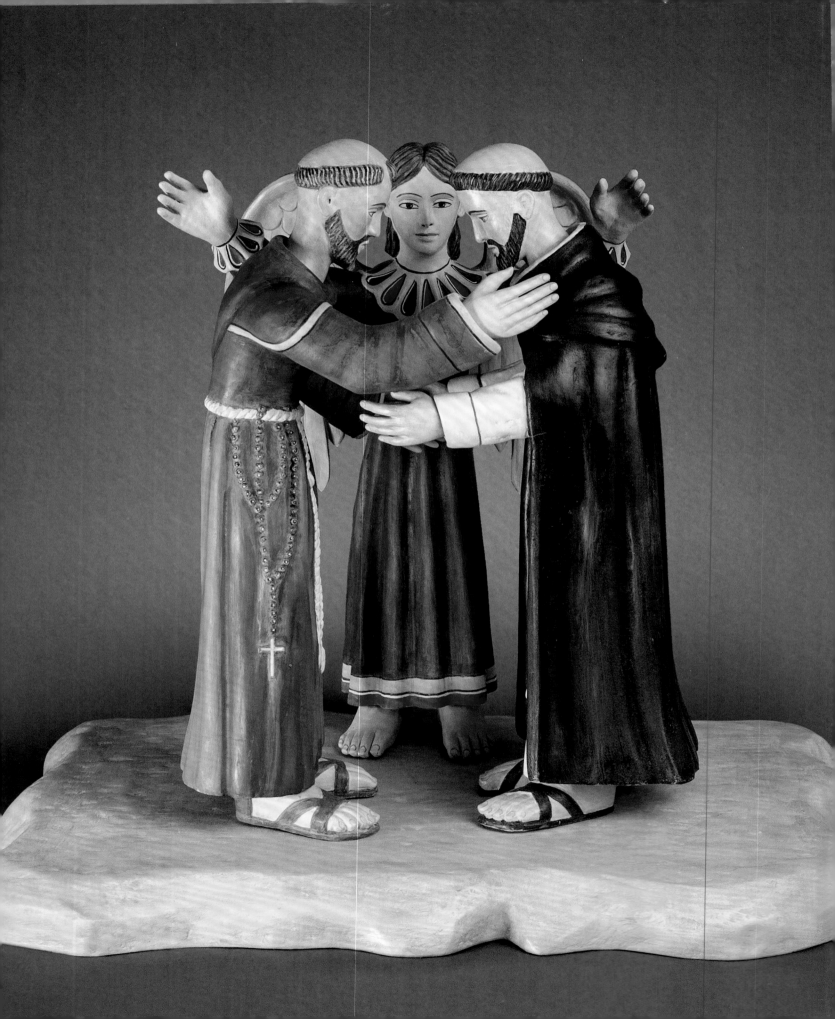

Cultural Convergence
in New Mexico

INTERACTIONS IN ART,
HISTORY & ARCHAEOLOGY

HONORING WILLIAM WROTH

Edited by Robin Farwell Gavin
and Donna Pierce

Museum of New Mexico Press
Santa Fe

Contents

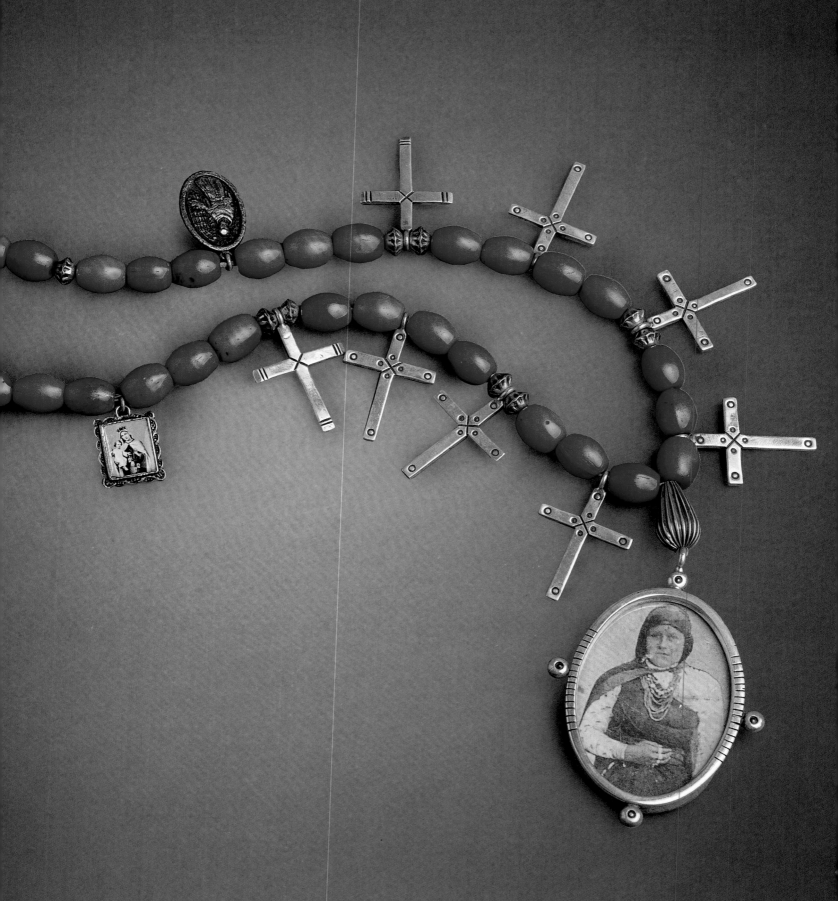

Preface

ROBIN FARWELL GAVIN
and DONNA PIERCE

William Wroth's contributions to the field and study of Spanish Colonial art in the American Southwest are legendary. The earliest of these, *Hispanic Crafts of the Southwest* (1977), built upon E. Boyd's seminal *Popular Arts of Spanish New Mexico* (1974) by bringing contemporary practitioners of the traditional arts into the discussion. This was followed by his 1979 *The Chapel of Our Lady of Talpa*, the first in-depth study of the history and style of a single building and its artistic contents by José Rafael Aragón. But it was the 1982 publication of *Christian Images in Hispanic New Mexico* that truly changed the course of scholarship on the artistic style of New Mexican religious imagery. Wroth's detailed analyses and thorough observations set the stage for all future study of this work. *Images of Penance, Images of Mercy* (1991) placed the long-misunderstood art and practices of the Penitentes of New Mexico into the context of similar practices of religious brotherhoods in Europe and Latin America. After numerous other publications, Wroth's final anthology concerning the traditional arts of the Southwest, *Converging Streams: Art of the Hispanic and Native American Southwest* (2010), brought together his many years of research and reflection on these traditional arts and the cross-cultural influences, practices, and beliefs that created them. Many of these publications were accompanied by groundbreaking exhibitions (see the bibliography).

But Wroth's creative endeavors did not stop there. His interest in Southwestern art and culture was by no means limited to Spanish Colonial traditions, and another groundbreaking publication and exhibition was *Ute Indian Arts and Culture from Prehistory to the New Millennium* (2000). In this project Wroth brought together Native scholars, historians, and art historians to literally "unearth" the artistic output of the Ute peoples and place it in the context of Ute history and the Ute worldview. He wrote both poetry and about poets (*All Worlds in One: Poems by William Wroth* [2008] and "'In That Luminous Darkness': The Poetry of Vicente Pascual Rodrigo" [2015]), and helped to found the poetry review *Coyote's Journal* (see Brandi, this volume).

Wroth selected the contributors to this publication, many of them colleagues he had worked with over the years. He also selected a number of works of art by artists whom he knew and whose work he admired. Fortunately, he was able to write not only the introduction to this volume but also his autobiography, bibliography, and an essay on the prehistory of Chimayó on which he had been working. The chapters in this volume begin with the impact of the interaction between Spanish and Native American cultures. This is followed by discussions of the history of Spanish peoples, institutions, and art, then proceeds to modern expressions and repercussions of cultural convergence. The volume closes with discussions of other aspects of Will's creative interests in poetry and art.

With Will's death in 2019, we lost a great scholar, mentor, and friend, but we are privileged to be able to benefit from and enjoy his many years of research and creativity.

Acknowledgments

ROBIN FARWELL GAVIN
and DONNA PIERCE

We would like to thank all the artists for sharing their creations and the authors for contributing their significant and thoughtful essays in honor of Will. We thank the Museum of New Mexico Press and its staff: Anna Gallegos and Lisa Pacheco agreed to take on the project without hesitation, and David Skolkin transformed it into a work of art. Together they have helped to create a fitting and lasting tribute. Thanks also to the Museum of New Mexico Foundation.

Will's family, Deborah, Celestina, Carmel, and Roy, have provided support and enthusiasm throughout this process. We know that it was only with their love that Will was able to be engaged and productive until the end.

Finally, we are also extremely grateful to the following friends, family, and colleagues of Will for their generous support of this book:

Gordon and Judith Wilson
Ed Garcia / Mercedes-Benz of Santa Fe
Flora and Balbino Fernandez
L. Kinvin and Deborah B. Wroth
Thomas G. Wroth and Elizabeth C. Wroth

Barbara C. Anderson
Raymond Bal and Elizabeth A. Kay
Diane Bird
Jamie Blosser and Andrew Tulchin
Cliff River Springs
Allison J. Colborne
Lane Coulter and Jan Brooks
Ray and Judy Dewey
Nancy Sue Dimit
Mark and Martha Varoz Ewing
Richard I. and Karen C. Ford
Ann Lane Hedlund
Rick Hendricks and Lois Stanford
Penelope Hunter-Stiebel
Victor and Rosalie Jaramillo
Enrique R. Lamadrid and Miguel A. Gandert
Willard and Kay Lewis

Helen R. Lucero
Patricia R. Musick
Andrew and Evita Ortega
Robert J. Ortega / Ortega's Weaving Shop, Inc.
Mary Powell
Bettina A. Raphael
Theresa Salazar and Timothy Troy
Cynthia Wheelock Smith
Levi and Paola Smith
Maggie Smith
Peter Smith and Letitia Chambers
Robert P. Smith MD and Margaret Creighton
Cordelia Thomas Snow
Linda A. Tigges
Kristin, Mac, and John Watson
Nancy Meem Wirth

I.

Infield-Outfield: The Transformation of the Pueblo Landscape with the Introduction of Iberian Canal Irrigation, New Field Systems, and Mediterranean Plants and Animals

RICHARD I. FORD

Ethnoecology in Mexico and Southwestern North America

Will Wroth was interested in the interface between Native American and Spanish cultures in all time periods throughout Mexico and the American Southwest. Many of his interests concern the cultures, economics, and environments of this immense area of the continent. This chapter will address his interests in two time periods. The first part will examine the evolving agricultural economy and its environmental maintenance by Native Americans before Europeans arrived with their links to the Iberian Peninsula of Europe. The second will concern the environmental and economic changes these foreigners imposed on Pueblo cultures and the new foodways and landscapes they created as they disrupted the lifeways of Pueblo people. Both sections will examine the ethnoecology of Mexico and the Southwest. To do so successfully, the chapter will consider both time periods in terms of ethnobotany and agrohusbandry, the management of water to sustain plants and animals in the economies, and the contrasting landscapes and their evolution.

Historically, defined events and dates begin with Francisco Vázquez de Coronado's *entrada* (entry) to the Southwest in 1540. To sustain his soldiers, friars, explorers, and Mexican Indians, Coronado herded many grazing animals for food and transport. Many Aztecs seeking fame and hoping for higher social standing on their return to Mexico accompanied him. To achieve these aims, they desired military combat.[1]

The major ecological division began in January 1598, when don Juan de Oñate finally departed Santa Barbara, Chihuahua, with his caravan of four thousand soldiers, friars, servants, and settlers. But the greatest ecological transformation and social and cultural disruptions occurred when Oñate and his followers reached Ohkay Owingeh Pueblo (formerly known as San Juan Pueblo) in New Mexico in July 1598. Death, theft, and destruction occurred almost immediately. In addition to these transformations, the Spanish introduced a new economy based on Iberian plants and animals and European land use patterns, especially canals, also known as Iberian irrigation.[2]

Origin of Agriculture in Mexico: The Three Sisters, Their Relatives, and Cotton

The first human inhabitants of Mexico were Paleo-Indians, hunters and gatherers of Pleistocene plants and animals, who had crossed the Bering Sea thirteen thousand or more years earlier. Paleontological records of mammoth kills exist in the Valley of Mexico and in Sonora.[3] Although the plant record is sparse, important plants included teosinte seeds, starch grains and phytoliths from *Zea mays* ssp. *parviglumis* or *Balsas teosinte*, and the squash *Cucurbita argyrosperma*[4] from a Central Balsas River valley rock shelter called Xihuatoxtla, indicating the presence of maize by 9000 BP but it could be as early as 10,000 BP. This is the first evidence of the gathering, preparation, and eating of teosinte seeds. An annual pioneer grass with hard, loose seeds encased in a husklike sheave, teosinte occupies the bare ground of large disturbed habitats such as river flood zones, burn scars, old milpas, and landslides. Teosinte has been found in several archaeological sites in southern Mexico. Reproduction did not include a cob with kernels. Teosinte formed extensive stands of grass shoots with several branched sheaves holding numerous detached seeds.[5] The Paleo-Indian gatherers selected traits that through interbreeding would form a miniature cob by 8,600 years ago. Some of these genetic traits were a nonshattering rachis holding the seeds together and the double ranking of each seed. A tunicate allele led to the opening of the seed coat to form a cupule with soft glumes inside holding two kernels of corn. Three additional mutations helped form the all-too-familiar cob that after several millennia of human selection increased noticeably in length, rows of kernels, and yield. A second plant under human cultivation and selection in the Balsas basin was a gourd with edible seeds, *Cucurbita argyrosperma*.

The human-selected maize traits formed a small, primitive cob. This new plant had twenty-four chromosome pairs, like teosinte and maize. These miniature cobs facilitated the efficient harvesting of maize kernels. Archaic hunters and gatherers carried this new plant to areas well outside the Balsas River drainage. By 6,200 years ago it was grown near Guilá Naquitz in Oaxaca;[6] in Coxcatlan Cave by 5,500 BP; in San Marcos Cave, Puebla, by 5,400 BP; and El Riego in Tehuacán by 4,300 BP.[7] All have AMS (Accelorator Mass Spectrometry) radiocarbon-dated evolved cobs.

While maize was being spread by Mexican Indians, apparently other early ancestors of domesticated plants were dispersed previously as seeds in the feces droppings of Pleistocene megafauna. Early Archaic Mexican Indians had the idea of selection and domestication of the larger fruits of squash (*Cucurbita pepo* subsp. *pepo*) and bottle gourd (*Lagenaria siceraria*). Guilá Naquitz and Coxcatlan Cave have the bottle gourd by 10,000–9,000 BP and 7,200 BP, respectively, and pepo squash by 8,000 BP. Both provided a hard gourd shell that could be used as a carrying or storage container. The bitter seeds of the bottle gourd were inedible by humans but those of the squash were consumed. These two Cucurbitaceae were confined to highland central Mexico until nomadic hunters introduced them to other groups northward as human diffusion spread these domesticates.

Meanwhile several varieties of common beans (*Phaseolus vulgaris*) were being domesticated. However, *Phaseolus vulgaris* and *Cucurbita argyrosperma* were present by 2,500 BP and were much younger than other domesticated plants in Tehuacán, demonstrating that each domesticate spread independently. When these were joined with the earlier domesticates, the seeds of the three sisters—beans, maize, and squash—and their relatives became a complementary dietary staple. When eaten in combination, the three sisters provided complementary amino acids creating a vegetable protein. By 5,500 BP agriculture had spread across Mexico and the family of the three sisters had been joined together in a few areas. Maize now had a short but fully formed cob and averaged twelve rows of hard, dark-colored kernels. There were two domesticated squashes, *Cucurbita pepo* and *Cucurbita argyrosperma*. The bottle gourd was a major container but not a food plant. Several land races of common beans (*Phaseolus vulgaris*) and lima beans (*Phaseolus lunata*)

had appeared in some gardens. In Sonora these garden plants were grown under irrigation at La Playa. The three sisters were now joined together in Sonora and northern Tamaulipas.

As the domesticates diffused northward, they were introduced as single plants and not as complete complexes. Maize has 5,000 BP dates for Romero and Valenzuela Caves in Tamaulipas. Kevin Hanselka has reexamined the wild plants from Romero's cave and other plants from the Ocampo region in Tamaulipas.[8] Bruce Smith has examined the *Cucurbita* and redated Ocampo domesticates.[9] The revised sequence of archaeological introductions indicates that by 6,000 years ago we find bottle gourd and common squash in Tamaulipas. At 5,000 BP there is a second squash, *C. argyrosperma*. By 4,000 BP maize is present. A third squash, *C. moschata*, is found at 3,000 BP. Finally, the common bean, *Phaseolus communis*, arrives by 1,300 years ago. Squash was selected for larger and more numerous fruits. Now the three sisters and their relatives are in northeastern Mexico.

There are numerous stories to unravel regarding beans. Common beans were the first legume domesticated. Next came sieve or small lima beans. Runner beans were a Mexican highland addition. Finally, in the low, hot country of the Pacific coast, tepary beans were domesticated. Three of these beans were brought into the American Southwest independently at different times.

Cotton (*Gossypium hirsutum*) appears to have originated in the Gulf of Mexico lowlands and the Yucatán. After its initial domestication, it was brought through exchange between foragers to the highlands, where it was raised under irrigation. Cotton was first found in an archaeological site in Tehuacán dating 5,400 years ago and in Guilá Naquitz in Oaxaca. Several thousand years later cotton fibers, cordage, and woven textiles were found in mountainous Chihuahua caves.[10] From there it was introduced to the agricultural fields in Tucson.

Sites in the Tamaulipas region reach into the Sierra Madre Oriental range on the west and have a foothill zone that merges with the Mexican plateau. This area has many Cochise Archaic campsites used for the procurement of numerous seasonal edible plants and animals. This geological area connects further west to the Sierra Madre Occidental in Chihuahua. Domesticated plants came into Chihuahua from the east and south and were added to the diet during the Middle Archaic (ca. 6,000 BP).

On the western side of Mexico these crops and others diffused north along water-determined routes of the Sierra Madre Occidental and its western basin and range. Swallow Cave, a high-altitude shelter, is known for its primitive maize,[11] common beans, and squash. At La Playa, a Sonoran Desert location, maize was first recovered as a cupule from a firepit.[12] From Sonora northward to Arizona was relatively easy to traverse, and maize appeared quite early (3,200 BP) in Arizona relative to elsewhere in the Southwest.

Two major rivers helped to determine agricultural land settlement patterns in northern Chihuahua. These were the Rio Grande along the modern international boundary and the Rio Conchos that flows from the west into it. Several ethnic groups occupied the banks of these rivers, and their historical ethnography exemplifies what Early Agriculture was like in the Archaic. Small family groups lived in grass-covered, temporary huts in Chihuahua. A few of the group names were recorded by early Spanish expeditions to northern Mexico–Choncha, Suma, and Mansa. They were hunters, fishermen, and plant gatherers with seasonal gardens of maize, squash, and beans, but the arid and drought-prone environment made agriculture risky. There were ample springs along both rivers for catching fish, riparian mammals, and migratory waterfowl in the El Paso area, where people lived in wickiup-type homes and could have small gardens.[13] Going down to Chihuahua, evidence of early maize, and possibly domesticated amaranth, has been found at several stone-terraced agricultural plots, or *trincheras*, and at Cerro Juanaqueña at 3,100 BP.[14]

Pre-Hispanic Water Control Systems in Mexico

The earliest water control system was a well five meters deep that tapped subsurface river water at San Marcos Necoxtla in Puebla. However, there is no evidence that it was used for agriculture.[15] While the wild seeds may have been planted in natural areas with standing water or where runoff saturated the ground, these wet areas may have been early proxies for irrigation and were later expanded or manipulated to create true irrigation ditches.[16]

Water control systems also facilitated the newly emerged agriculture, which now increased and gave more security in the form of dietary calories in the evolving human diet. Following the evolution of plants to their present genotypic form, water was needed seasonally to sustain a harvest. Three thousand years ago, water was stored and distributed to the fields from the Purrón Dam in Tehuacán, now dated to 1,300 BP,[17] and from the fossilized canal system at Hierve el Agua in Oaxaca.[18] From these beginnings, controlled runoff irrigation and seasonal rainfall sustained agriculture as domesticated crops were introduced northward in Mexico. The initial irrigation systems that we observe in Tehuacán and Oaxaca were ditches dug by hand with digging sticks that brought water to small patches of domestic plants. Maize was the dominant plant, which was now selected for larger cobs and became the staple in the Middle Archaic Mexican diet.

Water control for plant irrigation was essential for successful farming in an arid climate such as Sonora. A ditch was found at La Playa, from 4,000 BP, with the only cultigen of a *Zea mays* cupule excavated from a roasting pit. Similar ditches can be tracked to southern Arizona, where they evolved from small ditches into large canals that connected Hohokam communities, as they did in central Mexico. Outside the Tucson basin, a variety of water control methods have left their signature in the Stafford valley. Here James Neely and colleagues have discovered virtually every Southwestern water-control technique.

Moving Edible Plants into the Southwest

Agriculture evolved through human selection of genetic traits that would produce greater yields from the now domesticated plants and spread quite rapidly throughout northern Mexico by 6,000 years ago. The major Mesoamerican plants were present in Tamaulipas and Sonora by this time. Maize was the most productive crop, and it diffused into what is now the United States in southern Arizona and the Rio Grande Valley in the El Paso area.

The early domesticated plants diffused into northern Mexico by three principle means—band migration, intermarriage with wives carrying the new southern plant seeds, or trade to gain access to utilitarian plants such as bottle gourds and cotton. The linguistic theorist Jane H. Hill argued that maize and other domesticates were brought northward from Mexico by migrating bands of speakers of the Uto-Aztecan language.[19] Their movement was assured success as these bands moved north because of the biological security that agricultural products gave the migrants. William Merrill produced a detailed reanalysis of these lexica indicating that the agriculture-related vocabulary used by Hill can be reconstructed only for Proto-Southern Uto-Aztecan, supporting the conclusion that maize agriculture entered the Uto-Aztecan world after the division of the Proto-Uto-Aztecan speech community into southern and northern branches in the American Great Basin.[20] Additional lexical and biogeographical data suggest that the Proto-Southern Uto-Aztecan speech community was located near the modern Arizona-Sonora border when its members began cultivating maize, a development that may have occurred around four thousand years ago, when the earliest evidence of maize agriculture appears in the archaeological record of the Southwest.

Cochise and Early Agriculture people in Sonora and southern Arizona were probably related by their Southern Uto-Aztecan language and desert adaptation by 5,500 BP.[21] They were hunters

and foragers of numerous desert plants that yielded a high-caloric diet because of the diversity of succulents and leguminous trees in both areas. Agricultural plants were still secondary.

Over a dozen sites in the Tucson area have yielded maize remains. Las Capas is particularly noted for its many pit houses, earthen ditches, and garden plots at 3,200 BP, with maize appearing earlier, at 4,100 BP. It appears that maize spread northward from the Tucson basin to McEuen Cave about 3,700 BP,[22] as well as to the open-air Old Corn site (4,000 BP) across the New Mexico border. At one time evidence suggested the earliest date for maize in New Mexico was from Bat Cave, but this changed when W. H. Wills re-excavated this shelter and the 3,200 BP AMS dates on carefully excavated cobs yielded younger dates, but still ancient for maize in New Mexico.[23]

In the Zuni area to the west, corn was associated with the earliest known irrigation canal systems in the northern Southwest at 5,000 BP.[24] Tularosa Cave is south of Zuni and has an agriculture date of 1,900 BP. North of Bat Cave a western corridor brought maize to the Zuni and Chaco Canyon areas. In Chaco Canyon there are two early maize dates, 2,700 BP for a pack rat midden,[25] and 2,300 BP for Sheep Camp.[26] The inhabitants of Chaco planted kernels of maize in the mud flats on mesa top drainages and in the naturally dammed area of the Chaco wash.[27] By these means Chacoans had an early form of irrigation. Maize diffused northward to the 3,600 BP Three Fir shelter in northern Arizona.[28] Maize reached the Rio Puerco from Chaco at San Luis de Cabezon at 3,300 years ago.[29]

Domesticates were added to the Rio Grande Valley diet during the Middle Archaic (ca. 4,000 BP), and to the Keystone Dam site north of El Paso as early as 4,500 years ago.[30] Further up the Rio Grande early maize has been recovered from Pendejo Cave (which also had *Cucurbita moschata*);[31] Tornillo Shelter at 3,200 years ago;[32] and Fresnal Shelter (2,945 BP), which also had *Zea*, *Cucurbita*, and *Phaseolus*.[33] High Rolls Cave had maize by 3,500 BP.[34] Three additional Late Archaic sites in the Sacramento Mountains produced maize and cucurbits,[35] and LA 10577 (Laboratory of Anthropology site number) outside Albuquerque had maize by 3,400 BP.[36] On Albuquerque's West Mesa there are numerous Late Archaic sites, many with maize fragments. Additional new domesticates were adopted during the Late Archaic (900 BC), including beans and amaranth. However, domesticates are thought to have been little more than supplemental food in the Archaic and not a dietary staple, with most food, including beans and amaranth, being provided by hunting and wild food collection into the Late Archaic (900 BC to AD 200 or 500).

Further north, Jemez Cave on the Rio Jemez also has early maize in various stages of cob evolution at 3,200 BP,[37] but it is suspected this maize diffused with *Cucurbita pepo* up the Rio Grande. Bradley Vierra excavated the Chama Alcove shelter in the Chama drainage, which provided an important sample of evolving productive early maize about 2,400 BP.[38] La Bajada hill appears to have been a barrier to the rapid diffusion of maize northward. Maize does not appear as significant north of La Bajada until it was excavated at Nambe Falls at AD 400.[39] Taos was the last area to receive maize, at AD 700.

Wolf: Infield/Outfield Field System

Eric Wolf and Angel Palerm were raised and educated in Europe, where they became familiar with medieval agricultural techniques and field systems.[40] Throughout Europe the field system consisted of an infield of grain and vegetables and an outfield of pasture animals. Wolf and Palerm recognized this pattern when they began their fieldwork in Mexico, where the infield was based on irrigated fields and a variety of agricultural plots dedicated to different crops. These ranged from maize fields to kitchen gardens and orchards. The infields were highly productive in terms of the amount of produce gathered from the fields and the number of calories they yielded. The outfields lacked the diversity of plants of the former. The outfields were extensive in

acreage and yielded wild plants used for food, medicine, and decoration. The outfield was used for hunting as well. The outfield was part of the commons, land that could be used by community residents for many purposes.

Ditch irrigation was the most common type of irrigation in southern Arizona until 4,300 BP, when there was an evolution in the scale of ditches, which increased in size, water-carrying capacity, and land mass irrigated. Ditches evolved into canals. The Hohokam canals in southern Arizona are very impressive, and are unique in the pre-Hispanic United States.

Central Mexico benefitted from ditch irrigation during the early stages of plant domestication. These ditches created a limited infield for several native domesticated plants. At Hierve el Agua in Oaxaca, travertine in the water fossilized the ditches. Purrón Dam in Tehuacán left an archaeological network of ditches that revealed how important ditch irrigation was for the evolution of productive maize and the sustaining of other crops.[41]

Stafford (southern Arizona) had extensive water-control devices ranging from stone mulch grid fields to canals several meters deep, several meters wide, and many meters long.[42] There were no precontact canals in Northern New Mexico, despite Florence Ellis's claim to the contrary and her description of the Sapawe irrigation system.[43] A reexamination of the ditches next to El Rito show that they are Hispanic in scale and technology. These were first introduced by Spanish settlers and Mexican Indians on August 11, 1598.

Precontact Infield in the Northern Rio Grande

The issue of agricultural irrigation has long been an anthropological concern in the study of Pueblo New Mexico. Adolph Bandelier addressed it in 1882,[44] but in the twentieth century it took on greater concern when anthropologists attempted to explain the origin of the religious-social hierarchy in the eastern pueblos. The subject was broached in an article by Karl Wittfogel and Esther Goldfrank drawing on *Oriental Despotism*, Wittfogel's research into canal irrigation in China, where extensive irrigation projects were used to govern the Chinese empire.[45] This followed earlier work by Karl Marx and Friederich Engels.[46] The irrigation theme was selected by Fred Eggan to explain the differences in social organization between the "dry farming" of the western pueblos and the irrigation in the Rio Grande Pueblos.[47] Edward Dozier accepted Eggan's conclusion and applied the same hydraulic reasoning to the social-ceremonial hierarchy in Tewa Pueblos of New Mexico.[48] The historical problem is that the Chinese hydraulic empires were based on canal irrigation that brought massive amounts of water to multiple canals and communities that were linked by miles of canals. The pre-Hispanic Keres and Tewa Pueblos practiced irrigation as attested to by Spanish explorers,[49] but these were gravity-flow shallow ditch systems, operated by single families or relatives at best.[50] The extent of the pre-Hispanic ditch system is best exemplified by San Ildefonso, described by the Spanish explorer Gaspar Castaño de Sosa as "a very large valley totally under irrigation."[51] Nevertheless, there was no comparison with Hohokam canals in Arizona or with Mexican irrigation. Most of what Pueblo ethnologists were writing about were canal systems introduced in the sixteenth century by Oñate, Mexican Indians, and later settlers.

Unlike Mexico, sacred agricultural areas were not extensive in the pre-Hispanic pueblo infields. Mostly they consisted of portable shrines. Those in the field areas consisted of circles of stones where a ceremonial pot of water (a symbolic lake) was set, or within which turkey prayer feathers (symbols of rain) were placed. The pots were removed at the end of the agricultural ceremony, or the feathers were left to decay in place. Other examples included boulder shrines covered with numerous incised cupule depressions associated with bilateral families or sodalities.

Pioneer Tewa communities selected locations for permanent villages that had flowing springs for domestic and ritual purposes. At least one major spring was probably sacred to the women's society. Other springs were important sources of ceremonial water for other sodalities.[52] Furthermore, these communities excavated reservoirs to hold runoff from storms that could be used for irrigation. Many Tewa Pueblos had reservoirs (e.g., San Cristóbal, Puje, Pueblo Blanco).

A recurrent question in the Southwest has been whether the pueblos had irrigation before the Spanish arrived. The archaeological evidence confirms that they did, but the scale suggests that it was small in terms of field size and ditch length. The precontact ditches, not canals, were several feet wide and rarely two feet deep. The length varied from several hundred feet to a quarter of a mile, and they never ran between villages. The hand-dug ditches were constructed with a fire-hardened oak digging stick by a farmer, assisted by his male children. The farmer and his closest relatives maintained the ditches, cleaning them in the spring or at times when floods broke into the ditches and deposited sterile sand and silt in them. Generally, one extended family or several closely related families planted fields watered by the ditch. The ditch was created by placing rocks, soil, and logs together to form a diversion head gate in a secondary stream that was a branch of a larger stream. Primary rivers such as the Rio Grande and the Rio Chama were not dammed because they flooded violently in the spring and washed out any head gates. Smaller secondary streams such as the Rio Santa Clara, Rio Tesuque, Rio Nambe, Pot Creek, Rio El Rito, and Rio Taos could be controlled with dams to limit the extent of the damage when they flooded.

Archaeological surveys along the banks of these streams and ethnographic interviews have revealed that these ditches are still present. Some are still in use, as Ellis discovered at Pojoaque and Nambe.[53] Richard Ford and Roxanne Swentzell illustrated several at Santa Clara, where ditch irrigation was still practiced until 2011, when the Las Conchas fire burned Santa Clara Pueblo's watershed and led to destructive floods that removed the ditches.[54] James Moore described what he thought was a major ditch at Pot Creek, and Severin Fowles found other shorter ones upstream in abandoned infields at Fort Burgwin.[55]

As previously described, the three sisters—corn, beans, and squash—and their relatives in the same genera (*Zea*, *Cucurbita*, and *Phaseolus*) were domesticated in Mexico and introduced to the Southwest through contact diffusion before 4,000 years ago or the northward migration of bands. However, beyond the introduction of domesticates, in about 1,500 BP eight-rowed maize, *harinoso de ocho*, also was introduced from Mexico,[56] as well as non-Chapalote cobs with colored kernels (white, red, yellow) that were land races selected for flavor and for rituals of the sacred directions.[57] The outfield gravel mulches were managed as agricultural fields with cultivated ruderals. Plants that grew between the stones were often allowed to grow to maturity, as evidenced by the mature pollen found in the field.[58] These fields had maize and squash pollen as well as perennial *Opuntia*, *Ephedra*, and edible annuals, such as *Chenopodium*, *Amaranthus*, and sunflowers (*Helianthus annua*). Two native trees with edible fruit—*Prunus americana* and *Prunus virginiana*—grew along irrigation ditches. There is archaeological evidence of both in the form of pollen and pits from Tijeras Pueblo.[59]

Precontact Outfield

The outfield is the largest human-modified space associated with the pueblos. These areas are easy to distinguish today because they are extensive areas of lithic mulch fields. Some of these cover hundreds, if not thousands, of acres. Tewa sites such as Sapawe, Posu-owingeh, and the Rio del Osos terraces have these and other water conservation stone works covering many acres. They are easy to follow today because of the sagebrush (*Artemisia tridentata*) growing on them.[60]

After the field was cleared, gravel mulch would be brought to cover the surface to a depth of up to ten centimeters. The gravel was excavated from pits, scraped off the field surface, or brought from mesa sides. When barrow pits were formed by removing gravel, it made depressions that would collect runoff rainwater or melting snow, or large snowballs could be deposited in them and the melted water left in place. It is speculated that these well-watered pits were planted according to stone grids beneath them. While the mulch captured water, the fields could be further gridded with stones to form checkered areas to retard running water or to hold water in the squares. If the field was sloped, stones could be aligned to retard flowing water or to build terraces to further direct runoff. Although the details are unknown, it appears the fields were subdivided to accommodate specific crops. Now the complex outfields could be planted with the appropriate traditional Mesoamerican plants.[61] These indigenous outfields are where cotton was grown, as evidenced by the abundant cotton pollen recovered from them.[62]

The aboriginal outfields were very extensive. They were created by removing trees and shrubs using double-bitted stone axes. Large scattered basalt or quartzite boulders were dragged to the fields to serve as sharpening stones for rejuvenating ax bits when they became dull or were nicked and shattered from use. These sharpening surfaces are highly polished and are often called "slicks" by field survey archaeologists. A few naïve archaeologists have called them "boulder metates" because of their shape and polish.

The outfields were also sacred landscapes where rituals could be held. The large boulders became permanent shrines. Some had cupules ground into them; others had ground slicks on the surface for sharpening the axes initially used to clear the agricultural fields of trees and shrubs. Afterward, the boulders were left in place to facilitate recurrent annual agricultural ceremonies. In some cases, it appears that after the initial field clearance, the field slick rituals may have been discontinued, but they were duplicated on shrines in the pueblos, where dozens of slicks are found together in larger pueblos (e.g., Tsankawi). What started as individual farmer or family field rituals now were transformed into community agricultural ceremonies, probably with numerous farmers participating based on the number of adjacent, highly polished slicks.

Palynologists with appointments in the New Mexico Castetter Laboratory for Ethnobotanical Studies engaged in numerous pollen studies of archaeological sites. They found many examples of maize pollen in the mulch and stone grids in the outfields. Paleoethnobotanists usually find charred, disarticulated cupules as evidence of dietary maize in site middens, but pollen is an equally reliable indication of maize agriculture.

Dr. Glenna Dean developed a laboratory sampling technique called intensive systematic microscopy (ISM) to identify cotton pollen in archaeological soil.[63] As a result, cotton pollen has been found associated with lithic mulch fields in numerous sites in Northern New Mexico south of Pilar.[64] Cotton was important for weaving blankets and clothing and was used as a ceremonial substitute for clouds in rain rituals. Pollen evidence has revealed how widespread cotton cultivation was before the Spanish arrived, and how it disrupted this extensive indigenous industry. In an area dominated by Tewa- and Keresan-speaking pueblos from Pilar to Abiquiu, it extended southward to modern-day Interstate 40, and east to the Galisteo Basin. Pollen evidence of edible ruderals was abundant, with *Chenopodium* and *Amaranthus* pollen indicating the presence of these important food plants. Certainly they were not removed as weeds from the fields.

Spanish *Entradas*: Observations of Pueblo Water Management Techniques

Florence Hawley Ellis believed that Pueblo farmers were major irrigators and depended upon irrigation water for raising crops.[65] Frank Wozniak has criticized her archaeological methodology used to demonstrate irrigation at Chaco Canyon, Pojoaque Basin, and her presumed canal on El

Rito Creek.[66] Ellis presented convincing archaeological evidence only that the Chacoans moved into the Pojoaque Basin around AD 1200 for one site (LA 835). She used the spread of Chaco/McElmo black-on-white pottery to trace the spread of irrigation into the Rio Grande.[67] However, one would have to assume that these Chacoan immigrants introduced a technology that they had already abandoned, or were in the process of abandoning, in the San Juan Basin because it was maladaptive. Ellis's hypothesis of an introduced irrigation system in the prehistoric Pojoaque Basin relies upon too many unsubstantiated assumptions for it to be considered definitive.[68] Our recent research confirms that Pueblo farmers did irrigate with minimal-sized ditches, but not with canals, until the Spanish introduced the latter in 1598.[69]

The first *entrada* was conducted by Coronado, who brought live animals to provide fresh meat for his expedition members. The cattle and sheep he herded were the first the Pueblo people had seen. The same is true of his horses and chickens. However, notably, he did not record any irrigation in any of the pueblos he visited from Zuni to Pecos.[70] The second expedition was that of fray Agustín Rodríguez and Francisco Sánchez Chamuscado, who received permission to go north in 1581, but the expedition did not fare well. They learned about large villages with extensive fields, but little else, and they died before they could return to Mexico. In November 1582, fray Bernardo Beltrán and Antonio de Espejo received permission to search for priests left in New Mexico and had no luck other than to learn about their deaths. Espejo reported good land, water, and salt in the El Paso region. The nomadic Sumas brought the expedition mesquite, corn, and fish, but they reported no evidence of irrigation. De Sosa found irrigation ditches fed by lakes near Acoma. In 1598 don Juan de Oñate passed northward following the Rio Grande. Amy Clair Earls has studied the successful agriculture of the Piro living along the Rio Grande south of Albuquerque. They planted in the mud flats along the shoreline.[71]

After a thorough review of the Spanish literature, Wozniak concluded that irrigation was practiced by some Puebloans in the late sixteenth century, but not all Puebloan groups can be assumed to have utilized irrigation systems.[72] The Piros, Acomas, Zunis, Tewas, and several Pueblos of Keresans can be demonstrated to have had ditch irrigation agriculture in specific circumstances. Richard Flint investigated Tewa Pueblo irrigation on behalf of the Bureau of Indian Affairs Pueblo Agency.[73] He explained the difficulty Spanish explorers had recognizing irrigation in the winter, but confirmed extensive irrigation at San Ildefonso off the Rio Pojoaque. As part of her legal work on behalf of Tesuque, Pojoaque, and Nambe Pueblo's water rights claim, Ellis suspected that these Pueblos were practicing an early form of irrigated maize agriculture.[74] Excavations by Alan Skinner in the Nambe Falls area proved Ellis's suspicion correct, and her ethnographic work for the court cases revealed old ditches but not canals.[75] By following the maps in Paul V. Hodges's 1938 report, Louie Hena and I confirmed that some of these ditches were pre-Hispanic contact.[76] Their head gates were on the upper Rio Tesuque. Today they are shallow, narrow, and short, linking only a few fields. In our study of Santa Clara traditional water management, Roxanne Swentzell and I examined Santa Clara hand-dug ditches in 2011. At that time they were present but have since been eliminated by floods following the Las Conchas Fire.

These pre-Hispanic Tewa ditches did not link multiple villages and were not deep or particularly wide. They did create a narrow and limited infield for Mesoamerican crops. They gave agricultural security to farmers, who used the irrigation water from ditches to raise maize, squashes, common beans, bottle gourds, and tobacco. Two trees with edible fruits appear to have grown along these ditches, as they do on the Iberian and Pueblo canals today. American plum (*Prunus americana*) pits were found in Tijeras Pueblo, and chokecherry (*Prunus virginiana*) pollen at Nambe.[77] Both are starvation foods for the northern pueblos today. Most calories from edible plants, domesticated and ruderal, came from the more extensive outfield, consisting of stone mulched fields with cultivated ruderals, maize, cotton, and sometimes squash.

Iberian Canals: The Creation of a New Kind of Infield

Oñate and his caravan of settler associates and grazing animals arrived in 1598 in Ohkay Owingeh, renaming it San Juan de los Caballeros. Although officials in Mexico delayed his departure for three years, it appears Oñate prepared to settle a new colony in New Mexico by interviewing participants from previous *entradas* who had observed Pueblo agriculture and living conditions on those expeditions. He also recruited Tlaxcalan and other Mexican Indians with knowledge of irrigation to accompany him in order to lay out the needed canals and field systems in the new colony.

Shortly after arriving in New Mexico, they began to excavate irrigation canals. They started on August 11, 1598, with laborers consisting of Mexican Indians and conscripted local Tewa Indians, including women and teens. Even today, elders in Ohkay Owingeh tell about women being forced to dig the first *acequia madre* (mother ditch), still in use today and now known as the Chamita-Yunque Canal. The women used their own digging sticks to dig roots and carried the dirt to the banks in their *mantas* (cloaks). The first canal was several miles in length, and laterals were planned to get water to the new infields. The fields were based on the Spanish agricultural "long lot" system, which required the canal to be above the fields and the fields to be parallel to each other, extending from the *acequia madre* to the river, in this case the Rio Chama.[78] Each settler or Indian farmer received a narrow strip of farmland that could be further divided into a kitchen garden, introduced or native traditional crop fields, and orchards.

After the introduction of Spanish irrigation, differential infield agricultural areas were divided into eight named field types. No precontact pueblo had this number of named field types. The basic land pattern was divided into irrigated farmland (Sp. *surta*) and commons (Sp. *ejido*). The long-lots (Sp. *extensiones*) method of the canal system made this field system possible. The *acequia madre* anchored this farm type by water flowing in a canal above the fields. Laterals were dug perpendicular to the main canal (Sp. *linderos*), and water was released down these canals from the highest canal back to the river, where the remaining water returned. This created a series of field segments that could be planted with different crops but would still prevent cross-pollination between maize races or other crop varieties in their milpas.

Water rituals associated with the Iberian canals were Roman Catholic or Mexican Indian in origin. Several Catholic religious rituals were brought from Spain to the New World to assure the continuous flow of irrigation water and the fertility of the land, and these survive today. The idea that "el agua es la sangre de la tierra" (water is the blood of the land) unites the community of farmers to clean the canals. The priest blesses the irrigation water and removes some for a special blessing to make Holy Water that worshippers who bring containers to church on Good Friday can take home. The priest also organizes a procession to carry the patron saint of agriculture, San Isidro Labrador, through the community fields to bless them as well to assure good crops.[79] In other pueblos their patron saint is carried through the field on the saint's Holy Day and they pray for the same result. For example, on June 12, San Antonio is asked for sacred assistance as he is paraded through the fields at Ojito de San Antonio.[80]

Pueblo family rituals for successful crops in the infield continued despite the introduction of Catholicism. Basalt boulder shrines continued to be part of worship by Pueblo family members and community sodalities. The only new addition was a saint used by the priest to bless the field. The infield depended on canal irrigation to water the extensive array of crops, both aboriginal traditional crops and new ones introduced by the Spanish colonists.[81] A different irrigated field was devoted to each named crop. The aboriginal crops would have one field of corn of each color, another for each of the three named beans, and yet others for each of the three squashes. Bottle gourds had one field, and cotton was grown in an irrigated field. The Spanish-introduced

crops had separate fields. Chile had its field; wheat, barley, and each bean had one; vegetables were planted separately; and the condiments, dyes, medicines, and spices shared a common irrigated space, which received water more frequently than the other plants.[82]

Outfield: More Grazing, Less Agriculture

When the Spanish arrived, gravel mulch fields were left intact without replacement or expansion. The mulch formed the base of the plant pasture and continued to conserve water, hold heat in the stone cover, and serve as a nursery for ruderals selected for growth by grazing preferences of Iberian herd animals.

The area that served as the outfield in the pre–Oñate pueblo period was used for a limited grazing pasture for turkeys to catch grasshoppers. With the arrival of the Mexican settlers, the stone mulch fields were appropriated for the grazing of their herds of domesticated stock. Grass and ruderals grew between the stones and even on bare ground. These were encouraged by the capture of water in the gravel mulch. The area with stone gravel was very extensive, often covering several hundred acres, which provided ample grazing and composed most of the pasture (Sp. *pasteo*). These fields can be studied and measured today because the stones are still there after seven hundred years, and the captured water is still supporting a variety of plants. This is obvious today if one climbs a mesa overlooking these mulch fields at the beginning of spring. The extent of vivid green stands out in stark contrast to bare areas or unmulched surfaces because the lithic mulch continues to trap winter precipitation and spring rain for grass and ruderals. Portions of the pasture were planted with European alfalfa to feed the animals as it grew or to harvest and store for winter fodder. Some maize was planted here for human and animal food and as stubble for grazing.

The Spanish named two groups of domesticated animals. One was *ganado major* (large livestock), which included cattle, horses, mules, and donkeys. The second was *ganada menor* (small livestock), which included sheep, goats, pigs, and chickens. Sheep, the most numerous of the pasture animals, were introduced by the Spanish. Their wool quickly replaced cotton as the primary weaving material in the pueblos. Sheep harmed the mulch fields by encouraging erosion through overgrazing and destruction of the surface stone mulch. As a result, the lithic mulch fields became heavily grazed, preventing the planting of cotton and other crops. Now cotton could be grown only in canal-irrigated infields. The mulch fields became permanent pasture for the introduced grazing stock. Hogs could be released in the pasture but they were more likely penned in corrals.

The Spanish introduced many other exotic grazing animals that appropriated the new pasture areas and prevented Indians from planting.[83] The Oñate *entrada* brought live animals with them to slaughter, butcher, and eat while traveling northward. The published inventory gives counts of seven thousand heads of livestock, including 799 long-horned criollo cattle, 3,900 churro sheep, 846 goats, 356 oxen, 316 horses, 66 mules, 53 hogs, and an untallied number of chickens and geese. They duplicated the Pueblo farmers by also raising turkeys and grazing them in the outfields to eat the grasshoppers that would otherwise consume the vegetative growth of the corn stalks, leaves, and vegetables. The pasture areas supported all these animals.[84]

Fences and corrals further subdivided the new outfield with architectural features that had not been used prior to the arrival of the Spanish. The Spanish introduced wooden fences to further divide the pasture and to segregate the different animals. They also excluded animals by building wooden corrals to assure the isolation of species of different ages, physical condition, and health.

Summary: Iberian Agriculture

This imported agricultural tradition totally transformed Pueblo farming and how it is still practiced today. First, the Spanish colonists and their Mexican Indian allies introduced canal irrigation based on gravity-flowing water and an integrated network of interconnected canals. This water dispersal system required interdependence on the part of the farmers and intervillage cooperation to maintain and clean the canals.

Second, they introduced European animals used for food, work, and transportation. These edible animals—sheep, goats, cattle, hogs, and chickens—replaced some hunting and provided efficiently obtained and storable meat.[85] Chickens and geese yielded eggs. Obviously, some animals provided transportation, success in warfare, and the movement of goods. Others, such as oxen, could plow the fields and move heavy or bulky items in carts. Farming became more productive by using metal axes and crowbars, and animal-drawn plows and carts to haul crops home for storage or wood for construction and fuel.

Third, the diet of the Indians was improved with a new array of food plants that could be grown efficiently and with large-scale irrigation security. Although Mesoamerican plant foods eaten in combination provided complementary amino acids creating a vegetable protein, Iberian recipes and foods, such as wheat, had a complete protein. European plant foods came from the Iberian Peninsula or the Mediterranean coastline. Grains included barley, millet, oats, rice, rye, sorghum, and wheat. Leaf vegetables included artichokes, cabbage, chicory, garden cress, endive, lettuce, spinach, and watercress. Stem vegetables were asparagus, cauliflower, celery, and leeks. Root vegetables were also numerous, including beets, carrots, garlic, horseradish, onions, parsnips, radishes, and turnips. Fruit vegetables included cucumber, eggplant, and tomatoes. Legumes were numerous and important, including black-eyed peas, broad beans (fava), garbanzo beans (chickpea), lentils, peas, and vetch. Stone fruits were apricots, cherries, nectarines, peaches, and plums; citrus fruits included lemons, limes, oranges, and pomelos; and orchard fruits included apples, figs, jujubes, olives, pears, pomegranates, and quince. Other new fruits were grapes, melons, watermelons, and the nuts included almonds, chestnuts, and walnuts. Introduced culinary and medicinal herbs included borage, chives, coriander, fennel, lavender, mallow, mint, oregano, parsley, rosemary, rue, anise, caraway, castor beans, cumin, ginger, black mustard, saffron, and tamarind. New miscellaneous plants were sesame, sugarcane, flax, hemp, indigo, woad, alfalfa, and mulberry. It is obvious that the vegetable economy and food plants expanded enormously with the arrival of Spanish-speaking settlers.[86]

Fourth, other activities now could be conducted more efficiently. The introduction of metal tools and weapons made this possible. Warfare became more lethal with medieval weapons and more effective projectiles. Spanish soldiers and Indian warriors rode armored horses and used vicious war dogs to intimidate enemies. Farming became more efficient as metal tools replaced fire-hardened oak. Oñate's inspection in Santa Barbara listed metal tools and weapons and suggests the use of crowbars and shovels by the farmer.[87]

The Tewas in Ohkay Owingeh were the first Puebloans exposed to Iberian farming practices and gained a distinct advantage in productivity and efficiency over other Pueblos.

Conclusions

About twelve thousand years ago Paleo-Indians in southern Mexico were practicing plant gathering as one of their subsistence methods. One of the collected plants was Balsas teosinte, and another was a *Cucurbita*. Their selective processes were intensive enough that they changed these species genotypes on the way to domestication. By eight thousand years ago a low-productive maize cob had evolved. The squash was multifruited, with numerous edible seeds. Other species

2

Converging Stones in Divergent Streams: Mission-Era Petroglyphs among Seventeenth-Century Zuni Pueblos

KLINTON BURGIO-ERICSON

Experiencing Southwestern rock art is often an uncanny encounter. As one's eyes adjust from the inverted sea of expansive sky, brilliant and crossed by trolling fleets of cumulus clouds, geological features come slowly into focus. First one notices the smooth cliff faces and the earthy russet colors of sites such as the escarpment of El Morro National Monument in Cibola County, New Mexico. From the dazzling light and stark contrast of creeping shadows, new details come into focus. Then, as if in a sudden emergence, etched figures appear and one realizes that he or she is not alone. The presence of shimmering visages, angular stick figures, handprints, bear paws, and coiling spirals animate the landscape (fig. 2.1). Snakes zigzag across stones, lines of boxy mountain sheep traipse past, centipedes scuttle up cliff faces, and masks stare back with eerie, unmoved regard.

Perception of these ancient images depends upon one's angle, the position of the sun, and the viewer's cultural conditioning. Rock art represents site-specific markings on the landscape connecting Native ancestors to the present and evoking oral histories.[1] It includes painted pictographs and incised designs called petroglyphs that artists created by either abrasion or percussion. The latter involved direct blows from a hammer stone, or the use of a percussion stone against the rock that artists beat to make small chips or peck marks in the surface.[2] Of the countless petroglyphs in the Southwest, a distinct subset shows traces of cultural encounters among Spanish colonizers and Indigenous people in the sixteenth and seventeenth centuries. Mixing Native practices of marking with Colonial-era imagery and contexts, the designs present challenges to art history and archaeology. These disciplines have historically shared preoccupations with parsing the interrelations of ethnic groups through their material remains. Rather than acceding to essentialized cultural groups and trait lists, modern scholarship challenges simplistic models of past societies, and increasingly focuses on cultural interrelations and exchange.

Recent studies of early Colonial New Mexico have focused on two contrasting themes: the resistance of Native peoples to colonization, and the convergence of European and Indigenous

OPPOSITE

2.1. Petroglyphic panel with pecked ancestral figure, handprints, and other motifs. El Morro National Monument, Cibola County, New Mexico. Photograph by the author, 2013.

cultural traditions. Centering on moments of outright violence (such as the 1680 Pueblo Revolt), resistance studies have had less interest in the everyday experiences of Colonial life between these uprisings, when communities of Native, Spanish, and *genízaro* Indians (converted Native people who were captured and detribalized through war or abduction) became deeply entangled.[3] Other studies of New Mexico have focused more on the evidence for increasing cultural convergence by the end of the Colonial period.[4] In a study of sacred images, for instance, William Wroth describes conceptual convergences among Indigenous and Spanish image making at the popular level.[5] While acknowledging the vast cultural differences between the two traditions, Wroth also identifies parallels in how both recognized spiritual eminence or presence in the material world, representing "a sympathetic confluence of worldviews," despite ongoing social and political conflicts.[6]

This chapter contributes to the study of colonial encounter and cultural negotiations by introducing two unique petroglyphic slabs that were part of the built environment of the ancestral Zuni Pueblos of Hawikku and Kechiba:wa in western New Mexico (figs. 2.2–2.3).[7] The Hendricks-Hodge Archaeological Expedition collected both in 1919 for the Museum of the American Indian, Heye Foundation, and they presently reside in the collections of the National Museum of the American Indian. These unusual artifacts complicate themes of resistance and convergence, speaking instead to the intercultural complexity of the early Spanish Borderlands. Their placement in Franciscan structures brought together two very different expressive traditions: the Indigenous practice of pecking images on the landscape, and the Ibero-American use of religious architecture for evangelism and social control. As part of the architecture of missionization, the stones might suggest a convergence of material traditions, but they remained in largely divergent streams of thought and belief. This chapter places these slabs in their mission contexts, exploring implications of their petroglyphic techniques and their potential resistance to Spanish acculturation.

2.2. Front and back of the "IⱯRI" petroglyphic slab from Hawikku Pueblo, Cibola County, New Mexico, in raking light, ca. 1629–1672. National Museum of the American Indian, Smithsonian Institution (093637.000). Photographs by the author, 2014.

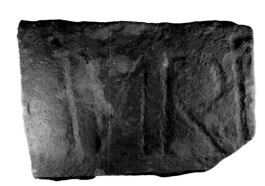

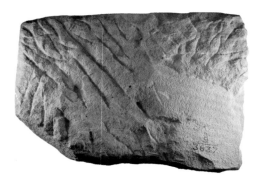

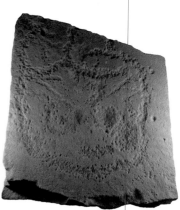

2.3. Back and front of a petroglyphic slab from the gospel wall of the *visita* chapel at Kechiba:wa Pueblo, Cibola County, New Mexico, in raking light, petroglyph date unknown, incorporated in the chapel wall ca. 1650–1680. National Museum of the American Indian, Smithsonian Institution (095804.000). Photographs by the author, 2014.

Zuni Missionization

Early Spanish explorers emerged from the rugged terrain of what is today eastern Arizona into the red and white sandstone mesas and valleys of the A:shiwi people in 1539–1540. The ancestors of today's Zuni Pueblo lived in six or seven towns along the Zuni River, including Hawikku and Kechiba:wa to the southwest, and another cluster of Halona:wa, Kwa'kin'a, Kyaki:ma, and Mats'a:kya to the north (fig. 2.4).[8] After an initial legacy of violence and confrontation, the full weight of colonization fell in 1629, when the Spanish planted Franciscan missions among Zuni and Hopi communities on the Colorado Plateau.[9]

These establishments were part of a wider campaign of evangelization that mendicant religious orders such as the Franciscans, Dominicans, and Augustinians undertook throughout Spanish colonies.[10] At a local level, this effort relied upon creation of missions or *doctrinas*, which were Indian parishes where regular-order friars administered liturgical functions and pastoral care in place of diocesan priests of the secular order. *Doctrinas* were theoretically temporary arrangements, for once evangelization of the local Indigenous population was complete, the friars were supposed to turn these parishes over to diocesan control through a process of secularization, although Colonial New Mexico never reached this point.[11] *Doctrinas* were residential institutions, where friars lived alongside lay brothers and staffs of Indigenous laborers in quarters known as *conventos*, most often inwardly facing rectangular arrangements of rooms around open patios or gardens, attached to their respective mission churches.[12] Many residential missions also administered *visitas* among nearby communities. These typically comprised small chapels or churches with lockable storage for liturgical items, which a friar would periodically visit to administer sacraments.[13] Among the Zuni towns, Franciscans initially established two *conventos*, one at Hawikku and the other at Halona:wa (present-day Zuni Pueblo), each with an additional *visita* chapel, at Kechiba:wa and either Mats'a:kya or Kyaki:ma.[14] By the time of the Pueblo Revolt in 1680, all were destroyed or abandoned, and missionaries rebuilt only at Halona:wa when they returned in 1700.[15]

As I have argued elsewhere, primary sources and the archaeological remains of the Hawikku mission indicate three distinct phases, matching Franciscan patterns of sequential construction of their *conventos*.[16] Early missionaries adapted an existing Zuni house from 1629 until 1632, when

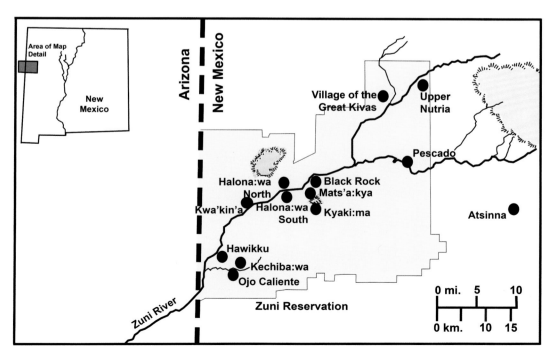

2.4. Map of Zuni Reservation, with important settlements and archaeological sites. After Richard B. Woodbury, "Zuni Prehistory and History to 1850," in *Handbook of North American Indians*, vol. 9 (Washington, DC: Smithsonian Institution, 1979), 467, fig. 1.

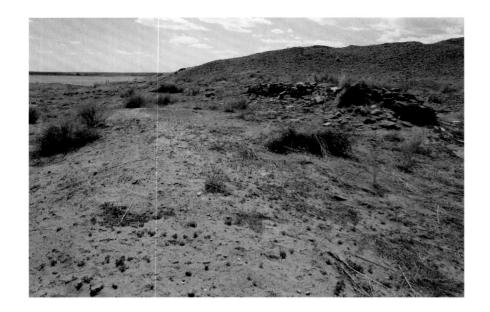

a priest incited the community and lost his life as Zunis burnt the mission. Franciscans later returned to Hawikku in the mid-seventeenth century, establishing a formal mission with a single-nave adobe church and residence attached to its southeastern flank (fig. 2.5). This phase produced the structure that archaeologists excavated in 1919, with additions and alterations that had accumulated during twenty-some years of use. Hawikku's mission burnt again in a 1672 Apache raid, and eventually fell to ruin.

The timeline for Hawikku's dependency at Kechiba:wa (figs. 2.6–2.8) is less clear, and its architectural remains have received little research or publication.[17] Spanish sources make almost no mention of it, and the unexcavated surface remains are the primary source of information, although this *visita* also appears in Zuni oral history. For example, former K'yakwe Mossi (Head Rain Priest/Rain Priest of the North) Mecalita Wytsalucy recounted the story of Apaches burning the Hawikku mission, killing its (noncelibate) priest, and capturing his Zuni wife and her sister. When the wife finally escaped, she found Hawikku's men living at Kechiba:wa, building the chapel.[18]

A mission report from 1663–1666 mentions Hawikku's *visita* at an unnamed nearby pueblo, almost certainly Kechiba:wa.[19] But the current ruins were not necessarily under construction at that time, since the first chapel might have been a repurposed domestic structure. Construction likely had begun before destruction of the Hawikku mission, since fray Juan Galdo's inventory mentions Kechiba:wa in 1672, but builders probably never completed it.[20] Oral histories seem to indicate that efforts continued on the Kechiba:wa chapel after Hawikku's mission burned, possibly including the salvaging of timbers for the smaller *visita*.[21]

2.5. Looking southwest over the excavated ruins of the Franciscan Purísima Concepción mission (foreground) and Hawikku Pueblo ruins (background), Cibola County, New Mexico. Mission established 1629, formal structure built mid-seventeenth century, destroyed 1672. Photograph by the author, 2011.

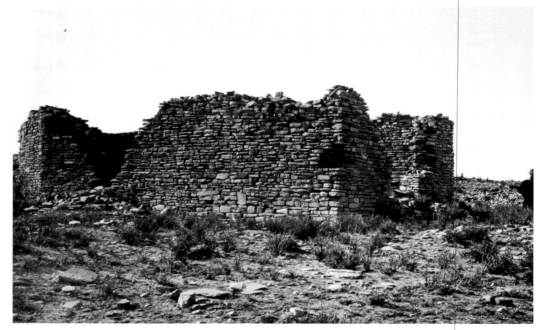

2.6. Detail of the ruined Franciscan *visita* chapel, Kechiba:wa Pueblo, Cibola County, New Mexico, ca. 1650–1680. Looking west, with the petroglyphic slab installed near the center of the image. Photograph by Victor or Cosmos Mindeleff, 1885. National Anthropological Archives, Smithsonian Institution (MSS 4362, vol. 2).

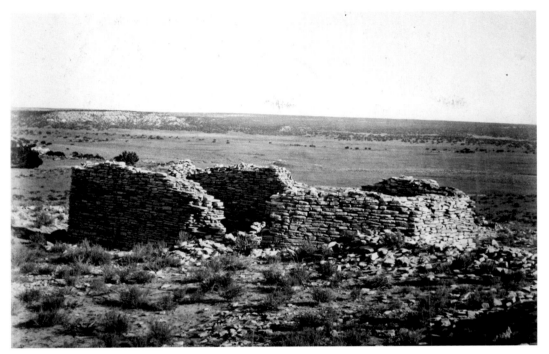

2.7. Detail of the *visita* chapel, Kechiba:wa Pueblo, Cibola County, New Mexico, ca. 1650–1680. Looking east, with the side doorway opening at center and polygonal apse to the right. Photograph by Victor or Cosmos Mindeleff, 1885. National Anthropological Archives, Smithsonian Institution (MSS 4362, vol. 2).

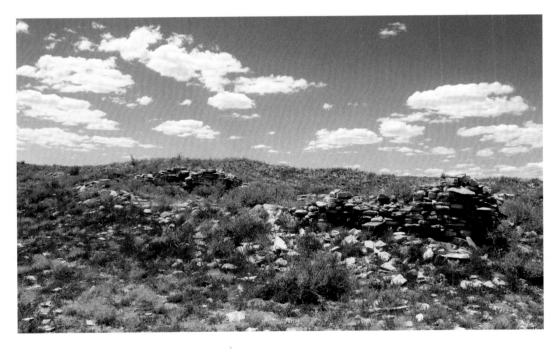

2.8. View of the *visita* chapel, looking west over its gospel wall, Kechiba:wa Pueblo, Cibola County, New Mexico. Photograph by the author, 2019.

When brothers Victor and Cosmos Mindeleff surveyed the site on September 22, 1885, the chapel's stone and mud-mortar walls stood eight to ten feet above grade, rising to fourteen feet at the highest.[22] It was a simple but well-constructed single-nave building approximately fifty feet long and twenty-five feet wide, bisecting an open plaza that slopes up gradually toward the west (fig. 2.9).[23] Although the Mindeleffs represented the chapel as essentially freestanding, personal inspection makes it clear that its octagonal apse was attached to a linear range of pueblo rooms extending southwest, essentially aligned with its nave walls, and pertaining to a larger room block covering the site's high ground (figs. 2.10–2.11). Beam sockets three to four feet high around the interior walls suggest that builders envisioned a raised wooden floor that would have been rare for seventeenth-century New Mexico.[24] This elevated floor may have allowed a shallow crypt

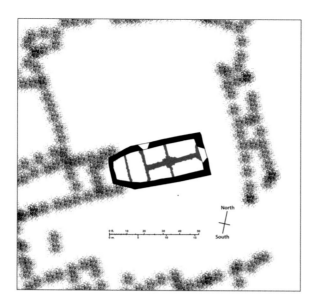

2.9. Plan of the *visita* chapel, in the plaza of Kechiba:wa Pueblo, with interior subfloor walls in lighter gray. Rock scatters follow the Mindeleff survey (*A Study of Pueblo Architecture,* pl. 49), but with added approximation of alignments southwest of the apse, based on personal inspection of the site.

2.10. View of the *visita* chapel looking southeast at its epistle wall, across the open plaza of Kechiba:wa Pueblo, Cibola County, New Mexico. Note the mounded rubble of pueblo rooms aligned with the chapel and abutting its apse in the right third of the image. Photograph by the author, 2019.

2.11. View of the *visita* chapel looking north at its gospel wall across the open plaza, Kechiba:wa Pueblo, Cibola County, New Mexico. Note the mounded rubble of pueblo rooms behind the apse in the left half of the image. Photograph by the author, 2019.

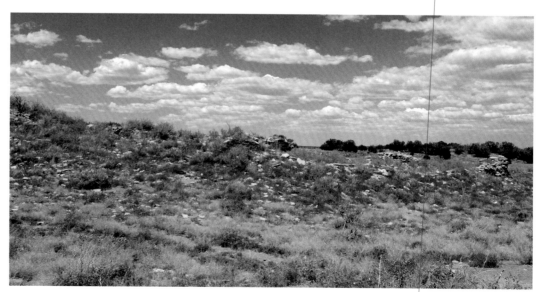

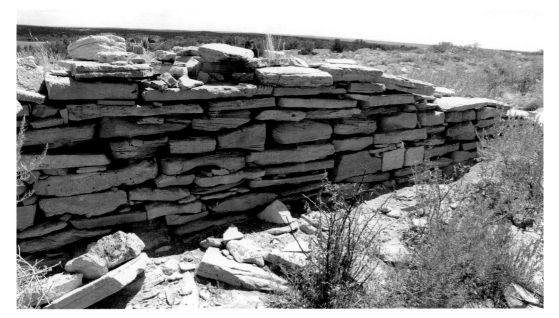

2.12. Masonry of the outside epistle wall, near the north corner of the Franciscan *visita* chapel, Kechiba:wa Pueblo, Cibola County, New Mexico. Photograph by the author, 2019.

beneath, a degree of craftsmanship belying the chapel's small size. Victor Mindeleff also noted the high-quality masonry, with small stones carefully chinking seams, and splayed openings "laid with extreme care [. . .] producing a highly finished effect" (fig. 2.12).[25] If this chapel was under construction in 1672, Galdo may have been responsible for its design and higher construction standards, given his apparent distaste for New Mexico's typical architecture.[26]

The main opening in the northeast facade splayed inward, and probably held a double-leaf doorway on pintle hinges.[27] A second, smaller door splayed outward in the northwest wall, at the foot of the sanctuary, but without trace of a sacristy attached to the epistle side. Perhaps one of the rooms abutting the apse served as storage for liturgical materials. The sanctuary walls angled together to form a polygonal apse, as was common among Franciscan churches in New Spain, and beam sockets for a raised wooden sanctuary floor are visible in an early photograph (fig. 2.13).[28] Finally, a window opening high in the southeast wall illuminated the sanctuary. The Mindeleffs observed no surviving woodwork, which was likely incomplete or reused by the 1880s.[29]

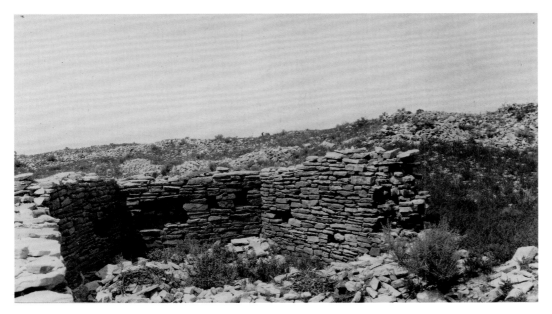

2.13. Apse of the Franciscan *visita* chapel, Kechiba:wa Pueblo, Cibola County, New Mexico. National Museum of the American Indian, Smithsonian Institution (N21049). Photograph by Samuel Kirkland Lothrop, 1923.

Kechiba:wa's chapel is notable not only for its quality construction but also its location in the center of the pueblo. Asserting Catholicism in the midst of community life, this location was rare in the seventeenth century.[30] It suggests either a forcefully coercive friar, or perhaps a faction of pro-Spanish Zuni ancestors who asserted themselves in claiming the space. Despite its centrality, however, Ferguson's comparative space syntax analysis indicates the *visita* was poorly integrated into the community and segregated in its centrality, making its location more likely to be a missionary's imposition than a community decision.[31]

The Hawikku Petroglyphic Slab

The Hawikku slab (see fig. 2.2) is a piece of reddish sandstone, 1 foot 6.9 inches long by 1 foot 1.2 inches tall, and approximately 2.6 inches thick.[32] Traces of a chiseled outline mark where its makers roughed it into this rectangular shape before grinding the front smooth. Two sides have stone percussion marks squaring the edges, and the back is beveled and rough, with scoring from a metal chisel to anchor it in the mud mortar of its structure. The finished design comprises the alphabetic abbreviation INRI, signifying the Latin for Iesus Nazarenus, Rex Iudaeorum or "Jesus the Nazarene, King of the Jews," pecked into the front surface (fig. 2.14). All the letters are capitals, with serifs at top and bottom, dotted *I*'s, and a reversed *N*. Their precision suggests use of percussion and hammer stones for control, and they may have been painted with what appears to be traces of white or yellow pigment encrusted in some of the serifs.

Close inspection reveals the fine lines of an initial design inscribed into the ground surface with a metal chisel (fig. 2.15). Most of these lines are no longer visible due to subsequent pecking and weathering, leaving only traces of an initial *I* on the left, and a vertical line between the pecked *I* and reversed *N*. The chisel cut a different, more convex lettering style, with a netted pattern scoring the cigar-shaped *I*. The pecked letters do not align with the chisel marks nor match their style; it appears the pecking artist rejected this initial chisel design. Perhaps a missionary cut the first marks, but a Native artist found chiseling unwieldy and reverted to more familiar petroglyphic methods.

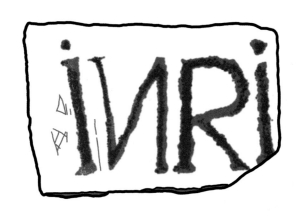

LEFT

2.14. Drawing of the surviving inscribed chisel marks (red) and pecked letters (gray) of the Hawikku petroglyphic slab. National Museum of the American Indian, Smithsonian Institution (093637.000).

RIGHT

2.15. Detail of the chisel-inscribed lines and pecked letters of the Hawikku petroglyphic slab, in raking light, ca. 1629–1672. National Museum of the American Indian, Smithsonian Institution (093637.000). Photograph by the author, 2014.

Furthermore, the slab seems to indicate the technological competencies of grinding stones known as metates, as much as those of rock art. Like metates, it has pecked, rectangular sides and a carefully ground, slightly concave face. In ethnographies, the tasks of quarrying, roughing, and finishing metates belonged to women.[33] In contrast, carving petroglyphs was mostly a male activity.[34] This stone's design and construction therefore involved differently gendered competencies and techniques, which might implicate multiple artists, both male and female, Zuni and Spanish.

The National Museum of the American Indian (NMAI) catalogue records no specific provenance for the Hawikku slab, which Frederick Webb Hodge collected in 1919. I have found no mention of it in the field notes, but it does appear in a 1924 manuscript titled "Hawikuh of the Zunis: A Scene of Franciscan Tragedies." After a romantic account of Franciscan deaths at Hawikku, Hodge describes finding the petroglyphic slab as follows: "The day was dying in the west when, strolling from the camp toward the brow of the Hawikuh knoll, my eye fell on a flat-topped rock which conjured up memories of generations agone and of the loneliness of him who pecked in the upper face the simple but meaningful initials INRI."[35] This description indicates the stone was on the north side of the pueblo's promontory, away from the mission itself, and sat with its inscription exposed. The front surface is weathered and discolored, flaking away and showing patches where lichen grew over the letters (removed by museum staff). The back remains unweathered, however, probably because builders embedded it in an architectural structure or platform, leaving the inscription visible.

This slab likely belonged to a standing cross that Franciscan missionaries erected in an attempt to sanctify the landscape to their purposes. Placards with INRI typically appear atop crucifixes, but this heavy stone might have been embedded in a masonry base instead, part of a standing cross near the town's northern approach. The Spanish erected crosses as claims on Indigenous territory. When Juan de Oñate visited the Zuni pueblos in November 1598, he saw standing crosses that previous *entradas* had left, to which Zunis offered prayer meal, painted prayer sticks, and feathers, interpreting the potent symbol through their own cultural framework.[36] The Hawikku slab likely came from a more substantial cross raised in the seventeenth century, when metal chisels were among missionary toolkits, and a longer occupation allowed for more durable construction.[37] The ornately carved stone crosses that stood in the forecourts or atria of many *doctrinas* in central Mexico are likely prototypes for this cross at Hawikku, even if it was located on the edge of the pueblo rather than in the mission's courtyard.[38]

Hodge imagined a solitary friar living in isolation among the Zunis, casting off familiar conventions of stonework to adopt petroglyphic pecking for his "lonely" inscription, which seems an unlikely and romantic fantasy. Franciscan missionaries in New Mexico did not live in cloistered seclusion and relied instead upon large staffs of Native laborers to build and sustain missions under often coercive conditions.[39] A Franciscan probably ordered the construction of the cross and its inscribed slab, perhaps chiseling the design but turning the work over to Zunis, who switched to more familiar stonework techniques. The pecked letters do not match the original inscription, and a literate friar likely would not have reversed the *N* or dotted the capital *I*'s. Instead, the petroglyphic artist seems to have treated letters as graphic design elements rather than linguistic signifiers, reversing the *N* and its diagonal stroke as a complimentary mirror to the stroke of the letter *R* at the center of the composition. The reversed *N* was an iconographic revision of sufficient exigency for Indigenous artists that it arose elsewhere in Colonial New Spain, seemingly independently. For example, a sixteenth-century atrial cross at the Asunción de Nuestra Señora mission in Tlaxcala, Mexico, exhibits the same alteration in its carved stone placard.[40]

In 2016, I worked with the Zuni Cultural Resources Advisory Team (ZCRAT) and Smithsonian staff as part of a Recovering Voices Program visit to review the institution's collections, providing opportunity to discuss Zuni artifacts with authorized and knowledgeable community

leaders. Curtis Quam, a ZCRAT member, suggested that the reversed *N* might be an intentional mark of resistance to Spanish colonization and forced labor in the missions. He speculates that the hardships of compulsory work might have led the stone's artist to produce the reversed signifier: "that anger, that hurt, that sadness [. . .] show us that this is [. . .] a way of retaliating against it. 'You can make me do this, but it's on *my* terms, it's with *my* hands' [. . .] and maybe this is a message from [our ancestors]. They knew the alphabet, and they knew the lettering [. . .]. Looking at this, it might be a sign of them rebelling and also just showing that, 'You can make me do this, but it's on my terms.'"[41] In Quam's reading, the reversed letter is a subtle act of resistance, in a time when New Mexico's semiliterate population venerated script as having almost magical properties.[42] In this interpretation, the pecked message to later generations of Zunis would have conveyed the maker's pride and unwillingness to fully embrace the imposition of Spanish Catholicism.

The Kechiba:wa Petroglyphic Slab

In contrast to the Hawikku petroglyph, which Spanish missionaries clearly instigated, the Kechiba:wa petroglyphic slab appears to have come from preexisting rock art that mission-era builders collected and reused in the *visita* chapel.[43] It is a slightly smaller, trapezoidal slab of lighter buff- to reddish-colored sandstone, with three sides roughly at right angles and the top (as installed) more sharply slanted, 1 foot 3.5 inches tall by 1 foot 1.4 inches wide, and 3.3 inches thick.[44] The makers dressed the slab without additional pecking or shaping, but beveled its back edges, and scored the back with a metal chisel like the Hawikku slab for better adherence.

This slab's distinctive feature is its petroglyphic image (fig. 2.16; see also fig. 2.3), with deeper and more pointed peck marks scattered more loosely across its surface in comparison to the tightly controlled pecking of the Hawikku stone. Some marks may also be incidental, from weathering or subsequent damage. As with the Hawikku stone, the maker probably used a hammer stone against a chisel-like percussive stone, rather than bashing the rock face directly. At least two spots are more deeply pecked than elsewhere, from successive reworking or deepening of specific marks.

The design incorporates recognizable motifs, such as the large circle with open ends, like a loosely rendered spiral circumscribing the composition.[45] Its ends do not fully meet but rather interlock in two opposing arcs, suggesting what ethnographers have described as a friendship symbol.[46] Within the large circle are other round shapes and concentric circles.[47] As it was installed, the large circle floats on the slab's compositional plane, with indecipherable designs running off its upper edge, indicating its origin in a larger, unidentifiable petroglyphic panel.

This image is hard to interpret without knowing its original orientation and complete appearance. If one views the stone in the opposite direction from how it was installed, it appears vaguely figural, with a face, mouth, and bulging eyes in a rounded head. This perspective might suggest the lumpy heads of the *koyemshi*, or mudheads, Zuni supernaturals who are the deformed offspring of a brother and sister during ancestral migrations, and who participate in ceremonial events as revered beings both comedic and powerful.[48] If figural, the petroglyph might also represent a skull or skeleton, which appear frequently in mission contexts as reminders of mortality. For his part, Mindeleff interpreted it as a "rudely drawn mask" by a Native artist.[49]

Perhaps this image is not figural at all though; a reading more consistent with Zuni rock art practices and interpretations might see it as a portion of a map instead. Today's religious leaders identify many examples of rock art as trail maps, with curvilinear lines indicating ancestral routes and pecked points representing settlements. In viewing the Kechiba:wa slab, ZCRAT member Octavius Seowtewa compared it to other petroglyphic maps: "This one is very interesting, because we've dealt with similar things like this. It looks like it might be a trail map, with different settle-

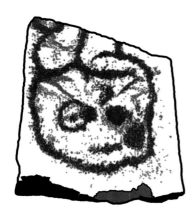

2.16. Drawing of the pecked design of the petroglyphic slab, from the Kechiba:wa *visita* chapel. National Museum of the American Indian, Smithsonian Institution (095804.000).

ments [tracing the lines with his finger] coming in, settling, and going back. So, it might be a trail of Hawikku, and Kechiba:wa, and all the other settlements [. . .]. These indentations would be settlements, and the actual trails going to settlements [. . .] and this [the concentric circle motif] is identified as looking for the middle place."[50] Although this interpretation might seem counterintuitive to non-Zunis who privilege figural representations, it is consistent with Zuni interpretations of rock art transmitting knowledge of place in combination with oral histories.

The petroglyphic style and removal from a larger panel suggest this piece came from pre-Hispanic rock art repurposed for the chapel. Hodge called it an "engraved stone from wall of church," but his notes provide no further information.[51] Fortunately, late nineteenth-century photographs show the slab in position, embedded at about waist height in the chapel's exterior southeastern wall (fig. 2.17; see also fig. 2.6). It stood upright amid coursed stone masonry, with smaller stones spanning its irregular top side. The builders treated it as a nonstructural veneer, taking trouble to affix the image in an upright, visible position, unlike other stones in the wall. It is possible that mud plaster would have covered the slab had the chapel been finished, but its positioning and visibility during construction were clearly intentional.

The Significance of Mission-Era Petroglyphs

While rock art of the US Southwest has inspired documentation and significant literature, Colonial-era petroglyphs are generally an afterthought. Regional surveys such as Polly Schaafsma's *Rock Art in New Mexico*, for instance, briefly mention "historic" examples, including images of horses and Europeans.[52] For Schaafsma, Spanish rock art—crosses, inscriptions, and figures of priests and soldiers—is a distinct component pertaining to Hispanic culture. The separation of Spanish and Pueblo rock art as two individual categories might be too clean, however, as an example of a tufa cave covered with crosses and a horned serpent suggests.[53] Richard Ford expands upon Schaafsma's work using survey data from Mesa Prieta in Northern New Mexico, where Spanish petroglyphs differ from Indigenous rock art in patterned and predictable ways. Ford's interpretation of crosses inscribed over Pueblo rock art panels illustrates the complexity of Colonial-era petroglyphs. He sees them as traces of detribalized *genízaro* Indians, who still recognized ancient power in the sites and sought to add to it with Christian crosses rather than effacing or exorcising ancestral Pueblo expressions.[54]

Within the relative dearth of Colonial rock art studies, the convergence of Native traditions with Spanish imagery requires more nuanced and focused research. The Zuni petroglyphic slabs represent a subset of rock art that became semimobile objects, incorporated into pueblo houses and mission structures, and then removed to East Coast museums.[55] The significance of the Hawikku petroglyphic slab lies partly in its technical characteristics, showing how Native artists rejected a Spanish chisel to adapt techniques according to their own sensibilities instead. The result was a culturally hybrid object speaking the orthographic language of European Christianity, but in visual and material idioms belonging to the Pueblo world, which became a visible component in the Colonial town's built environment.[56]

The Kechiba:wa slab is more complicated, with a range of antecedents. European builders had incorporated spolia—carved stones from earlier structures—for millennia. Among other significations, these reused stones served as trophies of conquest and demonstrated the grandeur and legitimacy of new patrons and institutions by appropriating the glory of previous eras.[57] Beyond mere triumphalism, spolia can communicate complex meanings and layers of identity when lodged in built environments near their place of origin, as with the compounding implications accruing to spolia from Iberian Classical, Visigothic, and Islamic periods, which late Medieval Christians incorporated into Castilian churches. In visible dialogue with descendent

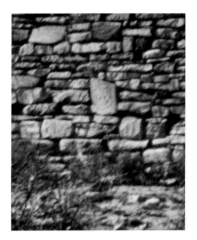

2.17. Detail of the petroglyphic slab in situ in the gospel wall of the *visita* chapel, Kechiba:wa Pueblo, Cibola County, New Mexico. Photograph by Victor or Cosmos Mindeleff, 1885. National Anthropological Archives, Smithsonian Institution (MSS 4362, vol. 2).

communities, these remnants recalled earlier eras with nostalgia; forged romanticized or mythological connections to the past; and reinforced indigenous identities and the local perseverance of customs.[58] Similarly, embedded pieces of pre-Hispanic sculpture (and early Colonial remnants) were common in New Spanish architecture, especially sixteenth-century missions. Examples recalling Indigenous cultures, beliefs systems, and aesthetics include reliefs in the walls of San Luis Obispo in Tlalmanalco (Mexico State, Mexico), and Aztec skulls from a pre-Hispanic temple set above the holy water fonts of San Bernardino in Xochimilco (Mexico City, figs. 2.18–2.19).[59]

Scholars have accepted Mexico's embedded stones without much serious consideration.[60] Many Latin Americanists have seen them as expedient appropriations of available building materials and symbolic acts of domination.[61] Others have recognized greater significance and Indigenous agency in embedded pre-Hispanic relics. Constantino Reyes-Valerio, for instance, argues that Native peoples concealed Indigenous religious understandings in these structures by choosing to preserve reliefs that the Spanish would see as merely decorative.[62] To Samuel Y. Edgerton, topoglyphs appearing on many Mexican missions communicated pride of place among second- and third-generation converts, which missionaries seemed to find agreeable.[63] Other embedded stones may evoke Mesoamerican termination rituals for the incorporation of earlier structures within new buildings, preserving and reinvesting the sanctity of a site.[64]

In a preliminary study of embedded pre-Hispanic reliefs, Eleanor Wake outlines a typology from numerous Mexican churches, as well as strong and meaningful pre-Hispanic precedents. This practice continued among all types of early Colonial buildings, with documentation of sustained Indigenous meaning under Spanish rule.[65] Wake believes that Native parishioners did not see embedded pre-Hispanic sculptures as symbols of Christianity's superiority; rather, the careful preparation of stones preserving their carvings, and their patterned placement, indicate that Indigenous associations remained present for Native viewers.[66] Most importantly, Wake tries to systematically document the location of embedded stones relative to their structures and landscapes, hypothesizing that they related to points on the horizon for calendrical observations.[67] She believes that stones not only evoked memories of Mesoamerican beliefs; they may also have been active survivals of Indigenous calendrical practices in the very fabric of Christian structures.[68]

As Mexican examples demonstrate, precedence existed for including Indigenous carvings in New Spanish mission walls, and New Mexico's Franciscans likely accommodated themselves to these materials. Zunis had their own practices of placing significant objects within masonry. Archaeological excavations at Hawikku noted frequent niches and recesses in domestic walls.[69] Another room incorporated a thin false wall to form a narrow, hidden compartment containing

LEFT

2.18. Pre-Hispanic "preciousness" glyph (*chalchihuitl*) embedded in the apse wall of the ex-Franciscan mission church of San Luis Obispo, Tlalmanalco, State of Morelos, Mexico. Built ca. 1560s. Photograph by the author, 2010.

RIGHT

2.19. Holy water font incorporating skull carving, probably from a pre-Hispanic Aztec temple, ex-Franciscan mission of San Bernardino de Sienna, Xochimilco, Mexico, ca. 1550. Photograph by the author, 2010.

2.20. Agate hammer stone embedded in the epistle wall of the *visita* chapel (nickel for scale), Kechiba:wa Pueblo, Cibola County, New Mexico. Photograph by the author, 2019.

a sealed ceramic jar with two *étowe*, or powerful fetish bundles.[70] The Hawikku mission may also have incorporated a pre-Hispanic loom anchor from a kiva floor as part of the paving of its residence.[71]

At Kechiba:wa, the eroding *visita* masonry shows that the petroglyphic panel was not the only embedded artifact. Today, an agate hammer stone is visible, encased within the epistle wall, and two broken grinding stones, or *manos*, elsewhere on the walls were probably also part of their masonry (figs. 2.20–2.21). The hammer stone is fully embedded inside and would not originally have been visible. Each of the *manos* represents roughly half of the former tools, broken in the middle. They have rectangular cross-sections and show grinding wear on both sides. Ceramic sherds and lithic flakes are also common throughout, used as chinking and mixed with the mud mortar (fig. 2.22).

While these artifacts were known to the builders who put them there, most would have been invisible when the walls were complete and plastered. It might be easy to dismiss these embedded artifacts as insignificant, but they represent the physical presence of Zuni ancestors at the site and within the fabric of the *visita* chapel, whether they had more explicit symbolic meanings or not. Indeed, ethnographic analogy suggests that refuse is culturally significant among

2.21. Broken grinding stones (*manos*), from the walls of the *visita* chapel, Kechiba:wa Pueblo, Cibola County, New Mexico. *Left*: in situ at the top of the epistle-side sanctuary wall. *Right*: in situ at the top of the gospel-side façade wall. Photographs by the author, 2019.

2.22. Ceramic sherds weathered out of the mud mortar from the epistle wall masonry in the *visita* chapel, Kechiba:wa Pueblo, Cibola County, New Mexico. Photograph by the author, 2019.

the pueblos in general, who associate it with the presence of ancestral spirits, and accumulated ash heaps or middens have often served as burial grounds, shrines, and locations for offerings.[72] Today, descendent Zuni community members conceive of archaeological sites as places where their ancestors reside and are living spiritual forces, manifesting partly through the accumulated traces of their lives and material customs. Remnant artifacts are tangible markers and footprints of this presence.[73]

Later ethnographic examples likewise attest to the significance of materials embedded in Zuni Pueblo walls to conceal or control and invest their power. John G. Bourke visited the pueblo in 1881 and noted a blue majolica plate set in an upper west-facing wall, which concealed a painting of the sun illuminated through a special opening around the autumn equinox, as part of a light-and-shadow calendar.[74] Frank Hamilton Cushing also saw markers for solar observations embedded in the pueblo's walls.[75] As at Hawikku, Mathilda Coxe Stevenson described the use of sealed rooms to contain esoteric materials, as well as the deposition of prayer sticks within mural compartments as part of ceremonial observations.[76] Visible and concealed objects embedded in the walls of Zuni structures were often charged with meaning.

While it is difficult to be certain whether Kechiba:wa's seventeenth-century residents saw detritus such as potsherds and broken *manos* in the same way, the practice of intentional architectural depositions has much older roots. For example, a pilot study by Margaret C. Nelson of four Eastern Mimbres sites (dated from ca. 1000 CE to 1450 CE) found that builders had deposited artifacts in the walls or floors of three-quarters of their houses, plastering over these objects afterward. The majority of depositions were grinding stones or projectile points, but a variety of other objects, such as pipes, fossils, and shaped stones, suggest to Nelson that what builders incorporated was less important than the basic act of depositing artifacts in their domestic walls.[77] Similarly, University of Nevada, Las Vegas excavations at the Elk Ridge Classic Mimbres site on the west fork of the eponymous river consistently found broken ground-stone artifacts and cores in its domestic walls.[78] Ancestral Pueblo sites likewise contained various forms of depositions, such as feathered prayer sticks, buried pots, architectural relics from earlier structures, and offerings.[79] Finally, excavations and repairs have revealed apparent caches or offerings in the walls and floors of Colonial-era mission churches as well. Hawikku itself included a deposition of deer forelegs beneath the main altar, while the Santa Ana mission church incorporated intra-mural caches of ceramics, and the rebuilding of the mission at Zia included an engraved stone signifying the pueblo's colonial land grant.[80]

No systematic study of such depositions in the fabric of Colonial missions in New Mexico yet exists, but several Pueblo missions have direct relationships with discarded artifacts in the form of middens. Some stood directly over ash heaps, or incorporated their fill as part of foundations and adobe brick construction, literally building the walls of these Colonial structures from ancestral remnants.[81] In locating missions on top of ash heaps, or incorporating midden fill and broken artifacts, builders may have been seeking to associate these new structures with ancestral remains, in continuity with those who came before. What through the lens of Western materialism might seem to be an expedient reuse of handy refuse, is potentially a more significant act when placed within the Zuni cultural landscape. Ethnographic analogy and patterns of incorporating traces of ancestral Pueblo creations in Colonial structures suggests that these inclusions were markers of cultural continuity and identity, rooting non-Native religious constructions in local materiality.

So what was the significance of the Kechiba:wa slab? Why did it merit such careful positioning in the partially finished *visita* chapel? Could Spanish missionaries have included the petroglyph to make a foreign liturgical environment more palatable to reluctant parishioners whom they forced to attend? This scenario has echoes of other evangelizing practices, as Quam puts it: "I think a lot of the Christian methods of gaining acceptance into communities were taking something of the community and applying it to Christian religion and culture. And we see that with our church [the Nuestra Señora de Guadalupe Mission in Zuni Pueblo], from what I've heard, there were drawings of *kokko* in the church walls."[82] Quam compares these Colonial-era conversion strategies of appropriation to the use of Zuni language by present-day missionaries, including the creation of a Zuni dictionary; a translation of the Bible into the language; and the distribution of proselytizing DVDs overdubbed in Zuni. Insertion of an Indigenous petroglyphic panel into the *visita* wall might have been a Franciscan attempt to gain trust and acceptance by connecting with familiar Zuni visual culture.

While members of the ZCRAT team who viewed the Kechiba:wa petroglyphic slab were careful to say that they could not be certain what it meant, Seowtewa offers another interpretation that emphasizes the agency of Zuni builders and community members instead. Hypothesizing that the petroglyph represents a trail map of places significant to ancestral Zunis, Seowtewa believes that embedding the slab might have reasserted cultural identity against the violence that the Spanish employed in mission construction and evangelization: "[The builders] didn't want to lose the identity of where they came from, and so [the stone] wasn't actually in the church—it was outside. [. . .] Not wanting to forget about where they came from, they might have put this up just as a reminder of them being the Zuni people."[83] Perhaps similar to the embedded handstones and ceramic sherds, the inclusion of ancestral materials may well have been a practical form of resistance to Spanish acculturative pressures. As with the Hawikku petroglyph's reversed letter and switch from European to Indigenous techniques, Seowtewa's reading of the Kechiba:wa petroglyphic slab finds agency among Zuni builders, who employed subtle adjustments to assert their identity and cultural claims through everyday building practices. While the great risk of violent Spanish retaliation prevented outright resistance in all but the most extreme circumstances, manipulation of construction materials and inclusion of ancestral artifacts may have allowed Zunis to affirm aspects of their communal identity, without missionaries fully understanding the implications.

The Zuni mission petroglyphs therefore occupy an ambiguous position in the study of hybrid material culture of the Spanish borderlands. Their form, text, and emplacement suggest converging cultural traditions, which might have reassured seventeenth-century Franciscans intent upon creating a monastic landscape from the Pueblo world.[84] Yet the construction details, range of interpretations, and response by descendent community members indicates a subtext of resistance,

reiterating Zuni cultural identity against colonial pressures. Relying upon various strategies, and benefitting from their remoteness, Zuni communities were able to resist Catholic influences, ultimately representing two divergent streams of belief, as the A:shiwi have preserved their religious traditions into the present, and Catholicism never became deeply rooted amongst them.[85]

Artifacts such as the Zuni petroglyphic slabs provide evidence for the agency of individual Zuni artists under Spanish Colonial rule. Reflecting aspects of both resistance and convergence, these deceptively complex artifacts expand the scope of hybrid material culture studies in New Mexico, and point to the need for more sustained attention to Colonial-era rock art, as well as alerting us to the possibility of significant embedded materials among missions of northern New Spain. The petroglyphic slabs' meaning depended not only upon iconographic content and physical context but also the diverse perspectives of their makers and users. The failed correspondence of a chiseled design and pecked lettering on the Hawikku slab dramatizes, in a microcosm, the divergent agencies at work in its construction, while interpretations of present-day Zuni community members open up multiple readings of these stones. Their significance falls ambivalently between the discourses of resistance and convergence, meanings which shift subtly into view the more one looks at them, like the silent, pecked faces of petroglyphic sentinels, horned serpents, and swirling migration spirals, becoming visible only with the right light and angle of perception.

Research for this paper occurred with the support of the Autry Museum of the American West, the Smithsonian Institution, the Crystal Bridges Museum of American Art, and the University of New Mexico. I would also like to thank Octavius Seowtewa, Curtis Quam, and the Zuni Cultural Advisory Team; Tom Kennedy, Kenny Bowekaty, and the Zuni Pueblo Department of Tourism; the National Museum of the American Indian and National Anthropological Archives; and Dick Ford, Robin Gavin, Joanna Gohmann, and Laurel Burgio-Ericson. Most especially I thank Will Wroth, who has been a supportive friend and interlocutor since I began exploring New Mexico colonial history. With sincere gratitude.

NOTES

1. M. Jane Young, *Signs from the Ancestors: Zuni Cultural Symbolism and Perceptions of Rock Art* (Albuquerque: University of New Mexico Press, 1988), 7–8, 13–14, 119, 138, 152–155.

2. Ibid., 48–50.

3. See Gwyneira Isaac, Klinton Burgio-Ericson, Chip Colwell-Chanthaphonh, T. J. Ferguson, Jane Hill, Debra Martin, and Ofelia Zepeda, "New Perspectives on Southwestern Anthropology," in *Handbook of the North American Indian*, vol. 1, ed. Igor Krupnik (Washington, DC: Smithsonian Institution, *in press*).

4. William Wroth and Robin Farwell Gavin, preface to *Converging Streams: Art of the Hispanic and Native American Southwest*, ed. William Wroth and Robin Farwell Gavin (Santa Fe: Museum of Spanish Colonial Art, 2010), 10–11.

5. William Wroth, "The Meaning and Role of Sacred Images in Indigenous and Hispanic Cultures of Mexico and the Southwest," in Wroth and Gavin, *Converging Streams*.

6. Ibid., 89.

7. LA 37 and LA 8758, respectively.

8. Keith W. Kintigh, "Late Prehistoric and Protohistoric Settlement Systems in the Zuni Area," in *Zuni Origins: Toward a Synthesis of Southwestern Archaeology*, ed. David A. Gregory and David R. Wilcox (Tucson: University of Arizona Press, 2007), 370; and Keith W. Kintigh, *Settlement, Subsistence, and Society in Late Zuni Prehistory* (Tucson: University of Arizona Press, 1985), 81.

9. Lansing B. Bloom, translator, "Fray Estévan de Perea's Relación," *New Mexico Historical Review* 8, no. 3 (July 1933): 211–235.

10. The Jesuit Order also played an important role in the missionization of areas such as Sonora but had a different form of government, was not a mendicant order, and was not part of the evangelization of New

Mexico. See Karen Melvin, *Building Colonial Cities of God: Mendicant Orders and Urban Culture in New Spain* (Stanford, CA: Stanford University Press, 2012), 17.

11. Samuel Y. Edgerton, *Theaters of Conversion: Religious Architecture and Indian Artisans in Colonial Mexico* (Albuquerque: University of New Mexico Press, 2001), 247–249; Melvin, *Building*, 2–3, 33. Secularization of the New Mexico missions took place under Mexican governance from 1833 to 1834, when the Bishop of Durango took over jurisdiction, although many parishes in the remote region simply went without priests. See John L. Kessell, *The Missions of New Mexico Since 1776* (Albuquerque: University of New Mexico Press, 1980), 210; and Marc Treib, *Sanctuaries of Spanish New Mexico* (Berkeley: University of California Press, 1993), 60.

12. The word *convento* also describes residential mission establishments as a whole, encompassing the church, residency, and subordinate structures. It does not have an accurate English correlative. See Klinton Burgio-Ericson, *Living in the Purísima Concepción: Architectural Form, Cultural Negotiation, and Everyday Practice in a Seventeenth-Century New Mexico Mission among the Zuni Indians* (PhD diss., University of North Carolina-Chapel Hill, 2018), 17n5.

13. John McAndrew, *The Open-Air Churches of Sixteenth-Century Mexico* (Cambridge, MA: Harvard University Press, 1965), 27.

14. Alonso de Benavides, *The Memorial of Fray Alonso de Benavides, 1630,* trans. Mrs. Edward E. Ayer, ann. Frederick Webb Hodge and Charles Fletcher Lummis (Albuquerque, NM: Horn and Wallace, 1965), 28; Bloom, "Fray Estévan," 228; Burgio-Ericson, *Living*, 168–173; Frederick Webb Hodge, *History of Hawikuh, New Mexico, One of the So-Called Cities of Cíbola* (Los Angeles: The Southwest Museum, 1937), 89–90, 96; Ward Alan Minge, "Zuni in Spanish and Mexican History," in *Zuni and the Courts: A Struggle for Sovereign Land Rights*, ed. E. Richard Hart (Lawrence: University Press of Kansas, 1995), 31.

15. Burgio-Ericson, *Living,* 178–179; C. Gregory Crampton, *The Zunis of Cibola* (Salt Lake City: University of Utah Press, 1979), 44–48; Minge, "Zuni in Spanish," 50–51.

16. See Burgio-Ericson, *Living*, chapters 4 and 6–8.

17. The town of Kechiba:wa appears to date from around 1425, based on ceramic analysis, and had an estimated population of around one thousand people at its peak; see Kintigh, *Settlement*, 68–69, 75. The primary publication of this structure occurred in 1891; see Victor Mindeleff, *A Study of Pueblo Architecture in Tusayan and Cibola* (1891; repr., Washington, DC: Smithsonian Institution Press, 1989), 81–82.

18. Wytsalucy told this story to tribal archivist Rose Wyaco in 1988, as part of an NEA-funded oral history recording project under the direction of the Zuni Archives Program and Andrew Wiget of New Mexico State University. It was published in Brenda L. Shears and Rose Wyaco, "Hawikku: A Fabled City of Cibola," *Native Peoples: The Arts and Lifeways* 3, no. 4 (Summer 1990): 21–22. See also Burgio-Ericson, *Living*, 175.

19. Hodge, *History*, 96; France V. Scholes, "Documents for the History of the New Mexican Missions in the Seventeenth Century," part 1, *New Mexico Historical Review* 4, no. 1 (January 1929): 56. Hodge mistakenly attributes the Kechiba:wa chapel to either friar Roque de Figueredo or Francisco Letrado, but my analysis of the chronology of the Hawikku mission (Burgio-Ericson, *Living*, 164–178) makes such a scenario unlikely. The chapel was almost certainly begun after construction of the formal mission in Hawikku, which began in the mid-seventeenth century.

20. See France V. Scholes, "Biblioteca Nacional de México, Legajo 1, partes 1 + 2, Documentos 34; Transcription of 'Inventario de los bienes y gastos de las misiones de Nuevo México,'" 1672, MSS 867, box 13, folder 8, 27, Center for Southwest Research, University Libraries, University of New Mexico, Albuquerque. Hodge (*History*, 96–97), for one, believed that the Kechiba:wa chapel was never completed.

21. Burgio-Ericson, *Living*, 325n26.

22. Mindeleff, *Study*, 82; Victor Mindeleff, 1881–1886, MS 2621, *Field Plans and Diagrams of Inhabited Pueblos and Pueblo Ruins of Arizona and New Mexico*, National Anthropological Archives, Smithsonian Institution, Suitland, Maryland.

23. Mindeleff, *Study*, pl. 49.

24. None of the beam sockets survives today. The unusually low subdividing masonry walls inside the church may have been intended to help support the floor and create burial chambers beneath it rather than being defensive features, as Mindeleff (*Study*, 82) believed. The original Mindeleff detail drawing of the chapel plan shows beam sockets all around its interior walls, including the apse, so the wooden floor probably extended to the sanctuary as well as the nave. The only other possible wooden floor in a seventeenth-century church was at Giusewa, for which James E. Ivey hypothesizes a heavy plank floor resting on joists,

over the original puddled adobe floor; see James E. Ivey, "Un Templo Grandioso: A Structural Assessment of the Mission Church at Jemez State Monument, New Mexico," n.d., unpublished paper in the collection of the author, 6. An example of a raised wooden floor survives from the eighteenth-century church of San José de Gracia in Las Trampas.

25. Mindeleff, *Study*, 82.

26. Galdo's 1672 inventory of the Zuni missions was sparse but seems to have communicated snarky disdain for the architectural style of New Mexico, as, for example, when he described the roof of the Halona mission, saying that "the nave of the church, which is beamed, is one of the good ones there are in this Holy Custody, if one allows that there are any good ones." See France V. Scholes and Eleanor B. Adams, trans., "Inventories of Church Furnishings in Some of the New Mexico Missions, 1672," in *Dargan Historical Essays*, ed. William M. Dabney and Josiah C. Russell (Albuquerque: University of New Mexico Press, 1952), 35.

27. For a discussion of this unusual orientation, which the Kechiba:wa *visita* chapel shared with the Zuni mission churches at Hawikku and Halona:wa, as well as the Hopi mission at Awatovi, see Burgio-Ericson, *Living*, 381 and 426n28. My observations of the Halona mission church in 2017 seem to confirm Gene E. Friedman's original hypothesis that the Zuni churches were likely oriented toward sunrise on the summer solstice.

28. The apse floor appears to have a circular depression, which might be the remains of looting in the area where the altar would have stood, a common phenomenon in mission ruins. The decrease in the chapel's wall height suggests that it might have been used as a source for building materials sometime after 1885. Further evidence for ongoing use of the site is a Zuni polychrome canteen (NMAI 072201.000; ca. 1840–1920) that Hodge collected, probably from the surface within the church ruins. It might have been left by a sheep herder, or as a provision for the traditional pilgrimage trail that passes alongside the Kechiba:wa ruins.

29. Mindeleff, *Study*, 82. A single small timber is visible leaning against the northwest wall in a photograph by the Mindeleff brothers (figure 7). From its size, it might have been part of a lintel.

30. Kubler claims that the mission location "gravitate[d] as closely as possible to the heart of the indigenous settlement." See George Kubler, *The Religious Architecture of New Mexico: In the Colonial Period and Since the American Occupation*, 4th ed. (Albuquerque: School of American Research and University of New Mexico Press, 1973), 18. In reality, seventeenth-century mission establishments were usually separated or marginally located in relation to their Pueblo towns.

31. T. J. Ferguson, *Historic Zuni Architecture and Society: An Archaeological Application of Space Syntax* (Tucson: University of Arizona Press, 1996), 145.

32. Catalogue no. 093637.000. Compared to the Munsell Color System, the stone is roughly 2.5YR 4/2 on its formerly exposed front side, and 5YR 7/2 on the back, similar to the reddish sandstone making up the ridge north of the Hawikku site, and which is common throughout its ruins. Its lower-right corner appears to have been broken during manufacture.

33. Frank Hamilton Cushing, *Zuni Breadstuff* (New York: Museum of the American Indian, Heye Foundation, 1920), 307–309.

34. Ethnographic accounts generally describe men's realm of activity as being outside of the village, where most petroglyphics occur. For example, see Julie C. Lowell, "Reflections of Sex Roles in the Archaeological Record: Insights from Hopi and Zuni Ethnographic Data," in *The Archaeology of Gender: Proceedings of the 22nd Annual Chacmool Conference*, ed. Dale Walde and Noreen D. Willows (Calgary: The University of Calgary Archaeological Association, 1991). However, it cannot be assumed that all rock art is a male activity; see Kelley Hays-Gilpin, *Ambiguous Images: Gender and Rock Art* (Walnut Creek, CA: Altamira Press, 2004), 85–105. The gendered association of rock art with male activities was probably not absolute in Zuni villages. For example, Stevenson describes women's role in creating an incised site she called the "Mother Rock" on Dowa Yalanne; see Matilda Cox Stevenson, *The Zuñi Indians: Their Mythology, Esoteric Fraternities, and Ceremonies* (Washington, DC: Government Printing Office, 1904), 294–295, pl. 12.

35. Frederick Webb Hodge, Hawikuh of the Zunis: A Scene of Franciscan Tragedies, 1924, Autry MS.7. MAI.4.18, Frederick Webb Hodge Manuscript Collection, Braun Research Library Collection, Autry Museum of the American West, Los Angeles, California, 11.

36. Juan de Oñate, "Expedition to the South Sea and the Salines," in *Don Juan de Oñate: Colonizer of New Mexico, 1595–1628,* ed. and trans. George P. Hammond and Agapito Rey (Albuquerque: University of New Mexico Press, 1953), 395. See also Diego Pérez de Luxán, *Expedition into New Mexico Made by Antonio de*

Acculturation versus Incorporation

Within linguistics, few aspects of language contact have received as much attention as borrowing, in large part due to the ready visibility of the relevant data, that is, their surface nature. In this tradition, which we label *linguistic acculturation*, the focus is on Native languages borrowing from the languages of the colonizers. The explanations for such change have tended to imply a passive stance on the part of Native people. For example, Lawrence Kiddle argued somewhat simplistically that, upon encountering a novel item from a conquering culture, Native people "frequently borrow the name of the object or practice from the language of the lending group at the same time as they borrow the culture trait itself."[10] Edward Sapir also adopted a passive view to explain cases where extensive borrowing *did not* result from language contact, suggesting that in such cases it is the structural properties of the Native language, rather than Native choice, that is responsible.[11] Sapir's view was echoed by Einar Haugen, one of the most prominent twentieth-century scholars of linguistic borrowing.[12] Finally, an important tenet in early studies of French, English, and Spanish loans in languages of the Americas was how well a given item was integrated into the local phonology. "Early loans are assumed to be the more distorted words, while the late[r] are more similar to their models."[13] This implies a relative chronology or seriation of loan words and presents a view of language change in which speakers exert little agency on the process.

Reactions against these traditional approaches began with Uriel Weinreich's pioneering *Languages in Contact*, which insisted on the study of the psychological and sociological concomitants of linguistic processes.[14] Shortly thereafter, Jacob Ornstein masterfully described and evaluated the many sociocultural factors evident in linguistic borrowing.[15] Critiques like these had a strong impact, but the focus on loan words and on relatively passive processes remained. For example, in a major work on language contact, Sarah Grey Thomason and Terrence Kaufman argued that the degree of bilingualism, as opposed to the many sociocultural factors summarized by Ornstein, was the primary influence on the extent of linguistic borrowing.[16]

Still, the notion that entire speech communities, as opposed to individual language learners, possess affective filters that affect linguistic acculturation has arisen in some quarters. An early example is the work of George Devereaux and E. M. Loeb, who coined the term "antagonistic acculturation," which holds that Native speech communities sought to subvert Colonial intentions by using their language as a secret code, especially in particularly sensitive semantic domains such as imposed religion.[17] Other studies have argued that perceived psychological filters against Native borrowing from colonizing languages lie mostly in the realm of linguistic ideology (what individuals or speech communities believe to be true about their language or languages in general). For example, Agnes Holmes, Wayne Holm, and Bernard Spolsky echo Sapir's comment on the "psychological attitude" against borrowing on the part of Navajo and other Athabascan languages.[18] Yet their investigation of English loans among Navajo school children reveals a very high number of direct borrowings from numerous semantic categories.[19] Another complication that has arisen in such analyses is the awareness that speakers may adjust their language use in a contextual way. For example, Edward Dozier noted that when Tewa speakers think someone listening to their conversation knows Spanish, they purge their speech of Hispanisms.[20] This implies that speakers have alternate Native expressions to choose from and illustrates how deeply sociocultural the processes of language change can become.

The main shortcoming of linguistic acculturation as an approach to linguistic change is its internal focus on language—language contact, grammatical structures, and language ideologies—in isolation from broader processes of culture contact. In reality, language is not separable from other domains of life, be they spiritual, cultural, political, or practical. And one might expect these domains to influence the manner in which languages change with culture contact, and

indeed, for the manner in which speakers respond to external pressures to change with context over time.

We emphasize this interconnection here by beginning with lists of Spanish and Anglo-American introductions and then investigating the manner in which these introductions were coded linguistically. When the speakers of a language adopt an element of a donor culture, they may encode it using a term from the language of the donor culture (a *loan word*), but they can also translate a term from the donor language into their own (a *calque*) or create a new word using their native language's own resources (a *neologism*). These various types of incorporation can be identified through morphophonemic and etymological analysis, and one might expect these different mechanisms to reflect different social strategies employed by speakers at the time of adoption.

We label this broader approach *linguistic incorporation*. It leaves open the possibility that Native people willingly incorporated introduced concepts into their language and culture without necessarily acculturating to the source culture. This process, which involves incorporating new things into an existing cultural pattern, has been emphasized by Marshall Sahlins and John and Jean Comaroff as a typical Native response to the European encounter.[21] Linguistic incorporation is essentially a historical linguistic version of their approach.

The only previous work we are aware of that follows a similar methodology to this study is that of Brown, who sampled the major culture areas of North and South America using a list of seventy-seven items for European introductions, computing the percentage of loan words in this sample for each language considered.[22] Yet Brown's conclusions continue the passive focus of linguistic acculturation studies. He concludes that the percentage of loan words is positively correlated with the degree of bilingualism, although he also found some cases (the Otomanguean family of Mexico and the Salishan family of the Pacific Northwest) where structural factors may have impeded linguistic borrowing.[23] And in a follow-up study, he concluded that "bilingualism, almost always involving a lingua franca as an auxiliary language, constitutes the single most important factor promoting lexical diffusion across area languages."[24] We will revisit this conclusion in the discussion of our results.

Materials and Methods

For this study we created a database of lexical artifacts for introduced items and concepts across Pueblo languages of the American Southwest from the 1600s onward, irrespective of whether these were marked by loans or not. For Tewa, we consulted the Ohkay Owingeh Language Program's Tewa dictionary and Brian Stubbs's Tewa vocabulary.[25] Northern Tiwa is represented by George Trager's Taos lexical card file from the archives at University of California, Irvine. Southern Tiwa is represented by Don Frantz and Donna Gardner's Isleta dictionary and archival materials by Carobeth Tucker Harrington and others.[26] Towa is represented by a Jemez dictionary assembled from various sources, especially Yukihiro Yumitani's PhD dissertation on Jemez grammar.[27] Keresan is represented by Wick Miller's Acoma card file from the archives at the University of Utah, and additional articles by Wick Miller and Robert Spencer.[28] For Hopi, we consulted the *Hopi Dictionary* and additional articles by Kenneth Hill and Frederick Dockstader.[29] Finally, for Zuni, we consulted Stanley Newman's *Zuni Dictionary*.[30]

To interpret each entry, we considered four main ways the speakers of a Native language could code a new concept from Spanish (and Anglo-American) culture. First, the concept could be coded using a neologism, which logically suggests incorporation into the local Native culture. As an example, the Tewa word for wheat, *tá-tá*, was created by putting together existing Tewa words for 'grass' and 'seed.' Second, the concept could be coded using a loan word from the source language, which suggests a more foreign status from a Native perspective. An example is

the Tewa word for horse, *kavayu*, which is clearly a loan from Spanish *caballo*. Third, the concept could be coded using a calque or loan translation, such as Tewa *kwiʔo-yiya*, literally 'irrigation ditch-mother,' modeled after Spanish *acequia madre*. The interpretation of calques would seem to lie somewhere between a neologism and a loan. Finally, the concept could be coded using a blended term that was part Spanish, part Native. A Tewa word for a bread oven, *pan-te*, is a good example, as it combines Spanish *pan* 'bread' with Tewa *te* 'house.' We consider these to be a variety of neologism, but since they occur infrequently in these data they play a minor role in our results.

It is important to emphasize that accurately distinguishing loan words from neologisms requires knowledge of historical relationships among related languages, cognate sets, and reconstructed protolanguages. A classic study on linguistic borrowing by Roland Dixon illustrates why this is necessary.[31] Dixon's study was in response to a paper that had argued that tobacco was introduced to the Americas by African slaves in the 1500s based on his finding that words related to tobacco and smoking in several American Indian languages resembled terms for similar concepts in certain African languages. The archaeological record proves beyond a doubt that tobacco use has great antiquity in the Americas, especially in the US Southwest.[32] Dixon posited that most of the supposed African loans can be shown to be chance resemblances when the Native forms are examined in their historical linguistic context. And the remainder, even if they do represent African loans in isolated cases, do not undermine the fact that words for tobacco reconstruct to the protolanguage of several American Indian language families that must be of greater time depth than European colonization. Examples from the US Southwest include Proto-Tanoan **sa* 'tobacco' and Proto-Uto-Aztecan **piva* 'tobacco.'

Dixon's analysis showed that although speakers can adopt loans for concepts that are not new, one is easily misled if one does not possess knowledge of the Native languages and the intrusive languages, as well as additional historical and archaeological knowledge. A good example of this is the Tewa word for a domestic cow, *wâ:-sí*. The term bears a resemblance to Spanish *vaca* 'cow' and could easily be interpreted as a Spanish loan but in fact it is a compound of *wâ* 'breast' and *sí* 'belly.' In addition, the Tewa term for 'milk' is *wâ:-pʼo*, literally 'breast-liquid,' and terms for 'milk' and 'breast' are cognate across Tewa and Tiwa (Taos *wə-* 'milk'; Isleta *wə-* 'milk'; Tewa *wâ:-* 'breast'). So the Tewa word for "domestic cow" is coded with Native lexical resources, but this does not mean that Tewa people had domestic cows prior to Spanish contact. Instead, archaeological and historical evidence shows that domestic cows were introduced by the Spaniards, and thus the Tewa term for "domestic cow" is a neologism.

To aid in interpretation of our analysis of terms for Spanish introductions, we grouped database entries according to the following chronological scheme:

•Our sixteenth century category includes lexical artifacts for concepts that existed in Pueblo culture at the time of Spanish contact but for which the Spaniards introduced a new term. This second term was coded either through a borrowing from Spanish or through neologism, which is implied by the existence of earlier Native words for the pre-Hispanic version of the concept.

•Our seventeenth century category includes lexical artifacts for new referents introduced to Pueblo culture by the Spaniards prior to the Pueblo Revolt.

•Our eighteenth century category includes lexical artifacts for new referents introduced to Pueblo culture by Spaniards (and in some cases, Anglo-Americans) following the Pueblo Revolt.

A summary of the database we compiled by language and chronological period is presented in table 3.1. This table shows that the number of items available varies across languages and that most of them relate to seventeenth-century introductions. Although it stands to reason that the

Table 3.1. Items in the database, by language and chronological group

LANGUAGE	NUMBER OF LEXICAL ITEMS			
	16TH C.	17TH C.	18TH C.+	TOTAL
Acoma	47	166	46	259
Hopi	21	85	25	131
Isleta	19	89	18	126
Jemez	56	114	40	210
Tewa	41	130	31	202
Taos	61	145	79	285
Zuni	17	59	16	92
Total	262	788	255	1,305

rate of Spanish introductions was higher during the seventeenth century than it was in subsequent centuries, we could not say whether the decline in the number of introductions for the eighteenth century and after reflects actual history or the nature of the available data. Accordingly, we standardize the data to percentages in the analyses below.

We have also classified each entry into one of seventeen semantic domains in order to determine whether certain domains were more or less likely to be coded using neologisms or loans. Lists of the glosses for the entries associated with these semantic domains are presented below. The glosses capture the range of items and concepts considered in this analysis. Note that there are several entries (from different languages) for many of the glosses in the lists. The domains are simply an intuitive classification of the entries we found in our search of the available literature. Recall also that a few of these items (those in the sixteenth century chronological group) represent terms for things that were part of pre-Hispanic Pueblo culture for which the Spaniards introduced additional terms that were incorporated into at least one Pueblo language.

Agriculture: dam, main irrigation ditch, farmer, garden, orchard, pitchfork, plow (n.), to plow, rake, straw/chaff, string of chiles, thresh grain, threshing floor

Catholicism: All Souls, All Souls food, altar (Catholic), angel, baptize, baptized, bell, jingle bells, bishop, bless, blessed, bread animals, candle, Catholic, Christmas, church, coffin, confession, cross (religious), devil, disciples, Easter, feast day, fiesta/celebration, God (Christian), godfather, godmother, godparent, godson, Heaven, Hell, Holy Ghost, holy water, Jesus Christ, Lent, Lent/ Easter, mass, mass (ceremony), paradise, prayer, prayer (Catholic), prayer meal, wheat, priest (Catholic), religion (Catholic), sacristan/acolyte, saint, San Diego, San Esteban, San José, San Juan, San Lorenzo, San Pedro, Santa Ana, Santa María, sexton, sin, to sin, sinner, song leader, soul, statue, Virgin Mary, wedding, wine, worship

Classes of persons (occupations; ethnic groups): Anglo, Apaches, aviator, Black person, blacksmith, blond, carpenter, Chinese/curly, Chinese/Japanese, clerk (store), Comanche, commoner, cousin, crazy, crippled/diseased, curly (hair), ditch boss, to be drunk, drunkard, European, half-breed, hunter, Indian, Japanese, kinky/curly (haired), machine, mail carrier, Mexican, Mexican/ Spaniard, Mexican/Spaniard/Anglo, Navajo, Navajo(s), orphan, rich, rubber, Spanish, speaker, spots/freckles, tire, waiter, waiter/waitress (food), whore

Clothing and related: apron, bead/necklace, belt (store-bought), blanket, bluing, boot, boots, bracelet, button, button (n.), to button, buttonhole, carpenter's apron, closet, cloth, coat,

collar, cotton, curtains, dresser, garter, glove, gloves, hair brush, handkerchief, hanger/hook, hat, hat/scarf, to iron, jacket, leather, mattress, necktie, needle (sewing), nightgown, night-clothes, pants/trousers, perfume, pillow, pillowcase, pin, pin (n.), to pin, safety pin, straight pin, pocket, pocket/purse, ribbon, ring (finger), rug, carpet, fancy rug, rug/blanket, satin, scarf, scissors, seamstress, shawl, sheet, sheet (bed), shirt, shoelace, shoes (store-bought), silk, skirt, sleeve, socks/stockings, stocking, suitcase, suspenders, sweater, thimble, thread, towel, under-clothes, underpants, undershirt, vest

Hispanic culture: *abuelo* (lit. 'grandfather,' Hispanic clown), captain, corn dance, fiscal, Matachines dance, morada (Penitentes' house), Santa Claus, trumpet, wind instrument

Domesticated animals: bacon, bay (horse), billy goat, bull, burro, burro/donkey, mule, calf (animal), canary, cat, chick, chicken, cow, cow/bull, donkey, male donkey, egg (chicken), eggs (chicken), ewe, goat, goose, honeybee, horse, kitten, lamb, lamp, lard, livestock, mare, mule, ox, ox/steer, parrot, pasture, pheasant (Mexican), pig, pigeon, pinto/spotted (horse), puppy, ram, rooster, sheep, sorrel (horse), stallion, tomcat

Domesticated plants: alder, alfalfa, apple, apple/apple tree, apricot, asparagus, banana, barley, beet, beets/turnips, cabbage, carrot, cherry, cherry/plum, chile, chile (stems, seeds), chile powder, chocolate, fruit, garlic, grape, grape/raisin, hay, hay/alfalfa, lemon, lettuce, melon, mulberry, muskmelon, oats, onion, onion (cultivated), orange (fruit), pea, peach, peach(es), pear, pears, peas, plum, potato, radish, rice, spinach, squash, strawberry, sweet potato, tomato, turnip, vegetables, watermelon, wheat

Economic: bank, banker, change (money), coin, dollar, drive, driver, drugstore, earn money, employer/storekeeper, foreman, gold, hundred, iron/metal, money, key, lock, lock (n.), lock up, to lock, merchant, trader, mile, million, mine, money, to have money, nickel/coin/button, number, padlock, post office, quarter (coin), railroad, railroad station, railroad tracks, railroad/train, saloon/bar/liquor store, shop, silver, store, store/shop, thousand, tobacco (commercial), chewing tobacco, train, unlock, watch (timepiece)

Foods: atole, baking soda, blood sausage, bread, bread (commercial), bread (store)/loaf, bread (yeast), bread pudding, whole wheat bread, butcher shop, butter, candy, cheese, coffee, cook (n.), cookies, cookies/cake, coriander, crackers/cookies, curd/cottage cheese, dough, iced drink, ham, hot (picante), ice cream, kitchen, liquor/wine, mutton, oven, oven/match, pastry/pie, pie, popsicle, pork, fried potatoes, mashed potatoes, powdered milk, raisin, saffron, sugar, candy, syrup, tamale, tea, tea (wild), tortilla, tripe, vinegar, wheat bread, wheat pudding, yeast

Government and related: cacique, cane of office, captain, field chief, council, council of governors, court, ditch boss, fiscal, flag, government, governor, jail, judge, king, law, lawyer, lieutenant, lieutenant governor, surveyor's mark, police, political leaders, president, sheriff, sheriff/judge, soldier, superintendent (of an agency), tax collector(s)

Health-related: doctor (western), doctor/doctor's office, eyeglasses, germs, hospital, leprosy, malaria, measles, mumps, mumps/goiter, paper napkin, nurse (medical), outhouse/toilet, physician, plant used for chest pains, pneumonia, scarlet fever, smallpox, chickenpox, soap/shampoo, tuberculosis, wash basin, wash cloth, whooping cough

Animal husbandry: barn, barn/stable, bit (horse), brand, bridle, bridle and bit, bronco rider, cattle guard, cinch/buckle, colt, corral, cowboy, fence, gate, harness, to hobble, polled (dehorned animal), ranch, rope/lasso/lariat, saddle (n.), shear sheep, sheep herder, sheep pelt, stirrup, barbed wire, wool

Literacy and schooling: book, book/paper, crayon, design/writing, eraser, letter/book/page, notebook, paper/book, paper/newspaper, pen (writing), pen/pencil, pencil, principal, to read, ruler/measuring stick, school, to teach, teacher, teacher/school, write down, to write, writing (n.), writing/spelling, letter

Material culture (especially tools and locomotion): adobe, airplane, automobile, axe (metal), axle grease, baking tin, balloon, barrel, baseball bat, basket (non-Indian), bathtub, beads (silver only?), bed, bed/mattress, bedstead, bell/telephone, bench/stool, board floor, boat/canoe, boat/ship, bottle, bottle/jar, dough bowl (for bread), box, box (wooden), brake, bridge, broom (commercial), bucket, bucket/tub, bullet, bullet/ammo, burlap bag, car/automobile, cement, chair, rocking chair, chair/pillow, coffee pot, cup, cup/dish, cupboard/dresser, dining room, doll, door/gate, dough bowl, faucet, file/rasp, fishing pole, fork, fork (eating, pitchfork), frying pan, garbage can, to put in gas, glass (drinking), glass (pane), mirror, glass/window pane, gun, gunshot, hammer (n.), door hinge, hook, ink, iron/metal, jack (cards), judge, kerosene, kettle, kettle (iron), key/can opener, knife (kitchen), knife (metal), knife (pocket), knife (steel), lamp, lamp (oil), lance, leather/leather strap, light bulb, machine/engine, marbles, match (n.), mattress, metal, mirror, mirror/drinking glass, mirror/glass, nail (n.), to nail, napkin, oil, oil (machine), pan, pan/basin, pen/pencil, pick (tool), picture/photo, pipe (water), pistol, plate, potato masher, pump/blower, rat poison/mouse trap, rolling-pin, round/ball, rubber, rubber plant, saucer, saw (tool), scissors, screen door, shoot with a gun, shovel/spade, sink/basin, soap, soap (for face), spike/nail, spoon, spoon (tablespoon), springs (bed), stairs, stove, wood-burning stove, stove/oven, sword, table, tea kettle, teaspoon, tin can, tobacco (store), trap, trunk/wooden box, tub, tub/dish pan, umbrella, wagon/vehicle, wheel, wheel/tire, window, window (mica), wire, electric wires

Miscellaneous: Albuquerque, Asia, balloon, basement, birthday, brown, California, camp, canyon, charcoal, chicken pull, cigar, city, communal area, community room, Cubero, electricity/radio, English language, Europe, fireplace, flat (not bright), Gallup, goat heads, good night (expression), history, isn't it so?, John, lake, lion/tiger, monkey, mop, ocean/sea, orange (in color), paint a picture, painter, pilot, pink, place name, poison, porch, room, rubber hose, run over with vehicle, rusty, Santa Fe, Santa Fe/Albuquerque, sawdust, South America/Africa, stairs, stink bug, street, Taos Village, to tease, tobacco, town/city, United States, valley, well (water)

Native plants and animals: buffalo, frog, raccoon

Units of time: April, August–September, December, February, Friday, hour, January, July–August, June, March, May, minute, Monday, New Year, New Year's Day, November–December, October–November, Saturday, second, September–October, Sunday/week, Thursday, Tuesday, Wednesday, a week

A summary of our assignments of database entries to semantic domains is presented in table 3.2. The four largest domains are material culture, domesticated plants, domesticated animals, and Catholicism. Again, we could not say whether variation in the number of terms in each domain is a meaningful reflection of Pueblo linguistic practice or simply reflects biases in the available material. Since Pueblo people had limited prior experience with animal husbandry beyond domesticated turkeys, we separated the domain of animal husbandry from plant-based agriculture.

Table 3.2. Assignment of items to semantic domains, by chronological group

DOMAIN	16TH C.	17TH C.	18TH C.+	TOTAL
Agriculture	13	14	0	27
Catholicism	0	125	1	126
Classes of persons (occupations, ethnic groups)	11	29	22	62
Clothing and related	37	75	27	139
Culture	4	4	1	9
Domesticated animals	3	123	0	126
Domesticated plants	0	117	25	142
Economic	1	41	30	72
Foods	11	47	38	96
Government and related	6	38	9	53
Health-related	5	11	15	31
Husbandry	5	38	1	44
Literacy and schooling	3	24	9	36
Material culture (especially tools and locomotion)	84	82	62	228
Miscellaneous	41	11	14	66
Native plants and animals	3	0	0	3
Units of time	35	9	1	45
Total	262	788	255	1,305

Results

For each of the 1,305 entries in the database we determined whether the term for a Spanish (or later Anglo-American) introduction in a given Pueblo language was coded using a neologism, a calque, a loan, or a compound that mixes a neologism and a loan. Table 3.3 summarizes the results of this analysis by language. The table shows that for all the sampled languages except Acoma, a majority of the concepts that have been introduced to Pueblo cultures since the sixteenth century have been coded using Native linguistic resources. It also shows that mixed Native-Spanish compounds and loan translations, both of which imply bilingualism, are quite rare. Finally, the number of loans that can be traced to English is very small relative to the number of

Table 3.3. Summary of etymological interpretations, by language

LANGUAGE	NEOLOGISM	COMPOUND	CALQUE	SPANISH LOAN	ENGLISH LOAN	TOTAL
Acoma	109	4		146		259
Hopi	61	12		50	8	131
Isleta	95	3		27	1	126
Jemez	118	8		84		210
Rio Grande Tewa	132	3	1	66		202
Taos	183	4		97	1	285
Zuni	63	1		22	6	92
Total	761	35	1	492	16	1,305

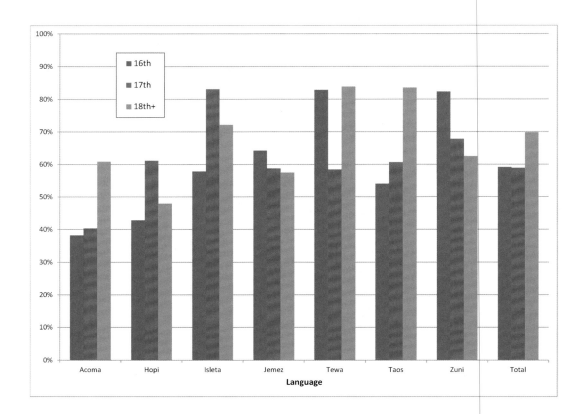

3.1. Percentage of introductions coded using Native linguistic resources, by language and time period.

loans that can be traced to Spanish. This pattern suggests that the dynamics of language contact have shifted substantially since Pueblo people became citizens of the United States, and it raises the possibility that language ideologies were very different during the initial era of Spanish colonization than they are today. We discuss this pattern in greater detail in our conclusions.

Since compounds, calques, and English loans are all rare categories, we emphasize the more basic distinction between loans versus various forms of Native encoding in the summaries that follow, referring to the percentage of ideas and things that were encoded using Native linguistic resources as the "neologism rate." Using this framework, figure 3.1 presents the neologism rate in each language and over time. Two points are apparent in this chart. First, the chart shows that, on average, the neologism rate was greater than 50 percent both before and after the Pueblo Revolt. This in turn suggests that Pueblo people willingly incorporated elements of European culture into their own traditions from the seventeenth century onward. From this perspective, Pueblo societies appear far less closed off from the outside world than the ethnographic and ethnohistoric literature sometimes suggests.

Second, there is interesting regional variation in the neologism rate. In most languages, the neologism rate for seventeenth-century introductions was about 60 percent, while in Zuni it was closer to 70 percent, in Isleta it was more than 80 percent, and in Acoma it was only about 40 percent. These differences are statistically significant (Chi-Square P < .0001). It is difficult to accommodate the geographical patterns reflected in this summary to variation in bilingualism or linguistic structure. Based on the patterns of Spanish colonization, one might expect rates of bilingualism in the seventeenth century to have been highest among native Isleta and Tewa speakers, and lowest among Hopi speakers; and yet Isleta is the language that shows the highest neologism rate, whereas Hopi and Tewa show the same rate. Also, one might expect rates of bilingualism to have generally increased over time, and according to linguistic acculturation one would therefore expect the borrowing rate to have increased and the neologism rate to have declined. Yet there is no evidence of a consistent increase in the borrowing rate in any language.

Part II
Art, History, and Culture of New Spain

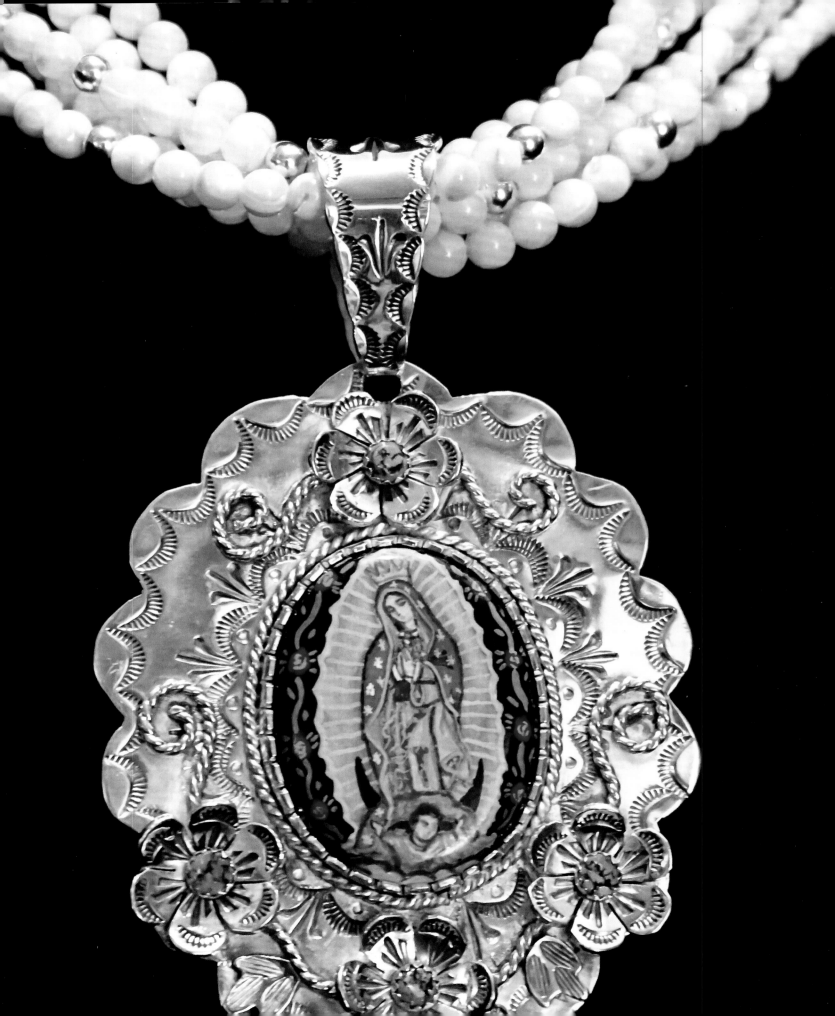

4
Devotion to La Virgen de Guadalupe in Seventeenth-Century New Mexico

JOSÉ ANTONIO ESQUIBEL

Catholic devotion to the Virgen de Guadalupe extends more than three and a half centuries in New Mexico's history. Evidence of individual and communal devotion of the beloved Guadalupana appears in several references to images of Nuestra Señora de Guadalupe extracted from surviving seventeenth-century documents. Those references confirm that this particular devotion existed among Spanish citizens and Indians in public and private forms in New Mexico by the mid-1600s, which was very likely associated with the advancement of Nuestra Señora de Guadalupe as a major Marian devotion promoted popularly from the 1640s onward in New Spain.

With so few records of seventeenth-century New Mexico surviving to the present day, the sources for understanding the personal, familial, and communal spiritual devotions of the era are insufficient. The loss of wills, settlements of estates, and records of local *cofradías* (confraternities) and *capellanías* (chantries) severely limit our knowledge of the material and social manifestations of expressions of faith. However, buried within the existing records, mainly related to Inquisition cases, there are scattered references to works of Catholic devotional art, and a small number of documents from ecclesiastical records identify specific paintings and statues of religious images in seventeenth-century New Mexican churches and in the households of prominent families of the frontier region.

Mexican Indian Connections

Among the personal effects of the household of captain Cristóbal de Anaya Almazán was a canvas painting (*lienzo*) of Nuestra Señora de Guadalupe. A listing of Anaya Almazán's personal property made in May 1662 makes prominent mention of this painting, which is described as "un lienso de n[ues]tra s[eño]ra de guadalupe de tres quadritas" (a canvas painting of Our Lady of Guadalupe with three pictures).[1] Of the seven religious images accounted for in the captain's possession, this is the only one for which the image of the saint is identified, the others simply being referred to as *"quadritos pequeños"* (small paintings).

Cristóbal de Anaya Almazán, born around 1626 in the Villa de Santa Fe, and his wife, doña Leonor Ramírez de Mendoza, a native of Mexico City, lived at their Estancia de San Antonio

along the Rio Grande in the vicinity of present-day Algodones, New Mexico, about nine miles north of the modern city of Bernalillo.[2] The property of the Anaya Almazán *estancia*, located in what was then known as the jurisdiction of Sandía, was adjacent to that of doña Leonor's father, Captain Tomé Domínguez, and consisted of a house with a living room, a kitchen and two rooms, and irrigated farm lands with an acequia (watercourse) and three springs.

Anaya Almazán's ownership of a canvas painting of Nuestra Señora de Guadalupe is the main indication of his devotion to Nuestra Señora de Guadalupe. Another is his own family's connection to the community of Cuatitlán (Cuautitlán), popularly known as the birthplace of Juan Diego, the humble Mexican Indian man to whom the Santísima Virgen de Guadalupe appeared in 1531. Anaya Almazán's devotion to the Virgen de Guadalupe may very well have resulted from the influence of his maternal grandmother, María de Villafuerte, who was born in the Pueblo of Cuatitlán around 1586 and was referred to as an India Mexicana, a woman of the Mejica or Aztec people in the Valley of Mexico.[3] In 1559, an unrelated Mexican woman named Juana Martín (also known as Juana García) explained the local miracle legend in her last will and testament stating that "the young man Juan Diego was raised here [Cuatitlán] . . . through him the miracle of Tepeyac occurred where the apparition of the beloved Lady Holy Mary whose image we saw in Guadalupe, who is truly ours and of our Pueblo de Cuauhtitlan . . . I give everything to the Virgin from Tepeyac."[4]

By 1608 María de Villafuerte and her husband, Francisco López Paredes, a Spaniard from Jérez de los Caballeros in the region of Extremadura, Spain, were among the early settlers seeking opportunity in New Mexico.[5] Their daughter, Juana López Villafuerte (born circa 1608), married Francisco de Anaya Almazán (born circa 1603), a Mexico City native who made his way to New Mexico by 1626.[6] Francisco's parents, Pedro de Almazán and Ynes de Anaya, immigrated to New Spain from Salamanca, Spain, and resided in Mexico City from as early as 1595.[7] The children of Francisco de Anaya Almazán and Juana López Villafuerte carried the racial designation of "*castizo*," a term referring to the racial composition of one-fourth Indian and three-fourths Caucasian.

A statement made in 1627 by fray Alonso de Benavides attests to the high degree of Spanish acculturation by María de Villafuerte. In a note, Benavides referred to María and another Indian woman, doña Ynes, writing that "they are as acculturated as Spanish women and they are treated as such, and their children are mestizos (half Spanish, half Indian) married with Spaniards."[8] Public knowledge of the Mexican Indian background of María de Villafuerte did not hinder the social status of members of the Anaya Almazán family in New Mexico's frontier society.

Francisco de Anaya Almazán earned the title and privileges of an *encomendero*, legally holding right to the *encomienda* tribute of the Pueblos of Cuarac, La Cienega, and Picurís, which were inherited by Francisco's son, Cristóbal de Anaya Almazán, in 1662.[9] Apparently, Cristóbal held the *encomiendas* of these pueblos until his death in 1680. What influence Anaya Almazán's devotion to Nuestra Señora de Guadalupe had on the Indians of these pueblos is not known. However, there is an intriguing connection to one of the significant influential Pueblo Indian leaders who assisted in the restoration of New Mexico to the Spanish crown in 1692 in the interest of his people, Luis Tupatú of Picurís Pueblo.

Mestizaje of New Mexico's Leading Families

Several other New Mexican *vecino* (tax-paying resident) families could claim a mixture of Mejica Indian and Spanish ancestry. Juan de la Cruz, a native of Catalonia, Spain, married Beatriz de los Ángeles, described as "india ladina Mexicana," "[an] acculturated Mejica Indian woman," of whom it was said "that she is treated as a Spanish woman."[10] This couple came to New Mexico

with don Juan de Oñate in 1598. Their son, Pedro de la Cruz, a mestizo, held title as *encomendero* of the Pueblo of Cuquina in the jurisdiction of Zuñi. Their daughter, Juana de la Cruz, a mestiza, married Juan Griego, a mestizo who spoke the Nahuatl language of Indians from the Valley of Mexico. His father, also named Juan Griego, originated from Greece, and thus his mother, Pasquala Bernal, was apparently a Mexican Indian woman who taught her son her native language. This couple also arrived in New Mexico in 1598. The males of the Griego Bernal clan were also *encomenderos*, and the females of this family married into the González, Durán, and Moraga families of seventeenth-century New Mexico.

The Montoya-Zamora family also possessed Indian and Spanish ancestry. Bartolomé de Montoya emigrated from Spain, being a native of Cantillana in the province of Andalucía. His wife, María de Zamora, was a Mexican Indian native of the Barrio de San Sebastián in Mexico City, located near the acequia of the city.[11] The Barrio de San Sebastián was one of four indigenous barrios of Mexico City in the sixteenth century, being formed from the older Aztec barrio of Atzacualco (Tzaqualco) of Tenochtitlán.

María de Zamora moved with her parents to Oaxaca when she was seven years of age, and then her family relocated to the Pueblo of Tezcuco, an indigenous community that quickly developed into a multiethnic one, where she married Montoya. Bartolomé de Montoya and his wife resided in the Barrio de San Lorenzo in the Pueblo de Tezcuco before coming to New Mexico as settlers in 1600.[12] Their daughter, Petronila de Zamora, married Pedro Lucero de Godoy, a man of Spanish background and an *encomendero* in New Mexico. Diego de Montoya, the son of Bartolomé de Montoya and María de Zamora, attained the privilege of the *encomienda* of the Pueblo of San Pedro.

It is intriguing that these particular *encomendero* families were descendants of Mejica Indians who formed an economic relationship with Pueblo Indians for mutual benefit. The *encomenderos* received compensation for supplying horses, arms, and provisions related to the protection of Pueblo Indians and for risking their lives in campaigns against bands of raiding nomadic Indians. The Pueblo Indians benefited from the defense offered by Spanish military arms and from the potential recovery of Pueblo Indian women and children captured by bands of raiding Navajo and Apache, which occurred regularly in seventeenth-century New Mexico.

The lack of historical records makes it difficult to determine which specific members of the Griego-Bernal-de la Cruz and Montoya-Zamora clans maintained a devotion to Nuestra Señora de Guadalupe and what influence these families had in fostering the Christian faith among Pueblo Indians. Records of sacraments destroyed during the Pueblo Indian uprising of 1680, particularly those of baptisms, would have contained information concerning *compadrazgo* (social bond with godparents) relations between *vecinos* and Pueblo Indians, and offered some indication of the degree of interrelationships among these groups through participation in Catholic religious ceremonies. Also, copies of wills for members of the prominent *encomendero* families would have included information on saints of devotion and possibly the identification of religious images in their possession.

Mexico City Connections

A series of unfortunate circumstances led to Cristóbal de Anaya Almazán and his father leaving New Mexico and traveling to Mexico City. A heated political conflict between governor don Juan Manso and the Anaya Almazán family resulted in the arrest of Francisco de Anaya Almazán, father of Cristóbal. When Governor Manso left the Villa de Santa Fe to conduct an inspection of the Zuñi region in western New Mexico sometime around the spring of 1658,

Anaya Almazán slipped out of the *villa* with his two sons, Cristóbal and Francisco, and his son-in-law, Alonso Rodríguez.[13] The group of men traveled south on the Camino Real to Mexico City with several supporters.

In Mexico City, Francisco de Anaya Almazán registered complaints to royal officials against Governor Manso and was cleared of charges the governor brought against him. Francisco and his sons also very likely visited with their immediate relatives who resided in Mexico City and may very well have worshipped at the church of Nuestra Señora de Guadalupe and viewed the famous *tilma* (outer cloaklike garment) with the image of the Guadalupana. Curiously, the godmother of one of Cristóbal's first cousins was a woman named doña Luisa de Montúfar, wife of Andrés de Vega.[14] Doña Luisa apparently belonged to the large extended family of fray Alonso de Montúfar, archbishop of Mexico City (1551–1572), who played an instrumental role in the spread of devotion to Our Lady of Guadalupe.

Soon after assuming the position as archbishop, Montúfar sanctioned and began to zealously promote the devotion to Nuestra Señora de Guadalupe. The funds he generated from wealthy miners and merchants supported the hermitage of Guadalupe in Tepayac, which further contributed to the prestige of the blossoming devotion. For Montúfar, the story of the apparition of Saint Mary to the Indian Juan Diego and the image of the Guadalupana upon the *tilma* were critical aspects of the Spanish Counter-Reformation in New Spain.[15] Indians and non-Indians alike began adopting the devotion, and several Spanish citizens of Mexico City formed the confraternity of Nuestra Señora de Guadalupe.[16]

The devotion became more widespread among Spanish residents following the publication in 1648 of a treatise by *bachiller* (bachelor degreed) Miguel Sánchez, a priest of Mexico City, titled *Imagen de la Virgen, Madre de Dios Guadalupe, milagrosamente aparecida en la Ciudad de México (Image of the Virgin, Mother of God, Who has Appeared Miraculously in Mexico City)*. Sánchez outlined in detail how the imagery of the *tilma* of Nuestra Señora de Guadalupe corresponded to imagery found in scripture, especially the Book of Revelations.[17] His consequential work popularized the accounts of the revelations of Nuestra Señora de Guadalupe to the Indian Juan Diego, which included five apparitions as well as some miracles associated with the *tilma* image. In the following year of 1649, the popularity of the devotion of the Guadalupana received an additional boost with the publication of an account of the miracles associated with Nuestra Señora de Guadalupe by Luis Lasso de la Vega, a priest, written in the Nahuatl language.[18]

By the time members of the Anaya Almazán family arrived in Mexico City, the devotion to Nuestra Señora de Guadalupe was practiced across a broad range of social classes and racial castes. While in Mexico City for as long as a year, the Anaya Almazán family may have taken the opportunity to visit and worship at the church of Guadalupe on more than one occasion. There was ample time for the Anaya Almazán family to acquire a canvas painting of Nuestra Señora de Guadalupe either by purchase or by gift.

The painting, like others of that time period, would have depicted the image of the imprint of Nuestra Señora de Guadalupe on the *tilma* of Juan Diego. The painting would have complied with strict requirements in accordance with an edict of 1637 condemning copies that were inaccurate.[19] There is also the possibility that the painting acquired by the Anaya Almazán family may have been touched to the original *tilma* to further imbue the painting with devotional significance.

In early 1659, before returning to New Mexico, the Anaya Almazán family made the acquaintance of don Bernardo López de Mendizábal, the newly appointed governor of New Mexico.[20] *Capitán* Alonso Rodríguez, the brother-in-law of Cristóbal de Anaya Almazán, even attended mass regularly in the company of López de Mendizábal's wife, doña Teresa de Aguilera y Roche.[21] The Anaya Almazán family found favor with the new governor and his wife, and traveled in their company from Mexico City back to the Villa de Santa Fe. It could very well be that a

canvas painting of Nuestra Señora de Guadalupe acquired by the Anaya Almazán family came to New Mexico during this particular journey in the early months of 1659.

There is a curious reference to the use of an image of Nuestra Señora de Guadalupe during another long journey on the Camino Real between New Mexico and Mexico City. It was recorded that in April 1663 fray Juan Ramírez, the custodian of the Order of San Francisco in New Mexico, would set up a table as an altar to celebrate Mass in the flatbed cart in which he also slept. In addition to the chalice and linen cloth, he displayed "una ymagen de Nuestra Señora de Guadalupe," which was probably a painting.[22] In all likelihood former governor don Bernardo López de Mendzábal and his wife, doña Teresa de Aguilera y Roche, who were prisoners of the Inquisition being transported under guard to Mexico City, participated in these celebrations of Mass by Ramírez in the three-month journey from New Mexico to Mexico City.

On July 19, 1664, after being charged and imprisoned, doña Teresa de Aguilera y Roche made a request of the officials of the Inquisition tribunal to have three novenas said, "one to the Blessed Virgin of Guadalupe at her sanctuary."[23] This is an example that the devotion to Nuestra Señora de Guadalupe was practiced by individuals of high social standing. She further asked that she be allowed to have her print of the Immaculate Conception, which she had in New Mexico. Through her tribulation before the Inquisition, she found consolation in the intercession of Saint Mary and was acquitted of all charges by the end of December 1664.[24]

Fostering Devotion to La Guadalupana

The events relating to the various apparitions of Nuestra Señora de Guadalupe particularly appealed to Mexican Indians and individuals of Spanish background born in New Spain. As some of these individuals traveled to northern settlements, the devotion to La Guadalupana spread into the frontier regions. In New Mexico, a number of Mexican Indian residents lived in the Villa de Santa Fe, whose numbers were significant enough to form the Barrio de San Miguel, located on the south side of the Santa Fe River. The historical documents consistently refer to these residents as "Indios Méxicanos," meaning Indians from the Valley of Mexico, without a specific reference to any particular tribal affiliation. Curiously, seventeenth-century records make no references to Tlaxcalan Indians living in the Villa de Santa Fe, yet this notion continues to persist in a number of published works of New Mexico history.[25]

Most of the Mexican Indians that lived in New Mexico during the seventeenth century were skilled workers, such as masons, leather jacket makers, shoemakers, blacksmiths, carpenters, and cart makers.[26] Some of these tradesmen worked in the Villa de Santa Fe, and others worked on the ranching *estancias* of *vecinos*. It is plausible to consider that at least a few Mexican Indian residents of New Mexico honored Santa María as Nuestra Señora de Guadalupe. Certainly, there was fertile ground for personal and communal devotion to Nuestra Señora de Guadalupe among the Mexican Indians and those *vecinos* with Mexican Indian antecedents living in New Mexico during the seventeenth century.

In regard to the indigenous Indian groups of New Mexico, in particular Pueblo Indians and nomadic tribes such as the Apache, Navajo, and Manso, the Franciscan friars of New Mexico utilized the image and story of Nuestra Señora de Guadalupe in their continuous attempts at converting these people to the Christian faith. During the 1650s fray García de San Francisco y Zúñiga and his companion, fray Benito de la Natividad, accepted the responsibility of ministering to the Manso Indians in the region of El Paso del Río del Norte, then a part of the realm of New Mexico. The mission they established at El Paso in 1659 was understandably dedicated to Nuestra Señora de Guadalupe.[27] Beginning in 1662 the mission church and *convento* were constructed over a period of six years, and the official dedication of the church occurred on Sunday, January 15, 1668.[28]

Careful consideration was given to decorating the church of Guadalupe del Paso with paintings and statues. Many of the works of devotional art for the new church were very likely shipped northward from Mexico City, or other northern frontier centers, such as Parral, Zacatecas, or Durango. In January 1668, fray Salvador de Guerra described the religious art that adorned the church at El Paso, including a canvas painting of Nuestra Señora de Guadalupe:

> There is placed, at the main altar, a beautiful canvas of Nuestra Señora de Guadalupe. There is also a statue of Our Lady, of wonderful workmanship and dressed in flowered silk and a silver crown; a beautiful Child Jesus half a yard high; a very handsome statue of our Seraphic Father St. Francis; and other little paintings, landscapes and reliquaries. The altar was decorated with bouquets in such a way that it filled the eyes. In one collateral [side altar screen] there is (a) statue of the Immaculate Conception made out of wood, a rich piece; a canvas of St Anthony; and landscapes. In another collateral there is a large and beautiful canvas of our Father St. Anthony finished neatly and decently.[29]

The occasion of the dedication of the church of Nuestra Señora de Guadalupe gave cause for religious and secular celebration, as documented by fray Salvador de Guerra:

> There was celebrated in the pueblo of El Paso del Río del Norte the dedication of the most beautiful temple to be found in these provinces and Custodia, in spite of the fact that some of those it has now could be displayed to advantage in any court. It was dedicated to the Blessed Virgin of Guadalupe in whose honor Padre Predicador fray Juan de Talaban, the present custodio, sang the mass, Padre Predicador fray Gabriel de Torija serving as deacon, and Padre Predicador fray Juan Álvarez as sub-deacon. Padre Predicador fray Nicolás de Frietas preached on the said day, in which the most Blessed Sacrament was placed [in the tabernacle].
>
> In addition to the divine services which were celebrated with great solemnity indoors, there was a great display of fireworks during Mass, as on the previous night. In addition to shooting more than twelve dozen firecrackers, a beautiful castillo, dos hombres armadas [two armed men], rockets, bombs, and bombards were fired.
>
> There were more than four hundred souls, from oldest to youngest, present in the said church—natives of the Mansos who are henceforth Christians and informed concerning our Holy Catholic Faith; also many who are about to receive Christian baptism.[30]

At El Paso, the Franciscan friars actively fostered the devotion to Nuestra Señora de Guadalupe. This apparently also occurred in the various Pueblo Indian communities of northern New Mexico, although the loss of documentation contributes to an extremely limited understanding of the degree of devotion to La Guadalupana among Pueblo Indians.

La Guadalupana as Intercessor

Although many religious images were destroyed during and following the Pueblo Indian uprising of August 1680, it is worthwhile to note that not all Pueblo Indians agreed with the leaders who organized the uprising against the Spanish residents. A number of Pueblo Indians rescued and hid religious images and church furnishings, which they relinquished when governor don Diego de Vargas came to New Mexico seeking reconciliation.

One of the first religious images shown to don Diego de Vargas by Pueblo Indians in 1692 was that of Nuestra Señora de Guadalupe. The image of Nuestra Señora de Guadalupe and the image of Nuestra Señora de los Remedios, today known as La Conquistadora Nuestra Señora de la Paz, were present when accords of peace were negotiated between Vargas and the influential Tewa leader don Luis Tupatú.

On the chilly afternoon of September 15, 1692, while encamped just north of the Villa de Santa Fe, Vargas and his soldiers caught sight of a group of Pueblo Indians riding on horseback on the road from Tesuque. Vargas had traveled from El Paso del Norte with his soldiers and Pueblo Indian allies on the rough remnants of the Camino Real with the hope of securing a peaceful agreement in reconciling the Pueblo communities as part of the Spanish government. The approaching Indians rode to the old Villa of Santa Fe, which had been transformed into a fortress defended by Tewa and Tano Indians loyal to Luis Tupatú, also known as Luis el Picurí. Some of the Indians of the fortress joined the Indians on horseback, and together they walked to Vargas's camp. An Indian approached Vargas seeking permission to receive Luis Tupatú. Vargas memorialized this decisive meeting in his journal:

> Don Luis dismounted from the horse he had come on and walked with his escort, all dressed in animal hides, as is their custom. On his forehead, near the crown of his head, he was wearing a palm-straw band that looked like a diadem. He showed me a small, silver image of Christ he had in his hands with a small piece of silk taffeta, which I saw had a printed image of Our Lady of Guadalupe. He was also wearing a rosary I had sent him. In his pouch he had an Agnus Dei, which I was told he wore. I welcomed him through the interpreters and gave the peace, telling him he would be safe. So that he might better understand my good intentions and that I was not going to harm him, I showed him the image of the Blessed Lady [Nuestra Señora de los Remedios, La Conquistadora], which was on a royal standard; the holy cross of the rosary, and the one I had sent him, all of which I took as my witnesses that the peace I was offering him in the name of the two majesties [God and King] was sure. He replied that he believed it was so. I ordered him to enter my tent, greeting him kindly with warm words and chocolate, which he drank with the fathers, the others who were present, and me.[31]

The following day Tupatú returned to negotiate further with Vargas, successfully securing the governor's pledge to attempt to unite in peace the Pecos and Taos Indians, who were hostile to his people and friendly with his people's enemy, the Faraones Apache. Tupatú's intent in negotiating was "so that his people might be free and safe from the enemy."[32] A month later the ceremony of the formal appointment of don Luis Tupatú as governor of the thirteen northern pueblos occurred at the Villa de Santa Fe. Swearing the oath of office, Tupatú received his written title and a cane as the sign of his authority. The negotiation of peace under the leadership of Tupatú and Vargas ranks among the most significant events that shaped the development of Pueblo Indian and Spanish societies in New Mexico.

Underlying the resolution of conflict were principles of love, peace, charity, reconciliation, and faith. Repeatedly, the records of Vargas's journals illustrate how these aspects of humanity, rooted in human spirituality, overcame hatred, distrust, anger, and violence to restore broken bonds among people in conflict. These qualities were reinforced visually through the representation of Santa María as Nuestra Señora de Guadalupe and as Nuestra Señora de los Remedios.

Don Luis Tupatú was a native of Picurís Pueblo, the pueblo community that had a relationship with two generations of the Anaya Almazán family. What influence the Anaya Almazán family had in cultivating a devotion to Nuestra Señora de Guadalupe among the Picurís Indians is not known. The fact that the small image of Nuestra Señora de Guadalupe in Tupatú's possession survived destruction during the revolt and that the image, as well as what the image represented, managed to be held in safe keeping for thirteen years before Vargas arrived in 1692, attests to the value attached to this particular manifestation of Santa María as well as to the power of her intercession as peacemaker.

NOTES

1. For the reference to the painting of Nuestra Señora de Guadalupe in the possession of Cristóbal de Anaya, see Archivo General de la Nación (AGN), Real Audiencia, Concurso de Peñalosa, vol. 3, leg. 22.

2. AGN, Real Audiencia, Concurso de Peñalosa, vol. 3, leg. 22; and France V. Scholes, Marc Simmons, and José Antonio Esquibel, eds., *Juan Domínguez de Mendoza: Soldier and Frontiersman of the Spanish Southwest, 1627–1693*, trans. Eleanor B. Adams (Albuquerque: University of New Mexico Press, 2012), 381.

3. AGN, Inquisición, vol. 356, exp. 144, f. 310v, Declaration of María de Villafuerte, widow of Francisco López, May 9, 1626, Villa de Santa Fe.

4. P. Mariano Cuevas, *História de la iglesia en México*, vol. 1 (Tlalpam, D.F., Mexico: Imprenta del Asilo Patricio Sanz), 273.

5. Fray Angélico Chávez, *Origins of New Mexico Families in the Spanish Colonial Era*, 2nd ed. (Santa Fe: Museum of New Mexico Press, 1992), 54.

6. AGN, Inquisición, t. 356, f. 314r, Declaration of Juana López de Villafuerte, age 18, wife of Francisco de Anaya Almazán, May 29, 1626, Villa de Santa Fe; and AGN, Inquisición, t. 582, exp. 2, ff. 309r–310r, Proceso y Causa Criminal Contra Cristóbal de Anaya por Proposiciones Heréticas, Nuevo México, 1661.

7. Chávez, *Origins of New Mexico Families*, 3. There is a baptismal record dated September 11, 1595, Catedral de México, Mexico City, for Agustín, son of Pedro de Almazán and Ynes de Anaya; see LDS Microfilm #0035168, Mexico, Mexico City, Asunción Church, Bautismos de Españoles.

8. AGN, Inquisición, t. 356, f. 293r and 314v, remittance of fray Alonso de Benavides, June 24, 1628, Villa de Santa Fe.

9. AGN, Real Audiencia, Concurso de Peñalosa, t. 2, leg. 1, no. 22, Auto de prison y embargo de bienes con su remate del Capitán Cristóbal de Anaya Almazán, 1662.

10. AGN, Inquisición, t. 304, f. 186v, Testificación contra Pedro Márquez, October 10, 1628, San Ildefonso.

11. AGN, Inquisición, t. 467, exp. 78, Testificación contra María de Zamora por Hechicera, 1607, ff. 342v–353v.

12. AGN, Inquisición, t. 467, exp. 78, Testificación contra María de Zamora por Hechicera, 1607, ff. 342v–353v.

13. AGN, Real Audiencia, Concurso de Peñalosa, t. 3, leg. 1, no. 1, f. 125.

14. Baptismal record for Isabel, dated November 13, 1613, Catedral de México (Asunción Church), daughter of Baltasar de Viana and Ana María de Anaya, in which the godparents were recorded as Andrés de Vega and doña Luisa de Montúfar. Mexico, Distrito Federal, Mexico City, Asunción Church, Bautismos 1612–1627, LDS #0035169, ff. 81r, 134v and 201v.

15. Ethelia Ruiz Medrano, "Los negocios de un arzobispo: El caso de fray Alonso de Montúfar," *Estudios de História Novohispana* 12, no. 012 (1992): 78.

16. Ibid., 80.

17. H. M. S. Phake-Potter, "Nuestra Señora de Guadalupe: La pintura, la leyenda y la realidad: Una Investigación arte-histórica e iconological," *Cuadernos de Arte e Iconografía* 12, no. 243 (2003): 91–491.

18. Ibid., 492–509.

19. Clara Bargellini, "Originality and Invention in the Painting of New Spain," in *Painting a New World: Mexican Art and Life, 1521–1821*, ed. Donna Pierce, Rogelio Ruiz Gomar, and Clara Bargellini (Denver: Denver Art Museum, 2005), 86.

20. Don Bernardo López de Mendizábal served as governor of New Mexico from July 11, 1659, to mid-August 1661.

21. AGN, Real Audiencia, Concurso de Peñalosa, t. 3, leg. 1, no. 1, f. 96r.

22. AGN, Inquisition, vol. 502, exp. 3, ff. 331v, 332r, and 343v, April 1663, Mexico City. Fray Juan Ramírez confirmed that he used an image of Nuestra Señora de Guadalupe while celebrating mass on the trip from Mexico to Santa Fe.

23. AGN, Inquisición, vol. 596, exp. 1, ff. 207r–207v, El Señor Fiscal del Santo Oficio Contra doña Teresa de Aguilera y Roche, Mujer de don Bernardo López de Mendizabal, Mexico City, 1664.

24. AGN, Inquisición, vol. 596, exp. 1, ff. 250v–252r, El Señor Fiscal del Santo Oficio Contra doña Teresa de Aguilera y Roche, Mujer de don Bernardo López de Mendizabal, Mexico City, 1664. See also Frances Levine

Doña Teresa Confronts the Spanish Inquisition: A Seventeenth-Century New Mexican Drama (Norman: University of Oklahoma Press, 2016), 160.

25. For historical information about Indios Mexicanos in the Villa de Santa Fe rather than Tlaxcalans, see José Antonio Esquibel, "Thirty Adobe Houses: The Villa de Santa Fe in the Seventeenth Century," in *All Trails Lead to Santa Re: An Anthology Commemorating the 400th Anniversary of the Founding of Santa Fe, New Mexico, in 1610*" (Santa Fe: Sunstone Press, 2010), 109–128, and William Wroth, "Barrio de Analco: Its Roots in Mexico and Role in Early Colonial Santa Fe, 1610–1780," in *All Trails Lead to Santa Fe*, 163–178.

26. For historical information about Indios Mexicanos in the Villa de Santa Fe as masons, leather jacket makers, shoemakers, etc., see José Antonio Esquibel, "The Formative Era for New Mexico's Colonial Population, 1693–1700", in *Transforming Images: New Mexican Santos In-Between Worlds*, ed. Claire Farago and Donna Pierce (University Park: Pennsylvania University Press, 2005), 64–79.

27. Anne E. Hughes, "The Beginnings of Spanish Settlement in the El Paso District," in *University of California Publications in History*, vol. 1, no. 3 (Berkeley: University of California Press, 1914), 305–306.

28. Ibid., 307–308.

29. Translation in France Scholes, "Documents for the History of New Mexican Missions in the Seventeenth Century," in *New Mexico Historical Review* 4, no. 2 (April 1929): 198. In a copy of the original document, this account of the altar and church of Nuestra Señora de Guadalupe by fray Salvador de Guerra reads, "En el atar m[ay]or esta locada n[uest]ra s[eño]ra de // Guadalupe en um hermoso lienso. una ymagen // de n[uest]ra s[eño]ra de bulto. Echura maravillosa bestida // de sela de primavera y corona de plata. Un // niño Jésus de dedia vara hermsosimo, Una // Echura de n[uest]ro Serafico p[ad]re S[a]n fran[cis]co mui lindo //y [o]tros quadritas. Paises. Relicarios, Ramilletes // que com lo d[ic]ho estava d[ic]ho altar que se benia a los // ojos. En un coroteral esta otro Echura de // la pur[isim]a y limpia consep[cio]n de talle rica piesa // y un lienso pequeño de s[a]n Ant[oni]o y paises=en el // otro corateral un lienso grande y mui her // moso de n[uest]ro P[ad]re San Antonio con todo [h]ases y de // sensia." Biblioteca Nacional de Mexico, Legajo 1, Parte 2, Documento 30, *Testimonio del estado que tiene la conversión de los Mansos y dedicación de su iglesia, fray Salvador de Guerra, 1668*, MSS 867, vol. 118B, no. 30 (f.2v), Center for Southwest Research, University Libraries, University of New Mexico, Albuquerque.

30. Translation in Scholes, "Documents," 196–197. This part of the account of fray Salvador de Guerra reads, "En este Pueblo del passo del Rio de // norte se çelebrado la dedicasion del mas her // moso templo que en estas provincias y custodia // V[ist]a a[ll]í (siendo asi que algunos de los que si tiena // pudieran lusen en qualquierra corte) siendo // Patrona de la Virgen s[anti]s[i]ma de Guadalupe // en Cuia solemnidad canto la missa el R[veran]do // P[adr]e fr[ay] Ju[an] de talaban P[redicad]or y custodio actual // sirviendo de diacano el P[ad]re P[redicad]or fr[ay] Gabriel // de torija y de subdiacano el p[ad]re P[redicad]or fr[ay] Juan // alvares y el p[ad]re P[redicad]or fr[ay] nicolas de freitas predico // d[ic]ho dia en que se coloco el s[antissi]mo sacramento // y a de mas de avierse oficiado los divines //exerçiçios con mucha solemnidad de puertas // adentor, Ubo fuegos asi em la missa como // la noche antes. En que de mas de dose doz[en]as // de cohetes que se dispararom se quemo un // Lucido Castillo, dos hombres armadas, unas // ydas y benidas de bombas y lombardos asistieron // en d[ic]ha Yglesia mas de quatrosientos almas // de menor a maior edad de naturals de la //nasion de los indios manssos, que alla el dia//de oi estan chirstianos, y en conosim[ien]to de n[uest]ra S[ant]a fee Catolica sin otras muchas que estan // sercanos aR[eci]vir el S[ant]o baustismo." Biblioteca Nacional de Mexico, Legajo 1, Parte 2, Documento 30, *Testimonio del estado que tiene la conversión de los Mansos y dedicación de su iglesia, fray Salvador de Guerra, 1668*, MSS 867, vol. 118B, no. 30 (ff. 1r–1v), Center for Southwest Research, University Libraries, University of New Mexico, Albuquerque.

31. John L. Kessell and Rick Hendricks, eds., *By Force of Arms: The Journals of Don Diego de Vargas, 1691–1693* (Albuquerque: University of New Mexico Press, 1992), 406–407.

32. Ibid., 410.

LÆTITIAM REDOLENTE ROSA MONS REDDIT APERTVS

Lethiferum uindex necuie ROSABA Chelydrum
Aurea, quæ uernant, carpere poma potes.

5
Devotional Geographies and Imagined Communities: A Sicilian Saint for the Spanish World

CRISTINA CRUZ GONZÁLEZ

During the early modern period, the Spanish world stretched from Europe to the Americas and Asia. In the Mediterranean, Spain controlled Sardinia, Sicily, and the Kingdom of Naples.[1] Recent scholarship has shown that the cultural routes that once linked the viceroyalties to Iberia were intricate, global circuits of exchange. What was the relationship between southern Italy, Spain, and Spanish America? How did that relationship appear in visual culture? This chapter hopes to contribute to the tenor of the discussion by drawing attention to the presence of Palermo's patron saint in the Spanish world. Taking stock of Saint Rosalía's proliferation within a cultural and visual landscape, I map her global devotion and more closely explore the nuanced and regional inflections that were specific to New Spain.

Sicily in the Early Modern Spanish World

Following the union of Castile and Aragón in 1479, Spanish governors and viceroys ruled Sicily and reaffirmed Palermo as a nodal point of Hapsburg and Bourbon power.[2] When Napoleon's troops took control of Naples, the Bourbon king and queen sought refuge and protection in Palermo, installing themselves and their vast retinue in 1806. The locals reportedly resented the presence of costly royals, government ministers, and contingent troops, yet Bourbon precautions and British protection proved prudent, for in 1810 the French army was deterred. Following the abdication of Napoleon in 1814, the Kingdom of Sicily merged with the Kingdom of Naples and became the Kingdom of the Two Sicilies, with Naples as its capital. Sicilians immediately rebelled against the Neapolitan Ferdinand I (third son of Spanish King Charles III) and then led an unsuccessful revolution for independence in 1848. A final uprising against Bourbon rule was led by Giuseppe Garibaldi in 1860; the Kingdom of the Two Sicilies became part of the Kingdom of Italy in 1861, with Victor Emmanuel II as its first king.

Until the seventeenth century, Rosalía was a minor medieval saint known for having lived a life of solitude and prayer at Monte Pellegrino in Palermo. In the fifteenth and sixteenth centuries there were but few references to her role as intercessor against epidemics. The saint's early

OPPOSITE

5.1. *Festival Book for July 1690: Laetitiam Redolente Rosa Mons Reddit Appervs.* Half-title verso from Giuseppe Maria Polizzi, *Gli Horti Hesperidi tributarii: Nella solennità MDCLXXXX alla vergine patrona S. Rosalía, liberatrice di Palermo sua patria dal mortifero dragone della pestilenza: Estino dalla fragranzia delle ritouate di lei odorose reliquie* (Palermo, Sicily: Tomaso Romolo, 1690). Photograph courtesy of the Beinecke Rare Book and Manuscript Library, Yale University. Artwork in the public domain.

modern cult, however, was stirred by two major events in the seventeenth century: the onset of a catastrophic bubonic plague in May 1624 and the discovery of her relics in July of that same year.[3] From 1624 to 1626, the epidemic ravished Palermo; at least ten thousand inhabitants perished in this city alone. Mercifully, the saint interceded on behalf of the plague-stricken—water from her Monte Pellegrino dwelling was found to be curative—and soon she would also prove a useful advocate against earthquakes. At the onset of the epidemic in 1624, Franciscan hermits, known as the Romiti di Monte Pellegrino, began searching for the saint's relics; miraculous visions would eventually lead to the discovery of her body. In 1625, the remains were authenticated by the viceroy's physician, Giovanni Francesco Fiochetto, and declared genuine by archbishop Giovanni Doria.[4] Thereafter, the relics were paraded, exhibited, and, eventually, disseminated throughout the Spanish world.

The saint's intercession was celebrated not only in public festivals but also with important artistic commissions. Indeed, as historian Samuel Cohn notes, "Rosalía became a turbine of artistic production."[5] Religious image and public performance were frequently intertwined: festival books were heavily illustrated (fig. 5.1, see page 86) and an early painted portrait by local artist Vincenzo La Barbera (whose daughter survived the plague) was paraded in the inaugural procession. Commissioned by Palermo's senate and now in the Museo Diocesano in Palermo, the work shows Rosalía interceding on behalf of the city. Wearing a coarse habit, the saint kneels solemnly and, with devout pleas, points to the Lazaretto (the hospital for the plague's victims). A skull, book, and lilies are positioned in the foreground, while the background provides a view of the harbor.[6]

La Barbera's painting is seldom discussed—not because of its quality but because the saint's place in the history of art was almost immediately secured by the genius and talent of the young Anthony van Dyck. As luck would have it, the Flemish artist arrived in Palermo on the eve of the outbreak in 1624. A guest of viceroy Emanuele Filiberto of Savoy, the commission of the viceroy's portrait was the primary reason for the artist's travel to Palermo. Now in the Dulwich Picture Gallery in London, the painting delivers "the perfect image of a seventeenth-century ruler."[7] That is, the half-portrait of the proud viceroy, dressed in his finest armor, is based on Titian's now lost portrait of Charles V (known through a copy by Peter Paul Rubens and an engraving by Lucas Vorsterman). The viceroy died of the plague soon after the portrait's completion.[8]

Van Dyck remained in Sicily long enough to be consumed by the crisis and bear witness to the city's response. In at least five surviving works, he gives image to the devotion, dressing the saintly relics with a human body. His half-length Rosalía at the Prado carries all the beauty and regret of a fleshy Magdalene (fig. 5.2). In a version now at the Museo de Arte de Ponce in Puerto Rico, perhaps the first of his Rosalía works, van Dyck follows La Barbera's design and positions the saint on the hillside, with her suffering faithful down below. As opposed to the Sicilian artist, however, Palermo is designated less by harbor and more by a cluster of buildings (including the cathedral's cupola). A collection of bones has been added to the foreground, transferring La Barbera's meditational tool into a symbol of the saint's relics and the plague's victims. The cityscape continues to diminish in subsequent works: it is more harbor than city in London (Apsley House), becomes a darkened landscape in Houston (Menil Collection), and is completely eliminated in the Prado version. At the Metropolitan Museum of Art, the terrestrial hermit becomes a heavenly Assumption.

There was a veritable Rosalía industry in the 1630s and in the decades to follow. More properly stated, there were multiple industries: publications multiplied, the saint's hermitage at Monte Pellegrino became a major pilgrimage site, relics were authenticated and disseminated, and church altars were dedicated.[9] Images often accompanied the publications and served to bolster her value in Sicily and eventually the Spanish world (fig. 5.3). The saint's first official biog-

between the two and the demand for both. A fairly common nineteenth-century *alabado* (hymn) survives, honoring the saint's penitential practices ("through penance you conquered the world") and the value of her mortification tactics ("you cut your flesh so unswervingly that for this reason, virgin, the church sings to you").[51] With extreme solemnity, devotees sang, prayed, and followed her example.

Concluding Remarks

The medieval Rosalía became an important Counter-Reformation saint due to the bubonic plague and the discovery of her bones in 1624. Her image hit the global stage with the work of Anthony van Dyck. Her devotion spread to Iberia and was mostly aided by Seville's archbishop, a native of Zaragoza who relied on the Franciscans for the promotion of her cult. In eighteenth-century New Spain, her following was considerable in central Mexico and the Bajío; due to Jesuit support, it was especially robust on the northern frontier. But in nineteenth-century New Mexico, she flourished as a product of the Penitentes and their paraliturgical practices. To label Rosalía *only* as an imported Sicilian devotion in New Spain does not do justice to the Mexican cultural and literary contributions (Rincón, Arriola, the *alabados*), nor does it begin to explain the patronage, production, and viewing contexts of the variegated visual corpus. The devotion was multifaceted and, in many ways, conveniently vague. The saint decorated church spaces, performed a Jesuit (and at times Sicilian) identity, advanced the missionary endeavor, surged in response to epidemics, modeled female piety, and was central to lay communities structured on penitential principles. The devotion's lack of precision, indeed, might be what made it pervasive and enduring.

NOTES

1. In 2017, in between presentations at a Franciscan conference in New York, I first spoke to William Wroth about the presence of Saint Rosalía in Spanish America. We continued the discussion the following year in Chimayó and Santa Fe. This paper springs from these conversations and the questions we raised.

2. Jeremy Dummett, *Palermo, City of Kings: The Heart of Sicily* (London: I. B. Taurus, 2015), especially 84–102. Eric Cochrane provides a review of the academic literature in "Southern Italy in the Age of the Spanish Viceroys: Some Recent Titles," *Journal of Modern History* 58, no. 1 (March 1986): 194–217. On the visual culture and its implications for a revised art history, see Michael Cole, "Toward an Art History of Spanish Italy," *I Tatti Studies in the Italian Renaissance* 16, nos. 1–2 (September 2013): 37–46.

3. The plague continued unabated from May 7, 1624, until June 1626. On the symbiotic relationship between saint and contagion, see Samuel Cohn, "Mechanisms for Unity: Plagues and Saints," in *The Routledge History of the Renaissance*, ed. William Caferro (London: Routledge, 2017), 242–258. See also Gauvin Bailey, *Hope and Healing: Painting in Italy in a Time of Plague, 1500–1800* (Worcester, MA: Clark University, College of the Holly Cross, Worcester Art Museum, 2005).

4. On the discovery of the relics and their authentication, see Bailey, *Hope and Healing*, 120; and Xavier Salomon, *Van Dyck in Sicily, 1624–1625: Painting and the Plague* (Milan: Silvana Editoriale, 2012), 34–36.

5. Cohn, "Mechanisms for Unity," 252.

6. Salomon, *Van Dyck in Sicily*, 90–91. In 1625, La Barbera produced a second version (with a dramatic pile of dead corpses in the foreground) for a patron's burial chapel in Sant' Anna la Misericordia in Palermo (ibid., 38).

7. Ibid., 58.

8. The viceroy's armor (showcased in the portrait) survives in the Royal Armories of Madrid (ibid., 58–67).

9. In 1630 she was included in the *Martirologium Romanum* by Pope Urban VIII. The papal catalog admits the anniversary of the discovery of her relics (July 15) and establishes September 4 as her feast day (the anniversary of her death day).

10. For a bibliography, see Carlo Pastena and Enza Zacco, *Sanctae Rosaliae Dicata: Bibliografía cronologica su Santa Rosalia* (Palermo: Regione siciliana, Assessorato dei beni culturali e dell'identità siciliana, 2017).

11. On the engravings and preparatory drawings, see Zirka Zaremba Filipczak, "Van Dyck's 'Life of St Rosalie,'" *Burlington Magazine* 131, no. 1039 (October 1989): 693–698. The altarpiece is now in the Kunsthistorisches Museum in Vienna (ibid., 695–696).

12. The Vaccaro paintings, produced between 1657 and 1670, are now at the Prado Museum and in a private collection. For Preti's lost frescoes and the surviving documentary sources, see James Clifton, "Mattia Preti's Frescoes for the City Gates of Naples," *Art Bulletin* 76, no. 3 (September 1994): 479–501.

13. Ibid., 483 and 492. At the height of the affliction in 1656, Cayetano spared the sick on his feast day (August 7). The saint had previously interceded during the plague of 1616, but his role in 1656 led to his sculptural inclusion at the urban gates and, arguably, his canonization in 1671.

14. Ibid., 499–500.

15. Dinko Fabris calls the 1670 composition by Provenzale a masterpiece, and perhaps his "most successful theatrical work." On *La colomba ferita* and *La mejor flor de Sicilia*, see Esther Borrego Gutiérrez, "La vida de santa Rosalía: De la ópera sacra italiana a la comedia de santos española," in *Homenaje a Henri Guerreiro: La hagiografía entre historia y literatura en la España de la Edad Media y del Siglo de Oro*, ed. Marc Vits (Madrid: Iberoamericana, 2005), 314–315; and Dinko Fabris, *Music in Seventeenth-Century Naples: Francesco Provenzale (1624–1704)* (Aldershot, UK: Ashgate, 2007), 132–153. Agustín Salazar y Torres's life exemplifies the global Golden Age. Born in Spain, he arrived in New Spain in 1645, at the age of nine. Accompanying his uncle, Marcos de Torres (bishop of Yucatan and later viceroy of New Spain), the young Salazar initially studied at the Jesuit College of San Ildefonso and, later, at the University of Mexico. At twenty-four, he returned to Spain in the company of the outgoing viceroy of New Spain, Francisco Fernández de la Cueva, the Duke of Albuquerque. Eventually, the duke became Viceroy of Sicily, and the dramaturgist became *capitán de armas* in the Sicilian province of Agrigento. After four years in Sicily, Salazar moved to Madrid, where he produced *La mejor flor de Sicilia* and, soon after, died in 1675. On Salazar's literary importance in Mexico, see Martha Lilia Tenorio, "Agustín Salazar y Torres: Discípulo de Góngora, maestro de sor Juana," *Nueva Revista de Filología Hispánica* 58, no. 1 (2010): 159–189.

16. Juan de Paredes, *Vida ejemplar de santa Rosalía de Palermo, especial abogada contra la peste* (Madrid: [s.n.], 1652); and Giuseppe Scuppes, *Resunta de la vida, invencion y Milagros de Santa Rosalia, virgin panormitana de la Casa Real de Sicilia, abogada y defensora de la peste* (Madrid: Julián de Paredes, 1652).

17. Manuel Calasibeta, *La Rosa de Palermo, antidote de la peste y de todo mal contagioso* (Madrid: Bernardo de Villa Diego, 1668).

18. Ibid., iv. Unless stated, all translations from the Spanish are my own.

19. On this subject, see David Chillón Raposo, "La sensibilidad estética siciliana en la ciudad de Sevilla a finales del siglo XVII: El origen de la devoción a Santa Rosalía," *Espacio, Tiempo y Forma: Serie VII, Historia del Arte* (Nueva Época) 5 (2017): 247–272.

20. Ibid., 251–252. Records from Seville's cathedral point to the sale in 1723 of one of these Italian miters ("encrusted with coral and gold") to a bishop from Nicaragua.

21. Ibid.; and María Jesús Sanz Serrano, "Escultura y orfebrería panormitanas en Sevilla," *Archivo Hispalense* 198 (1981): 75–91.

22. Chillón Raposo, "La sensibilidad," 254–260.

23. Juan de San Bernardo, *Vida y Milagros de Sta. Rosalía Virgen* (Seville: En la Imprenta de Manuel Caballero, 1731).

24. The convent was approved by the Congregation of Bishops and Regulars in 1694, but the king did not sign off until 1700. See Carlos Francisco Nogales Márquez, "Las fiestas de inauguración del Convento de Religiosas Capuchinas de Santa Rosalía de Sevilla en 1763," in *La clausura femenina en España: Actas del symposium*, ed. Francisco Javier Campos Fernández de Sevilla (San Lorenzo de El Escorial, Spain: Real Centro Universitario Escorial-María Cristina, 2004), 575. On the life of the founding abbess, see Clara Gertrudis Peres, *Copia de la carta en que la R. Madre Sor Clara Gertrudis Perez, abadesa del convento de Sta. Rosalia, capuchinas de Sevilla da quenta a los demas conventos, del feliz transito, y heroycas virtudes de la venerable madra Sor Josepha Manuala de Palafox y Cardona* (Seville: [s.n.], 1724).

25. Tinoco produced a second painting of the saint for an altarpiece in the Carmelite church of Our Lady of Solitude. See Fernando Rodríguez, *Una cuestión de matices: Vida y obra de Juan Tinoco* (Puebla, Mexico: Gobierno del Estado de Puebla; Universidad Iberoamericana; Golfo Centro, 1996), 155–156, 294–295, 303–305.

26. The Berrueco is in the Museo Universitario de la Benemérita Universidad Autónoma de Puebla. Talavera's painting is in the sacristy of the Templo de Santa Barbara Almoloya in Cholula.

27. The altar in Nealtican is dedicated to San Diego de Alcalá, and the one in Acatzingo is dedicated to San Juan Nepomuceno.

28. Two anonymous examples survive in La Profesa in Mexico City. Miguel Cabrera produced his own version in 1765 for the Franciscan monastery in San Luis Potosí (it is now in the Aranzazú chapel). Another by Cabrera is in Santa Fe, New Mexico (La Conquistadora Chapel).

29. The oil-on-copper painting is in the collection of Andres Blaisten in Mexico City.

30. The object belongs to Daniel Liebsohn in Mexico City. The work attributed to Páez is in the collection of Jan and Frederick R. Mayer in the Denver Art Museum.

31. In the collection of Diego Monroy Ponce in Mexico City. See Jaime Cuadriello's description in *Painted in Mexico, 1700–1790: Pinxit Mexici*, ed. Ilona Katzew (Los Angeles: Los Angeles County Museum of Art and Delmonico Books, 2017), 438, 466–467.

32. Páez's composition was exhibited in the International Exhibition in Philadelphia (1876) and briefly mentioned by the dean of Colonial Mexican painting, José Bernardo Couto ("the colors are not too pleasing but the design is excellent"). See José Bernardo Couto, *Diálogo sobre la Historia de la Pintura en México* (Mexico City: Oficina Tipográfica de la Secretaría de Fomento, 1889), 71. The communion painting is now in the Museo de Arte Colonial in Morelia. See Carmen Alicia Dávila and Nelly Sigaut, eds., *Museo de Arte Colonial de Morelia* (Morelia, MX: Colegio de Michoacán-Secretaria de Cultura del Estado de Michoacán, Morelia, 2006), 74–79.

33. Luis González Rodríguez, "Testimonios sobre la destrucción de las misiones tarahumares y pimas en 1690," *Estudios de Historia Novohispana* 10 (1991): 230.

34. Peter Masten Dunne, SJ, *Black Robes in Lower California* (Berkeley: University of California Press, 1952), 439.

35. Carlos Roxas cited in Bernard L. Fontana, *A Gift of Angels: The Art of Mission San Xavier de Bac* (Tucson: University of Arizona Press, 2010), 121–122.

36. Ibid., 122. Cristóbal de Cañas's account of the epidemic in the Sonoran town of Chinapa (1728), although less colorful, also details the procession of an esteemed Rosalía statue. Virginia García Acosta, Juan Manuel Pérez Zevallos, and América Molina del Villar, *Desastres agrícolas en México: Catálogo histórico, I, Época prehispánica y Colonial (958–1822)* (Mexico City: Fondo de Cultura Económica, 2004), 114.

37. On these works and the artist's overlooked oeuvre, see Luisa Elena Alcalá, "La obra del pintor novohispano Francisco Martínez," *Anales del Museo de América* 7 (1999): 175–187.

38. Lucas del Rincón, *Oración Panegyrica a Glorias de Santa Rosalía de Palermo, que el dia quinze de Julio en la anniversaria memoria de la invención de sus Sagradas Reliquias, y en fiesta particular, que se celebró en el Colegio Máximo de S. Pedro y S. Pablo de la Compañia de Jesús* (Mexico City: Herederos de la Viuda de Francisco Rodriguez Lupercio, 1724).

39. Rincón would later (1737) publish the first Spanish translation of the history of Nuestra Señora de la Luz, a Jesuit devotion especially hailed in the Bajío.

40. For this present chapter, I consulted the two copies at the Bancroft Library and another at the Huntington Library. Several copies contain pasted prints not only of Rosalía but also of the Virgin of Guadalupe. On Arriola and the extant copies in Mexico, see Estela Castillo Hernández, "Vida y virtudes de la esclarecida virgen y solitaria anacoreta Santa Rosalía, Patrona de Palermo, poema lírico de Juan José de Arriola" (PhD diss., Colegio de México, 2013).

41. For the female imitation of Christ and its visual correspondences, see Cristina Cruz González, "Beyond the Bride of Christ: The Crucified Abbess from Mexico to Madrid," *Art Bulletin* (December 2017): 102–132.

42. Michael Mathes, "Oasis culturales en la Antigua California: Las bibliotecas de las misiones de Baja California en 1773," *Estudios de Historia Novohispana* 10 (1991): 394.

43. Emily Umberger, "Bac on the Border," *Anales del Instituto de Investigaciones Estéticas* 29, no. 91 (2007): 69–123; and "A Tale of Two Saints at San Xavier del Bac," *Kiva: Journal of Southwestern Anthropology and*

History 85, no. 2 (2019): 134–160. For the cupola with drum, see Fontana, *Gift of Angels*, 89–122. It is not the first appearance of Rosalía in a Mexican cupola—she is carved in the crowded cupola of the Rosario Chapel in Puebla.

44. Medieval saints became plague intercessors during the Renaissance at an unprecedented rate. On this subject, see Cohn, "Mechanisms for Unity," 249–254.

45. *Triduo devoto a la Santissima, Augusta, e Inefable Trinidad, Padre, e Hijo, y Espiritu Santo, tres Personas distintas, y un solo Dios verdadero. Consagrado por medio de las Santas tres Rosas, Rosalía; Rosa de Santa Maria, y Rosa di Viterbo. Dispuesto por un Sacerdote de la Compañia de Jesus* (Mexico City: San Ildefonso, 1760). It was reprinted in 1765, 1774, and 1795.

46. See, for example, Charles Carrillo and Thomas Steele, *A Century of Retablos: The Janis and Dennis Lyon Collection of New Mexican Santos, 1780–1880* (New York: Hudson Hills Press, 2007), 96. For the Hermanos Penitentes (the Penitential Confraternity of our Father Jesus the Nazarene) and their relationship to the material culture of the region, see William Wroth, *Images of Penance, Images of Mercy: Southwestern Santos in the Late Nineteenth Century* (Norman: University of Oklahoma Press, 1991).

47. Cristina Cruz González, "Crucifixion Piety in New Mexico: On the Origins and Art of St. Librada," *RES: Anthropology and Aesthetics* 65–66 (2014–2015): 98–100.

48. Tom Riedel, "The Regis Santos: A Teaching Collection at 50 Years," *Jesuit Higher Education: A Journal* 6, no. 1 (2017): 70.

49. On the evolution of Saint Librada, and her import and importance in New Mexico, see González, "Crucifixion Piety in New Mexico," 87–102.

50. Ray John de Aragón, *The Penitentes of New Mexico: Hermanos de la Luz* (Santa Fe, NM: Sunstone Press, 2006), 30–32.

51. Thomas Steele, *The Alabados of New Mexico* (Albuquerque: University of New Mexico Press, 2005), 361–363.

6

The Catholic Church in Late Spanish Colonial New Mexico: The Bishops of Durango and Secularization of the Missions

RICK HENDRICKS

Introduction

Secularization refers to the process of converting a mission under the control of priests belonging to a regular order, such as the Franciscans, to a secular parish under the control of a bishop. The Bishopric of Durango placed secular priests in New Mexico as early as the 1730s in Santa Fe and the El Paso del Norte area, but this did not lead to a general secularization of the missions. The *villas* (chartered municipalities) of Santa Fe, Santa Cruz de la Cañada, and Albuquerque, as well as the pueblo of El Paso, had been secularized by royal order at the request of Pedro Tamarón y Romeral, bishop of Durango, in 1764, but they were returned to the Franciscans as unsubsidized missions in 1768.[1] Statistics for 1776 show twenty-six subsidized missions and four unsubsidized communities, and it would be another fifty years before significant progress toward secularization was secured.

There are a number of reasons why the struggle was so protracted. The most often cited obstacle is the opposition of the Franciscan Order to surrendering its hegemony over New Mexico to the Bishopric of Durango, but there were financial factors that were considerable hurdles to overcome as well. With the establishment of missions in New Mexico, the Spanish crown provided each Franciscan with an annual stipend. In addition, supply caravans transported supplies from Mexico City to the New Mexican mission field every three years. The stipends and delivery of supplies amounted to a very significant subsidy in support of Franciscan missionary activities in New Mexico. This arrangement also suited the faithful very well indeed. The Franciscans took care of the spiritual needs of their flock, and the Crown provided for most of the temporal needs of the priests. By the 1760s the bishop of Durango was ready to secularize the missions in the most well-established and presumably prosperous communities in New Mexico, which meant that the parishes where secular priests would serve had to take over their support. But the bishop badly misjudged the financial soundness of Santa Fe, Santa Cruz de la Cañada, Albuquerque, and El Paso. Moreover, the populace of these towns, which was not accustomed to providing for all of their priests' needs, apparently had no inclination to do so.

When efforts at secularization were renewed at the end of the eighteenth century with the placement of interim priests in these same four communities, the results were remarkably similar.[2] Of the priests sent by Durango to the four communities in the 1790s, only one, José Manuel de Aganza of El Paso, enjoyed a benefice provided by his family that gave him sufficient income for his needs. The interim priests assigned to the towns in the north were all quite poor and found the situation they encountered in their secular pastorates untenable. They also found that they were not really welcome.

Franciscans Divided

The church in New Mexico in the late eighteenth century faced challenges it had never confronted in its long history in the province. Civil-military authorities in the person of the governor above all were actively seeking to subjugate the church to crown authority, consistent with the tenets of the Bourbon Reforms. The Franciscans, long the exclusive representatives of the Roman Catholic Church in New Mexico, were seriously divided against themselves. Criollos (Spaniards born in the New World), and *hijos de provincia* (peninsular Spaniards who joined the Franciscan Order in the New World), and *peninsulares* (European Spaniards who joined the Franciscan Order in Spain) were at odds, particularly over access to positions of authority and prestige. This internal conflict coincided with Bishop Francisco Gabriel de Olivares y Benito's efforts to bring about the secularization of the New Mexico missions, which the Franciscans strenuously and vociferously opposed. Bishop Olivares initiated this move toward secularization with the placement of interim priests in the three villas in New Mexico, which were Santa Fe, Santa Cruz de la Cañada, and Albuquerque. Other secular priests were placed in El Paso.[3]

By the last quarter of the eighteenth century, the tension between peninsular Spaniards and criollos within the Franciscan Order had reached levels comparable to those of the society at large. In 1782 European friars accused American-born governor Juan Bautista de Anza and custodian fray Juan Bermejo, himself a peninsular Spaniard, of discrimination against the European Franciscans, even though peninsulars outnumbered criollos at the time. Additional complaints against Anza and Bermejo related to the paucity of annual stipends, which remained at 330 pesos, as it had throughout the Colonial period; questions over authority to assign friars; and personal service of the Indians, which Anza prohibited. Although the governor usually stayed above the fray, he did have occasion to brand one Franciscan seditious, disobedient, and disrespectful.

The root of the larger conflict within the Franciscan Order was the *alternativa*, the alternation of ecclesiastical offices between peninsulars and criollos, the latter believing that the system was biased in favor of peninsular Spaniards. More peninsular Spaniards ended up in New Mexico because criollos and *hijos de provincia* in Mexico City succeeded in having European friars sent out of the viceregal capital to missions operating under the jurisdiction the Holy Gospel Province. For this reason, of a group of forty-six Franciscans who arrived in Mexico City from Spain in 1778, sixteen Europeans were assigned to New Mexico missions.

The First Diocesan Clergy

The Bishopric of Durango dates from 1620, and from that date, at least in theory if not in practice, the newly established see had ecclesiastical authority over New Mexico.[4] The formal description of the new diocese's boundaries encompassed the present-day Mexican states of Durango and Chihuahua, as well as parts of Sonora and Sinaloa. New Mexico was not specifically mentioned; rather, the northern limit of the diocese was to be the North Sea. Beginning with the first bishop, fray Gonzalo de Hermosillo, all leaders of the Durango see interpreted this to include

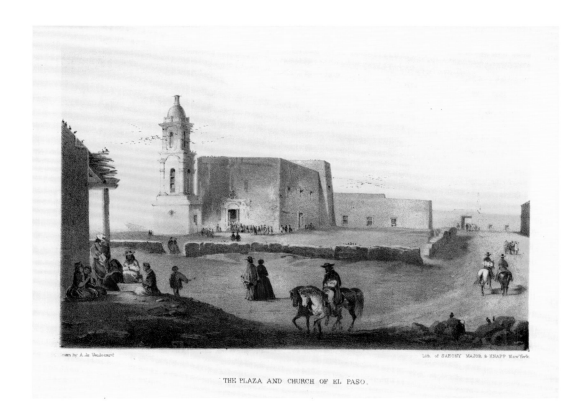

THE PLAZA AND CHURCH OF EL PASO.

6.1. "The Plaza and Church of El Paso," drawing by A. du Vaudricourt, lithograph of Sarony, Major and Knapp, New York, ca. 1848–1855. Artwork in the public domain: https://texashistory.unt.edu/ark:/67531/metapth31834/m1/1/. University of North Texas Libraries, The Portal to Texas History, https://texashistory.unt.edu; crediting Star of the Republic Museum.

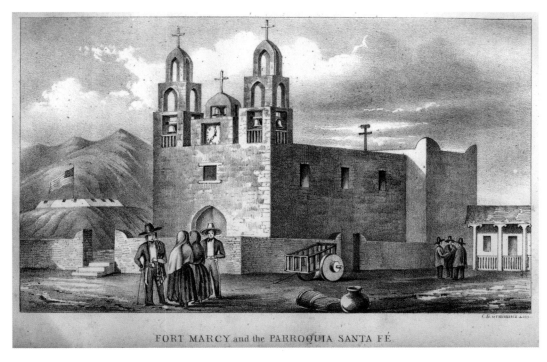

FORT MARCY and the PARROQUIA SANTA FÉ.

6.2. "Fort Marcy and the Parroquia Santa Fé," report of Lieut. J. W. Abert, of his examination of New Mexico, in the years 1846–1847 (Washington, DC: Wendell and van Benthuysen, 1848). Artwork in the public domain.

New Mexico.[5] In reality, however, following the establishment of the Custody of New Mexico in 1616, the province remained firmly under the control of the Franciscan Order, with Franciscan authorities in Mexico City having the final say about matters related to the mission field in the far north of New Spain for the next century and more. Most residents of the colony had never met a secular priest before the opening decades of the eighteenth century unless they had seen one before coming to New Mexico or on a journey out of the province. It was the blue-robed Franciscan friars that ministered to the religious needs of New Mexico.

The first rather tentative attempt by Durango to exercise any real authority over New Mexico came in 1725 when bishop Benito Crespo y Monroy visited the El Paso area in a fore-shortened ecclesiastical visitation of New Mexico.[6] Bishop Crespo met considerable resistance on the part of the Franciscans serving in the El Paso area missions and did not travel to the northern part of the province. But his presence in far southern New Mexico bore unexpected fruit. Antonio de Valverde Cosío requested on behalf of local Suma Indians that the bishop establish a mission staffed by "black priests," by which they meant diocesan priests and not Franciscans. This was obviously a reaction against what they observed of the Franciscans who served the mission of Nuestra Señora de Guadalupe del Paso del Norte since its establishment in 1659 and at other missions such as Senecú, Ysleta, and Socorro. Valverde, easily the wealthiest man in El Paso, established a benefice on his Hacienda de San Antonio de Padua in 1728, the proceeds of which were to provide for the temporal needs of the priests assigned to the proposed mission.

A royal cedula of December 7, 1729, recognized the authority of the Bishopric of Durango over New Mexico, eliminating any doubts resulting from the vagueness of the 1620 founding document. Franciscan authorities in Mexico City fairly howled in protest. The commissary general recalled the martyrs of 1680, stated that no bishop had ever suffered a similar fate, and argued that were it not for the Franciscans, New Mexico would have been lost. Eloquent and justified though these complaints might have been, Durango was undeterred.[7] On the basis of the cedula, Bishop Crespo named fray Salvador López vicar and ecclesiastical judge in El Paso. In 1730 the viceroy of New Spain, the Marqués de Casafuerte, approved the establishment of a secular "mission" to the Sumas called Santa María de las Caldas across the river from El Paso del Norte. As a result, Crespo named a New Mexico native, *bachiller* (holder of a university degree) Santiago Roybal, to the curacy at Las Caldas.[8] The previous year, Crespo had named Roybal his vicar in Santa Fe and had begun a measure of jurisdiction over New Mexico. As vicar, Roybal was the bishop's official representative in the capital of New Mexico; he was also the bishop's eyes and ears, keeping him informed on events happening in the distant province. Roybal shuttled back and forth between Las Caldas and Santa Fe through 1739, after which time he served in the latter town until his death in 1774.

In 1731 *bachiller* Juan José Ochoa de Herive began to serve at Las Caldas.[9] By 1737 *bachiller* Francisco Javier de Garate had replaced Ochoa.[10] Garate remained in Las Caldas until 1739.[11] In that year, the bishop of Durango named a second vicar for New Mexico, tapping *bachiller* Francisco Pedro Romano as vicar, ecclesiastical judge, and interim priest of Las Caldas, where he served until his death in 1746. Romano enjoyed the support of a benefice established on the Hacienda de San Antonio, as his predecessors presumably had.

Vicar Romano's testament provides a glimpse into the material culture of the secular clergy serving in New Mexico in the first half of the eighteenth century. Franciscans who served in New Mexico took a vow of poverty, but some secular clergy accumulated sizeable estates. Romano's possessions included seven stallions and two mares, four male colts, four mules and one burro, 179 head of cattle, 272 sheep and 120 wethers, and 86 she goats and 40 billies and castrated goats. Vicar Romano's personal library may have been the largest in eighteenth-century New Mexico, consisting of ninety-four volumes, mostly religious works. He had the usual clerical garb and vestments, printed images of Our Lady and Christ on the Cross, and paintings of the Virgin and saints. Romano owned a vihuela, a harp, and a violin.

Romano had numerous luxury items. He had a writing desk with small drawers called a *var-gueño*, and a *caja de Michoacán*, a type of painted and lacquered furniture produced in that region of central Mexico. He also owned Chinese porcelain and majolica. Several pieces were religious, such as two silver reliquaries; a rosary with a silver figure of Christ; and two Jerusalem crosses, one silver

and the other of tortoise shell. Some luxury items also had utilitarian function, such as two old belt knives with silver handles; some silver sword guards and sheaths; two silver-plated cups from Michoacán; and some silver shoe buckles and belt buttons. The vicar owned jewelry, including two examples of the popular *bejuco*, a gold-braided chain with a fish and small silver shells and a small silver chain with a fish; four tombac bracelets; a gold ring; and a ring with three emeralds. Romano obviously enjoyed tobacco products. He had four snuffboxes, although none was silver; two lead jugs of snuff, one containing a pound and the other a half pound; three silver cigarette cases, one shaped like a small barrel with gold sprinkles; and a metal spittoon from China.[12]

The bishop of Durango strengthened his efforts to establish a foothold in New Mexico in 1754 when he named José Lorenzo de Rivera vicar and ecclesiastical judge of El Paso, a position he held until 1779. Prior to his assignment in El Paso, Rivera was priest and principal sacristan in the city of Chihuahua. Another of the few native New Mexicans who became priests and served in their home province in the late Colonial period was Nicolás Téllez Girón, born in El Paso to prominent citizens. He accompanied Vicar Rivera north from Durango when he was named to fill the benefice established on the hacienda of Nuestra Señora de los Dolores de Carrizal. Téllez Girón worked in the El Paso area until his death in 1784.[13]

Renewed Efforts at Secularization: Northern Towns

The bishop of Durango began a serious effort to exert his authority over New Mexico in the late 1790s and early 1800s by placing interim priests in the secularized parishes of the three villas of Albuquerque, Santa Cruz, and Santa Fe. The following capsule biographies offer a view of these diocesan priests before and after their service in New Mexico parishes.

Bishop Olivares assigned *bachiller* Gregorio Olidén as interim priest of Santa Fe in 1797. Born in Durango around 1752, Olidén served at San Bartolomé in Chihuahua and in Sonora before receiving his assignment in New Mexico. Olidén's time in Santa Fe was brief. He arrived in March, and the bishop formally removed him in July when he ordered Olidén to hand over his parish to José Bibián de Ortega. Nevertheless, Olidén remained in New Mexico until October 1798 because he was so poor that he struggled to acquire sufficient funds to leave the province.[14]

In 1797 Bishop Olivares also appointed Ortega interim priest of Santa Cruz de la Cañada in New Mexico.[15] Ortega was born in Real de Oro in 1763. During his studies in the Tridentine Seminary in Durango, Ortega was sometimes referred to as a *coyote* (the son of a mestizo and Indian woman) and at other times as a *mulato*. After completing his studies, Ortega served in Carichic in the Sierra Tarahumara, beginning in 1796. The following year he was named interim priest of Santa Cruz de la Cañada. He arrived in New Mexico by March 1798 and remained until June 1804, although he had resigned the previous year.[16] Subsequently Ortega served in Huejotitán from 1808 to 1813, in San Buenaventura in 1814, in San Bartolomé from 1815 to 1817, and in Mátachi in 1824.

Juan José de Sida, a *mulato*, was born in Durango. After entering the Tridentine Seminary in Durango, Sida left to seek a mining bonanza in the Real de Catorze to provide for his impoverished family. He eventually went to Guadalajara for his ordination, and then was an assistant priest in Sombrerete from 1787 to 1797. He served as priest and coadjutor of the Real of Mapimí from 1797 to 1801. In November 1801 Sida was named interim priest of Albuquerque. He arrived in New Mexico in May 1802 and departed in March 1803. After disappearing from the historical record for a decade, Sida resurfaced at the Presidio de Guajuquilla, where he was chaplain from 1813 to 1816.

Juan José Lombide was born in Durango in 1771. Following the completion of his studies at the Tridentine Seminary, he became cathedral chaplain in 1795. That same year he enrolled in the university in Mexico City. Two years later he became an assistant priest at the church of Nuestra

Señora de Guadalupe near Durango, where he was still serving in 1798. From there he moved to Santa María de Otaez. Lombide arrived at Santa Cruz de la Cañada in January 1802 and remained until November 1803. After leaving New Mexico, Lombide was assigned to the Real of San Antonio de las Ventanas, where he was from 1805 to 1811. He was back in his native Durango from 1812 to 1816, after which he accepted his longest and final position as interim priest and vicar at San Ignacio de Tamazula from 1817 to 1831.

The Diocesans' Failure in the North

The attempt to replace Franciscan missionaries with secular priests in New Mexico was unsuccessful for several reasons. The diocesan priests placed in secularized parishes in the north met with a generally hostile reception from Franciscans. There were several underlying reasons for this attitude. First, Franciscans had enjoyed hegemony in the religious arena in New Mexico since the colony's inception. Franciscan sentiment for preserving this control coalesced around the memory of the martyrdom of twenty-one of their brethren during the Pueblo Revolt of 1680. Second, there had always existed a rivalry for the harvest of souls between secular and regular clergy, and this was present in Colonial New Mexico, as it was in other Spanish possessions. Third, the tension that was to emerge in the broader society in Spanish America between those born in the Old World and those born in the New World also existed in the church. All the diocesan priests sent to New Mexico were native to New Spain, but many of the Franciscans were peninsular Spaniards. Although this attitude on the part of the Spaniards could be construed as a type of superiority complex, some opposition to the secular priests had more easily identifiable racial overtones, as both Bibián de Ortega and Juan José de Sida were probably *mulatos*.

The diocesans also received a hostile reception from the communities to which they were assigned. This was not the result of a particular affection for the Franciscans. It was instead because the diocesan priests imposed a new financial burden on their parishioners. The Spanish government provided an annual stipend of 330 pesos to each Franciscan for most of the Colonial period. This sum covered most of the Franciscans' modest needs, and the people to whom they ministered typically provided only food and, in the case of Natives, personal service. The only other expenses associated with support of the Franciscans were the fees they collected for performing rites such as marriage and baptism. None of the seculars assigned to communities in the north enjoyed benefices, and two of them, Olidén and Sida, were extremely poor.

Finally, New Mexicans seemed to react negatively to change, and the diocesan priests brought different ways of performing their religious duties. Over time, the Franciscans had developed their own way of serving the people, making practical adaptations to the frontier environment in which they lived and worked. The diocesan priests, most of whom had received their religious education in Durango, were unprepared for what they found in New Mexico.

Renewed Efforts at Secularization: Southern Towns

Juan Manuel Aganza was born into the local elite of El Paso in 1765.[17] After completing his studies in the Tridentine Seminary in Durango, his first appointment was as interim priest of San Francisco de Lajas. A position as honorary assistant in the Analco neighborhood in Durango followed. He then served at Canatlán. From 1795 to 1797, Aganza was the assistant priest in the jurisdiction of Guarisamey, serving in the mining district of Santa Cruz de los Gavilanes.[18] Aganza returned to seminary to become an elementary school teacher but did not remain long in that position and in 1798 received the requisite licenses to serve in his native El Paso. Aganza enjoyed the support of a benefice provided by his family.[19]

José Ignacio Suárez Nájera was born in Chihuahua. Suárez attended seminary in Durango and received minor orders in 1779.[20] He received the orders of subdeacon and deacon in 1782 by the bishop of Guadalajara and entered the priesthood the following year. He served in El Paso from 1798 until 1802.[21] Suárez was dead by 1805.

José Serapión Prado (he usually signed entries in the sacramental registers "José Prado") was priest and vicar of the Real de Papigóchic from 1783 to 1802, when he received a new assignment in El Paso. Prado served at the church of Nuestra Señora de Guadalupe from 1802 to 1811.

Born in Chihuahua in 1770, José Antonio Ulibarrí became the priest and teacher of Christian doctrine (*doctrinero*) at the Tarahumara mission in the pueblo of Jesús de Carichiqui near the Valle del Águila in Chihuahua in 1798. He remained in that position until 1802. By 1805 he was serving in Carrizal, and in 1808 he removed to El Paso.

Luis Antonio de Ibave was born in Chihuahua in 1762.[22] After completing his studies at the Tridentine Seminary in Durango, Ibave became the priest of Santo Tomás de Temósachic, serving there from 1789 to 1792. While in Temósachic, Ibave was punished for some form of misbehavior that has been lost to time. He next became the assistant priest in Nombre de Dios in 1793. Two years later, Ibave began to serve as priest of Nuestra Señora de la Purísima Concepción de Pueblo Nuevo.

In May 1809 the commandant general of the Provincias Internas, Nemesio Salcedo, expressed his agreement with Bishop Olivares that Ibave should be named interim priest of Santa Fe.[23] According to Salcedo, the rivalry within the factions of the Franciscan Order in New Mexico was such that they could not be relied on to fill the post. Ibave requested the additional title of rural dean and authority to approve marriages and bless vestments and other sacred items. He also sought clarification regarding whether he owed obedience to any Franciscan or whether he was responsible only to diocesan authorities in Durango. In September 1809, Ibave arrived in Santa Fe and received the parish from fray Francisco de Hozio.[24] He was still serving in Santa Fe in 1813.[25] The aged and infirm Ibave was living in Chihuahua in 1828.

Rise of the Mexican Church

In April 1811 José Serapión Prado forwarded a royalist pastoral letter from the bishop of Sonora to the governor of New Mexico, informing the faithful of the dire consequences of rebellion. The bishop reminded the people of their Christian duty as loyal vassals to support the cause of King Fernando VII. Prado asked the governor to deliver the letter to the Franciscan custodian, who was in residence in El Paso, to distribute copies to the missions of New Mexico.

José Miguel Prado, a native of the real of Santa Eulalia, Chihuahua, served as assistant to the priest in charge in El Paso, who was his uncle José Serapión, beginning as early as 1808.[26] In September 1811 he took over for his uncle, who was ill.[27] By the end of the year, he, too, was replaced when Juan Tomás Terrazas received an appointment as interim priest of El Paso. The selection of Terrazas was an important step toward the secularization of the El Paso mission.[28]

Terrazas was a native of Babonoyaba, Chihuahua, where he was born in 1781.[29] Terrazas decided to become a priest at an early age and prepared himself through study on his own. He then spent two years in preparation in Durango. He was admitted to Holy Orders in 1805. Terrazas was replaced in 1814 when Juan Rafael Rascón was selected as vicar of El Paso.

Juan Rafael Rascón was born in Cusihuiriachi, Chihuahua, in 1783.[30] As a young man he studied Latin at the insistence of his father, who wanted his son to enter the priesthood. In 1801, José Serapión Prado, minister of La Purísima Concepción de Papigochic, certified that Rascón studied Latin grammar for three years, during which time he was an excellent student. After completing his studies with Prado, Rascón moved to Mexico City, where he continued his education in the Colegio de San Juan de Letrán.

In October 1815, Rascón participated in the public act that required all citizens to take a loyalty oath to the restored Spanish monarch, King Ferdnando VII. Local civil and military authorities held a ceremony to reaffirm allegiance to the king and protest the words and deeds of all those fighting for Mexican independence from Spain. At a gathering of the inhabitants and officials of El Paso and the surrounding towns along with the clergy, the authorities received the oath of loyalty from the citizenry. The people swore fealty to the king and denounced the rebels' Constitution of Apatzingán of 1814, which had declared Mexican independence.

Afterward, officials, troops, and the public headed to the church of Nuestra Señora de Guadalupe, holding aloft a banner bearing an image of the king. Rascón said mass and sang a Te Deum for the monarch. Following the church services, officials paraded the royal standard around the public plaza, crying "Viva el Rey!" The militia marching at the rear of the procession fired salutes while men and women from local Indian communities danced in the vanguard in a great show of joy and pleasure. When the procession arrived at the *casas reales* (government headquarters), the royal standard was raised to great jubilation. That night a dance under the *portales* (arcades) of the plaza brought the festivities to an end.

Ladrón de Guevara's Visitation: Secularization Attempts of Bishop Castañiza

When Dr. Juan Francisco Castañiza was named bishop of Durango in 1816, some priests from Mexico City joined him, many with ties to the prestigious Colegio de San Ildefonso. Among them was Juan Bautista Ladrón Niño de Guevara. Castañiza tapped him as his secretary, a post Guevara held for six years. In this position, Guevara was the bishop's administrative secretary and oversaw assistants involved in the administration of the records of the parochial clergy, the bishop's private correspondence, and the issuing of titles of clerical appointments.[31]

Guevara departed Mexico City in late 1816. Soon after arriving in Durango in February 1817, he was named visitor general, *subdelegado de facultades sólitas*,[32] ecclesiastic governor, and vicar-in-chief of the province of New Mexico. The ecclesiastical visitation of New Mexico lasted one and a half years, during which time Guevara was also parish priest of Santa Fe. Of that time, he was four months in El Paso.

Guevara was still in New Mexico in 1818 when he learned of a vacancy at the cathedral of Durango. At the same time, the governor of New Mexico, the local justices, and the military commanders recommended Guevara through the viceroy of New Spain to the king as first bishop of New Mexico. This was a position Guevara clearly wanted, but nothing came of the suggestion, and he petitioned to be admitted to the competition for the position in the cathedral of Durango.

Once reestablished in Durango, Guevara filled numerous roles. In October 1820 he wrote the bishop summarizing his extensive report on his ecclesiastical visitation of New Mexico, which he also remitted. His report was a scathing indictment of the Franciscans in New Mexico. The documents, said Guevara, would more than suffice to inform the bishop of the "deplorable state of so recommendable a part of your bishopric." Historian W. H. Timmons called Guevara's report "a tremendous indictment of Franciscan administration of the missions of New Mexico, including the El Paso area."[33] According to Guevara, most Indians in the missions wallowed in ignorance and did not perform their Christian duties. As educators, the Franciscans were largely dysfunctional. With the exception of San Juan and Santa Clara, the mission churches were a disgrace, as was the parish church in Santa Fe. Many churches were decorated with sacred images painted on animal hides, and it was thought that they were not worthy of veneration and should be destroyed. Cemeteries and burial practices were horrible. Parish sacramental registers were a shambles; not a single one in the entire colony was kept in accord with the dictates of the Council of Trent. The general populace was sacrilegious.[34]

Trujillo. From it Trujillo had smelted enough silver for two rosaries and a crucifix. Vélez, engaging in his customary face-to-face diplomacy, met with Ute leader Cuero de Lobo (Wolf's Hide), who signaled to the Spanish governor that he could guide a party straight to the source. Twice, once in the summer and again in the fall of 1765, Vélez's lieutenant, Juan Antonio María de Rivera, sought in vain to track Cuero de Lobo and the silver.[16]

Advisers to Carlos III had called for a high-level inspection of the entire northern frontier of New Spain, from the Gulf of Mexico to the Gulf of California. Led by the resplendent marqués de Rubí, who held the rank of field marshal, the entourage trooped into Santa Fe's plaza in August 1766 to as fitting a welcome as Governor Vélez could muster. Not often did Bernardo de Miera rub elbows with professional army engineers. That chance came with the Rubí inspection. Before he left town a month later, the marqués de Rubí bragged that if ever Miera needed a recommendation at court, he could count on Rubí. Likely Vélez offered the same.[17]

Miera didn't ride with either of Rivera's probes into Ute country, nor did Vélez commission him to draw any maps. When finally in 1776 the Santa Fe map maker did go on a much lengthier vision quest with Fathers Domínguez and Silvestre Vélez de Escalante (another *montañés*), they had with them a *genízaro* guide who had been with Rivera as far as Colorado's Gunnison River.

The governor who relieved Vélez from his second term—Colonel Pedro Fermín de Mendinueta of the regular army—was as much a hawk as Vélez's earlier successor, Marín del Valle. Again, the peace nurtured by the "captain who amazes" unraveled (fig. 7.2). Yet for six months after surrendering the governorship on March 1, 1767, Tomás Vélez Cachupín hung around Santa Fe during the spring and summer. Was it New Mexico's women, green chile lamb stew, trout fishing? Without further royal appointment, the exceptional two-term ex-governor finally sailed back to Spain. Soon after dictating a last will from his sickbed in Madrid in early 1769, he died.[18]

No one could have proven a more worthy predecessor for famed governor Juan Bautista de Anza than *montañés* Tomás Vélez Cachupín, and no one a more apt bridge between Vélez and Anza than Bernardo de Miera y Pacheco. No one knew the physical and human geography of New Mexico better than Miera. After attending the frontier summit held in Chihuahua in 1778, at which he revised his most famous map, Miera rode back to New Mexico in Anza's train. His wife, María Estefanía Domínguez de Mendoza, was the new governor's second cousin.

New Mexicans resented Anza from the start, this Sonoran creole and his drastic plans for reform. "Take us off our land, resettle us in supposedly defensible compounds, tear down Santa Fe's plaza, and level the barrio of Analco! Who did he think he was, God?" They'd had it with their overbearing governor. Two dozen aggrieved *vecinos* took off in May 1780 without license for Arizpe, Sonora, to lay their complaints before commandant general Teodoro de Croix. Croix listened. New Mexico, the protestors swore, was being run into the ground by four individuals—the governor, his wife, the corrupt presidial paymaster, and Bernardo de Miera y Pacheco. Because of Miera's dangerous projects, like the dam he engineered that washed out overnight, and his unsavory influence with the Anzas, they wanted "the painter" exiled from the kingdom. Croix did order Anza to leave the Santa Fe plaza where it was and to forgive the protestors, but Miera was never exiled.[19]

After Anza's victorious campaign against Comanche war leader Cuerno Verde—of which Anza had Miera draw a map (fig. 7.3)—and all through the succeeding peace negotiations, the *montañés* painter remained at the governor's side. It's possible that the orphaned Anza saw in the little Spaniard a surrogate father figure. Miera reiterated to Anza the successful policies of Governor Vélez Cachupín: stern regulation of the Taos trade fairs, appropriate gifts, mutual exchange of prisoners, swift punishment of renegades on both sides, and close identification of Comanche leadership. Anza, for his part, made repeated references to governor or general don Tomás Vélez.

For thirty years, since moving with his family to Santa Fe, Bernardo de Miera had lived through the alternate administrations of hawks and doves, of "let Comanches feel Spanish steel" and of "bring them to peace through diplomacy and trade." He had feared them, fought them, and painted early portraits of them on his maps. Sadly, Miera died "of natural causes" in 1785, less than a year before Anza's definitive peace with the Comanches.[20]

If it took the Basque Anza to close the deal, two self-assured *montañeses*—Tomás Vélez Cachupín and Bernardo de Miera y Pacheco—deserve prominent second billing. While the nostalgic Vélez came and went twice, Miera, a European-born Spaniard, had transformed himself over the years into the quintessential Hispanic New Mexican. Just try counting the Mieras in New Mexico today!

NOTES

1. Vélez Cachupín had come to the Americas in the entourage of Güemes and then served as master of the horse for the viceroy at the viceregal palace in Mexico City. See John L. Kessell, *Miera y Pacheco: A Renaissance Spaniard in Eighteenth-Century New Mexico* (Norman: University of Oklahoma Press, 2013), 41.

2. For Vélez Cachupín, see Malcolm Ebright, Teresa Escudero, and Rick Hendricks, "Tomás Vélez Cachupín's Last Will and Testimony, His Career in New Mexico, and His Sword with a Golden Hilt," *New Mexico Historical Review* 78 (Summer 2015): 285–322; and Malcolm Ebright and Rick Hendricks, *The Witches of Abiquiu: The Governor, the Priest, the Genízaro Indians, and the Devil* (Albuquerque: University of New Mexico Press, 2006); and for Viceroy Güemes, Kessell, *Miera y Pacheco*.

3. Kessell, *Miera y Pacheco*, 24.

4. Ibid., 24–26.

5. Repartimiento y entero de tierras, Microfilm MF 513, part II, roll 1, frames 827–840, Ciudad Juárez Municipal Archives, University of Texas at El Paso.

6. Malcolm Ebright, "Advocates for the Oppressed: Indians, Genízaros and Their Spanish Advocates in New Mexico, 1700–1786," *New Mexico Historical Review* 71 (October 1996): 320–325.

7. Eleanor B. Adams and Fray Angélico Chávez, eds., *The Missions of New Mexico, 1776: A Description by Fray Francisco Atanasio Domínguez with Other Contemporary Documents* (Albuquerque: University of New Mexico Press, 1956), 83; Ebright and Hendricks, *Witches of Abiquiu*, 89–92.

8. Adams and Chávez, *Missions of New Mexico*, 275.

9. Ebright et al., "Tomás Vélez Cachupín's Last Will," 291–295; Kessell, *Miera y Pacheco*, 41.

10. John L. Kessell, ed., *Remote Beyond Compare: Letters of don Diego de Vargas to His Family from New Spain and New Mexico, 1675–1706* (Albuquerque: University of New Mexico Press, 1989), 223.

11. Adams and Chávez, *Missions of New Mexico*, 58.

12. Kessell, *Miera y Pacheco*, 41–55, 64–66, 76–77.

13. Ebright et al., "Tomás Vélez Cachupín's Last Will," 296–297.

14. Kessell, *Miera y Pacheco*, 78–82.

15. Adams and Chávez, *Missions of New Mexico*, 290. For a lively retelling of New Mexico's Salem, pick up *The Witches of Abiquiu* by Malcolm Ebright and Rick Hendricks.

16. See Steven G. Baker, *Juan Rivera's Colorado, 1765: The First Spaniards among the Ute and Paiute Indians on the Trail to Teguayo* (Lake City, CO: Western Reflections, 2015).

17. Kessell, *Miera y Pacheco*, 83–84.

18. Ebright et al., "Tomás Vélez Cachupín's Last Will," 298–299.

19. Kessell, *Miera y Pacheco*, 146–148.

20. Ibid., 163–164.

8

The Santuario de Chimayó in Tewa Pueblo History, Thought, and Practices from Ancestral Times to the Present Day

WILLIAM WROTH

The Santuario is a small church built between 1813 and 1816 at the initiative of local merchant Bernardo Abeyta in El Potrero Plaza of the village of Chimayó in Northern New Mexico (fig. 8.1). The church is dedicated to Our Lord of Esquipulas, a miraculous image of Christ Crucified originating in Colonial Guatemala. The Santuario has long been and still is an important pilgrimage shrine. It is visited by people of all cultures and faiths, from all over the region and from further afield. This chapter concerns the history and significance of the site of the Santuario for the neighboring Tewa Pueblos in the pre-Hispanic and Spanish Colonial periods, its adoption by the Hispanic community in the early nineteenth century, and its continued attraction for pilgrims to the present day. The discussion here provides one way of looking at the complex relationships formed between the Tewa people and their Hispanic neighbors for more than four hundred years. While other studies have dealt with material relationships, such as sharing of goods and trade, here the focus is on the deeper cultural meanings, for both peoples, of the site of the Santuario. These meanings are still relevant today and have broadened to include peoples of other cultures.

Chimayó is a Hispanic farming community settled in the early eighteenth century after the 1680 Pueblo Revolt and Spanish Reconquest of 1692–1696. It was a *visita* (a district with a church or chapel but without its own priest) of the larger town of Santa Cruz de la Cañada. Like many similar communities it is composed of several plazas, that is, separate small settlements of related families living in close proximity, usually close to a water source, and often forming with their homes an enclosed plaza. The Santuario was constructed in the plaza of El Potrero about one mile from the older and more formally established Plaza del Cerro (also known as the Plaza de San Buenaventura), which was well settled by the 1740s and possibly as early as 1706.

The Santuario is likely the oldest Catholic pilgrimage church in the United States, with many thousands of pilgrims still visiting every year, over thirty thousand during Holy Week alone. While it is almost unique in the United States, it is best understood as part of the much larger context of miraculous pilgrimage shrines in Spain and New Spain, and in fact in many other places in the Catholic world.[1]

8.1. Elizabeth A. Kay, *Santuario de Chimayó*, Chimayó, New Mexico, 1985. Ink wash, 6 × 8 ½ in. Courtesy of the artist.

At the original shrine to Our Lord of Esquipulas in Guatemala, pilgrims come to be healed by the miraculous image of Our Lord, on a sprouted cross, entwined with leaves and vines. In many Mexican and New Mexican versions of this image, the cross is painted green, adding to the life-giving power of the image, and there are often, as at the Santuario, abstracted short branches sprouting from the cross. Pilgrims also come to Esquipulas in Guatemala to be healed by the white clay found near the site, which is said to be effective in curing illnesses. In the same way at Chimayó, pilgrims come not only to pray before the miraculous image of Our Lord of Esquipulas but also to obtain healing earth from a dry well in a room next to the church. The healing earth at the Santuario is both rubbed on the skin and ingested with water to cure illnesses.

Ancestral Tewa Significance of the Site of the Santuario

The Santuario stands near a site sacred in ancestral traditions of the nearby Tewa-speaking Pueblo Indians. For the Tewas, the powerful hill known as Tsi Mayoh rises up just east of the present church. The Tewas have a long tradition of pilgrimage to Tsi Mayoh, which may have later inspired the establishing of a Catholic pilgrimage shrine at this place. By the early 1800s this indigenous sacred location may have been consciously chosen, either by Franciscan friars (fig. 8.2) or by Bernardo Abeyta, for the site of a church dedicated to Our Lord of Esquipulas. In many cases in Mexico and elsewhere, church authorities intentionally placed churches, chapels, and shrines in locations that were significant in the pre-Christian religion. The most prominent examples in Mexico are churches that in the early Spanish Colonial period became important pilgrimage shrines, such as Our Lady of Guadalupe near Mexico City, Our Lord of Chalma in the state of Mexico, and Our Lady of Ocotlán in Tlaxcala. In many such cases the site had a reputation for its healing qualities prior to the founding of the church.[2]

Elders in Chimayó today recount several stories that credit Bernardo Abeyta with finding the statue of Our Lord of Esquipulas in a miraculous manner, similar to many such stories in Mexico

and Spain. The most salient one recalls that sometime in the early 1800s, while doing his usual penance in the hills above El Potrero, don Bernardo saw a bright light shining from a cave near the Santa Cruz River. He was drawn to the spot, and digging into the cave he found the miraculous crucifix that soon became the center of devotion in his chapel.

This story provides the suggestion of a link with the pre-Hispanic Tewa view of the area now known as El Potrero. For the nearby Tewa-speaking Pueblos (Ohkay Owingeh, Santa Clara, San Ildefonso, Nambe, Pojoaque, and Tesuque), it is one of four sacred hills, known in Tewa as *tsin*, which are said to be both dangerous places and places that serve a protective function for the villages.[3] It could be said that this account of finding the miraculous cross in a cave is an echo of the Tewa view, for each of the hills is said to have a cave upon it. The story thus replaces the power of the hill with the finding of a miraculous image of Jesus, also associated with prodigious healing powers. There is evidence of an ancient trail through the hills from Ohkay Owingeh Pueblo to Tsi Mayoh that was used by Tewas and perhaps other Puebloans to make the pilgrimage.[4]

Tewa accounts of their traditional history say that in ancient times Tsi Mayoh was a place where smoke, fire, and hot water were once emitted. The cave on Tsi Mayoh was the home of a giant monster, a malevolent spirit that periodically wreaked havoc on the people in the pueblos, but the Tewa twin war gods vanquished this monster, thus transforming the hill from one of danger to one with protective qualities. At this time the fires were extinguished and the hot waters dried up, leaving mud and then sand. This is said to be the origin of the healing earth at the Santuario.

The significance of the four sacred hills for the Tewa continues to be expressed in some of their ceremonies. In some dances appear the Tsave Yoh, spirit beings inhabiting the caves on the four hills, including that of Tsi Mayoh. Reflecting Tewa traditional history, the Tsave Yoh are frightening masked beings who carry whips and use them on unsuspecting Pueblo members watching the ceremony. They serve the purpose of ensuring correct behavior and thus enact a protective function by bringing an individual's actions back into communal harmony.

Tewa mothers would reportedly scare disobedient children with the threat that the "Tsabiyu [Tsave Yoh] will come to whip you or to take you. . . . And a child may be told that Tsabiyu . . . has ears in the chimney. . . . So to a crying child or a lazy one, a mother might say, 'I am going to knock on the chimney.'"[5] The cavelike chimney is an analogy to the Tsave Yoh's dwelling place in caves, where once "fire and smoke belched forth."

In addition to their corrective function, the Tsave Yoh also serve a healing function and visit homes, where they heal by lightly striking with their whips on the afflicted part of the body of an ill or injured person, and then providing a plant-based remedy for application to the afflicted area. Thus both the protective and the healing qualities associated with the sacred hill of Tsi Mayoh are replicated in Tewa ceremonies. In Tewa thought, the Tsave Yoh serve a more general protective function, guarding the villages from their homes in the caves on the four sacred hills.[6]

8.2. Ray Herrera, *Saint Francis*, Santa Fe, New Mexico, 2000. Tree of heaven wood, acrylic paints, 5 ft high. St. Francis (1181/82–1226) founded the Franciscan Order in 1210. The Franciscans were the only missionaries in New Mexico throughout the Colonial period. Courtesy of the artist.

The Tewas today are still very much aware of the significance of Tsi Mayoh and know it as an integral part of their cosmology and their sacred history. It is not merely one point in a cosmological schema; rather, the hill and the valley below it are actually part of the Tewas' traditional lands, which extend much further east than Chimayó, and much further north.

Tewa territory is defined by the presence of physical phenomena such as land forms and water sources that have sacred significance and where certain ceremonies and prayers take place; they also may be "read" as history and cosmology. In contrast to modern views of territory, in which lands are protected by military presence and are valued solely for their size and exploitable resources, Tewa and other Pueblo territories are defined by their sacred geography. This of course does not preclude the lands' material value, such as water sources and land for agriculture. In the Santa Cruz valley and elsewhere, Tewa people do not consider pre-Hispanic sites no longer inhabited as "abandoned." Rather they are called *owing ke'jee*, meaning "old homes" or "old villages," and they still often have ceremonial uses.[7]

In the 1910s, anthropologists John P. Harrington and Barbara Freire-Marreco learned from Tewa informants at Santa Clara Pueblo that Tsi Mayoh was one of the places where fire and smoke belched forth in ancient times, and that the site of the Santuario was used for healing by ancestral Pueblo people: "The Indians say that Chimayo used to be a Tewa Indian pueblo. . . . This pueblo was situated where the church now is, the informants stated. The church is on the south side of the creek. Where the church now is there used to be a pool, they say, called *Tsimajo-pokwi* (*pokwi* = pool). The earth or mud of this pool has healing properties."[8] This is affirmed by Tewas today. One Tewa elder, citing what his grandfather told him, said that in ancient and more recent times Tewas bathed in the Santa Cruz River under Tsi Mayoh and used the sands there for healing. It is of note here that the earliest modern account of the healing powers of the Santuario comes from the Tewa potter María Martínez of San Ildefonso Pueblo, who described being taken there by her mother to be healed in the 1890s when she was a child.[9]

Healing with mineral substances has long been a part of Pueblo traditions. An example is healing with rock flour, which is prepared by grinding particles from boulders, thus leaving the shallow depressions called "cupules" by archaeologists. The healing particles are mixed with water to make a medicine known in Tewa as *woh p'o* (healing water). This practice is ancient, possibly dating to the archaic period, and is still known and used by Tewas today. According to Elsie C. Parsons, pregnant Zuni women would make a drink out of ground rock from a nearby stone shrine with feminine connotations in order to have a daughter.[10]

The name Tsi Mayoh has been translated as "place of obsidian or good quality flaking stone." Obsidian is found in abundance in the hills west of the Rio Grande, where indeed the Tewa names of two such prominences include the word for obsidian: Tsi-como (Obsidian Covered Mountain or Cerro Chicoma) and Tsi-pin (Flint/Flaking Stone Mountain or Cerro Pedernal). But no obsidian is found on the hill called Tsi Mayoh. Thus the name has puzzled most commentators: "Just why the name was originally applied has been forgotten. No obsidian or other flaking stone is known to exist at the place."[11] An elder who is a fluent Tewa speaker informed me that the correct name was not Tsi Mayoh but rather Tsa Mayoh, meaning "nursing place," which he attributes to the breastlike shape of the hill. This name could also refer to the healing earth, which certainly makes it a nursing-back-to-health or nourishing place.

Tsa Mayoh appears to be a much more fitting term, and indeed the verb *tsäe* in Tewa means "to suckle or nurse."[12] The problem, which cannot be solved here, is that the earliest Spanish documents all use some form of the word "Chimayó" to designate the area, for instance "Zimayo" and "Tsimayo." It could be as simple as a mishearing or mistranscribing of the true name.

The Hispanic settlers were and still are well aware of the ancient Tewa presence in Chimayó, and the significant power of the hill is expressed in several ways. For instance, they call the cave

on Tsi Mayoh La Cueva del Chivato (Cave of the Billy Goat). *Chivato* in New Mexican and Mexican Spanish also means "a troublesome, mischievous, or mean person," thus reflecting the original Tewa significance of the cave as the place where the malevolent spirit resided. The cave is also said by elders in Chimayó to be connected with San Ildefonso Pueblo (about twelve miles away) by underground passageways, reflecting the Tewa view that labyrinths underlay the sacred hills.[13] The idea of the malevolent giant was transformed in Hispanic folklore into the *gigante* (giant), and several Spanish place-names near Tewa sacred hills include this term, for instance Arroyo del Gigante and Mesa del Gigante, both close to San Ildefonso Pueblo.[14] The "Gigante" in Hispanic place-names most likely derives from the original giant monster inhabiting the sacred hills.

Tewa Settlements in Santa Cruz de la Cañada and Chimayó in the Spanish Colonial Period

In Pueblo tradition, the Santa Cruz valley, including the area of Chimayó, has always been Tewa land. The Tewas have a deep attachment to the region; they did not willingly leave it during the period of conflict encompassing the Pueblo Revolt and the Spanish Reconquest of New Mexico. Although the written historical record preserves primarily the bare facts of military and administrative engagement, it is clear that the region around Chimayó retained its significance for Tewa people throughout the period of conflict, and it does so to the present day.

The loss of Pueblo and other Native American traditional lands has been a problem from Euro-American Colonial periods to the present day. One of the primary justifications for taking possession of Indigenous lands was that they were not being "used" productively. The Euro-American view expects lands either to be lived upon or exploited by agriculture or other practices. If the land is "empty," then settlers should be free to take possession of it. Such an attitude resulted in the taking of lands by Anglo-American settlers beginning in New England in the seventeenth century. Such an attitude ignores the spiritual value of such land, which in the Pueblo view is not separated from its material value.[15]

In the seventeenth century the Santa Cruz area was sparsely settled with a few Hispanic ranches, which during the Pueblo Revolt of August 1680 were overrun and the settlers dispersed. While a few of these settlers apparently established ranches in Chimayó, there is only one reference to Chimayó in accounts of the revolt, a reference that has been overlooked in previous scholarship. The account of the revolt by governor Antonio de Otermín, translated by Charles W. Hackett, gives the testimony of one Jerónimo, a Tiwa from Puaray Pueblo (near today's Bernalillo), stating that the residents of Puaray and other nearby Pueblos that had been burned by the Spanish were considering moving to Ssima, a place-name that puzzled Hackett and other scholars. But another version of this testimony makes it clear that this is a reference to Chimayó, "that the people of Alameda, Puaray, and Sandia had discussed going to settle in Zimaya, jurisdiction of la Cañada," clearly a reference to Chimayó in the jurisdiction of Santa Cruz de la Cañada.[16]

During the Pueblo Revolt (1680–1692) the area was also settled by Tewa-speaking people, known as the Tanos, whose prerevolt pueblos had been south of Santa Fe in the Galisteo Basin. The Tanos were active participants in the revolt; they were also among the Pueblo people who occupied Santa Fe and were forcefully removed by Vargas in 1693. After 1680 many of them had resettled at two new pueblos in the Santa Cruz valley, which were later given by don Diego de Vargas the same names as they had had in the Galisteo Basin: San Lázaro (one mile south of the later Santa Cruz plaza) and San Cristóbal (near today's village of La Puebla), the latter known by the Tewas as Tsa-warii (also Tsa-wadi).[17]

The Reconquest of New Mexico (1693–1696) led by Vargas brought back a few of the prerevolt settlers, plus many new ones from central and northern Mexico. In March 1695, in order

to establish the Spanish town of Santa Cruz de la Cañada, Vargas attempted to forcibly resettle the Tano residents of both pueblos. At this time Vargas was trying to convince the people of San Lázaro to move to Yunque at San Juan Pueblo (Ohkay Owingeh), and later he wanted them to move back to their former home in the Galisteo Basin. They rejected both options. He then tried to convince them to move to the Chimayó area along with the residents of San Cristóbal, and he sent lieutenant governor Luis Granillo to show the Tanos the lands in Chimayó to be offered to them. Granillo's report to Vargas gives a rosy picture of his meeting with the Tanos and of the designated lands. He writes that the Tanos were pleased with the lands and were planning to establish a new community. They "made the plan for its foundation, saying that the number of houses would be seventy-eight, so that the people of both pueblos could live there." The request for seventy-eight houses suggests a population of Tanos at San Cristóbal and San Lázaro of three hundred or more residents, not a small number, plus "Tano Indians and the captive women who escaped from the villa of Santa Fe, should they wish to live with them, they would allow this and receive them, designating and giving them land."[18] The "captive women" most likely were widows and family members of the Tano and Tewa men who were killed by Vargas in retaking the Palace of the Governors in December 1693.[19] Although Granillo's report states otherwise, the Tanos, seeing a lack of sincerity on the part of Vargas, were not pleased with the offered lands and responded that the land was too barren to sustain them.

Not only were the Tewas and Tanos disenchanted with Vargas's efforts to relocate them, at the same time they were under attack from the Franciscan friars, who did not realize, or care, that one of the main causes of the 1680 Pueblo Revolt was the attempt to suppress their traditional lifeways and ceremonial practices. The issue is clearly stated in this report by fray Gerónimo Prieto from San Juan Pueblo, December 26, 1694:

> During the time I have served as minister to the said natives [San Juan Pueblo], I have seen nothing . . . other than some stones of many colors that they pile together, with a large one in the middle, where they place offerings for what they wish to request, either ground corn or *almagre* [red ochre] or feathers or green grass. And when I knocked them down, the interpreter came to tell me that the people said I should not have done so, that it was their custom, which they had always observed, and that the kingdom had revolted [in 1680] because this had been taken away from them, and that if it was taken away from them again, they would again rise in rebellion.

Although the concerns and intentions of the Tewas and Tanos are clear, fray Gerónimo ignored this warning and told them such practices were "a deception of the devil." He exhorted them to appeal only to (the Christian) God for help. And he continued to destroy this shrine (and possibly others): "I have torn them down several times, but each time they have again set them up." His overall attitude toward the Pueblo people is summed up by his conclusion: what else would one expect from "such barbarous people"?[20] Yet the warning of the interpreter proved to be prophetic, and was certainly one of the causes of the 1696 rebellion, leading to the deaths of the unpopular friars.

With these pressures from both civil and religious authorities, the Tanos and some of the northern Tewas retreated into the mountains above Chimayó, where they established defensible positions and were apparently well provisioned with weapons, food, clothing, and horses. Fray José Arbizu, resident friar at San Cristóbal, who was later killed by the rebels, wrote in March 1696, "The situation is that the natives of said pueblo [San Cristóbal], with Chimayó as their destination[,] are leaving me, and in the sierra [the mountains east and north of Chimayó] they have placed their corn supplies and clothing. . . . The sierra, I know, has an abundance of water, for the said river [later named Rio Quemado] which joins that of the Chimayó [later Rio Santa Cruz]

flows down from it. Many traps have been set [by them], with stockades." The next day he wrote further to say that the Tanos of San Cristóbal have "ascended the sierra of Chimayó, where they had, and still have, all their food supplies and weapons of war and have set up stockades to make themselves invincible."[21] Here they were joined by disenchanted Tewa members of Santa Clara, San Juan, Nambe, Cuyamungue, Pojoaque, and Jacona Pueblos. Their vastly superior familiarity with their ancestral lands and their superior mobility enabled them to evade the less knowledgeable and less mobile Spanish forces.[22]

Vargas and his troops were reluctant to pursue them into the rough and little-known mountainous lands above Chimayó. In a report of June 12, 1696, he noted, "They were altogether on a hill at the foot of the sierra, which had very rough terrain. These Indians were in a funnel canyon that could not be entered on horseback." In another entry, dated July 6, 1696, Vargas reports information from Domingo, the governor of Tesuque, that "the rebel Tano Indians, the treacherous, apostate traitors, were quartered and camped in the sierra, which they knew like the back of their hands." This problem is stated in another way in a summary report by Baltazar de Tovar written September 20, 1696: "The pueblos of Nambe, Cuyamungue, Pojoaque, San Cristóbal, and Jacona had gathered in Chimayó and were all together on a very rough hill. It was located at the foot of the sierra, which could not be attacked on horseback. They had transported supplies and the horses they had to the sierra beforehand."[23]

In early June 1696 the rebellious Tanos killed fray José Arbizu at San Cristóbal and a visiting friar from Taos, fray Antonio Carbonel, as well as "Simón de Molina and Diego de Betanzos, a stonecutter by trade, both of whom had come with the families from Mexico City and whom the reverend father, fray José Arbizu, had employed to make doors for the church and build the convent." They also killed two Mexican Indian boys who were fray José Arbizu's servants.[24] The attack on San Cristóbal appears to have been part of a coordinated plan of the rebellious Tewas and Tanos, for at the same time there were attacks at San Ildefonso and Nambe Pueblos in which the resident friars were killed.

After the deaths of the friars Vargas increased efforts to defeat and disperse the Tanos and rebel northern Tewas. By December 1696 he had quelled the rebellion. However, it is clear that it was a victory of attrition rather than one of decisive battles. Vargas's troops found and confiscated Tano caches of food supplies, tools, clothing, and even some horses, wherever possible, without ever entering into their strongholds in the sierra above Chimayó. They also encountered and captured individual or small groups of Tewas and Tanos who came occasionally into the valley to retrieve or steal more supplies.

Throughout his journals for the months of June through November 1696, Vargas constantly blames the "apostate" and "accursed" Tanos for stirring the northern Tewa and Tiwa Pueblos (Taos and Picuris) into rebellion, yet he was unable to decisively defeat them. Admittedly he had his hands full, also dealing with the rebellion in Cochiti, Jémez, Acoma, and San Ildefonso. A typical effort of Vargas to defeat the Tanos above Chimayó occurred on July 28, 1696:

> On the twenty-eighth, I left to make war against the Tewas and Tanos. I made a dawn raid on the sierra that is six leagues from Villa Nueva [de Santa Cruz]. Because we had not sent scouts to the rancheria and were unfamiliar with the outpost, the enemy attacked our horses while the camp was scattered and spread out. . . . This happened because of the rugged terrain of that outpost. The [Indian] women and children had time to save themselves and fled with some of their clothing, although our men took much of what they found the Indians had left there, in addition to thirty horses . . . [army general Roque Madrid went back] to reconnoiter and saw there were only a few Indians . . . the alferez fired at them and knocked one down. My lieutenant, Luis Granillo, had gone ahead with four soldiers after some horses when one of the rebels came

out at them from among some rocks. He wounded one of them [the soldiers] in the shoulder through his leather jacket. They took a coscomate [granary] of maize from the Indians that day. On the following day, I returned to the sierra of Chimayó to look for them and their maize. A coscomate containing seven coas [tilling hand tools] and a large hoe was found.[25]

This is not exactly a glorious battle victory, but more a cautious effort to weaken the enemy through confiscating their supplies, tools, and horses. On August 29, Roque Madrid reported to Vargas that near San Cristóbal Pueblo he had, with six soldiers, followed a trail of more than thirty Indians on horseback who had been lying in ambush: "As soon as they saw us going in that direction, they went up through the cañada until they reached the sierra. I went in pursuit of them, but they refused to wait and entered the sierra. . . . Only one Indian on foot showed himself to us from the heights of the sierra . . . [but he] refused to say one word no matter how much we insisted. As a result we became irritated from asking them and returned."[26] Vargas's response was merely a show of arms, intended to intimidate the Tewa and Tano rebels: "I, the governor and captain general, was going in person with men-of-arms to search for the enemy. This was so that the enemy would recognize that they were not to impede our intention, for if they did, they would be pursued until our arms rigorously humbled them, and their own safety required them to live in their pueblos as his majesty's vassals."[27] Again there is no mention here of actually pursuing the rebels into the sierra, and it also shows that the Tanos were not afraid to brazenly venture all the way back to their pueblo near Santa Cruz, most likely to retrieve hidden supplies.

In October 1696 Vargas put most of his efforts into defeating rebel members of Taos and Picuris Pueblos, among whom were some Tewas and Tanos. He was able to gain submission of most of the Taos rebels, but the Picuris were more recalcitrant, and many of them, and some Tewas and Tanos, chose to flee to the eastern plains with the Jicarilla band of Llanero Apaches. Vargas made a long pursuit of the fleeing rebels and on the way encountered a sign from them that they were far from thinking of capitulating: "Asked [an Indian prisoner] who had put an arrow upright across a rock with two lines crossing it, making it understood that they would kill whoever crossed there, he said they had not done it. Either the Apaches, when they had crossed with the stolen horses, or the enemy Tano Indians who lived in the sierra of Chimayó could have done it." Vargas finally caught up with the last group of rebels, which was presumably slower because of the presence of fifty women and children whom they made captives, and a few men whom they killed. On the 28th he reported that "harsh, snowy weather and storm" prevented them from going any further, and they soon retreated to friendly Pecos Pueblo: "We reckoned that we had lost more than 200 horses and 5 mules. . . . The Indian allies who had come of this campaign had lost even more." While some of the rebels may have come back on their own, many stayed on with the Apaches until 1706.[28]

By autumn of 1696 there had been a dispersal of the Tanos in the sierra above Chimayó. Many Tanos (and some northern Tewas from Santa Clara Pueblo) had fled west to settle with the Hopi Indians, establishing the Tewa-speaking village of Hano on First Mesa. Others may have stayed with the Apaches. The lack of sufficient food supplies and the increasing cold weather caused some of them to come in voluntarily and surrender, despite their distrust of Vargas.

Yet it is quite possible that some Tanos stayed in, or came back to, the sierra above Chimayó in the early eighteenth century. While there is no Colonial record documenting this possibility, there is oral history from the Hispanic village of Pueblo Quemado (now Córdova). Lorin W. Brown collected traditional oral accounts in Córdova in the 1930s for the Federal Writers' Project; one of them provides information about Alto Huachin (also known as Wiyo), the large fourteenth-century site on the ridge above today's Córdova, which he said was resettled by the Tanos during and

after the Reconquest. The site was located and described by Brown in his Federal Writers' Project report of September 9, 1938:

> This is the Alto Huachin, the site of an Indian Pueblo of long ago inhabited by the Tano Indians. . . . These ruins should be of interest to the archeologist since they have never been excavated except for the tentative test holes dug by amateur seekers of curios. . . .
>
> Alto Huachin . . . was so named after the last chief or governor of the ill-fated Pueblo. These Tanos dwelt here, continually harassed by the Navajos, Apaches, and other predatory tribes. . . . How many attacks the pueblo survived we do not know. . . . We do know that some time previous to the year 1751 the enemies of the Pueblo on the Alto Huachin finally prevailed, killing most of the inhabitants, after which they set fire to the buildings; for at this time [after 1751] the site of the erstwhile Pueblo was known to the settlers of Santa Cruz de la Cañada by the name of "El Pueblo Quemado" or The Burned Pueblo. . . .
>
> A few of the surviving Tanos from Alto Huachin took refuge in a small valley about two or three miles above. . . . Here they finally died out, and the pitifully small ruins of the last stand of a one-time flourishing community may be seen today. The valley is still known as La Cañada de los Tanos.[29]

While Brown's account of Alto Huachin might be dismissed by some commenters as mere "folklore,"[30] it is best understood as traditional history, deeply embedded in the memories of the residents of Córdova and preserved through oral transmission through the generations. Brown, a journalist by training, was himself embedded in the community. His mother was Cassandra Martínez of Taos; in 1922 she moved with her young son to Córdova, where she taught school and they lived until 1933. Brown returned from 1936 to 1941 during his work on the Federal Writers' Project. Memories of the Tanos at Alto Huachin, and probably more remote locations in the sierra above Chimayó, are further affirmed by the fact that the "small valley about two or three miles above" mentioned by Brown may still be found on the US Forest Service maps and is named Cañada de los Tanos.[31]

In recent years there has been new and renewed appreciation of the value of the oral history of Indigenous peoples, particularly the Pueblo and Navajo Indians.[32] Certainly the same appreciation should apply to the oral history of Hispanic communities, and Lorin Brown's account needs to be taken seriously.

Further record of oral history from Córdova was provided by Michel Eagle, circa 1981, who was told that the Tanos lived at Alto Huachin (LA 158) until circa 1730: "Local tradition places the burning of the pueblo around 1730, and it is from the burning of the pueblo that Córdova, known as Quemado (Spanish—'burnt') until 1920, takes its name and dates its founding. Local belief is that the inhabitants were Tanoans."[33] While this is a much later account (circa 1981 versus 1938) and done most likely by a student, it is still based upon "local tradition," which is handed down through the generations. Therefore it can't be discounted.

There is no archaeological or documentary evidence that the Tanos or other Tewas lived at the site of the Santuario de Chimayó during the Reconquest and post-Reconquest period, but they were clearly close by. In 1706 settler Luis López petitioned for land in Chimayó, probably the site of the later Plaza del Cerro; he gave one of the boundaries as the "ditch that the Thano Indians made when they lived at San Cristóbal." López's petition is early evidence of the post-Reconquest Hispanic settlement in Chimayó, as well as of the presence of Tewas in the vicinity.[34] Other settlers moved into the area in the early 1700s, and today's Plaza del Cerro was established by the 1740s. A document from 1752 names it the Plaza de San Buenaventura.

It is likely that the Tewa presence in the Chimayó area gradually receded during the early eighteenth century, until it approximated the current situation in which the Tewas were living only in what are today their pueblos. But this did not mean the end of contact with their Hispanic neighbors living in the Santa Cruz valley. In addition to a spiritual confluence from their mutual respect and practices at the Santuario, there were also peaceful interactions for mundane reasons, such as the trading of foodstuffs and other goods—one can imagine, for example, Tewa people arriving in Hispanic communities with a wagonload of some crop that their Hispanic neighbors perhaps did not grow.[35] Throughout the Colonial period and continuing into the present, such contacts provided another means for the Tewa people to stay in touch with the sacred site of Tsi Mayoh.

The Santuario Today

The Tewa understanding of the healing power emanating from the area around the Santuario reaches back to ancestral Pueblo traditions and continues through the historic period to the present day. As has been discussed, in the early nineteenth century, Hispanic Catholics in Chimayó most likely were moved to adopt the sacred site into a Catholic devotional tradition centered on a miraculous healing image of Christ Crucified on a "living" cross entwined with leaves and vines, thus transferring the pre-Hispanic healing earth at the site to a Christian context. While from the strictly Catholic point of view, the healing at the Santuario is attributed to the image of Christ Crucified, most pilgrims of Catholic and other faiths come to the Santuario both to pray before the image of Our Lord of Esquipulas and for the healing earth in the *pocito*, or dry well, connected to a room immediately adjacent to the nave of the church. Today the Santuario de Chimayó brings not only Indigenous and Hispanic people together but also people of other backgrounds who are focused on the same purpose: to benefit their lives or those of their loved ones through miraculous healing means that are both explicitly Christian and at the same time part of the natural world. The pilgrimage to Chimayó provides a sense of harmony and purpose among the participants seldom found in our world today.

My deep thanks to Richard Ford, John Garcia, Robin Gavin, Scott Ortman, and Deborah Wroth for their helpful comments on an earlier version of this chapter. Celestina Savonius-Wroth provided invaluable aid in working with me on this chapter in December and January 2018–2019. Volume editor Robin Gavin has also helped with the final editing. This chapter is a companion piece to my paper "Engaging the Senses: The Pilgrimage Shrine of Santuario de Chimayó in Northern New Mexico," in Aesthetic Theology in the Franciscan Tradition: The Senses and the Experience of God in Art, *ed. Xavier Seubert and Oleg Bychkov (New York: Routledge, 2020).*

NOTES

1. The first scholarly work on the Santuario and its miraculous image is Stephen F. de Borhegyi, "The Miraculous Shrines of Our Lord of Esquipulas in Guatemala and Chimayó, New Mexico," *El Palacio* 60, no. 3 (1958): 83–111. For a summary history of the Santuario, see William Wroth, *Images of Penance, Images of Mercy: Southwestern Santos in the Late 19th Century* (Norman: University of Oklahoma Press, 1991), 48–50, 180–181nn44–48; and William Wroth, "Santuario de Chimayó," http://newmexicohistory.org/places/santuario-de-chimayo. See also Charles Carrillo, "Our Lord of Esquipulas in New Mexico" *Tradición Revista* 4, no. 2 (1999): 50–54. For a recent overview of the community of Chimayó, see Victor Dan Jaramillo, *Los Chimayosos: A Community History* (Parker, CO: Outskirts Press, 2018).

2. For an overview of the placement of Christian churches on or near pre-Christian sacred sites, see Victor Turner and Edith Turner, *Image and Pilgrimage in Christian Culture* (New York: Columbia University Press, 1978). This work includes lengthy discussions of Guadalupe, Chalma, and Ocotlán. See also Gonzalo de

Balsalobre, *Relación auténtica de las idolatrías, supersticiones, y vanas observaciones de los indios del Obispado de Oaxaca* (1656; repr., Juchitán, Mexico: Casa de la Cultura del Ismo, 1981). One of the remedies ordered by the Bishop in Oaxaca for idolatry among the Zapotec Indians of San Miguel Sola was to build a chapel on a hill where these practices took place. See also William Wroth, "Miraculous Images and Living Saints in Mexican Folk Catholicism," in *Folk Art of Spain and the Americas*, ed. Marion Oettinger Jr. (New York: San Antonio Museum of Art and Abbeville Press, 1997), 161.

3. Alfonso Ortiz, *The Tewa World* (Chicago: University of Chicago Press, 1969), 19, 141–142.

4. Richard Ford, personal communication, 2018. On Good Friday in 2005, Jamie Blosser walked with Tewa friends by trail from Ohkay Owingeh to the Santuario (personal communication, January 2019). María Martínez and her father walked by trail from San Ildefonso Pueblo to the Santuario in the 1890s. See Alice Marriott, *María: The Potter of San Ildefonso* (Norman: University of Oklahoma Press, 1948), 33.

5. Elsie Clews Parsons, "Tewa Mothers and Children," *Man* 24 (1924): 148–151, reprinted in *Pueblo Mothers and Children: Essays by Elsie Clews Parsons, 1915–1924* (Santa Fe, NM: Ancient City Press, 1991), 136.

6. Ortiz, *Tewa World*, 75, 159–161. John P. Harrington first reported the information concerning the sacred caves in *The Ethnogeography of the Tewa Indians* (Washington, DC: 29th Annual Report of the Bureau of Ethnology, 1916), 342. Harrington received this information from British anthropologist and folklorist Barbara Freire-Marreco, who was living at the time at Santa Clara Pueblo (John Peabody Harrington Papers, Tewa, 1908–ca. 1949, National Anthropological Archives, Smithsonian Institution).

7. Harrington (in *Ethnogeography*, 74) defines the term "keji as 'old' said of things not persons." (In many, but not all, of his specific place-name references he uses the term "ruin" for *keji*, perhaps reflecting the current academic usage, which prevails to the present day).

8. Ibid., 341–342.

9. Marriott, *María*, 30ff.

10. Information from Richard Ford, "Archaic Period Petroglyphs in the Northern Rio Grande" (lecture, Santa Fe Archaeological Society, October 17, 2017). Elsie Clews Parsons, "Zuñi Conception and Pregnancy Beliefs," *Proceedings of the 19th International Congress of Americanists, 1915*, reprinted in *Pueblo Mothers and Children*, 29–30, 35n6.

11. Harrington, *Ethnogeography*, 341.

12. Tessie Naranjo et al., *Khap'on Tewa Verbs and Pronouns* (Canelo, AZ: Canelo Project, 2015), 229. Because the name Tsi mayoh is universally used in the literature, I will continue to use it in this chapter.

13. Don J. Usner, *Sabino's Map: Life in Chimayó's Old Plaza* (Santa Fe: Museum of New Mexico Press, 1995), 16.

14. See Roberto Valdez y Herrera, "Place Name Lore of the Rio Arriba," in *Rio Arriba: a New Mexico County*, ed. Robert J. Torrez and Robert Trapp (Los Ranchos, NM: Rio Grande Books, 2010), 264. Arroyo Gigante still appears on Forest Service maps, east of San Ildefonso Pueblo. See also T. M. Pearce, ed., *New Mexico Place Names: A Geographical Dictionary* (Albuquerque: University of New Mexico Press, 1965), 63.

15. A relevant example today is the attempt by Jemez Pueblo to regain possession of their traditional lands in the Valle Caldera, which were long ago alienated from them because they were "empty"; see Paul Tosa et al., "Movement Encased in Tradition and Stone: Hemish Migration, Land Use, and Identity," in *The Continuous Path: Pueblo Movement and the Archaeology of Becoming*, ed. Samuel Duwe and Robert W. Preucel (Tucson: University of Arizona Press, 2019), 60–77.

16. Charles W. Hackett, *Revolt of the Pueblo Indians of New Mexico and Otermín's Attempted Reconquest, 1680–1682*, vol.2. (Albuquerque: University of New Mexico Press, 1942), 361; Elizabeth A. Brandt, "Sandia Pueblo" in *Handbook of North American Indians, Vol. 9: Southwest* (Washington, DC: Smithsonian Institution, 1979), 345. The reference to "Zimaya" appears in the account transcribed in Barbara De Marco, "Voices from the Archives II: Francisco de Ayeta's 1693 Retrospective on the 1680 Pueblo Revolt," *Romance Philology* 53 (Spring 2000): 495.

17. For a comprehensive recent history of the Tanos, see Lucy R. Lippard, *Down Country: The Tano of the Galisteo Basin, 1250–1782* (Santa Fe: Museum of New Mexico Press, 2010).

18. Diego de Vargas, *Blood on the Boulders: The Journals of Don Diego de Vargas, New Mexico, 1694–1697*, ed. John L. Kessell, Rick Hendricks, Meredith D. Dodge (Albuquerque: University of New Mexico Press, 1998), 612. San Lázaro governor Cristóbal Yope told Vargas in March 1695 that San Lázaro consisted of sixteen families, totaling 155 people. Many of them joined with the members of San Cristóbal to move into the sierra above Chimayó (ibid., 607).

19. Approximately eighty Tanos and other Tewas who occupied the Palace of the Governors, and transformed it into a pueblo, were killed by Vargas when he retook it in December 1692 (personal communication, Cordelia Snow, September 2019). See also J. Manuel Espinosa, *The Pueblo Indian Revolt of 1696 and the Franciscan Missions in New Mexico* (Norman: University of Oklahoma Press, 1988), 44.

20. Espinosa, *Pueblo Indian Revolt*, 120. Idolatrous shrines were reported at the same time from Cuyamungue and Tesuque by fray José Diaz and from San Ildefonso by fray Francisco Corbera (ibid., 121, 166).

21. Ibid., 171, 177.

22. This idea has been explored in depth by Joseph Aguilar in "An Indigenous Archaeology of Resistance: San Ildefonso Pueblo and the Siege at Tunyo, 1694" (lecture, Santa Fe Archaeological Society, January 16, 2018). During the Reconquest period, the San Ildefonso people protected themselves from the Spanish by dispersing into the western regions of their lands, which were difficult to access and not well known by the Spaniards. See also Joseph Aguilar and Robert W. Preucel, "Seeking Strength and Protection: Tewa Mobility during the Pueblo Revolt Period," in Duwe and Preucel, *Continuous Path*, 149–165.

23. Vargas, *Blood on the Boulders*, 752, 790, 898.

24. Ibid., 870, 871.

25. Ibid., 881.

26. Ibid., 1007.

27. Ibid., 1006.

28. Ibid., 1047, 1048, 1056. (Oct. 20 and Nov. 7, 1696). See also Severin Fowles and B. Sunday Eiselt, "Apache, Tiwa, and Back Again: Ethnic Shifting in the American Southwest," in Duwe and Preucel, *Continuous Path*, 166–194.

29. Lorin W. Brown, *Hispano Folklife of New Mexico: the Lorin W. Brown Federal Writers' Project Manuscripts*, ed. Marta Weigle and Charles L. Briggs (Albuquerque: University of New Mexico Press, 1978), 55–56.

30. At least one group of Tanos did not move to Hopi. In April 1706 Vargas's successor as New Mexico governor, Francisco Cuervo de Valdes, resettled some Tanos in Galisteo Pueblo (Tanu'ge): "I settled the old pueblo of Galisteo with 150 Christian Indian families of the Tano nation who were found dispersed since the year 1702, and living in other pueblos, ranches and frontiers in poverty and misfortune, whereas today they are very happy in their pueblo entitled Santa Maria de Gracia de Galisteo" (formerly Santa Cruz de Galisteo). See Charles W. Hackett, *Historical Documents Relating to New Mexico, Nueva Vizcaya, and Approaches Thereto, to 1773*, vol. 3 (Washington, DC: Carnegie Foundation, 1937), 379, cited by Lippard, *Down Country*, 259. The resettled Tanos stayed in Galisteo until around 1782, when they abandoned the pueblo and moved to Santo Domingo.

31. Brown, *Hispano Folklife*, 56–57 (MS no. 24, "'Alto Huachin' History of Cordova E. 3 pp. 9 September 1938"). Part of this account is reprinted in Ann Lacy and Anne Valley Fox, eds., *Stories from Hispano New Mexico: A New Mexico Federal Writers' Project Book* (Santa Fe, NM: Sunstone Press, 2012).

32. See Chip Colwell, "Oral Traditions," in *The Oxford Handbook of Southwest Archaeology*, ed. Barbara Mills and Severin Fowles (Oxford: Oxford University Press, 2017); Duwe and Preucel, *Continuous Path*; and Robert W. Preucel, "The Journey from Shipap," in *The Peopling of Bandelier*, ed. Robert P. Powers (Santa Fe, NM: School for Advanced Research Press, 2005).

33. Michel Eagle, Report, LA 158, Pueblo Quemado, ca. 1981 (NMCRIS 129777), Archaeological Records Management Section, New Mexico Historic Preservation Division, Santa Fe. My thanks to Dedie Snow, Stephen Townsend, and Bridget Barela for tracking down this report for me. I have corrected some typos in the report.

34. Usner, *Sabino's Map*, 40. See also Usner, this volume, 143–144.

35. For a discussion of exchange of agricultural knowledge, see Marc Simmons, "Agricultural Convergence in the Indian-Spanish Southwest," in *Converging Streams: Art of the Hispanic and Native American Southwest*, ed. William Wroth and Robin F. Gavin (Santa Fe, NM: Museum of Spanish Colonial Art, 2010), 71–82.

9
The House on the Hill:
The Bernardo Abeyta House in Chimayó

VICTOR DAN JARAMILLO

The large house on the hill across the road from the famous Santuario de Chimayó has been photographed, sketched (fig. 9.1), and written about since the early 1900s. The Palace of the Governors Photo Archives in Santa Fe has seventeen photographs that feature the house.[1] The earliest photographs of the house in the archives were taken by Jesse Nusbaum (ca. 1911; fig. 9.2), Sheldon Parsons (ca. 1915; fig. 9.3), and T. Harmon Parkhurst (ca. 1925). These same men also took some of the earliest photographs of the nearby Santuario de Nuestro Señor de Esquipulas (Santuario de Chimayó).

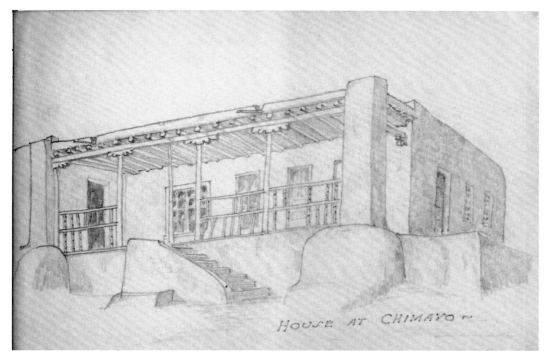

9.1. John Gaw Meem, "House at Chimayo," n.d. This sketch of the "House at Chimayo" is part of a sketchbook belonging to John Gaw Meem, an architect known for historic preservation and for his Pueblo-Spanish style designs in New Mexico. The sketch is not true to life in every detail, but it shows his admiration for the architecture of the Abeyta house. Sketchbook, n.d., MSS 675 BC, box 17, John Gaw Meem Collection, Center for Southwest Research, University Libraries, University of New Mexico.

The house is certainly a glorious example of Spanish Colonial architecture. While it has undergone much remodeling over the years, each room has its vigas (round log beams), one room has a split-cedar ceiling, and three rooms still have a hard-packed mud floor. The house stands out because of its location on a knoll overlooking the Chimayó valley, its thick adobe walls and buttresses, the five rooms and a *dispensa* (storeroom) that make for a larger than usual structure of almost two thousand square feet, and the two elaborate *portales* (covered porches).

9.2. Jesse Nusbaum, "Birds-Eye View of Chimayó, New Mexico," 1911(?). A view of El Potrero, one of Chimayó's *placitas* (neighborhoods). The bell tower in the center is that of the Santo Niño Chapel. The Bernardo Abeyta house is in the lower center. The Santuario de Chimayó is toward the right but is not visible in this photograph. Palace of the Governors Photograph Archives (NMHM/DCA), neg. no. 014450.

9.3. Sheldon Parsons, "Adobe home, Chimayó, New Mexico," 1915(?). This photograph shows the south side of the Bernardo Abeyta house. In the center is the smaller porch with its railing and the two *hornos* (outside ovens). On the left is the door to the *dispensa* (storeroom), and on the right is the easternmost room, which did not survive. Palace of the Governors Photograph Archives (NMHM/DCA), neg. no. 013771.

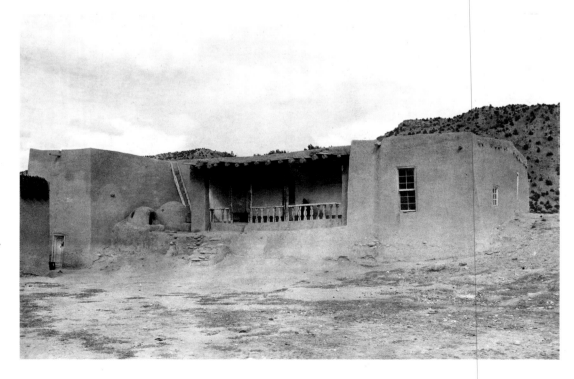

10

Saving the Ortega Papers and Two Hundred Years of Chimayó History

DON J. USNER

On May 7, 2000, as my mother, Stella Chávez Usner, was backing out of her driveway in Los Alamos, leaving for a week to stay with her 102-year-old mother in Chimayó, she noticed an ominous cloud of smoke billowing up over the Jemez Mountains to the west. She had heard about the blaze, deliberately lit as a prescribed fire on the flanks of Cerro Grande but rumored to be getting out of control. At that moment, few suspected the flames would get to the townsite, but gut-level instinct caused her to pause and think: what is the one thing I would take from the house if it was threatened with fire?

This is a question we are told to ask ourselves in preparation for disaster, but few of us take the time to answer and make a list of critical possessions. My mom hadn't either, but she instinctively pulled back into the driveway to retrieve from her closet a single box containing a stack of documents that were passed down to her through three hundred years of our family's residency in the Plaza del Cerro in Chimayó. She hurried back to her car and left, not knowing it was the last time she'd see her home of thirty-eight years, which burned to the ground on May 11.

I imagine this remarkable rescue of the documents was only the most recent, even if the most dramatic, of many thoughtful acts that brought the papers through the centuries, during which they easily could have been lost on many occasions. The chain of custody shepherding the papers along included seven generations of my Ortega family line, each person taking care to hand down the sheaf of worn documents intact.

I had dipped into these papers when doing research for a master's thesis and a subsequent book (*Sabino's Map: Life in Chimayó's Old Plaza*), so I knew the collection comprised several hundred documents, including at least one land grant paper, wills and testaments, land sales, personal letters, records of justices of the peace, litigation, and a miscellany of other records. But their near destruction in the Cerro Grande Fire made me resolve to read them more thoroughly. This had been my intention for years, and now I felt that, clearly, the time had come.

Most of these documents involve my ancestors in one way or another—as authors of documents, parties to disputes or land sales, neighbors of petitioners, or witnesses in official or semiofficial transactions. Seeing their signatures and writing has a particular poignancy for me.

OPPOSITE

10.1. Buildings on the west side of the Plaza del Cerro, including the Oratorio de San Buenaventura, the community *capilla*. Photograph by Don J. Usner, 1990s.

But the lineages of most families mentioned in the faded pages are intertwined—a vast network of individuals who coexisted, intermarried, quarreled, celebrated, and helped each other out through hard times over many generations.

So, it was not only curiosity about my family history that compelled me to take a close look at these documents. I found in doing research for *Sabino's Map* that oral tradition tells the history of the Plaza del Cerro over the past hundred years. My grandmother, born in 1898, and others in Chimayó related to me recollections from much of that time span. But I realized that these documents would allow me to go two hundred years farther back. This would be a unique opportunity to expand on my story about this old plaza, which, because of its state of preservation and the wealth of historical information about it, already stood out among New Mexico's many Spanish and Mexican plaza towns.

Photocopies of the original documents had been combined with records from the Borrego family and made available to the public in the State Records Center and Archives in Santa Fe as the Borrego-Ortega papers. There they joined some other collections of family papers from New Mexico. But the Ortega collection is unique in originating from a single, small Colonial plaza town, the Plaza del Cerro, and in covering the Colonial, Mexican, territorial, and early statehood periods of New Mexico history.

My mother and a few other extended family members had perused the papers, and a few scholars and archivists had also sampled them, but no one had taken a close look at the whole collection. And so, I dove in—or I should say, *we* dove in, for my mother was a constant and invaluable partner in the journey from day one, translating words beyond the ken of my conversational Spanish and providing crucial genealogical information about people named in the papers.

Our first goal was to transcribe the documents. We elected to focus on the originals in our own possession, which we call the Ortega Papers, rather than the entire Borrego-Ortega collection. Still, we were overwhelmed. Our collection alone includes over three hundred documents. These had been shuffled many times over the centuries and were not in any particular order. As we picked them up one by one, we experienced a dizzying effect of dancing back and forth through time between 1706 and 1932, the dates that bookend the collection. Many of the documents present daunting challenges because of eccentric handwriting, nonstandard spelling, obscure terminology, archaic Spanish usage, and degraded condition.

Our transcriptions at first looked like redacted CIA documents, with numerous blanks where we could not make out the writing or the meaning of words or phrases. We learned that reading old documents like these is an art, not a science, with no guide that can make the task easy. Numerous conundrums made progress slow, but gradually words fell into place.

Enigmatic words such as *"vacallos"* vexed us for hours, until it dawned on us that this was a case of nineteenth-century dyslexia: the writer meant to write *"cavallos,"* an irregular spelling of caballos (horses). Similarly, it took a while to see that the word "Sibulos" referred to Cíbola, a name originally applied to a mythical realm of golden cities (the Seven Cities of Cíbola) that legend placed in the expansive plains east of the Rio Grande Valley, but later referred to the Great Plains in general, and to the bison that roamed there.

We worked through the documents during those years after the fire, organizing and transcribing them slowly. Spurred on by a small grant from the New Mexico State Archives, I arranged the papers chronologically and scanned them in high resolution so that we could work with digital files instead of handling the fragile originals. I gave a presentation about the papers at the New Mexico State Records Center and Archives and published a few articles in magazines.

Several years lapsed, during which I worked on the documents only occasionally. And then came the request from William Wroth for me to contribute a chapter for a book. I saw this generous invitation as another opportunity to transcribe, translate, and interpret more of the documents.

It has been a long journey, poring over these papers. I came to the daunting task not as an academic or professional historian, and with no background in paleography. My effort stems from a passionate desire to understand what these faded papers can reveal about the history of Chimayó as a microcosm of Northern New Mexico. Although the events and people reported may not have shaped matters of great historical import, the records provide a unique window into the minutiae of life in this small plaza town through the eras of four governments (fig. 10.1, see page 140).

Luiz Lopes (spelled "Lopes" and later, "Lopez," in the documents; the spelling was later standardized to López), a resident of Santa Cruz de la Cañada, penned the oldest document in the Ortega collection. This 1706 petition to governor Francisco Cuervo y Valdés for a grant of land begins with a wispy heading composed almost entirely in abbreviations that begins, "[To] Señor Gobernador y Capitán General" (To Sir Governor and Captain General) and then continues in a flowing and clearly legible hand:

> Luiz Lopes, a native of this kingdom, a resident of La Cañada, married and with children, I appear before your majesty in my best form . . . and I say that I find myself in this kingdom as an original settler . . . having entered [the kingdom] since the year ninety-three, and that I come to settle again, I find myself without land or farmland or a house, and knowing of a piece of royal lands, barren and uninhabited, above the Cañada of Chimayó . . . that have never been planted, and I have no evidence that they have an owner, unless it is the king, may God keep him, which border with an arroyo that divides the lands of Francisco Martin, and with an acequia that the Thano Indians cleaned out when they lived in San Cristobal, which is from the south, and another arroyo that goes down to the northern part whose boundary comes to . . . the road to Taos.
>
> To your honor, I ask and beg you that it may serve you to make me a grant of the said lands, as a . . . settler of this kingdom, in the name of your majesty . . . to me it is a necessity, I hope to achieve justice from the greatness of your honor and I swear to our God and the sign of the cross that this my request bears no malice and is necessary.

A note at the bottom of the page records that the petition was presented in "la Villa de Santa Fe" on September 10, 1706.

The reverse side of the petition approves the grant to Lopes: "[I,] Don Francisco Cuervo y Valdes, military leader of the Order of Santiago, governor and captain general of this kingdom and province of New Mexico and *castellano* [commander in chief] of its armed forces and the forts of your majesty . . . make the grant of land that he requests in the name of your majesty without prejudice." The document closes with the flowing signatures of Governor Cuervo y Valdes and his civil and military secretary, Alphonso Rael de Aguilar (figs. 10.2a and b).

The Lopes grant of 1706 reveals much about the resettlement of Chimayó and the Santa Cruz valley after the Pueblo Revolt of 1680. From it we can ascertain that Lopes returned to Chimayó sometime after 1693, along with many other Spanish settlers. Genealogical research suggests that Lopes had fled as a child to El Paso with his mother, his father having been killed in the violence as the Spanish were expunged from New Mexico. Lopes's reference to the "Thano" Indians moving into the valley in the absence of the Spanish colonists is a fact that is chronicled well in other historical resources. These "Thano" people (now more commonly spelled Tano) were not from the nearby Tewa Pueblos of Santa Clara or San Juan; they moved into the Santa Cruz valley from the Galisteo Basin to live in two villages in the valley, San Cristóbal and San Lázaro. Lopes was referring to the first of these two villages, which was abandoned by the Tano after don Diego de Vargas made a military sweep of the valley in 1696.

LEFT

10.2a. Luis Lopes's 1706 petition for a land grant in Chimayó (side 1). Collection of the author's family.

RIGHT

10.2b. Luis Lopes's 1706 petition for a land grant in Chimayó (side 2). Collection of the author's family.

The next document in the collection, authored by *maestre del campo* (field marshall) Roque Madrid and dated September 21, 1706, records Lopes's act of possession. Madrid, whose high rank placed him just below the governor (who himself held the rank of captain general), was an influential figure in the Spanish military and government. He went with Lopes to the "Cañada de Chimallo" and, in accordance with tradition and legal requirements, notified neighbors in the vicinity of the proposed grant. None protested or made claims to the land. So, in accordance with custom, Madrid and Lopes tore up clumps of grass, threw rocks in the air, and fired gunshots, proclaiming Lopes's possession in the name of the king.

Madrid went on to describe the boundaries of the grant as "on the eastern part, with an arroyo that comes down to the road to Taos and divides the lands of Cristóbal Martin, and on the north by the same arroyo beside the road to Picurís, and to the west along a ditch that the Tano Indians cleaned out" (por lo parte del oriente, con un arroyo que baga con el camino de Taos, y dibide las tierras de [Cristóbal] Martin, y por el norte con dicho arrollo junto al camino de Picures, y por el poniente con una sanga que la sacaron antiguamente los yndios Thanos).

Using these clues in this record of the act of possession and others in Lopes's original petition, I and other historians have placed the location of the Lopes grant where the Plaza del Cerro was later built and still stands in Chimayó. The acequia (irrigation ditch) described is almost certainly the Acequia de los Martínez, which passes east to west just south of the plaza, or the Acequia de los Ortega, which runs along the northern side of the plaza and provided irrigation water to the plaza interior.

Lopes's documents emphasize that he is making a bid for land that had no owner "except for the King our lord, may God keep him." These last words suggest at least rhetorical deference

to the distant monarch, King Philip V, who nominally ruled over New Mexico and much of the New World. The language also conveys the presumption that the thousands of Native people who had lived in the area for centuries had no use for the land. Archaeologists have determined that the pueblo villages in the Chimayó area had been long abandoned by the time of Spanish colonization, but the question as to whether or not local Tewa people were using the land in some capacity is not resolved by this document.

Both of these initial Lopes documents describe an acequia as one of the boundaries of the land. The language used in this statement—la acequia que sacaron los Indios Thanos—is of special import. While I originally took this to mean literally "the ditch that the Tano Indians took out," I later learned that, in the context of acequia management and maintenance, the verb *sacaron* is more accurately translated as "cleaned out." This phrase is commonly used to refer to the annual clearing out of an irrigation ditch. Taken this way, it indicates that the Indians who had settled in the valley after the revolt had not dug the ditch but had merely cleaned out one dug by Spanish colonists (fig. 10.3). Such a fine distinction in meaning is more than academic. It turns out to be of consequence today, as Pueblos in the Northern Rio Grande are making a claim to land and water that they believe they unfairly lost in the Spanish conquest and in adjudication of water rights in the valley centuries later. If the Tanos built the ditch, it would indicate that they, while technically new to the Santa Cruz valley, were the first to divert the water for irrigation; therefore, their descendants could claim senior water rights. If, however, those native Tanos who moved into the valley were merely using ditches established by Spanish settlers, descendants of the European colonists could claim priority and be first in line for water rights. The humble Lopes petition has found a place in the legal documents being assembled on both sides of the water rights claim today.

In carefully preserving Lopes's document the Ortega family could not have anticipated a battle over water two centuries later. They kept the paper close because it represented proof of the first legal ownership of land upon which the family would build an aggregate of many parcels. The familial relationship between Lopes and the Ortega family is unclear, but a document in our files records the purchase of at least part, and perhaps all, of Lopes's grant in 1758 by Grabiel Ortega, the progenitor of the Ortega family in Chimayó. (Curiously, this first Ortega in the lineage always spelled his name Grabiel, rather than Gabriel—an apparent transposition of letters that has persisted in the spelling of his descendants' names for generations.)

Much of the Lopes grant remains today in the hands of heirs of Grabiel, the first Ortega to appear in Chimayó. Although I haven't traced it completely, I believe a clear line of ownership can be demonstrated down to my small tract of land, first recognized under US law by a patent signed by president Calvin Coolidge in 1926. The chain of property ownership forms the backbone of the Ortega paper collection and attests to the family's determination to legally establish and protect their ownership of land, the most vital commodity on this far border of the Spanish and Mexican territories, where few other riches could be found.

10.3. A detail of the 1706 Lopes document, showing the language describing the "asequia que sacaron los Indios Thanos." Collection of the author's family.

The large number of documents relating to land acquisition range from elaborate transfers involving several people to simple sales from one farmer to another. Some, especially those from the 1700s, are signed by or refer to impressive historical figures such as governors Francisco Cuervo y Valdés, José Chacón Medina Salazar y Villaseñor (Marquis de la Peñuela), Gaspar Domingo de Mendoza, Juan Bautista de Anza, Pedro Fermín de Mendinueta, Juan Páez Hurtado, and other civil and military authorities in Santa Fe. But over time, as the Spanish Crown lost its grip in this remote outpost, the authority devolved to alcaldes (municipal magistrates) in Santa Cruz de la Cañada or *teniente alcaldes* (lieutenants to the alcaldes) in local plazas such as the Plaza del Cerro, La Cuchilla, Truchas, and La Puebla. Still other papers, essentially contracts or receipts, are signed only by the parties involved and do not bear official authorization other than the signatures of *testigos*, or witnesses. Several papers note that witnesses were called to sign because of a lack of official scribes or notaries (figs. 10.4–10.7).

The value of the land described in the documents varies widely. When Luis Lopes sold his land to Grabiel Ortega in 1758 in the *puesto* (place) of San Buenaventura (the first mention in the documents of the Plaza del Cerro's patron saint), Lopes received fifty "pesos al corriente de la tierra," a quasimonetary unit that indicated an exchange of agricultural products in lieu of currency.

In 1820 Mariano Crus sold two *"cuartitos"* (little rooms), one with a door, in the Plaza del Cerro for ten pesos de la tierra. This quarter-page document qualifies the sale by saying that the rooms have no vigas (ceiling beams), suggesting they were roofless, and closes by saying that Crus has asked Rumaldo de Ortega to write and sign for him because he himself doesn't know how to write.

In another 1820 sale, don Julian Quintana, *juez rector* (presiding judge), records the sale of several parcels of land from Pascual and Nicolás Ortega to Manuel Ortega, Grabiel's son. These included a garden that Pascual had acquired through inheritance from his father, twelve *varas* in size, for sixteen pesos de la tierra; and another piece of land in the "Milpa del Llano" for twenty pesos. The same document states that Nicolás (who was Manuel's brother) sold Manuel eighty-four varas of land for eighty pesos de la tierra, and another twelve-vara garden (with a well on the property) for "one fat ox." All these properties were situated bordering or near the Plaza del Cerro.

In 1843, several tracts in Truchas and Chimayó were combined in one sale from Matias Ortega and his brother to Gerbacio Ortega; apparently, the price for all the land was a mere sixteen *pesos fuertes*, a designation that it seems would indicate hard currency—that is, silver coins. But in this case, the payment was made not in cash but in the form of an ox, a serape with five designs on it, and some *tela*, a kind of fabric used to hold the warp on a weaving loom.

Parcels changing hands in land sales or transfers vary in size from garden plots of less than ten varas to irrigated farmlands of nearly three hundred varas. It's difficult to translate these areas into modern metrics, because a vara could signify a linear distance of about thirty-three inches or an area of about eight square feet. Likewise, the documents describe vague boundaries defined by hills, arroyos, roads, or landmarks such as large trees or rocks. Nevertheless, in some cases these suffice to allow a reasonable guess at a property's location.

Such is the case with a petition for a land division by Antonia Lopes, probably daughter to Luis Lopes, on April 18, 1766. Describing the split in the parcel of land, the document refers to a "blue rock outcropping that is on the edge of the hill on the eastern part" of the land (una peña azul que está al la margen del serro [cerro] de parte de el horiente [oriente]). I puzzled over this "blue rock," suspecting it was at the base of the hill on the east side of town, but it wasn't until I mentioned it to my mother that I was able to identify the spot. She recognized it as a place she used to go in childhood to play and for a view of the Chimayó valley. Broken wooden crosses stand at the foot of the rock, and a fence line extends from it due west, marking the boundary between parcels of land—quite likely the very boundary identified in Antonia Lopes's petition (figs. 10.8 and 10.9).

10.4

10.5

10.6

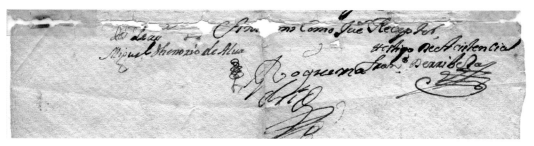

10.7

10.4. Signature of Francisco Cuervo y Valdes, "Governor and Captain General" of New Mexico, 1704–1707. Collection of the author's family.

10.5. Signature of don Gaspar Domingo de Mendoza, governor of New Mexico, 1739–1743. Collection of the author's family.

10.6. Signature of Pedro Fermín de Mendinueta, governor of New Mexico, 1767–1777. Collection of the author's family.

10.7. Signature of Roque Madrid, alcalde of La Villa de Santa Cruz de la Cañada, 1706. Collection of the author's family.

Most properties described in the papers are located somewhere near the Plaza del Cerro, which is mentioned many times. Some documents bring up the issue of lands held in common by the community in and around the plaza. One suggests that the whole interior of the plaza might have once been considered a commons. In this 1827 record of a land sale from Mariano Silva to Luis Ortega (fig. 10.10), the seller makes clear that his sale does not include land inside the plaza: "That I, inside the plaza, did not sell any rights [to the] common patio" (Que yo para dentro de la plasa no le bendi ningún derecho patio común).

10.8. A section of Antonia Lopes's petition of 1766 mentioning the *peña azul* on a parcel of the land's eastern boundary. Collection of the author's family.

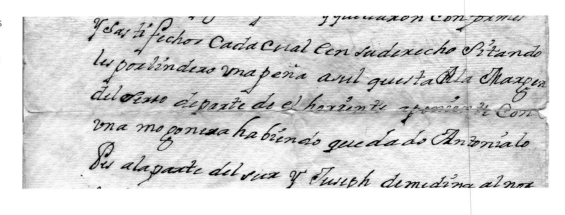

10.9. The *peña azul* on the eastern boundary of the Antonia Lopes petition. Photograph by Don J. Usner, 2010.

10.10. The first page of a land-transfer document from 1827 that mentions *patio común* in the Plaza del Cerro. Collection of the author's family.

10.11. A section of the 1848 document authored by Antonio Royval that states that "los mas señores" (also referred to as "los mas ansianos")—the oldest people from the area—confirm that there has always been a twelve-*vara* walkway inside the Plaza del Cerro. Collection of the author's family.

Two other papers concern a dispute about the public access ways, *pisos de la plasa*, around the inside perimeter of the plaza. Such public walkways were common in the old community, guaranteeing residents access throughout the plaza, along acequias, and out of the plaza to the river and to the hills and mountains. Documents from 1848 and 1855 address incursions upon these long-recognized access ways.

In the 1848 document, alcalde Antonio Royval reports that Luis de Ortega (adopted son of Grabiel) claims that his neighbor Juan José Cena is damaging Ortega's house by irrigating up to the foundations. To investigate the claim, Royval visits the "Plasa de Sanbuena Abentura" (the Plaza de San Buenaventura, another name for the Plaza del Cerro) with the two parties and demands that they show documents that demonstrate their rights in the *pisos de la plasa* around the inside perimeter of the plaza, where the damaging water was reaching Ortega's house.

Ortega and Cena state that they don't have any documents, since they inherited the properties, at which point Royval calls for the "most senior" people living in the plaza to come weigh in on the matter. With everyone together, the judge asks the elders if they know how much land inside the plaza should be considered pisos, to which Ysidro Ortega responds that it should be twelve varas. This testimony prompts Royval to measure out the distance and advise Cena that the twelve-vara right-of-way should be protected—and he advises all parties to avoid violating this rule, on penalty of being fined twenty-five pesos (fig. 10.11).

The second document to address the issue of the pisos, dated 1855, is authored by *juez de paz* (justice of the peace) Alonzo Martines of the Seventh Precinct (the area by this time was organized into counties and precincts in the Territory of New Mexico). In it, Martines describes another dispute sparked by the encroachment into the pisos de la plasa, blocking the customary walkways. Juez Martines reports that he, at the request of "Xerbacio de Ortega" (Gerbacio Ortega) visited the plaza, obtained documents that gave the location of plaza roads, and consulted with the oldest men of the community. This judge, too, concluded that residents must uphold the tradition of maintaining twelve varas of clear public right-of-way around the plaza (fig. 10.12).

Like the reference to the acequia in the 1706 Lopes papers, these rulings about public access are not without relevance today. When surveyors from the US government came to the plaza to settle small land holding claims in the early twentieth century, the old *pisos* had become established as public roadways. The surveyors, however, mapped property lines over them, breaking them up into a series of private properties in front of adjacent houses. As a result, there is today no legal public access to many houses around the plaza.

This oversight went unnoticed for decades but came to light recently when a landowner on the plaza sought to borrow money for improvement on his home, only to be told he was ineligible

10.12. Page one of an 1855 document by Alonzo Martines mentioning his consultation with the "oldest men" (*hombres mas antiguos*) from the plaza concerning the public walkways (*pisos communes entrandoles a todos*) around the plaza. Collection of the author's family.

because of the lack of secure access to the property. The time is ripe for plaza landholding maps to catch up with the rulings of 1848 and 1855.

Squabbles about access ways aside, the Ortega papers make clear that the family's landholdings grew steadily from their nucleus around the Plaza del Cerro in the Lopes grant, both through purchase and through marital inheritance. Grabiel Ortega started the trend of land acquisition. His son, Manuel Pablo, built on his landholdings. The acreage held increased exponentially when Manuel Pablo's son, Gervacio Ortega, married Guadalupe Vigil, from Santa Cruz de la Cañada; this union brought a considerable list of real estate to the family's holdings from Guadalupe's mother, Pascuala Romero.

In the next generation, the marriage of Gervacio's son José Ramón Ortega y Vigil to Petra Mestas, daughter of the well-landed Francisco Antonio Mestas, also brought to the clan extensive acreage in the lower Santa Cruz valley. By the late nineteenth century, José Ramón and Petra's conjoined estates embraced hundreds of varas of land in places some of whose names are barely remembered: Rancho de los Cuarteles, Los Llanitos, Bosque de Cirguelas, La Lagunita, El Charco, Barrio del Sombrillo, La Cieneguita, El Arenal, El Romerío, El Llano, Las Joyas, Plaza de Santa Cruz, Santo Niño, and La Milpa de las Jarras.

Wills, testaments, and settlements of estate, which make up a second strong focus in the Ortega papers, provide a glimpse into the material life of people living in Chimayó. They also say much about their deep religious and spiritual grounding and their attitude toward death.

The testaments of faith are impressive for their length and piousness. While there is a consistency to the form and even some of the content of these documents, and they consistently affirm the writer's absolute allegiance to the institution of the Church, personal touches come through. "I profess to live and die as a faithful Catholic Christian, having as my intercessor and protector always the Immaculate Queen of the angels, Holy Mary, my guardian angel . . . keeper of my

conscience," wrote Gervacio Ortega in his page-and-a-half testament, adding, "And I believe that my soul belongs to God, and my body to the earth, as food for the worms" (fig. 10.13).

Some wills divide meager estates, parceling out land, fruit trees, livestock, and houses among heirs so that each might inherit a single limb, a portion of an animal, or a room in a house. Gervacio's will of 1851 includes long lists of possessions and gives a good idea of the material life of a relatively well-off Chimayoso. In addition to one thousand varas of land, his five-room home, and several other houses, Gervacio left to his heirs a grist mill in La Puebla; four teams of oxen, one team of bulls, sixteen cows, eleven calves, a mule, a horse, a mare, a colt, two asses, and thirteen goats; and household goods consisting of ten wooden chests, nineteen blankets, four rugs, four sheets, ten pillows, two chests made of "new wood," eighteen carved wooden statues of saints and sixteen of ceramic, six retablos, four crosses of tin, two white sieves, two firearms,

10.13. The first section of Gervacio Ortega's will and testament, 1851. Collection of the author's family.

10.14. Lines from Gervacio Ortega's will and testament, leaving some of his belongings to his "Indito," Jose de Jesus Ortega. Collection of the author's family.

10.15. Lines from Juan Antonio Lopes's document that mention a servant (*serbiente*) belonging to Maria Manuela Lopes, 1857. Collection of the author's family.

three yellow jugs, four hoes, four hatchets, two iron rods, one branding iron, nineteen large and two small china dinner dishes, two linens, fifteen china cups, three pitchers, and one harness.

Gervacio also specifically left to his Indian servant (his "Indito"), Jose de Jesus Ortega, a room in a house in "Chimallo," thirty varas of land, a calf, an apple tree, a peach tree, a saddle, a bit (for a horse), a pistol, and two goats (fig. 10.14).

Gervacio's gift of property to his "Indito" brings into focus the practice of servitude in Spanish Colonial New Mexico. It also comes up in an 1857 paper that records a land transaction in which Juan Antonio Lopes, acting on behalf of Maria Atensio, transfers twenty varas of land to a priest in exchange for funeral services for Maria Manuela Lopes, a servant in Atensio's home (fig. 10.15).

These are the only instances of servitude I've found, so far, in the Ortega papers, even though Native American *criados* were a common feature of almost all homes in Spanish Colonial New Mexico, and the practice persisted well into territorial days. Modern-day scholars have argued that *"criado"* and *"serviente"* are little more than euphemisms for "slave." It's an uncomfortable fact of New Mexico history. Between 1700 and 1880 thousands of indigenous women and children were held in New Mexico and Colorado households as slaves. The practice persisted until well after the American takeover of New Mexico.

In my upbringing, I was told that some of my ancestors kept *criados* in the house, and it was common knowledge that my fifth great-grandfather, Francisco Antonio Mestas, had children by his *criada* as well as by his legitimate wife. But it was always emphasized that these were not slaves but servant-helpers who were practically "part of the family" and were granted their independence upon reaching adulthood. According to many people looking into this today, though, this kind of talk masked the fact that the Native Americans serving in Spanish and, later, Mexican and even American territorial households in New Mexico were de facto slaves who were bought, sold, and traded.

The Ortega papers shed some light on this delicate subject. The two servants mentioned are not handed down like property, as part of estates, but instead are declared to be beneficiaries of the estate. Also, Gervacio's will, at least, makes it clear that a servant could receive and own his

and kept in leather pouches, wooden chests, and cardboard boxes, we have the papers secured in chronological order, in archival folders, locked in a file cabinet. We've summarized the content of most of them and transcribed many, so that we can continue to flesh out the story they have to tell. We know now that it is a richer and more complex story than we imagined—and our work is far from done. Many of the papers remain to be transcribed and translated. As we and others chip away at them, they will evoke an ever-sharper picture of life in the plaza that Chimayó *vecinos* made for themselves in this remote and lovely valley (fig. 10.20).

10.20. The old general store and post office on the south side of the Plaza del Cerro. Photograph by Don J. Usner, 1990s.

11

Trails, Trade, and the Transformation of Traditional Art in Spanish New Mexico

ROBIN FARWELL GAVIN

Since prehistoric times, trails have traversed the broad landscape of New Mexico. Native American trails led from Chaco Canyon and other prehistoric settlements south into Mexico and east across the Plains, perhaps as far as Cahokia Mounds (Illinois). In 1680 trails connected the Rio Grande pueblos and enabled their runners to carry secret codes coordinating the Pueblo Revolt. From 1598 to 1821, goods from Spain's vast empire traveled over El Camino Real (The Royal Road) from central New Spain (today's Mexico and Guatemala) to the remote northern frontier. Starting in 1821 the Santa Fe Trail brought American and (New) Mexican merchants face-to-face, while French fur traders and trappers roamed trails from Canada and Louisiana through New Mexico into Mexico. The Spanish Trail was forged in 1829, establishing the road from Santa Fe to the Pacific. In 1880 the railroad opened the door to tourists, health seekers, anthropologists, artists, and writers, bringing a profound change to the traditional cultures of New Mexico. And with the designation of Route 66 in 1923, automobile tourism began to flourish. Today, cyber-trails bring the world to our fingertips.

As art historian Gabrielle Palmer noted: "The [trail] is more than some marks in the desert. It marks the birth of a new society. It's very relevant to history today. . . . How are we going to accommodate each other, live with each other? So it's more than it seems at first glance. It's the lesson of the trail."[1] Each of these trails has had an impact on every aspect of life—art, food, economy, religion, warfare, cultural traditions, ceremonies, and songs. When Spanish immigrants first settled in Nuevo México, they brought with them the traditions and aesthetics of their homeland. These had already been transformed by Muslim artisans in Spain and indigenous cultures in other areas of the Americas, as well as by Spain's trade with Asia. Further contact with people from around the world was made possible by this extensive network of trails that helped to shape the traditional art of Hispano New Mexico into a unique expression that resonates still today.

OPPOSITE

11.1. *Casta* (Caste) painting, Mexico, eighteenth century. Oil on canvas, 34 ½ × 27 ¾ in. The diverse population of Colonial Mexico was documented in a series of eighteenth-century paintings referred to as *casta* paintings. In this image, the man is thought to be a Spaniard, the woman a mestizo, and the child, a *castizo*. Photograph by Blair Clark. Spanish Colonial Arts Society, Museum of Spanish Colonial Art, Santa Fe. Purchased in memory of Frank Servas, 2018.18.

El Camino Real, 1598–1821

El Camino Real from Mexico City to Santa Fe officially opened in 1598 when don Juan de Oñate and 129 soldiers, their families, and Native servants forged their way north from Zacatecas, Mexico, using well-traveled Native trails to establish the first Spanish-speaking settlement in New Mexico.[2] From 1598 to 1821, the Camino Real was the main route of communication between Colonial New Mexico and the viceregal government in Mexico City. Over this route came people and goods from all across Spain's vast empire—from Mexico and South America, Europe, Africa, and Asia.

New Mexico's seventeenth-century colonists included not only *peninsulares* (people born in Spain) but also *criollos* (people born in America of Spanish parentage), *indios* (Native Americans), *mestizos* (people of Spanish and Native parentage), *castizos* (people of Spanish and *mestizo* parentage), *negros* (Africans), *mulatos* (people of Spanish and African parentage), and *moriscos* (people of Spanish and *mulato* parentage). In the eighteenth century, *genízaros* (detribalized Indians) also became recognized members of New Mexican communities.[3] This diverse population brought equally diverse cultural traditions and aesthetic sensibilities to the far northern frontier (fig. 11.1, see page 158). Although Spain restricted trade to its colonies throughout the Colonial period, there were numerous incursions—particularly in the eighteenth century—into Spanish New Mexico by French and, later, American traders and trappers.[4]

One of the many travelers along the Camino was a *peninsular*, don Bernardo de Miera y Pacheco (1713–1785). Born in northern Spain, Miera was living in northern Mexico by 1741.[5] In 1754 he moved his family to New Mexico, where he lived until his death. Trained as an engineer and cartographer, Miera served as *alcalde mayor* (district administrator) for the jurisdiction of Pecos and Galisteo. He is variously listed in New Mexico documents of the period as a rancher-farmer, soldier, mathematician, cartographer, and artist. As an artist, he was responsible for the design and construction of at least four identified Colonial New Mexican altar screens and numerous paintings and sculptures. Through his work, he helped to introduce elements of the international baroque style to the far northern frontier. His overall stylistic goal, like that of European and Mexican academic artists of the period, was naturalism: his figures have naturalistic poses and

11.2. Don Bernardo de Miera y Pacheco, *San Rafael,* Santa Fe, 1780. Oil on pine panel, 49 × 23¾ × 1½ in. This retablo illustrates Miera's use of baroque stylistic conventions, with the figure brought to the foreground, the background quickly receding, a naturalistic pose, and somber colors. Photograph by Jack Parsons. Spanish Colonial Arts Society, Museum of Spanish Colonial Art, Santa Fe. Gift of Dr. Frank E. Mera, 1954.77.

11.3. *Nuestra Señora de Candelaria,* Mexico, eighteenth century. Oil paint on paper engraving, 18 × 12 in. Inscription: La Hermosisima [imagen de Nuestra Sra] de Candelaria que devotos los gremios de cereria y confiteria veneran en el Santuario de Nuestra Señora de los Dolores del [convento] de San Francisco en la ciudad de Los Angeles (The beautiful [image of Our Lady] of Candlemas that the devout of the wax [candle] makers and confectioners' [bakers'] guilds venerate in the Sanctuary of Our Lady of Sorrows in the [friary/convent] of Saint Francis in the city of the Angels [Puebla, Mexico]). Spanish Colonial Arts Society, Museum of Spanish Colonial Art, Santa Fe. Purchased from Dr. H. J. Spinden, 1954.56.

are generally well-proportioned, with heavy, voluminous drapery and the dark, somber colors typical of the baroque style of Spain and Mexico (fig. 11.2).

There is very little extant information about other *santeros* (artists who painted or sculpted religious images known as *santos*) of this time period, and Miera appears to have been one of the most skilled. Yet the work of other artists also shows a familiarity with the baroque in both style and motifs. Some of these artists were undoubtedly settlers from southern New Spain, while others are identified as *indios* in the documents, working under the direction of friars with access to academic baroque prints, paintings, and sculptures from Spain and her colonies that were shipped up the Camino Real (figs. 11.3–11.4). These local artists produced sculptures

11.4. *San Antonio de Padua*, Spain, eighteenth century. Hardwood, gesso, oil paint, gold leaf, 9 ½ in. high. This image of Saint Anthony illustrates the naturalistic pose (bent knee, weight on one leg) and realistic (pleated) drapery of baroque art. Spanish Colonial Arts Society, Museum of Spanish Colonial Art, Santa Fe. Purchased in Spain, 1962.016.

(known as bultos and typically carved of cottonwood root), paintings on pine panels (referred to as retablos), altar screens, gesso reliefs, and paintings on animal hide.[6] Oil paints imported from elsewhere in New Spain were available during this time period but were combined with and soon replaced by water-based pigments made from local vegetal and mineral sources.[7]

While the Camino Real provided a conduit between New Mexico and the rest of Spain's vast empire, once in New Mexico the colonists encountered an additional system of trails and trade. For millennia, Native peoples of the Southwest traveled trails to Mexico, the Pacific coast, and the Plains. As Puebloan cultures became established between 800 and 1100 CE, they traded local turquoise, salt, and pottery for exotic items such as conch shells, parrot and macaw feathers, copper bells, chocolate, and buffalo hides.[8] After their arrival in the sixteenth century, Spanish immigrants relied on the Pueblos to supply them with both decorative and utilitarian ceramics, hides, textiles, and produce, while Pueblo peoples sought iron tools, livestock, and clothing in exchange.

11.5. *The Crucifixion*, New Mexico, eighteenth century. Natural pigments on animal hide, possibly elk, 71 ¾ × 52 ¾ in. This image of the Crucifixion has been traced to a print of a painting by Peter Paul Rubens that was distributed by the Catholic Church throughout the Spanish colonies and undoubtedly was brought up the Camino Real to New Mexico. Spanish Colonial Arts Society, Museum of Spanish Colonial Art, Santa Fe. Purchased from Tony Garcia, 1958.34.

This trade network resulted in the creation of one of the more exceptional and earliest hybrid art forms of the Colonial period in New Mexico—the painted hide. Brain-tanned leather (*gamuza*, like chamois) was one of the principal trade items *vecinos* (New Mexican settlers) acquired from Pueblo peoples, who in turn often acquired the hides from Plains tribes. As James W. Abert, a lieutenant in the US Corps of Topographical Engineers, reported from the Pecos Valley in 1846, "At one time we passed a group of Indians; they had pack mules laden with buffalo robes and meat. . . . They told me that they were 'Teguas' [Tewa] Indians; that they had been far out on the prairies trading with the Camanches [*sic*], and were now going to sell their robes in Santa Fé."[9] Since canvas was expensive and had to be brought up from Mexico, brain-tanned hides of buffalo, elk, and deer were often used as supports for paintings. The images, painted by anonymous painters, were inspired by prints and paintings originating from throughout the Spanish empire, brought up the Camino to homes and missions on the northern frontier (fig. 11.5). While

11.6. Altar frontal, Mexico, late eighteenth century. Hand-spun linen embroidered with silk and metallic threads, 26 × 72 in. Altar cloths such as this are believed to have been embroidered by nuns in the convents of Mexico. Many such textiles are mentioned in the documents from New Mexican churches. Spanish Colonial Arts Society, Museum of Spanish Colonial Art, Santa Fe. Purchased from Byron Harvey III, 1965.25.

images on these hide paintings were iconographically accurate, they were rarely slavish copies, and often incorporated motifs and elements such as Pueblo rain clouds, stepped clouds, rainbows, and Pueblo pots, attesting to the multicultural community in which they were created and foreshadowing the style to come.[10]

In addition to settlers, tradespeople, prints, paintings, and hundreds of other objects made their way up the Camino, brought as heirlooms and furnishings for the homes and churches of the *villas* (chartered municipalities) and *poblaciónes*, *ranchos* (smaller communities) of New Mexico. These included items such as embroidered silks and linens, ivories, majolica, porcelain, painted and inlaid furniture and jewelry boxes, filigree jewelry, hair combs, clothing, and more.[11] Felipe Tafoya of Santa Fe counted among the family belongings in 1764, "una colcha fabrica de China bordada de seda y con el fleco de lo mismo, la que tenia dicha mi esposa" (a coverlet from China embroidered with silk and with a fringe of the same, which my wife had).[12] In 1846, Abert noted, "Scattered about through New Mexico, one frequently meets with fine specimens of art, particularly oil paintings. These were sent over from old Spain."[13] All of these items in turn had an effect on objects made in New Mexico.

There is scant evidence for wooden furniture in prehistoric New Mexico; Pueblo peoples typically used built-in *bancos* (benches) and *petates* (woven mats) or folded textiles for seating, while storage consisted of shelves in niches and poles strung horizontally for hanging textiles.[14] Spanish *carpinteros* (carpenters) introduced not only iron tools for woodworking but also European construction techniques, such as mortise-and-tenon and dovetail joinery. Designs and motifs typical of Hispanic furniture of the Renaissance and baroque periods included rosettes, pomegranates, acanthus leaves, and lions. Colonial New Mexican furniture borrowed from these sources, adapting the designs to the soft but brittle pine that was the only abundantly available wood suitable for furniture construction. Chests were the most numerous pieces of furniture, most likely owing to their versatility as suitcases, storage containers, tables, and seats (see Pierce, fig. 12.5, this volume).[15]

Cloth and clothing were among the most numerous items transported up the Camino Real to New Mexico. With the introduction of sheep and wool, the Spanish had transformed weaving in the Southwest, producing yards of woolen cloth and blankets that were warmer and more durable than the cotton and turkey feather *mantas* (textiles) of the Pueblos. But *vecinos* still relied on trade for finer and fancier fabrics. Up the trail came taffeta from Castile, silk from China, embroidered ribbons from Spain, linen from Rouen, brocades, velvets, chintzes, satins, *indianilla* (cotton prints), and more.[16] Printed designs on these fabrics as well as motifs and symbols used

11.7. Colcha (embroidered bedspread), New Mexico, late eighteenth century. Hand-spun *sabanilla*, vegetal-dyed and undyed wools, 56¾ × 43¼ in. Here the double-headed eagle motif, used in Mexican embroideries such as that in figure 11.6, has a superimposed heart that may further represent the insignia of the Confraternity of Our Lady of Mount Carmel, as shown on the title page of the *Book of Accounts XXIV* for the Confraternity in Santa Cruz, New Mexico, 1760–1780. Spanish Colonial Arts Society, Museum of Spanish Colonial Art, Santa Fe. Purchased from Fred Harvey Shop, La Fonda, 1957.41.

on embroidered cloths were incorporated into New Mexican embroideries, known as colchas (figs. 11.6–11.7).

Significant political changes took place in the late eighteenth century that affected the arts of Spanish New Mexico. The Bourbon Reforms, implemented beginning in the 1750s, spurred production in the silver-mining cities of northern Mexico, which in turn depended upon *vecinos* for basic supplies such as woolen goods, sheep on the hoof, hides, and salt. Bourbon policy also included "fiscal reforms designed to promote trade and economic growth in the frontier provinces in order to strengthen them internally. In addition . . . the production of goods for the '*gratificación de los indios gentiles de paz*' (fulfillment [of the peace agreements] of the peaceful Indians) stimulated provincial industry in New Mexico and provided the impetus for further economic expansion."[17] At the end of the eighteenth century many new towns were established along the northern frontier to protect Spain's territory, and the expansion and renovation of the presidio in Santa Fe spurred other construction and renovation projects in the *villa*.[18]

It was at this time that a new style began to emerge. Late eighteenth- and early nineteenth-century *santeros*, such as the anonymous Laguna Santero, Pedro Antonio Fresquis, and Molleno, seem to have rejected the baroque conventions—promoted by Miera and illustrated in the many artworks that traveled the Camino—in favor of a flat, two-dimensional style more in harmony with Pueblo aesthetics.[19] This change in style coincided, not surprisingly, with a Pan-American movement toward independence from Spain. Throughout the colonies, a rising sense of nationalism naturally resulted in the rejection of the artistic conventions of the Spanish-introduced guilds. Since the beginning of the Colonial period Native peoples had been participating in the production of artworks (and in some areas, such as the Cuzco school in Peru, had been acknowledged masters), and with new nationalistic fervor, artists in New Mexico, as in all of the Americas, began to work in a style much more expressive of their unique experience—an Indo-Hispano style.[20]

The Santa Fe Trail, 1821–1880

News of Mexico's hard-fought independence from Spain, declared in August 1821, traveled quickly up the Camino Real, where it was met, at least in Santa Fe, with celebration.[21] Among other consequences, independence meant that trade was no longer restricted by Spain, as it had been throughout the Colonial period. A scant three months after Mexico opened its borders the first legal American traders made their way from Independence, Missouri, to Santa Fe, creating the Santa Fe Trail. William Becknell, the leader of these earliest expeditions, noted in 1822, "Those who visit the country for the purpose of vending merchandise will do well to take goods of excellent quality and unfaded colors. . . . A very great advance is obtained on goods, and the trade is very profitable; money and mules are plentiful, and they do not hesitate to pay the price demanded for an article if it suits their purpose, or their fancy."[22]

After the formal opening of the Spanish Trail between Santa Fe and Los Angeles (1829–1848), Santa Fe established itself as an "inland port," where traders, trappers, and merchants from Mexico, California, Missouri, Louisiana, and Canada met and bartered with New Mexican/Mexican merchants and Plains and Pueblo Indians in a truly international market. Traders from the States not only stopped to barter and trade in Santa Fe but then continued on to northern Mexico on the Camino Real, renamed the Chihuahua Trail. Marian Sloan Russell, whose husband was a trader on the trail, described the market in Santa Fe in the 1850s: "The marketplace in Santa Fé was a wonder. . . . There were colorful rugs . . . and deep-fringed shawls, gay with embroidery. . . . There were strings of prayer beads. . . . There were beaded moccasins and chamois coats, leather trousers, silver trimmed saddles, spurs and knapsacks; great hand-carved chests and cupboards, Indian baskets and jars without number. So many things that were fine and splendid; so many things that were rude and clumsy, the Santa Fé market afforded."[23] The trade proved quite lucrative and was responsible for a large influx of Anglo-Americans into New Mexico. Trader Alphonso Wetmore noted in 1828, "The capital employed in the trade this year, is about three hundred thousand dollars. . . . The returns consist of bullion, Mexican dollars, fine gold, beaver, and horses, mules, and asses. One hundred packs of beaver are embraced in this year's return."[24]

Perhaps the most obvious change that affected the arts of New Mexico with Mexico's independence and the subsequent opening of the Santa Fe Trail was the increased supply of tinplate. While tin had been available to Nuevomexicanos during the Colonial period, and there were coppersmiths and blacksmiths that undoubtedly worked with tin, there is to date no evidence that tin was mined in New Mexico before the twentieth century; tin most likely traveled the Camino Real primarily as finished objects ready for purchase.[25] The opening of the Santa Fe Trail coincided with a florescence in tin crafts throughout the Western world spurred by Britain's mass production of tinplate and the canning of food.[26] In 1846 the American Army of the West occu-

pied New Mexico, and many of their supplies, such as lard, sardines, and coffee, were shipped in tin cans. These discarded cans provided local tinsmiths with a free source of material and were fashioned into frames, crosses, candle sconces, and more (fig. 11.8).

The Santa Fe Trail trade also brought new forms of furniture that were adapted to local tastes and materials, such as laundry tables and pie safes (fig. 11.9).[27] Items that had been standard during the Colonial era, such as chests, were redesigned to fit different needs and aesthetics. The iconic New Mexican chest-on-legs (fig. 11.10) was a variation of a chest on short legs popularized in northern Spain (fig. 11.11). The inspiration for this design was likely the Spanish *vargueños* (writing desks) that were placed on *pies de puente* (bases), an aesthetic that was reinforced perhaps by New England dressing tables on high legs transported over the trail.[28]

Decorative details were typically chip-carved geometric panels, rosettes, and circles. Chairs were not common in Spain or Colonial New Mexico and were usually reserved for persons of high status or for special occasions. Several centuries of Islamic presence in Spain coupled with a peripatetic royal court made the use of cushions for seating not only convenient but preferable. This custom was transferred by Spanish colonists to the Americas, where it merged easily with Native seating on *petates*.[29] Thus, when W. W. H. Davis visited New Mexico in the 1850s he noted the local—and to him unusual—custom of sitting on cushions: "The furniture, as well as the manner of arranging the same, differs materially from the style in the States. Few chairs or wooden seats of any kind are used, but in their stead mattresses are folded up and placed around the room, next to the wall, which, being covered with blankets, make a pleasant seat and serve the place of sofas. This is an Eastern custom, and was undoubtedly borrowed from the Moors."[30]

Among the most popular items shipped across the trail were fabrics, particularly printed fabrics such as calico. In 1846, Abert remarked on the homes of New Mexico, "The houses throughout the country are furnished with mattresses, doubled up and arranged close to the walls, so as to answer for seats. . . . The walls, midway up, are covered with calico, to prevent the whitewash rubbing off; and the whole interior of the houses of the wealthy is covered with mirrors."[31] Calico designs also inspired motifs on local colcha embroideries and on the garments of painted santos (fig. 11.12).

It was during this time period that a distinctive New Mexican artistic style, whose beginnings are found in the eighteenth-century, solidified. Artists borrowed from late baroque and Neoclassical imported prints, paintings, and sculptures brought up the Camino Real and across the Santa Fe Trail, and combined them with local Native influences to create their unique Indo-Hispano style. This style is particularly evident in the retablos, where baroque realism is replaced by two-dimensional figures outlined in black; the emphasis is on pattern, created with large areas of solid color, and on decoration (fig. 11.13).[32] Most bultos are static and rigid in stance, with elongated proportions, in stark opposition to Mexican baroque and rococo images with flowing drapery and naturalistic poses; they are in fact much more similar in execution and design to indigenous kachina figures (fig. 11.14). In some examples, motifs such as feather headdresses (fig. 11.15) and Pueblo rain clouds (fig. 11.16) further attest to the multiethnic character of the artwork.[33]

11.8. *El Santo Niño de Atocha*, Mexico (print) and New Mexico (frame), mid-late nineteenth century. Tin, hand-blown glass, print, solder, 22¼ × 17¾ in. The tin frame was made by Higinio V. Gonzales (1842-1921), a New Mexican tinsmith, musician, and poet, and is in the Federal or Territorial style, popular at the time in both the eastern United States and Mexico. The inscription on the print reads, "EL Sto. NINO DE ATOCHA / Lit. de Cabrera / Calle de Tacuba No. 2," indicating the image was printed in Mexico City in one of the numerous nineteenth-century lithography studios on Calle de Tacuba. Spanish Colonial Arts Society, Museum of Spanish Colonial Art, Santa Fe. Purchased from Elmer Shupe, 1956.39.

11.9. *Trastero* (dish cabinet), New Mexico, nineteenth century. Pine, oil paint, 57 × 32 × 20 in. The design of this cupboard was most likely based on pie safes that were popular on the East Coast. The cross-shaped cutouts in the upper panels may indicate a religious use, such as the storage of vestments. Spanish Colonial Arts Society, Museum of Spanish Colonial Art, Santa Fe. Gift of Cornelia Thompson, 1958.11.

11.10. Valdez family, chest-on-legs, Velarde, New Mexico, late-eighteenth to early-nineteenth century. Pine, iron, 31 ¼ × 34 ¼ × 15 ½ in. Iron hardware by Victor Vera, Southwest Spanish craftsman (ca. 1965). Spanish Colonial Arts Society, Museum of Spanish Colonial Art, Santa Fe. Bequest of Eleanor Bedell, 1975.78.

11.11. Chest-on-legs, Spain, eighteenth century. Stained wood, iron hardware, 35 × 59 × 23 in. The lengthening of the end stiles on this chest to form short feet is a method of construction peculiar to Spain's northern provinces, particularly Asturias and Navarra. Decoration on Spanish chests often included chip carving, geometric panels, rosettes, and circles on the front face. These elements frequently were reproduced on furniture in the colonies; see Carmella Padilla and Donna Pierce, *Conexiones: Connections in Spanish Colonial Art* (Santa Fe, NM: Museum of Spanish Colonial Art, 2002), 35. Spanish Colonial Arts Society, Museum of Spanish Colonial Art, Santa Fe. Gift of Nancy Reynolds, 2000.6.

11.12. *Libro de oraciones* (Book of prayers), Mexico, nineteenth century. Paper, ink, calico cover, 3¾ × 2¾ in. Equally important as this early book of prayers is the homemade calico cover, a rare example of the fabric of this time period. Spanish Colonial Arts Society, Museum of Spanish Colonial Art, Santa Fe. Anonymous gift, 1957.10.

11.13. Molleno, *San Francisco de Asís*, New Mexico, nineteenth century. Pine, natural pigments, gesso, 14¾ × 9¾ in. Inscribed on the reverse in pencil: "San Francisco Pitido En el Año De 1845 por El escultor Molleno" (Saint Francis painted in the year 1845 by the sculptor Molleno). Photograph by Jack Parsons. Spanish Colonial Arts Society, Museum of Spanish Colonial Art, Santa Fe. Bequest of Norma Fiske Day, 1975.9.

11.14. José Aragón or follower, *San Rafael*, New Mexico, nineteenth century. Wood, gesso, water-based paint, 17½ in. high. The static pose and use of blocks of color show more stylistic similarity to Native American kachina figures than to the late baroque sculpture of Mexico and Spain. Photograph by Addison Doty. Spanish Colonial Arts Society, Museum of Spanish Colonial Art, Santa Fe. Purchased from Tony Garcia, 1960.047.

11.15. A. J. Santero, *Santa Bárbara*, New Mexico, nineteenth century. Pine, gesso, water-based paint, 12 × 7 in. A feather headdress here adorns the image of Saint Barbara in place of the more typical crown. Spanish Colonial Arts Society, Museum of Spanish Colonial Art, Santa Fe. Bequest of Ann and Alan Vedder, 1990.144.

11.16. *Santa Gertrudes*, New Mexico, nineteenth century. Pine, gesso, natural pigments, thread spools, 8¾ × 6¾ in. Threads and yarns (notions) were some of the staples of the Santa Fe Trail trade, with spools reused here to form a decorative frame. As this piece was collected from Ohkay Owingeh and a Pueblo rain cloud motif appears in the background, it may have been painted by a Pueblo artist. Spanish Colonial Arts Society, Museum of Spanish Colonial Art, Santa Fe. Purchase, 1958.1.

11.17. José Rafael Aragón (ca. 1790–1862), *San Calletano*, New Mexico, mid-nineteenth century. Pine, gesso, natural pigments, 11 × 8 in. Signed lower right "ARAGON/ JOSERAFEL"; inscribed lower left "SCALLETANO." One of only three works signed by Rafael Aragón, this retablo is the quintessential example by the artist, who, along with other artists in a workshop, created a distinctive New Mexico style in the early nineteenth century. Spanish Colonial Arts Society, Museum of Spanish Colonial Art, Santa Fe. Purchased from Dr. Herbert J. Spinden with funds from Amelia White, 1954.54.

The local artists whose work defines this distinctive New Mexican santo style—José Rafael Aragón (ca. 1790–1862), his brother José Aragón (ca. 1785–?), José Manuel Benavides (ca. 1798–ca. 1845), and José Anastacio Casados (1787–?)—appear to have formed an informal workshop in Santa Fe based on social, familial, and sacramental (*compadrazgo*) relationships (fig. 11.17). Three were listed as *escultores* (sculptors) in the documents, while one, José Aragón, inscribed his work as having been made in an *"escultería"* or *"chamisal"* (sculpture workshop), suggesting that he self-identified as a sculptor. They lived in proximity to one another and to a number of *carpinteros*. All appear to have been born in New Mexico, and among their neighbors and extended families were *vecinos* identified as both *genízaros* and *indios*.[34]

Textile production also expanded and improved in the late eighteenth and early nineteenth centuries.[35] Although hand-woven textiles were not among the most popular trade items traveling east on the Santa Fe Trail, they were one of the main export items south into Mexico and west along the Spanish Trail (1829–1848).[36] Additionally, textiles were part of the purchases of the "Extraordinary Fund," a fund set up by the comandante general in 1787 "for the purpose of purchasing gifts for the Indian treaty partners."[37] These gifts included "woolen stockings and a variety of blankets, textiles, and cloth" (woven by the *vecinos* of New Mexico) to supplement items imported from the south. These Rio Grande blankets (fig. 11.18), as they are known today, were typically woven in two widths on the horizontal treadle looms that had been introduced to the Americas by the Spanish. Yarns were hand-spun and hand-dyed, with most of the dyes made from local plants and minerals (the main exceptions were indigo and cochineal).[38] Textile designs were primarily band-and-stripe patterns, often combined with elements borrowed from Mexican Saltillo serapes (fig. 11.19).

11.18. Rio Grande blanket, New Mexico, mid-nineteenth century. Churro wool, natural dyes of indigo, logwood, chamisa, 93 ¼ × 51 ½ in. This classic band-and-stripe pattern in natural dyes is an excellent example of the weaving tradition that was the basis of New Mexico's economy throughout the eighteenth and nineteenth centuries. Blankets such as this were traded on all the trails coming into New Mexico. Spanish Colonial Arts Society, Museum of Spanish Colonial Art, Santa Fe. Gift of Mr. and Mrs. John Gaw Meem, the Harry P. Mera Collection, 1962.70.

11.19. Saltillo serape, Tlaxcala (possibly), Mexico, late-eighteenth to early-nineteenth century. Churro wool, cotton, natural dyes (cochineal, indigo, logwood), 89 × 47 ½ in. Serapes were a basic garment for Mexican vaqueros, or cowboys, and were an important trade item, particularly after the opening of the Santa Fe Trail. Examples made in Saltillo, Mexico, were highly prized, thus the name "Saltillo serape." Their designs were later incorporated into New Mexican Rio Grande textiles. Spanish Colonial Arts Society, Museum of Spanish Colonial Art, Santa Fe. Gift of Robert T. Coffland in memory of Mary Hunt Kahlenberg, 2015.51.

The Railroad, 1880–1920s

The arrival of the Atchison, Topeka, and Santa Fe Railway in 1879–1880 signaled vast changes for the traditional cultures of New Mexico. Its impact was substantial: "By the 1890s, railroads had become the largest employers in the United States, the greatest consumers of iron, steel and coal from the nation's industrial plants, and the most efficient and extensive movers of people and products in the history of the world."[39] Among these people was a young English immigrant entrepreneur, Frederick Henry Harvey, who single-handedly changed the character of rail travel. By establishing a chain of hotels and restaurants along the railroad that vastly improved the quality of food and service, Harvey made rail travel pleasurable and desirable. The Harvey Company promoted tourism to the Southwest, not only through brochures and ads but also with its "Indian Detours"—touring cars that left La Fonda hotel on the plaza in Santa Fe and took people on guided tours of the Pueblos and villages of Northern New Mexico. Part of the Harvey enterprise were the "Harvey girls," young women from the East and Midwest recruited by the company to staff the Harvey hotels and restaurants and run the Indian Detours. Becoming a Harvey girl allowed young women to safely leave home and see the country while also earning a living.

Artists and writers also arrived, lured by the beauty of New Mexico and seeking a place that would be more accommodating to their alternative lifestyles. Tuberculosis patients came searching for a cure from the epidemic of the late 1800s; many never left after discovering the clear air and blue skies of New Mexico. The construction of the railroad itself brought men from the world over, many of them marrying and settling in New Mexico. This influx of Europeans, Asians, and Anglo-Americans drastically changed the character and composition of New Mexican social and political culture.[40]

As faster and lower cost transportation replaced the mule- and ox-drawn wagons of the Santa Fe Trail, goods started arriving on a daily basis and in much larger quantities, lowering costs and increasing accessibility. Mercantile companies, such as the Charles Ilfeld Company and Gross, Kelly and Company, established new "department stores," filled with groceries, liquor, hardware, saddlery, dry goods and furnishings, millinery and dressmaking, and carpets and textiles (fig. 11.20).[41] These stores, selling both retail and wholesale, provided access to items previously unavailable or too expensive for most *vecinos* in rural New Mexico, such as sheet tin for roofing, building parts such as metal hinges, glass for mirrors and windows, enameled housewares, tools for woodworking, enamel paints, and agricultural equipment.[42] Customers traveled many miles to purchase merchandise in quantity and at the lowest prices, as noted by Daniel Kelly of Gross, Kelly and Company: "A wealthy Mexican rancher from Chihuahua brought his ox train to Las Vegas [to Gross, Kelly and Company] to purchase winter and spring supplies . . . including such items as molasses, sugar, salt, soap . . . kegs of lard, barrels of whiskey, feed and grain for the animals, muleshoes, oxshoes, horseshoes, kegs of nails, bolts of calico, blankets, ammunition, shot, overalls, gloves, and other commodities."[43]

Nuevomexicanos could also now purchase items by mail order from Sears, Roebuck and Company and Montgomery Ward, as well as from manufacturers of religious items. The arrival and popularity of plaster religious statues (manufactured as far off as France), machine-made furniture, and commercial textiles effectively put many traditional artists out of work (fig. 11.21).

Those that continued to work, however, were able to take advantage of new tools and materials. Weavers incorporated aniline dyes (discovered in Europe in 1856 and distributed in the United States a few years later),[44] now more accessible, into their textiles (fig. 11.22); woodworkers used new tools and designs inspired by furniture forms popular in Mexico and the United States, arriving on the railroads; and *santeros* such as José Benito Ortega (1858–1941) incorporated milled lumber into their work. Tinsmiths such as Higinio V. Gonzales (1842–1921) continued

11.20. *Portrait of Martina Trujillo Romero* [right] *and Candelaria Córdova Romero* [left], Córdova, New Mexico, ca. 1900. Charcoal-enhanced photograph, 16 × 20 in. The women in this charcoal-enhanced photographic portrait are both wearing Victorian-era black dresses popular on the East Coast at the turn of the nineteenth century. The dresses, and paper patterns to make them, would have been transported over the railroad and then sold by merchants to *vecinos*. Spanish Colonial Arts Society, Museum of Spanish Colonial Art, Santa Fe. Purchased from Dr. Helen Lucero, great-granddaughter of Martina Trujillo Romero, 2015.34.

11.21. *Saint Dominic and Saint Francis*, New Mexico, late-nineteenth century. Tin, glass, catalogue print, 8¾ in. diam. The print in this tin frame is cut from a catalogue page advertising plaster statues of Saint Dominic and Saint Francis available by mail order and delivered by train. Photograph by Jack Parsons. Spanish Colonial Arts Society, Museum of Spanish Colonial Art, Santa Fe. Gift of Ina Sizer Cassidy, 1952.50.

to create decorative and utilitarian pieces with stamps and punches shipped across the railroad along with wallpaper that was used to embellish their works.[45] Nevertheless, the increase in availability of machine-made merchandise drastically diminished the local, community-driven market for the traditional arts.

11.22. Rio Grande blanket, New Mexico, nineteenth century. Wool, synthetic dyes, 80¼ × 53½ in. This blanket displays the diamond motif of the Mexican Saltillo serape and the bold, eye-dazzling aesthetic of contemporary Navajo textiles using popular synthetic dyes. Spanish Colonial Arts Society, Museum of Spanish Colonial Art, Santa Fe. Gift of Mr. and Mrs. John Gaw Meem, the Harry P. Mera Collection, 1962.079.

11.23. Chimayó blanket, New Mexico, mid-twentieth century. Commercial wool, synthetic dyes, 84¾ × 51 in. The central motif here is a thunderbird, a design borrowed from the Great Lakes region, with a Pueblo rain cloud adaptation woven on its chest. Spanish Colonial Arts Society, Museum of Spanish Colonial Art, Santa Fe. Gift of Joseph and Reine Moure, 2004.53.

Route 66 and the Revival, 1920s–1970s

The official designation of Route 66, touted as the "Mother Road," in 1923 signaled a new era in tourism. Automobile travelers now had the luxury of a direct route on a paved road from Chicago to Los Angeles, but with the freedom to stop and explore. Until 1937, Route 66 entered New Mexico at Tucumcari, ran west to Santa Rosa, and then turned north to Las Vegas and Santa Fe before heading south again to Albuquerque and Los Lunas. This circuitous route added three hundred miles to the east-west crossing of New Mexico, and, a number of politicians argued, kept tourists in the state longer.[46] The increase in automobile travel coincided with a growing interest in the traditional arts of the state. Seeing the vast changes brought about by the influx of machine-made products, a number of enterprising individuals set out to help revive and recover the traditional arts, while others did so almost accidentally—as a side effect of their efforts to capitalize on the expanding tourist market.

One such example is the "invention" of the Chimayó blanket. The earliest documentation of weavers in the small community of Chimayó, New Mexico, is from the late eighteenth century, when they were producing traditional Rio Grande band-and-stripe blankets, *jerga* (yardage), and *sayal* (sackcloth) for household use. By the late 1800s, however, hoping to take advantage of railroad and, later, Route 66 tourism, Santa Fe merchants such as Jake Gold and Jesucito Candelario recognized the need for a new type of blanket that had the appearance of the popular Navajo blankets but was much lighter, smaller, and less expensive.

For these "buggy blankets" (to cover one's legs for warmth in a buggy), they turned to the weavers of Chimayó, supplying them with yarn, designs, and sometimes looms. The yarns were commercially spun and dyed, cutting costs and time from the traditional hand-spun and hand-dyed yarns. Cotton string warps were also introduced, as they were strong, smooth, and provided some luster. Motifs borrowed from Navajo blankets and other Native American motifs from as far as the Great Lakes region were woven into designs that had no precedent in earlier Rio Grande weavings (fig. 11.23).[47]

The enterprise was such a success that by the 1930s merchants began to request new items from the weavers to fulfill customer demands. Santa Fe merchant Julius Gans is credited with introducing jackets, vests, and purses into the Chimayó repertoire. These were then distributed to wider markets, such as Fred Harvey Company shops, which also sold Chimayó placemats, runners, and coasters. It is estimated that some one hundred weavers were employed in Chimayó in the 1930s.

Other enterprising individuals (many of whom arrived in the 1920s), concerned about the decline in the traditional arts, set about trying to provide new markets and training for Hispano/a artists. One result was the formation in 1925 of the Spanish Colonial Arts Society whose purpose was to encourage and promote Spanish Colonial arts.[48] The following year the society held the first annual Spanish Market, which continues today. While trying to provide a new market for artists, society founders Mary Austin and Frank Applegate, among others, also encouraged the artists to change their work to better appeal to the taste of new, nonlocal collectors. They suggested changes in style as well as content, in some cases steering artists away from traditional forms, such as *santos*, toward items deemed more collectible by Anglo-Americans, such as lazy Susans and screen doors (fig. 11.24).[49]

In 1929, Concha Ortiz y Pino opened the Colonial Hispanic Crafts School in Galisteo, which taught embroidery, tanning, saddle making, weaving, and woodworking. Although it lasted only a year, the school became a model for the New Mexico Department of Vocational Education schools that were opening across the state.[50] In the 1930s, Cleofas Martínez Jaramillo organized La Sociedad Folklórica (The Folklore Society) and Regina Cata of Ohkay Owingeh and Anita Gonzales (Thomas) of Santa Fe formed the Club Suspiros (Club of Sighs) to help revive colcha

11.24. José Dolores López (1868–1937), *Lazy Susan,* Córdova, New Mexico, ca. 1930. Pine, 46 ¾ × 19 in. diam. José Dolores López is today credited with founding the Córdova style, a style of woodcarving that features the natural color and grain of the wood embellished with finely chip-carved designs. The donor purchased this piece from the artist at Spanish Market ca. 1930. Spanish Colonial Arts Society, Museum of Spanish Colonial Art, Santa Fe. Gift of Mrs. Lois Field, 1970.18.

embroidery (fig. 11.25).[51] These efforts were all in addition to, and intertwined with, Franklin D. Roosevelt's New Deal programs.[52]

Attempting to broaden the market for Hispano arts, from 1930 to 1933 the Spanish Colonial Arts Society opened the Spanish Arts shop, which carried items created by Nuevomexicanos and offered their work by mail order across the country. When the shop closed, it was replaced by the Native Market, which was run by Leonora Curtin (Paloheimo) from 1934 to 1940. Both worked closely with the vocational schools, bringing students and artists to the shops to demonstrate the traditional arts and providing them with supplies and materials to do their work. The emphasis was on reviving traditional arts rather than encouraging contemporary painting or sculpture.[53]

11.25. Regina Cata (1886–1971) and Anita Gonzales (1908–1999), *Mi Querencia*, Santa Fe and San Juan (Ohkay Owingeh) Pueblo, New Mexico, 1935. Cotton, commercial yarn, synthetic dyes, 102 × 76 in. Inscription: Año del '35 en la primavera esta colcha fue pintada Por Regina Cata de San Juan y por Anita Gonzales fue bordada Durante las reuniones del "Club Suspiros" (In the spring of the year 1935, this embroidery was designed by Regina Cata of San Juan [Pueblo] and embroidered by Anita Gonzales [Thomas] during the meetings of the "Club of Sighs"). Photograph by Blair Clark. Spanish Colonial Arts Society, Museum of Spanish Colonial Art, Santa Fe. Gift of Edward L. Gonzales, 2011.2.

It was on this platform that the art of the latter twentieth century was built. After centuries of change and diverse influences, Nuevomexicanos in the 1960s and 1970s reclaimed control and the direction of their artistic heritage. Artists such as Teresa Archuleta-Sagel (fig. 11.26) and Juanita Jaramillo Lavadie spurred the revival and renewal of textile arts; a group of artists formed their own contemporary Spanish Market to counter what they viewed as the restrictive guidelines of the Society's traditional Spanish Market; and informal artist-led workshops, such as La Cofradía de Artes y Artesanos Hispánicos (organized by cofounders Luis Tapia, Star Tapia, Frederico Vigil, Wilberto Miera, and María Luisa Delgado Roybal), and La Escuelita (organized by José Benjamín López, with Leroy López, Félix López, Manuel López, Olivar Martínez, Clyde Salazar, Olivar Rivera, José Griego y Maestas, and Luisito Lujan), were formed to share techniques and to encourage individual artistic development.[54]

Cybertrails: New Mexican Art Today

Today's trails have become cybertrails, with information, materials, and stylistic variations available to most anyone to use and study at the click of a mouse. While some artists choose to remain more traditional in their imagery, focusing their attention on excellence in technique (fig. 11.27), others choose to use their medium as commentary on social and political themes, reflecting both their respect for and understanding of the past and their concern for the future (fig. 11.28). Still others use traditional materials in new and stunning combinations (fig. 11.29), or traditional subject matter executed in new materials. As the next generations of artists continue to navigate this challenging territory, or *nepantla* (the place in between),[55] located between traditional and contemporary; between regional and global; between *español*, *indio*, and *mestizo*, they will be forging new trails.

OPPOSITE

11.26. Teresa Archuleta-Sagel, *Río Saltillo*, Española, New Mexico, 1996. Wool, natural dyes, 60¼ × 43 ¾ in. Photograph by Jack Parsons. Spanish Colonial Arts Society, Museum of Spanish Colonial Art, Santa Fe. Spanish Market Purchase Award, 1997.002.

11.27. Ramón José López, *La Sagrada Familia*, Santa Fe, New Mexico, 1994. Vegetal and mineral pigments (*amaigre*, clay, indigo, *terre verde*, yellow ochre) on tanned buffalo hide, deer sinew, 48 × 42 in. Spanish Colonial Arts Society, Museum of Spanish Colonial Art, Santa Fe. Spanish Market Purchase Award, 1994.12.

11.28a AND 11.28b. Luis Tapia, *Doña Sebastiana Relaxes after a Hard Day at the Office*, La Ciénega, New Mexico, 2003. Carved and painted wood, 35 × 20 × 22 in. Photograph by Dan Morse. Spanish Colonial Arts Society, Museum of Spanish Colonial Art, Santa Fe. Partial gift of Diane and Sandy Besser, 2008.95.

11.29. Justin Gallegos Mayrant, *Tribute to the Río Arriba Painted Tin Workshop*, Santa Fe, New Mexico, 2017. Tin, solder, 19 ½ × 11 × 3 in. Photograph by Blair Clark. Spanish Colonial Arts Society, Museum of Spanish Colonial Art, Santa Fe. Spanish Market Purchase Award, 2017.018.

1. Gabrielle Palmer, interview with James K. Gavin, Santa Fe, 2005. Notes on file with James Gavin. Gabrielle Palmer was project director for the Camino Real Project and chief curator for the exhibit *El Camino Real: Un Sendero Histórico*, a joint project with the Latin American Institute, University of New Mexico, 1990.

2. El Camino Real continued in use after 1821 but the name was changed to the Chihuahua Trail. For the history of trade and travel on El Camino Real, see Gabrielle G. Palmer, comp., *El Camino Real de Tierra Adentro*, New Mexico Bureau of Land Management Cultural Resources Series no. 11 (Santa Fe: BLM New Mexico State Office, 1993); *El Camino Real de Tierra Adentro: Historia y Cultura*, Primer Coloquio Internacional (Chihuahua, MX: National Park Service and Instituto Nacional de Antropología e Historia, 1997); *El Camino Real de Tierra Adentro* (Chihuahua, MX: National Park Service and Instituto Nacional de Antropología e Historia, 1997); Douglas Preston and José Antonio Esquibel, *The Royal Road: El Camino Real from Mexico City to Santa Fe* (Albuquerque: University of New Mexico Press, 1998); Gabrielle G. Palmer and Stephen L. Fosberg, comps., *El Camino Real de Tierra Adentro*, New Mexico Bureau of Land Management Cultural Resources Series no. 13 (Santa Fe: BLM New Mexico State Office, 1999); Joseph P. Sánchez and Bruce A. Erickson, *From Mexico City to Santa Fe: A Historical Guide to el Camino Real de Tierra Adentro* (Los Ranchos, NM: Rio Grande Books, 2011); and Miguel Vallebueno Garcinava, José Luis Punzo Díaz, and Rubén Durazo Alvarez, *El Camino Real de Tierra Adentro: Travesía histórica y cultural al Septentrión Novohispano* (Durango, MX: Gobierno del Estado de Durango, 2011).

3. See José Antonio Esquibel, "The Formative Era for New Mexico's Colonial Population: 1693–1700," in *Transforming Images: New Mexican Santos in-between Worlds*, ed. Claire Farago and Donna Pierce (University Park: Pennsylvania State University, 2006), 64–79; and Paul Kraemer, "The Dynamic Ethnicity of the People of Spanish Colonial New Mexico in the Eighteenth Century," in Farago and Pierce, *Transforming Images*, 80–98. Ilona Katzew, *Casta Painting: Images of Race in Eighteenth-Century Mexico* (New Haven, CT: Yale University Press, 2004), discusses the genre of *casta* (caste) painting as well as the development of these racial categories.

4. David J. Weber, *The Taos Trappers: The Fur Trade in the Far Southwest, 1540–1846* (Norman: University of Oklahoma Press, 1971).

5. For more information on Miera's life and work, see Donna Pierce, "From New Spain to New Mexico: Art and Culture on the Northern Frontier," in *Converging Cultures: Art and Identity in Spanish America*, ed. Diana Fane (New York: Brooklyn Museum, 1996), 59–68; Donna Pierce, "The Life of an Artist: The Case of Captain Bernardo Miera y Pacheco," in Farago and Pierce, *Transforming Images*, 134–137; Felipe Mirabal and Donna Pierce, "The Mystery of the Cristo Rey Altar Screen and Don Bernardo de Miera y Pacheco," *Spanish Market Magazine* 12, no. 1 (1999): 60–68; Josef Diaz, ed., *The Art and Legacy of Bernardo Miera y Pacheco: New Spain's Explorer, Cartographer, and Artist* (Santa Fe: Museum of New Mexico Press, 2013); and John L. Kessell, *Miera y Pacheco: A Renaissance Spaniard in Eighteenth-Century New Mexico* (Norman: University of Oklahoma Press, 2013).

6. In New Mexico, the word *retablo* has come to be associated with small paintings of saints and holy personages on pine panels. In documents of the Colonial period, however, *retablo* referred to an altar screen, and small paintings were listed as *imágenes sobre madera*.

7. For more information on eighteenth-century artists and techniques, see William Wroth, *Christian Images in Hispanic New Mexico* (Colorado Springs, CO: Taylor Museum of the Colorado Springs Fine Arts Center, 1982); Donna Pierce and Marta Weigle, eds., *Spanish New Mexico: The Spanish Colonial Arts Society Collection* (Santa Fe: Museum of New Mexico Press, 1996); E. Boyd, *Popular Arts of Spanish New Mexico* (Santa Fe: Museum of New Mexico Press, 1974); Christine Mather, *Colonial Frontiers: Art and Life in Spanish New Mexico: The Fred Harvey Collection* (Santa Fe, NM: Ancient City Press, 1983); Carmella Padilla and Donna Pierce, *Conexiones: Connections in Spanish Colonial Art* (Santa Fe, NM: Museum of Spanish Colonial Art, 2002); Marie Romero Cash, *Santos: Enduring Images of Northern New Mexican Village Churches* (Niwot: University Press of Colorado, 1999); Charles M. Carrillo and Thomas J. Steele, *A Century of Retablos: The Janis and Dennis Lyon Collection of New Mexican Santos, 1780–1880* (Phoenix: Phoenix Art Museum, 2007); Charles Carrillo, "A Saint Maker's Palette," in *Saints and Saint Makers of New Mexico*, by E. Boyd, rev. and ed. Robin Farwell Gavin (Santa Fe, NM: Western Edge Press, 1998), 99–104.

8. Arthur W. Vokes and David A. Gregory, "Exchange Networks for Exotic Goods in the Southwest and Zuni's Place in Them," in *Zuni Origins: Towards a New Synthesis of Southwestern Archaeology*, ed. David A. Gregory and David R. Wilcox (Tucson: University of Arizona Press, 2007), 318–357; and Carroll L. Riley, "The Pre-Spanish Camino Real," in Palmer, *El Camino Real*, 13–20.

9. James W. Abert, *Abert's New Mexico Report 1846–'47* (Albuquerque, NM: Horn & Wallace, 1962), 42.

10. Kelly Donahue-Wallace, "Hide Paintings, Print Sources, and the Early Expression of a New Mexican Colonial Identity," in Farago and Pierce, *Transforming Images*, 145–158; Donna Pierce, "Hide Painting in New Mexico: New Archival Evidence," in Farago and Pierce, *Transforming Images*, 138–144; Kelly T. Donahue (Wallace), "An Odyssey of Images: The Influence of European and New World Prints on Eighteenth-Century Hide Paintings in New Mexico," in *A Moment in Time: The Odyssey of New Mexico's Segesser Hide Paintings*, ed. Thomas E. Chávez (Los Ranchos, NM: Rio Grande Books, 2012), 55–88.

11. See Donna Pierce, "Unpacking a Colonial Bride: The 1721 Dowry of Luisa Gómez del Castillo of Santa Cruz de la Cañada, New Mexico," in *Scholar of the City Different: Papers in Honor of Cordelia Thomas Snow*, ed. Emily J. Brown, Matthew J. Barbour, and Genevieve N. Head (Albuquerque: Archaeological Society of New Mexico, 2019), 181–196; Donna Pierce and Cordelia T. Snow, "A Harp for the Playing: Domestic Goods Transported over the Camino Real," in Palmer and Fosberg, *El Camino Real*, 71–86; Donna Pierce, "Heaven on Earth: Church Furnishings in Seventeenth-Century New Mexico," in Palmer and Fosberg, *El Camino Real*, 197–208.

12. Linda Tigges, ed., and J. Richard Salazar, trans., *Spanish Colonial Lives: Documents from the Spanish Colonial Archives of New Mexico, 1705–1774* (Santa Fe, NM: Sunstone Press, 2013), 578.

13. Abert, *New Mexico Report*, 58.

14. Ruth Underhill, *Life in the Pueblos*, rev. ed. (Santa Fe, NM: Ancient City Press, 1992), 77–79.

15. For furniture making in Hispanic New Mexico, see Lonn Taylor and Dessa Bokides, *New Mexican Furniture 1600–1940* (Santa Fe: Museum of New Mexico Press, 1987); Donna Pierce, "Furniture," in Pierce and Weigle, *Spanish New Mexico*, 61–79; Donna L. Pierce, "New Mexican Furniture and Its Spanish and Mexican Prototypes," in *The American Craftsman and the European Tradition, 1620–1820*, ed. by Francis J. Puig and Michael Conforti (Minneapolis: the Minneapolis Institute of Arts, 1989), 179–201; Alan C. Vedder, *Furniture of Spanish New Mexico* (Santa Fe, NM: Sunstone Press, 1977); Robin Farwell Gavin, "Carpinteros in Colonial New Mexico," in Brown, Barbour, and Head, eds., *Scholar*, 55–80; and William Wroth, "Painted Chests Attributed to the Workshop of the Laguna Santero," in Brown, Barbour, and Head, eds., *Scholar*, 225–244.

16. Pierce and Snow, "Harp for the Playing."

17. Ross Frank, *From Settler to Citizen: New Mexican Economic Development and the Creation of Vecino Society, 1750–1820* (Berkeley: University of California Press, 2000), 70.

18. José Antonio Esquibel and Charles M. Carrillo, *A Tapestry of Kinship: The Web of Influence among Escultores and Carpinteros in the Parish of Santa Fe, 1790–1860* (Los Ranchos, NM: LPD Press, 2004).

19. Robin Farwell Gavin, "Creating a New Mexico Style," in *Converging Streams: Art of Hispanic and Native American Southwest*, ed. William Wroth and Robin Farwell Gavin (Santa Fe, NM: Museum of Spanish Colonial Art, 2010), 37–52.

20. See Farago and Pierce, *Transforming Images*; and Wroth and Gavin, *Converging Streams*.

21. Robert J. Torrez, "Mexican Patriotism in New Mexico, 1821–1846," in *Telling New Mexico: A New History*, ed. Marta Weigle, Frances Levine, and Louise Stiver (Santa Fe: Museum of New Mexico Press, 2009), 129–140; Kate L. Gregg, ed., *The Road to Santa Fe: The Journal and Diaries of George Champlin Sibley and Others Pertaining to the Surveying and Marking of a Road from the Missouri Frontier to the Settlements of New Mexico, 1825–1827* (Albuquerque: University of New Mexico Press, 1952), 134–135. For examples of art that may suggest Royalist sympathies during this time period, see Donna Pierce, "Possible Political Allusions in Some New Mexican *Santos*," in Farago and Pierce, *Transforming Images*, 58–61. For the history of trade and travel on the Santa Fe Trail, see Max L. Moorhead, *New Mexico's Royal Road: Trade and Travel on the Chihuahua Trail* (Norman: University of Oklahoma Press, 1995); Jane Lenz Elder and David J. Weber, *Trading in Santa Fe: John M. Kingsbury's Correspondence with James Josiah Webb, 1853–1861* (Dallas, TX: Southern Methodist University Press, 1996); Max L. Moorhead, ed., *Commerce of the Prairies by Josiah Gregg* (1844; repr., Norman: University of Oklahoma Press, 1954); Marian Russell, *Land of Enchantment: Memoirs of Marian Russell along the Santa Fe Trail* (Evanston, IL: Branding Iron Press, 1954); Stella M. Drumm, ed., *Down the Santa Fe Trail and into Mexico: The Diary of Susan Shelby Magoffin, 1846–1847* (New Haven, CT: Yale University Press, 1962; repr., Lincoln: University of Nebraska Press, 1982); and Gregg, *Road to Santa Fe*.

22. Capt. Thomas Becknell, "Journal of Two Expeditions from Boone's Lick to Santa Fé," in *Southwest on the Turquoise Trail: The First Diaries on the Road to Santa Fe, Overland to the Pacific*, vol. 2, ed. Archer Butler Hulbert (Denver: The Stewart Commission of Colorado College and the Denver Public Library, 1933), 67. Thomas Becknell, William's brother, kept the journals of the trips.

23. Russell, *Land of Enchantment*, 52–56.

24. "Alphonso Wetmore's Diary of 1828," in Hulbert, *Southwest on the Turquoise Trail*, 178.

25. Donna Pierce, "Tinwork," in Pierce and Weigle, *Spanish New Mexico*, 103–122; Lane Coulter and Maurice Dixon Jr., *New Mexican Tinwork, 1840–1940* (Albuquerque: University of New Mexico Press, 1990).

26. Pierce, "Tinwork," 110.

27. Taylor and Bokides, *New Mexican Furniture*, 1987.

28. Pierce, "New Mexican Furniture," 195–196; William Voss Elder III and Jayne E. Stokes, *American Furniture 1680–1880 from the Collection of the Baltimore Museum of Art* (Baltimore: Baltimore Museum of Art, 1987), 86–91).

29. Donna Pierce, "Furniture," in Pierce and Weigle, *Spanish New Mexico*, 70; Robin Farwell Gavin, "La Sala de Estrado: Women's Place in the Palace," *El Palacio* 115, no. 4 (Winter 2010): 48–55.

30. W. W. H. Davis, *El Gringo: New Mexico and Her People* (1857; repr., Lincoln: University of Nebraska Press, 1982), 178.

31. Abert, *New Mexico Report*, 52.

32. Farago and Pierce, *Transforming Images*; Wroth and Gavin, *Converging Streams*.

33. See Wroth and Gavin, *Converging Streams*, pl. 151.

34. Esquibel and Carrillo, *Tapestry of Kinship*. The three pieces by José Aragón and inscribed with the word *escultería* are all actually retablos rather than bultos, suggesting that the word was applied to an artist's workshop in general. Six other retablos state that they were made in "el Chamisal," another word for "workshop" in Colonial New Mexico (ibid., 47). For in-depth discussion of the cultural complexity of this new artistic style, see Farago and Pierce, *Transforming Images*; and Wroth and Gavin, *Converging Streams*.

35. Ward Alan Minge, "Efectos del Pais: A History of Weaving along the Rio Grande," in *Rio Grande Textiles*, new ed. of *Spanish Textile Tradition of New Mexico and Colorado*, comp. and ed. Nora Fisher (Santa Fe: Museum of New Mexico Press, 1979, 1994), 5–21; Frank, From *Settler to Citizen*, 119–177; Kellen Kee McIntyre, *Rio Grande Blankets: Late Nineteenth-Century Textiles in Transition* (Albuquerque, NM: Adobe Gallery, 1992).

36. Joseph P. Sánchez, "Origins of Old Spanish Trail, 1678–1840: The Route from Santa Fe to Los Angeles," *Tradición Revista* (March 2011): 13–18; Elizabeth von Till Warren, "The Old Spanish National Historic Trail," *Pathways Across America* (Summer 2004), https://test.oldspanishtrail.org/our-history.

37. Frank, *From Settler to Citizen*, 132.

38. Frank, *From Settler to Citizen*, 133; Fisher, *Rio Grande Textiles*; Robin Farwell Gavin and Josie Caruso, "Looking for Red in All the Wrong Places: Cochineal in Spanish Colonial New Mexico," in *A Red Like No Other: How Cochineal Colored the World*, ed. Carmella Padilla and Barbara Anderson (New York: Museum of International Folk Art, 2015), 242–251. While indigo arrived from Mexico in lumps, cochineal was typically brought across the trails as predyed yarns (such as bayeta cloth) that were then raveled and reused. For an example of bayeta, see Elder and Weber, *Trading in Santa Fe*, 138; and Cordelia Thomas Snow, "Reconsidering Cochineal in Spanish Colonial New Mexico," in Padilla and Anderson, *Red Like No Other*, 254.

39. Martin Sullivan, foreword to *Inventing the Southwest: The Fred Harvey Company and Native American Art*, by Kathleen L. Howard and Diana F. Pardue (Phoenix, AZ: Heard Museum, 1996), x.

40. For a history of the Harvey girls, see Lesley Poling-Kempes, *The Harvey Girls: Women Who Opened the West* (New York: Paragon House, 1989); for tuberculosis patients in New Mexico, see Nancy Owen Lewis, *Chasing the Cure: Tuberculosis and the Quest for Health* (Santa Fe: Museum of New Mexico Press, 2016); and for the impact of tourism and the railroad on New Mexico, see Marta Weigle, *Alluring New Mexico: Engineered Enchantment, 1821–2001* (Santa Fe: Museum of New Mexico Press, 2010); Marta Weigle, "Historical Introduction," in Pierce and Weigle, *Spanish New Mexico*, 21–25; Chris Wilson, *The Myth of Santa Fe: Creating a Modern Regional Tradition* (Albuquerque: University of New Mexico Press, 1997); Suzanne Forrest, *The Preservation of the Village: New Mexico's Hispanics and the New Deal* (Albuquerque: University of New Mexico Press, 1989).

41. Richard Flint and Shirley Flint, "Charles Ilfeld Biography," July 22, 2015, Office of the New Mexico State Historian, http://www.newmexicohistory.org/people/charles-ilfeld-biography.

42. See, for example, *Charles Ilfeld Company (Wholesalers of Everything) Catalogue* (Milwaukee: J. H. Yewdale & Sons, nd.).

43. Daniel T. Kelly, *The Buffalo Head: A Century of Mercantile Pioneering in the Southwest* (Santa Fe, NM: Vergara., 1972), 48.

44. Dorothy Boyd Bowen, "A Brief History of Spanish Textile Production in the Southwest," in Fisher, *Rio Grande Textiles*, 3–4.

45. Maurice Dixon, *The Artistic Odyssey of Higinio V. Gonzales: A Tinsmith and Poet in Territorial New Mexico* (Norman: University of Oklahoma Press, 2015).

46. Stephen D. Mandrgoc, "*La política y los caminos*: Building Route 66 in New Mexico," in *Historic Route 66: A New Mexican Crossroads, Essays on the Hispanic Heritage of Old Highway 66*, ed. Joseph P. Sánchez and Angélica Sánchez-Clark (Los Ranchos, NM: Rio Grande Books, 2017), 35.

47. See Helen R. Lucero and Suzanne Baizerman, *Chimayó Weaving: The Transformation of a Tradition* (Albuquerque: University of New Mexico Press, 1999); Mary Terrance McKay and Lisa Trujillo, *The Centinela Weavers of Chimayo Unfolding Tradition* (Chimayó, NM: Centinela Traditional Arts, 1999).

48. Marta Weigle, "A Brief History of the Spanish Colonial Arts Society," in Pierce and Weigle, *Spanish New Mexico*, 26–35.

49. Wiegle, "Historical Introduction," 12; Charles Briggs, *The Woodcarvers of Córdova, New Mexico: Social Dimensions of an Artistic "Revival"* (Knoxville: University of Tennessee Press, 1980).

50. Kathryn Córdova, *¡Concha! Concha Ortiz y Pino, Matriarch of a 300-Year-Old New Mexico Legacy* (Santa Fe, NM: La Herencia, 2004), 55.

51. Wiegle, "Historical Introduction," 14; Regina Cata was born in 1886 in the San Luis Valley. After marrying Eulogio Cata, she moved to his ancestral pueblo home at Ohkay Owingeh. She is credited as one of the founders of Arte Antigua, another club founded to revive colcha embroidery, and with leading the 1930s revival of the pottery tradition of Ohkay Owingeh; see Nancy C. Benson, *New Mexico Colcha Club: Spanish Colonial Embroidery and the Women Who Saved It* (Santa Fe: Museum of New Mexico Press, 2008), 103–105. Anita Gonzales (who met her husband, Tom Thomas, when he was working at a New Deal camp in New Mexico) won a blue ribbon for her colcha work at the 1933 Spanish Market and was a longtime member of the Spanish Colonial Arts Society. See foreword to Pierce and Weigle, *Spanish New Mexico*, 1:vi–viii; and Karen Nilsson Brandt and Sharon Niederman, *Living Treasures: Celebration of the Human Spirit* (Santa Fe, NM: Western Edge Press, 1997), 176.

52. For more on the impact and importance of New Deal programs and vocational schools on the traditional arts of New Mexico, see Weigle, "Historical Introduction"; Tey Marianna Nunn, *Sin Nombre: Hispana and Hispano Artists of the New Deal Era* (Albuquerque: University of New Mexico Press, 2001); William Wroth, "The Hispanic Crafts Revival in New Mexico," in *Revivals! Diverse Traditions, 1920–1945: The History of Twentieth-Century American Crafts*, ed. Janet Kardon (New York: Abrams Art Books, 1994); William Wroth, "New Hope in Hard Times," *El Palacio* 89, no. 2 (Summer 1983): 22–31.

53. Sarah Nestor, *The Native Market of the Spanish New Mexican Craftsmen, Santa Fe, 1933–1940* (Santa Fe: Colonial New Mexico Historical Foundation, 1978).

54. Tey Mariana Nunn, "¡Orale!," in *Borderless: The Art of Luis Tapia*, ed. Carmella Padilla (Long Beach, CA: Museum of Latin American Art, 2017), 43; Stephanie Lewthwaite, *A Contested Art: Modernism and Mestizaje in New Mexico* (Norman: University of Oklahoma Press, 2015), 215.

55. See Charlene Villaseñor Black, "Artist in Between," in Padilla, *Borderless*, 15.

12

"And a Silver Toothpick": The Estate Inventory of Antonio Durán de Armijo of Taos

DONNA PIERCE

Introduction

Documentation of the daily life and material culture of Colonial New Mexico is rare considering the destruction of documents during the Pueblo Revolt of 1680 and again during the post-Colonial era. We are fortunate, however, to have close to two hundred wills and estate or household inventories from the eighteenth century that have survived in various archives.[1] Among those is that of Antonio Durán de Armijo, a mestizo (half Spanish, half Mexican Indian) blacksmith from Taos who was killed by unidentified Plains Indians on the night of August 1, 1748.

Spanish settlement in New Mexico began in 1598 and endured until the highly successful Pueblo Revolt of 1680. Surviving Spaniards and some Indian allies fled south to the area around modern-day El Paso, Texas, where many remained until the new governor, Diego de Vargas, led a reconquest in 1692–1693 followed by an aggressive resettlement effort. Around 152 pre-Revolt families returned to New Mexico, and other settlers were recruited from Mexico City and northern Mexico.[2]

The Durán de Armijo Family

The Durán de Armijo family immigrated to New Mexico from Zacatecas, Mexico, in 1695. The family was among the colonists recruited by Juan Páez Hurtado for the resettlement of New Mexico.[3] Vargas himself and others had spearheaded prior recruitment efforts, including the principle one from Mexico City in 1693.[4] Several of the families in the 1695 recruitment group in the records of Páez Hurtado were fabricated from single individuals and children "borrowed" from other families in order to secure additional funding from the Spanish government. But this does not seem to be the case with the Durán de Armijo family, which genuinely consisted of parents José de Armijo and Catalina Durán, both listed as mestizos, and their sons Antonio, Marcos, José, and Vicente, who went by the surname Durán de Armijo.[5] The group of colonists arrived in Santa Fe in May 1695 after several difficult months on the road.

The oldest son, Antonio, was born in Zacatecas around 1677, since he was eighteen years old when he married María de Quirós on October 17, 1695, a few months after his arrival in Santa Fe.

The daughter of José de Quirós and María de la Cruz, María was from a pre-Revolt family that had lived in El Paso, where a soldier from the presidio married into the family and introduced the surname Arias de Quirós.[6] Since pre-Revolt families were privileged over recent recruits in the politics and social hierarchy of Northern New Mexico, the marriage indicates that the Durán de Armijos were quickly moving up in society. Antonio was literate, and frequently served as a witness and even as an official "notary" in Colonial documents. He also served as *procurador* or legal advocate for presidio soldiers in disputes. Apparently he had some prior training in medicine, since he lists himself as a "master barber" (the term used at the time for both barber and surgeon) as early as 1695 and appears as such in subsequent documents.[7] He still served as a sergeant of the militia in 1731 at the age of fifty-eight and belonged to the Confraternity of La Conquistadora in Santa Fe. In the 1750 census he is listed in Santa Fe as the head of household, with his wife María still alive and eight dependents.[8] He was eighty years old when he died three years later, on June 22, 1753.

Antonio and María had three children: Antonio, Juan, and Inez. Since their oldest son was also named Antonio, they will be referred to as Antonio I and Antonio II hereafter. Antonio II married Barbara Montoya of Chimayó in 1742.[9] A prestigious pre-Revolt family of mestizos and *castizos* (¾ Spanish, ¼ Indian), the Montoyas had been *encomenderos* (landowners granted authority to exact tribute from local Indians) and residents since the first settlement of New Mexico in 1598.[10] The marriage serves as another example of the Durán de Armijo family's upward mobility within the social hierarchy of New Mexico. The widow of Diego Romero of Taos, Barbara inherited land near Taos where later she lived with Antonio II, and he worked as a blacksmith. They had been married only three years when Barbara made her will, stating that she was seven months pregnant at the time.[11] It is unknown if she died in childbirth, but she was survived by their only child, a daughter named Gertrudes.[12] Unfortunately, three years after Gertrudes was born, Antonio II was killed, leaving the young Gertrudes an orphan.

As we will see from Antonio II's estate settlement, Gertrudes was taken to Santa Fe and placed in the care of her grandfather, Antonio I.[13] She may be one of the unnamed children mentioned in his household in the census of 1750. She later married Manuel Vigil of the Montes Vigil family of Santa Fe, fellow mestizo immigrants to New Mexico with the Durán de Armijo family in 1695.[14] The couple lived on her inherited property in Taos, where Manuel became a civic leader and the *alcalde mayor* (district administrator) of the area. They had eight children, five girls and three boys. Two of the girls were married when Gertrudes died in her early thirties in September 1775.[15]

Estate Inventory of Antonio Durán de Armijo

Since Antonio II died intestate, a detailed inventory of his estate was made and careful placement of the orphaned child was attended to by local officials, including the governor of New Mexico, Joachim Codallos y Rabal, who decreed on August 5 that the now-orphaned Gertrudes be brought to Santa Fe "with the greatest care and comfort possible, being in perfect health, and without peril of death or other grave inconvenience. After she has been brought hence, I will make the proper provision [for her] according to the law."[16]

Three detailed and careful inventories were made of the estate goods of Antonio II (fig. 12.1). The first was made at the house and lands in Taos by the lieutenant assistant alcalde of the area, Antonio Martín, and was completed by at least August 4. With the inventory in hand, on August 5 the governor ordered that Gertrudes and the entire estate be conveyed to Santa Fe. At that time Antonio II's nephew, Josef Antonio Armijo, was appointed as temporary trustee of the estate. On August 9, Antonio Martín made a few additions to his original inventory. The second full inventory was made on August 24 after the goods arrived in Santa Fe and were turned over to Miguel de Alire, who had been appointed by the governor as trustee of the estate.

On August 26, Gregorio Garduño was appointed by the governor to appraise the goods, resulting in a third inventory that included values totaling 3,559 pesos. Fifty-three pesos were turned over to the government for expenses such as paper and "handling," leaving a total of 3,506 pesos for the heiress. Of this amount, 1,362 pesos were in cash and goods to be used for the maintenance of the child who had been placed in the care of her grandfather, Antonio I. Another 2,144 pesos were in livestock for her future income and maintenance; the livestock was distributed among various ranchers to be raised and increased for Gertrudes's benefit. Finally, the governor appointed Miguel de Alire as guardian ad litem for the duration of Gertrudes's minority. Alire in turn paid off Antonio II's debts, and he also paid several priests in Santa Fe and Taos in goods from the estate for masses to be celebrated for Antonio II's soul.

An analysis of Antonio's goods provides a glimpse into the lifestyle of a mestizo tradesman in Colonial New Mexico and evidences the opportunity for upward social mobility there. Antonio II's father and grandparents had arrived in New Mexico as relatively poor immigrants from Zacatecas. As only a second generation New Mexican, Antonio had amassed a rather impressive estate.

The three estate inventories are remarkably similar, with one or the other including additional information (such as color). Here I will combine all to provide the most complete description possible. Where discrepancies arise, they will be noted. Since few objects survive from Colonial New Mexico and even fewer can be linked to specific persons, descriptions in the estate inventories have been matched in the illustrations here with artifacts from archaeological excavations or with extant examples or similar ones seen in paintings and portraits from Mexico, Peru, and Spain.

12.1. First page of inventory, estate settlement of Antonio Durán de Armijo, 1748, New Mexico State Records Center and Archives, Santa Fe, Spanish Archives of New Mexico (SANM) I:240.

In property, Gertrudes inherited the lands and house in Taos, with the former described as two large and one small field, all planted in corn at the time of Antonio's death. The settlement documents order that the corn be harvested and the proceeds turned over to Gertrudes's guardians. The house in Taos is described as being two stories, with four rooms above and four below, fronted by a porch below and balcony above. An outbuilding of two rooms included a stable and Antonio's blacksmith shop. Antonio's nephew, Josef Antonio Durán, petitioned the governor for the forge and tools, claiming that he had served his uncle as a blacksmith apprentice for twelve years but that the goods had ended up among Gertrudes's inheritance. After the settlement of the estate Josef Antonio again petitioned for the forge and blacksmith tools and eventually received them. Gertrudes also inherited a house in Santa Fe described as having three rooms: "one with seventeen vigas (ceiling beams); one with seven vigas, and a kitchen of nine vigas." A double door gave access to the house. And, finally, from her mother's estate Gertrudes inherited farmland in the Rio de las Trampas area.

In addition, Gertrudes inherited six Indian slaves of the type referred to as "rescued," meaning Indians captured in war or rescued or traded from other Indians who had captured them.[17] Later referred to as *genízaros*, such Indians were incorporated into Spanish households to be educated and Christianized. In other wills, they are sometimes given their freedom and occasionally a small inheritance. The six Indians included four (later three) women, two of whom had served Antonio for six years, and two newer ones, the latter with two small boys. In the final inventory the three remaining women and two boys were valued at 100 pesos each for the former and 80 pesos each for the latter, totaling 460 pesos. One of the Indian women and one of the boys were transferred to other households in New Mexico to pay Antonio's debts. Antonio I petitioned to have two of the women and one boy in his household to care for his orphaned granddaughter.

The house in Taos was furnished with seven chests, three large and four small, all but two with lock and key; a large wooden cupboard or armoire (*armario*); two tables, one large with

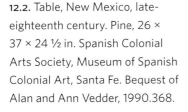

12.2. Table, New Mexico, late-eighteenth century. Pine, 26 × 37 × 24 ½ in. Spanish Colonial Arts Society, Museum of Spanish Colonial Art, Santa Fe. Bequest of Alan and Ann Vedder, 1990.368.

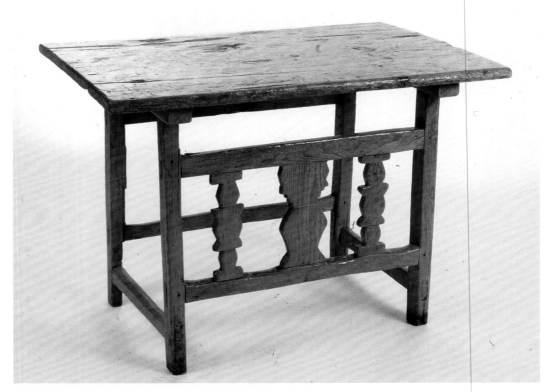

a drawer and one small one (fig. 12.2); one bench; and two chairs. The Alire inventory made in Santa Fe describes two of the chests as "large chests from Michoacán with their [locks and] keys; two small ones of the same with their [locks and] keys; and two small ones made locally (*de la tierra*)." In the final inventory two "chests from Michoacán" are described as medium-sized with locks and are valued at sixteen pesos; two others are described as small and valued at six pesos. What happened to the other three chests is unknown; they may have been present but not considered valuable enough to warrant an appraisal.[18]

Although not mentioned, one or more of the chests from Michoacán may have contained small drawers, as was common (fig. 12.3), but many chests did not (fig. 12.4).[19] The Michoacán area of central Mexico had been known since before the arrival of the Spanish for the production of lacquered furniture and utensils, including small gourd cups, or *jícaras* (from the Aztec word *xicalli*), used for drinking chocolate. During the pre-Hispanic era lacquer was made from *aje*, an insect that thrived in the area. During the Colonial period, the craft was continued with the encouragement of missionary friars and influenced by imported lacquerware from Asia. Painted and lacquered furniture from Michoacán was exported all over New Spain, including to New Mexico, where it is frequently mentioned in documents such as Antonio's estate inventory.[20] The second inventory describes two of the chests as "de la tierra" (from the land), meaning they were made locally in New Mexico, where a thriving furniture-making industry had been established, as seen in surviving examples (fig. 12.5; see also fig. 12.2).[21]

Inside the chests were various articles of men's and women's clothing, starting with a red velvet woman's cape (*dengue*) embroidered with silver thread, the single most valuable item in

12.3. Chest with drawers, Michoacán, Mexico, eighteenth century. Hardwood, gesso, water-based paint, gold leaf, iron hardware, 15 ½ × 19 ¾ × 16 ½ in. Spanish Colonial Arts Society, Museum of Spanish Colonial Art, Santa Fe. Gift of Mrs. H. M. Greene, 1956.89.

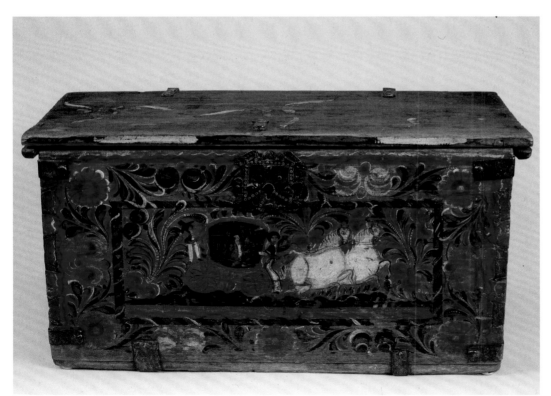

12.4. Chest, Michoacán, Mexico, early-nineteenth century. Pine, oil paint, iron hardware, 13 ³⁄₁₆ × 24 ¾ × 12 ¾ in. Collected in New Mexico. Spanish Colonial Arts Society, Museum of Spanish Colonial Art, Santa Fe, 1958.28.

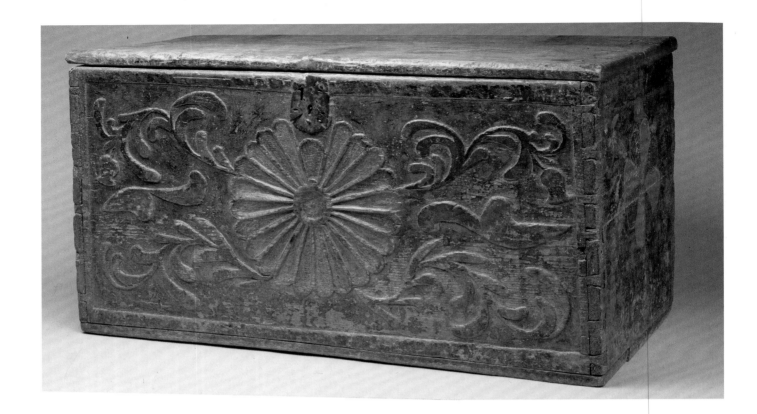

12.5. Chest, New Mexico, late-eighteenth century. Pine, oil paint, iron hardware (not original), 24½ × 46 × 18 in. Spanish Colonial Arts Society, Museum of Spanish Colonial Art. Gift of Mr. and Mrs. John Gaw Meem in memory of E. Boyd, 1975.69.

the entire inventory and valued at one hundred pesos. Silver or gold braid trim (galloon or passe-menterie) was made from silk, cotton, or linen thread wrapped with tiny ribbons of real gold or silver leaf.[22] The silver- or gold-wrapped thread was then woven into fabric or braided into tape or ribbon and sewn onto clothing as trim (fig. 12.6). It can be seen in portraits of the era on both men's and women's clothing (figs. 12.7–12.8). The fact that such trim was worn in New Mexico is documented in estate and traders' inventories. In addition, a few actual examples from New Mexico survive, including several fragments excavated from various locations,[23] as well as a three-piece silk suit with gold braid trim decorating the jacket and the waistcoat.[24]

Other women's clothing included a new, red, ankle-length skirt (*tobajilla*) with ruffles and fringe (*fleco y punta*) of silver thread valued at thirty-five pesos. The word *tobajilla* describes a type of shorter skirt—often hooped with ribs of cane or branches and petticoats—that revealed the ankles (fig. 12.9). In the second and third inventories, the *tobajilla* was described as *salomonica*, an expression used to mean "twisted" or "ruffled."

Men's clothing consisted of a short man's coat of blue wool cloth from Castile with but-tonholes worked in silver thread. Such coats were very common in Colonial Latin America and can be seen frequently in portraits of the era (fig. 12.10). The inventory also lists red velvet men's breeches; one pair of blue velvet breeches; a short waistcoat of wool cloth (*paño*); a shirt and breeches of bleached cotton (*blancos de manta*; later *de patio viejo*), probably for work; and buck-skin trousers with ten silver buttons. Buckskin clothing was made from brain-tanned leather, a technique learned from the American Indians, and became extremely popular in Latin America and Europe, appearing occasionally in Colonial paintings (fig. 12.11). Buckskin jackets and suits were made locally in New Mexico and, by the eighteenth century, were also imported from Mexico, where they were dyed a distinctive cinnamon color and often trimmed with silver braid

12.6. *Woman with a Harpsichord*, Mexico, 1730–1750. Oil on canvas, 61½ × 40¼ in. Denver Art Museum. Gift of Frederick and Jan Mayer, 2014.209.

BELOW LEFT

12.7. *Portrait of María del Carmen Cortés Santelizes y Cartavio*, Peru, ca. 1760. Oil on canvas, 30½ × 25 in. Denver Art Museum. Funds from Frederick and Jan Mayer, Carl and Marilynn Thoma, Jim and Marybeth Vogelsang, and Harley and Lorraine Higbie, 2000.250.1-2.

BELOW RIGHT

12.8. *Portrait of Simón de la Valle y Cuadra*, Peru, ca. 1760. Oil on canvas, 30½ × 25 in. Denver Art Museum. Funds from Frederick and Jan Mayer, Carl and Marilynn Thoma, Jim and Marybeth Vogelsang, and Harley and Lorraine Higbie, 2000.250.1-2.

12.9. Pedro José Díaz (active 1770–1810), *Portrait of Doña María Rosa de Rivera, Countess of Vega del Ren*, Lima, Peru, ca. 1780. Oil on canvas, 78¼ × 51 in. Photograph by the Conservation Center. Collections of Marilynn and Carl Thoma, Chicago, Illinois.

and buttons, such as those mentioned on Antonio's trousers (fig. 12.12). To protect themselves from both weather and arrows, New Mexicans often wore vests or jackets from Mexico or New Mexico made of multiple layers of quilted buckskin. As we will see, Antonio had both.

Also listed was one pair of black wool stockings (*medias*). Often of bright colors and embroidered at the ankles with colored or silver or gold thread, stockings made of silk or cotton were worn by both men and women in New Mexico. Some examples include a man's pair, described as "blue silk stockings with fancy embroidery," and a woman's pair, as "blue silk stockings embroidered with silver lace."[25] A second lieutenant at the garrison of Santa Fe left an extensive list of clothing when he died in 1789, including "one pair of French cloth stockings" and "two pair of Chinese embroidered silk stockings."[26] For everyday wear, however, most people, like Antonio, used simple black wool stockings that were knitted in New Mexico and even exported south to Mexico. Antonio's other accessories were one (later two) pair of (wool?) socks (*calzetas*), a black silk handkerchief, two handkerchiefs of linen or cotton cloth (*cotense*; later *cotencio de sol*), one pair of Cordovan leather shoes and two pair of plain leather, three pair of woolen stockings for a child and two pair of children's shoes, one new ordinary sombrero, and one silk ribbon hatband.

12.10. Ramón de Torres, *Portrait of don Estéban de la Carrera y Prado*, Mexico, 1782. Oil on canvas, 38 × 32 in. Denver Art Museum. Gift of Frederick and Jan Mayer, 17.2014.

BELOW LEFT

12.11. José Joaquín Esquivel (attributed), Portrait of a gentleman, Mexico, late 1700s. Oil on canvas, 34½ × 27¼ in. Denver Art Museum. Gift of Frederick and Jan Mayer, 15.2014.

BELOW RIGHT

12.12. Francisco Clapera, *De Español y Negra, Mulato*, Mexico, ca. 1785. Oil on canvas, 20 × 15½ in. Denver Art Museum. Gift of Frederick and Jan Mayer, 2011.428.4.

In addition there were numerous pieces (lengths) of fine fabric for the making of clothing, including a piece of fine linen from Brittany (Bretaña) valued at sixteen pesos. Shirts and blouses made of linen from the Brittany coast of France were desired by men and women from the fifteenth through the eighteenth centuries in Europe and Latin America. In fact, Queen Elizabeth I of England favored them. In one of the inventories, Antonio's example was referred to as "imitation" (contra hecha) Brittany linen but still had a high value at sixteen pesos. The inventories also list lesser-quality linen for lining; glazed linen (mitan); and unbleached muslin (manta vareada).

Sixteen varas (Spanish standard of measurement, about thirty-three inches) of narrow lace from Lorraine (Loreña), France, four fingers in width, were valued at twenty-three pesos. From the sixteenth century on, production of both needle and bobbin lace had become a sophisticated art form in Italy, France, Flanders, and Spain and was exported to the Americas.[27] Ruffled lace sleeves and large kerchiefs were very popular in the eighteenth century and appeared in formal portraits (see figs. 12.6–12.7, 12.9). The lace—along with ten varas of fine red ribbed silk from China (valued at six pesos eight reales) and various trim decoration, such as six varas of ribbon from China woven with gold and silver (later atisuado) and five varas of wide red ribbon from Spain—indicate that Barbara may have been on the verge of having a new outfit made before her untimely death and that these valuable goods were saved by Antonio for Gertrudes's future use.

Other loose fabric in Antonio's possession included blue serge (sarga azul), 6 ½ varas at twenty-six pesos; wine-colored (wool) cloth (paño) from Castile, Spain (listed as of second quality in the Alire inventory, but Garduño does not say this and values it at eighteen pesos, higher than most other fabrics); as well as lengths of reversible silk, red velvet, and blue bombazine, a fine, twilled silk and cotton fabric (at ten pesos). For the construction of clothing the household had at least eight skeins of silk thread, seven of untwisted red, one of twisted red. The second and third inventories also mention one skein of blue twisted silk and one of pita floja, a sturdy thread made of agave fiber. All inventories mention one pair of large tailor's scissors (de sastre) along with two small pairs of pocket (de bolsa) scissors. Other scissors in the household include a pair of sheep shears (de harria; arrieras) and a pair of barber's shears (de barbero).

Jewelry in the home included a silver-gilt relicario (a locket with religious imagery), possibly similar to the one seen here, but Antonio's was gilded (fig. 12.13).[28] Antonio also had a rosary of small silver beads or discs (platillos) with a silver cross of Caravaca. The cross of Caravaca is a double-barred cross flanked by two angels (fig. 12.14). The town of Caravaca in the province of Murcia in southeastern Spain was ruled by Muslims around 1231, when such a cross carried by angels miraculously assisted a priest in the conversion of the local Muslim ruler, in turn saving the priest's life. Said to contain a fragment of the True Cross, the crucifix inspired pilgrimages throughout the ages, was introduced to the Americas by missionaries, and is still worshipped in Caravaca today. The cross became associated with horses during a subsequent miracle when the town (now under the rule of the Christian Knights Templar) was under siege by Muslims and the water wells became stagnant. Knights on horseback snuck out in the night in search of fresh water but found only wine, which was carried back on horseback and used to revive the wells and the populace. As a result, the cross of Caravaca became associated with horses and horseshoes, making it relevant to a blacksmith such as Antonio. It was prayed to for prosperity and protection against danger; the former seems to have worked for Antonio, but not the latter, in view of the manner of his sudden death.

Also listed was one pair of pendant pearl earrings (zarzillos; later aretes de perlas) (see figs. 12.6–12.7, 12.9). The first inventory mentions "some coral bracelets weighing two ounces"; these are described in the two later inventories as "twelve strings of corals weighing four ounces" and are valued in the final inventory at twenty-four pesos, more than the reliquary or the pearl earrings valued at ten pesos each. Pearls and coral were abundant in Mexico and South America, and

FAR LEFT

12.13. *Relicario* (reliquary locket), *Saint Matthew*, Mexico, eighteenth century. Silver, ivory, glass, 3½ × 2¼ in. Collected in New Mexico. Spanish Colonial Arts Society, Museum of Spanish Colonial Art, Santa Fe, 1955.54.

LEFT

12.14. Cross of Caravaca, Spain, eighteenth century. Brass, 6 in. high. Spanish Colonial Arts Society, Museum of Spanish Colonial Art, Santa Fe. Bequest of Margretta S. Dietrich, 1961.41.

were harvested at numerous locations along both the Atlantic and Pacific coasts.[29] Pearls were exported to Spain in such tremendous quantities that when the Peruvian author Inca Garcilaso de la Vega (1539–1616) visited Seville in the late 1500s he commented that pearls from the Americas "were sold in a heap . . . as if they were some kind of seed."[30] Even young children had their own pearl and coral jewelry. And it was not exclusive to the upper classes; travelers to Mexico mention women of African and Indian descent wearing pearl and coral jewelry.[31] Apparently this was true as well in New Mexico, where in 1753 Juana Galvana, a resident of Zia Pueblo, owned a pair of matching coral bracelets and two silver reliquaries.[32]

Other jewelry mentioned included one small silver cross and two bronze ones, and one "Roman" bronze medallion or medal. Although the final inventory does not use the word "Roman," official medals blessed by the Pope depicting various saints were exported from Rome throughout the Christian world and appear in archaeological excavations in New Mexico. Eleven rosaries of yellow glass beads were mentioned. In one inventory these are listed with the blacksmithing tools and may have been for use in making rosaries with metal crosses or medallions added by Antonio. All Europeans used glass beads as gifts or trade items with Native Americans, including Spaniards in the Southwest. Most beads distributed by Spaniards were probably made in Venice, Spain, or the glass factory that was operating in Puebla, Mexico, by 1542 (see below). Glass beads were popular as bracelets, choker necklaces, or rosaries, often with pendant *relicarios* (reliquaries) with religious imagery.

Also listed in the inventory were objects of silver that Antonio himself may have made, such as two pairs of silver buckles: one large pair, probably shoe buckles that could be transferred from one pair of shoes to another (see fig. 12.9), and one pair of small silver buckles (in the second inventory the latter are listed among the horse gear). Fourteen small silver *higuitas* (dangles) were mentioned. Made in the shape of a fist with the thumb protruding, *higas* derived from Muslim custom and were (and still are) believed to protect against the evil eye. They were commonly used as jewelry on infants and also as decoration on horse gear such as saddles, bridles, or *anqueras* (rump covers).

And, finally, of all things, Antonio owned a silver toothpick! As a blacksmith, Antonio may have made this himself. Small grooming tools made of silver or gilt silver, sometimes with embedded jewels, were very fashionable at the time and were worn as jewelry by men (fig. 12.15). Toothpicks, ear picks, small knives, tiny scissors, and files were usually suspended from the belt on a gold chain known as a chatelaine (*castellana*), as a sort of Colonial version of a modern-day Swiss Army knife (see fig. 12.11, lower left).[33]

Among the household furnishings, four small lacquered gourd cups or bowls from Michoacán (*jarritos vidriados de* Mechoacan; later *ollitas*) are listed. Most likely, these are the small lacquered gourds or *jícaras* made in Michoacán and used for drinking chocolate (mentioned above). Chocolate was a New World product—unknown in Europe before the encounter with the Americas. It had been cultivated and consumed by ancient civilizations there for centuries before the arrival of Europeans.[34] The beans of the cacao tree were fermented, dried, roasted, ground on a heated stone (*metate*), and mixed with water and spices, including chile, to make a drink. In the sixteenth century, chocolate drinking spread rapidly among Spaniards, and then from Spain across Europe in the seventeenth century. In a painting of a mixed-race family in their kitchen in Colonial Mexico, the woman prepares chocolate on the stove (fig. 12.16). In Latin America and Spain the vessels of choice for drinking chocolate were the handle-less Chinese porcelain teacup (as we will see, Antonio had two); small majolica cups made in imitation of the former (Antonio had one); and the lacquered gourd cups made in Michoacán (Antonio had four).

Among the Maya and Aztecs chocolate had been a drink reserved for the upper classes or for special occasions; during Colonial times it spread to all classes for daily use and was consumed in tremendous quantities all over Mexico, as well as in New Mexico, where sherds of porcelain and majolica chocolate cups have been found in archaeological excavations at Colonial sites.[35] Mentions of chocolate drinking also appear in Colonial documents. For example, in Santa Fe in

12.15. Toothpick, Colombia or Ecuador, late-seventeenth to early-eighteenth century. Gold, emeralds, 2½ × ½ in. Denver Art Museum. Gift of the Stapleton Foundation of Latin American Colonial Art, made possible by the Renchard family, 1990.525.

12.16. José de Alcíbar, *From Spaniard and Black, Mulatto,* Mexico, ca. 1760. Oil on canvas, 31 × 38¼ in. Photograph by James Milmoe. Denver Art Museum. Gift of the Collection of Frederick and Jan Mayer, 2014.217.

6. De Eſpañol, y Negra, Mulato.

the early 1660s, then governor Bernardo López de Mendizábal and his Italian-born wife, Teresa de Aguilera de Roche, took chocolate every afternoon at three o'clock, and her personal chocolate chest included at least one Chinese porcelain cup, along with lacquered *jícaras* from Michoacán.[36] Governors and military leaders requisitioned chocolate for their troops, Franciscan friars imported it for use in the missions, and merchants carried it in their inventories.[37]

The Durán de Armijo inventories listed two cups and two bowls of Chinese porcelain, at two pesos each, which were described in the Garduño inventory as "ordinary," indicating that Chinese porcelain was common enough in New Mexico to elicit this comment. After the opening of trade with Asia through the Manila galleon sea route in 1565, Chinese textiles and porcelain were imported into Mexico in large quantities. The popularity of porcelain was described by the English pirate Henry Hawks in 1582: "They have brought from China dishes and cups of earth so fine that every man that may have a piece, will give the weight of silver for it."[38] Large quantities of porcelain made their way to remote areas, including New Mexico, where it has appeared in archaeological excavations and is mentioned frequently in documents.[39]

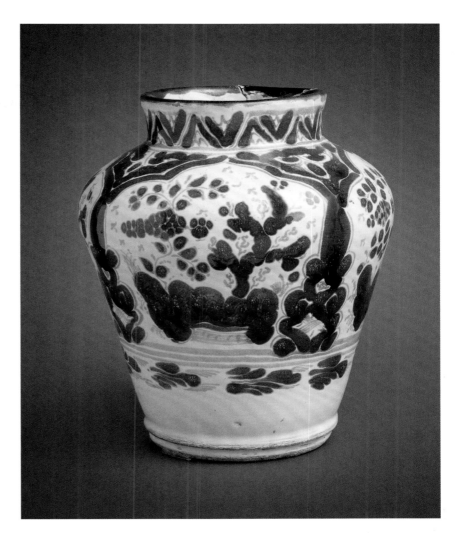

In contrast to the Chinese porcelain, Antonio's one cup or bowl "from Puebla" was valued at only two reales. This would have been made of Talavera or majolica, lead, and tin-glazed earthenware, made in the town of Puebla, Mexico (fig. 12.17).[40] The thriving industry there inspired fray Juan Villa Sánchez to claim in 1745 that the pottery of Puebla "excels that of Spain and equals the beauty of the wares of China . . . [and] is in great demand throughout the kingdom."[41] Indeed, majolica from Puebla was brought to New Mexico in huge quantities, as described in shipping and estate inventories and as evidenced in archaeological excavations.

For the preparation of chocolate, Antonio had a chocolate pot (*caldereta*) with its whisk (*molinillo*) for making chocolate. Spaniards had learned to drink chocolate from the Maya in the Yucatán and from the Aztecs in central Mexico.[42] Tall, cylindrical, earthenware vessels were used by the Maya to prepare chocolate. A Maya vase from the Late Classic period (ca. CE 750) shows a standing woman pouring the liquid chocolate from one cylindrical vessel into another set on the floor—a technique described in other sources for creating foam, the most desirable part of the chocolate drink and much like the head on a glass of beer.[43] Possibly related to the tall vessels used by the Maya for chocolate preparation, a tall narrow vessel of copper or silver evolved in the Colonial period to heat and beat the beverage, using a wooden whisk (known as a *molinillo*) to raise the foam by rubbing the handle rapidly between the hands (see fig. 12.16). Basically a Colonial blender, the chocolate pot sometimes had a straight handle and a lid with a hole in the top to accommodate the handle of the whisk.

12.17. Damián Hernández, Puebla, Mexico, seventeenth century. Earthenware with lead/tin glaze (majolica), 7 in. high × 6 in. diameter. Spanish Colonial Arts Society, Museum of Spanish Colonial Art, Santa Fe. Purchased from the Art Institute of Chicago, ex–Herbert Pickering collection, 2005.11.

Other copper utensils included a copper jug for drinking water, two copper pots (*ollas*), two large (later small) copper kettles, and two small copper spoons. Copper was one of the few metals excavated and worked in Mexico prior to the arrival of Spaniards, and a thriving copper industry existed in the province of Michoacán and continued throughout the Colonial era to the present. All copper utensils in the inventory had relatively high values, with the jar for drinking water valued at twelve pesos, the two large pots at twelve pesos, and the two small kettles at twenty pesos. Other household utensils consisted of seven pewter plates, described in the final inventory as *estaño* (tin), and two small bottles or flasks (*limetas*). Although not indicated, these bottles may have been made of glass. If so, they could have been imported from Spain or Italy but were more likely from one of the glass factories established in Puebla, Mexico, by 1542, when a local official stated that "white, crystal, green, and blue" glassware from Puebla is used "by Spaniards and natives of these parts and as far away as Guatemala, and even further, arriving as far as Peru and other places."[44] Two hundred years later, a local priest claimed that Puebla glassware, "if not quite able to compete with Venice, [was] at least equal to that of France, double, strong, clean and clear, and of exquisite manufacture."[45]

Other utensils included three wire sieves or strainers with their hoops (one or more of these may have been for straining lye for soap), one iron spit, an iron griddle and spoon, five grinding stones (*metates*), and three *jícaras de* Navajo, two large and one medium.[46] As mentioned, the word *jícara* comes from the Aztec word *xicalli* and refers to small ceramic or gourd cups for drinking chocolate. In this instance they probably refer to either ceramic cups or bowls, or possibly baskets, for which the Navajo were well known. Also mentioned are a bronze candlestick and the base of another, a small case (*estuche*) with silver hinges containing four knives and one whetstone, one small mirror (which is later listed in the Garduño inventory as broken, presumably in route to Santa Fe), and six large *suacales*. This latter word appears in other Colonial documents and seems to describe the crates made from thin wooden branches used to store goods and that were also strapped to pack saddles for hauling materials, similar to the *equipales* of today.

Household textiles included two blankets from Villa Alta (in Oaxaca, Mexico) and two cotton coverlets, one embroidered and one painted (probably summer bedspreads). The embroidered spread may have been a locally made colcha, such as the one seen in figure 12.18.[47] Antonio also had a locally made cotton tablecloth (*mantel*); two locally made (wool) blankets (*frezadas*); one blue and one yellow wool bedspread (*colchita*) made in New Mexico, possibly similar to the one seen in figure 12.19; one mattress; and one pillow. It is interesting to note that the two blankets imported from Villa Alta were valued at only five pesos total, whereas the two cotton blankets or bedspreads from New Mexico were valued at twenty pesos, and the two wool blankets made in New Mexico were valued at fourteen pesos, making the locally made textiles more valuable than the imported ones.

And finally, the inventory included one book of Christian catechism, implying that at least one person in the household was literate, probably Antonio, since his father was a notary and scribe, as well as ten religious prints, a large one of the Virgin Mary, two medium-sized ones of Saints Dominic and Vincent, and the remainder small ones of various saints.

Farming and blacksmith tools and supplies (presumably stored in the outbuilding) included a long list of hides such as nine (later one) thick elk skins; two white buckskins; one white elk skin campaign tent; two (later ten, then eight) buffalo hides; and five calfskins. The fact that hides were also used as currency, particularly the soft buckskin ones referred to as *gamuzas*, may explain the variation in number from inventory to inventory.[48] Three rather mysterious bags of buckskin clothing, described in the first inventory as "Comanche clothing," with one belonging to Antonio and two belonging to other people, disappeared from the estate in the second and third inventories.

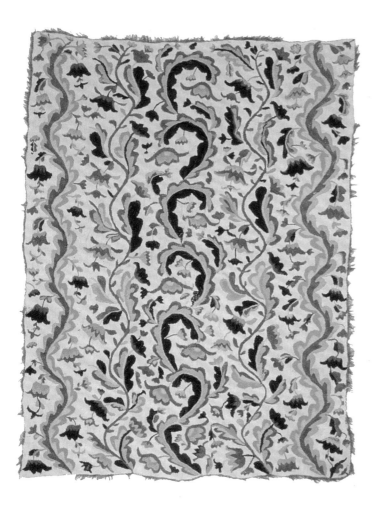

Also mentioned in the outbuildings were one ordinary sombrero (probably for work); one hand saw; two ounces of wire; one iron safe (*registro*); one iron mold to make silver into bars; two punches; two small augers; two large files; one small hand vice; two chopping knives; three chisels, two small and one large; pointed nippers; three large round files; one small knife file; one triangular file; two small squares; six small half round files; two small pruning knives; eight large punches; three chisels; two pinchers; two burins; four bits for an auger; one poker; and one *pavonador*. The latter seems to be a tool or vessel for applying bluing to iron to prevent rust and corrosion. Marc Simmons noted that bluing was common in Mexico in the Colonial era and suspected it was in New Mexico as well, but did not have evidence.[49] Antonio's inventory seems to provide that evidence.

The inventories also listed one chest without a key that held the tools; two iron anvils (*yunques*), one large and one medium-sized, valued at 120 pesos; and one small two-horned anvil (*vigornia*). Other items included one branding iron; four pairs of iron tongs; one iron sledge hammer (*macho*); two large (later medium) and three small hammers; four small *coas* (digging sticks); two hoes; one axe; six sickles; one iron ladle; one nail-head mold; two sets of scales, one damaged; one eight-pound weight with a balance scale; one adz; four sacks for charcoal; one *arroba* (twenty-five pounds) plus eleven (later twenty) pounds of old scrap iron in pieces; one ounce of broken silver; one vice for a forge (*tormillo de fragua*), valued at forty pesos; and forge bellows with their copper tube (*fuelles de fragua con alcribris de cobre*). Again, Marc Simmons suspected that such tubes (*tuyères*) that conducted air directly from the bellows to the fire pot were used in New Mexico but did not have documentation.[50] Antonio's estate inventory provides that.

Weapons and horse gear included one musket or shotgun (*escopeta*), the stock well-trimmed with silver, and its case (*funda*), described as "San Miguelena."[51] It is unclear if this latter description refers to the shotgun or its case or both, and it may mean that it is from the town of San Miguel (now de Allende) in northern Mexico. It could also mean that the lock mechanism was of the preferred Miquelet type. This gun may have been elaborated in silver by Antonio himself, and is one of the more valuable items in his inventory, valued at eighty pesos. Also listed are one short cavalry sword (*espadín*) for use on horseback, one lance, one leather shield (*adarga*) painted in oils, and another unpainted (the latter is not listed in the final inventory). *Adargas* were heart-shaped shields made of several layers of rawhide leather that had been introduced to Spain by Muslims in the eighth century and were popular for use on horseback due to their flexibility and light weight (fig. 12.20). Round versions made with a similar technique of manufacture were also used by Plains Indians. Also mentioned are gunpowder pouches, saddle pads, and a belt knife (*cuchilla de zinta*), also described as "San Migueleno," like the shotgun and/or its case.

Antonio also had one leather jacket (*cuera*). Although described as used, it is valued at twenty-five pesos, indicating the usefulness of these jackets made of multiple layers of leather to repel arrows and weather. These were so common that they became required attire for presidial soldiers on the northern frontier. Antonio also had a padded vest of elk skin with copper buckles (*vericu de anta con ebillas de cobre*); one baldric or cross-body shoulder belt for a sword of Spanish leather (*tahilí de* Cordovan); one pair of spurs with large round rowels (*de rosa*), at fifteen pesos; and one used cowboy-style (*baquera*) saddle with long stirrups and embossed decorations (*realzada* or *de realce*), valued at fifty-five pesos. By 1850, the *silla de vaquera* was a work saddle with a small horn and light housing, but it is unclear exactly what it looked like a century earlier.

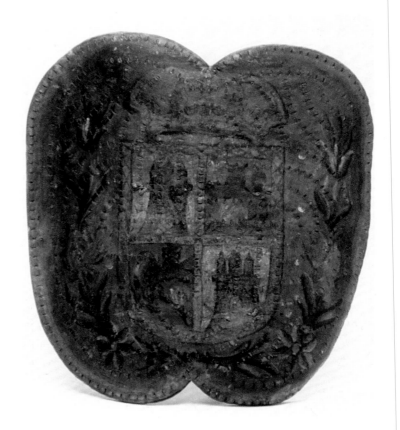

12.20. *Adarga* (shield), Mexico or New Mexico, late-eighteenth to early-nineteenth century. Rawhide, oil paints, 19 × 20¼ in. Museum of International Folk Art, Santa Fe. Gift of the Fred Harvey Collection, IFAF, FA.79.64-130.

The saddle embossment could have been of cutout leather or silver thread. The inventory also lists one (later two) headstalls (*jaquimas*); one well-made bridle; two new saddle trees (*fustos*), one with stirrups (*fierros*) and one without; five pairs of yoke straps; one oxcart with three yokes (*yugos*) and two whips; two saddle girths; one wool saddle pad; a braided leather rope (*reata*); and two new saddle trappings for horses (*adarezos*), one embroidered and the other of rough woven wool (*dos adarezias la una bordado y la otra lisa de jerga*, later *dos adaresas nuevas*). Saddle covers were often used over saddle trees (*fustos*), such as the one mentioned above with stirrups, and were later referred to as *mochilas*.

Farm and ranch produce included ten (elsewhere eight) *fanegas* (approximately one and a half bushels) of wheat, later valued at thirty-two pesos; ten *fanegas* of piñon nuts belonging to Antonio, later valued at eighty pesos; five *fanegas* of piñon nuts that belong to Antonio's brother Vicente; and two that belonged to his cousin Antonio Armijo; twelve balls of spun wool (these do not appear in the final inventory); and twenty-four *vellones* (fleece of one sheep) of matted wool (in the second and third inventory these are listed as "one small bale of wool").

Gertrudes inherited a large herd of livestock. Since it took a while to round up and count all the animals, I will rely on the final inventory here, which lists thirty-two breeding cattle; nine of the same, two years old; three young bulls; fifteen calves born in the current year; four tame oxen; seven female and one male goat; seventeen female and six male sheep, two years old; 296 sheep; and eighty-seven lambs born that year. In spite of the horse gear in Antonio's possession at the time of his death, there is no mention of horses in his estate goods.

Conclusion

In view of the dearth of documents from the Colonial era, we are fortunate to have the detailed estate settlement of Antonio Durán de Armijo II with its three separate inventories, which allow us to glimpse the lifestyle and material possessions of a family that was on the rise socially in Colonial New Mexico.[52] As a mestizo blacksmith and a second-generation immigrant, one would not expect Antonio to have such an extensive estate or to own imported luxury goods such as Chinese textiles and porcelain and lacquered chests from Michoacán, Mexico. Hopefully, future analyses of other estate goods should shed further light on the material culture and daily life of Colonial New Mexico.

NOTES

1. Over 150 unpublished estate inventories and wills are located in the New Mexico State Records Center and Archives in Santa Fe, Spanish Archives of New Mexico (SANM) I and II. Household inventories associated with trials by the Inquisition can be found in the Archives of the Archdiocese of Santa Fe and the Archivo General de la Nación in Mexico City. A few other inventories are located in assorted private and public archives in New Mexico, Mexico, and Spain.

2. José Antonio Esquibel, "The Formative Era for New Mexico's Colonial Population: 1693–1700," in *Transforming Images: New Mexican Santos in-between Worlds*, by Claire Farago and Donna Pierce (University Park, PA: Penn State Press, 2006), 64–79.

3. John B. Colligan, *The Juan Páez Hurtado Expedition of 1695: Fraud in Recruiting Colonists for New Mexico* (Albuquerque: University of New Mexico Press, 1995).

4. See José Antonio Esquibel and John B. Colligan, *The Spanish Recolonization of New Mexico: An Account of the Families Recruited in Mexico City in 1693* (Albuquerque: Hispanic Genealogical Society of New Mexico, 1999).

5. Fray Angélico Chávez, *The Origins of New Mexico Families in the Spanish Colonial Period in Two Parts: The Seventeenth Century (1598–1693), and the Eighteenth Century (1693–1821)* (1954; repr., Santa Fe: Museum of New Mexico Press, 1992), 136.

6. Esquibel, "Formative Era," 64–79, 70.

7. For other references to Antonio as notary and barber-surgeon, see J. Richard Salazar, trans., and Linda Tigges, ed., *Spanish Colonial Lives: Documents from the Spanish Colonial Archives of New Mexico, 1705–1744* (Santa Fe, NM: Sunstone Press, 2013); and *Spanish Colonial Women and the Law: Complaints, Lawsuits, and Criminal Behavior, Documents from the Spanish Colonial Archives of New Mexico, 1697–1749* (Santa Fe, NM: Sunstone Press, 2016), references throughout.

8. Virginia Langham Olmstead, *Spanish and Mexican Censuses of New Mexico, 1750–1830* (Albuquerque: New Mexico Genealogical Society, 1981), 1.

9. Chávez, *Origins*, 136–137. Salazar and Tigges state that Barbara married Juan Durán de Armijo, but all other documents state otherwise. See Salazar and Tigges, *Spanish Colonial Lives*, 184n2.

10. Esquibel, "Formative Era," 70–72. For a discussion of the various *castas* (castes) in New Mexico, see Paul Kraemer, "The Dynamic Ethnicity of the People of Spanish Colonial New Mexico in the Eighteenth Century," in Farago and Pierce, *Transforming Images*, 80–100.

11. Barbara's will is included with the papers in support of Antonio's will in SANM I:240.

12. Chávez inaccurately refers to the daughter as Barbara Gertrudes; elsewhere she is called María Gertrudes. Chávez, *Origins*, 137.

13. Estate Settlement of Antonio Durán de Armijo, 1748, SANM I:240. Also see Works Progress Administration translation, SANM I:240. Although this is one of the better translations from that project, I have contradicted it in many instances here.

14. Esquibel, "Formative Era," 77; Chávez, *Origins*, 311–312, 400.

15. Gertrudes's estate settlement also survives. See SANM I:48.

16. Antonio Durán de Armijo, 1748, SANM I:240.

17. For more information on *genízaros*, see Malcolm Ebright and Rick Hendricks, *The Witches of Abiquiu: The Governor, the Priest, the Genízaro Indians, and the Devil* (Albuquerque: University of New Mexico Press, 2006).

18. Barbara's will mentions three chests, one large and two medium-sized, containing her clothes and personal items. They may have been three of the seven listed later in Antonio's estate inventory.

19. Teresa Castelló Yturbide and Marita Martínez del Rio de Redo, *El arte de maque en México* (Mexico City: Fomento Cultural Banamex, 1980). Also see Mitchell A. Codding, "The Decorative Arts in Latin America, 1492–1820," in *The Arts in Latin America, 1492–1820*, ed. Joseph J. Rishel and Suzanne Stratton-Pruitt (Philadelphia: Philadelphia Museum of Art, 2006), 98–113. These prized painted and lacquered chests from Michoacán were relatively common in New Mexico. Of the 150 chests listed in the estate inventories that I have reviewed, forty-nine, or roughly one third, are specifically identified as being from Michoacán.

20. Other mentions can be found in SANM I:48, 240, 252, 351, 371, 530, 539, 590, 793, 1055, 1060, 1219.

21. For general discussions of furniture made in New Mexico, see E. Boyd, *Popular Arts of Spanish New Mexico* (Santa Fe: Museum of New Mexico Press, 1974); Alan C. Vedder, *Furniture of Spanish New Mexico* (Santa Fe, NM: Sunstone Press, 1977); Lonn Taylor and Dessa Bokides, *New Mexican Furniture, 1600–1940: The Origins, Survival, and Revival of Furniture Making in the Hispanic Southwest* (Santa Fe: Museum of New Mexico Press, 1987). Although the latter is the most comprehensive study of the subject to date, Boyd is the only author above to make specific connections to Spanish and Mexican prototypes. For brief discussions on the latter topic, see Donna Pierce, "New Mexican Furniture and Its Spanish and Mexican Prototypes," in *The American Craftsman and the European Tradition, 1620–1820*, ed. Francis J. Puig and Michael Conforti (Minneapolis: Minneapolis Institute of Art, 1989), 179–201; Donna Pierce, "Furniture," in *Spanish New Mexico: The Spanish Colonial Arts Society Collection*, ed. Donna Pierce and Marta Weigle, vol. 1 (Santa Fe: Museum of New Mexico Press, 1996), 61–79; and Robin Farwell Gavin, *Traditional Arts of Spanish New Mexico: The Hispanic Heritage Wing at the Museum of International Folk Art* (Santa Fe: Museum of New Mexico Press, 1994). For a discussion of the Native American elements in Colonial furniture, see William Wroth and Robin Farwell Gavin, eds., *Converging Streams: Art of the Hispanic and Native American Southwest* (Santa Fe, NM: Museum of Spanish Colonial Art, 2010).

22. Elena Phipps, *Looking at Textiles: A Guide to Technical Terms* (Los Angeles, CA: Getty Museum, 2011), 52, 56. The gold or silver ribbon had usually been glued to a very fine backing or substrate made from paper, leather, animal gut, or membrane.

23. For example, from the Palace of the Governors in Santa Fe. See Cordelia Thomas Snow, "A Brief History of the Palace of the Governors and a Preliminary Report on the 1974 Excavation," *El Palacio* 80, no. 3 (1974): 1–22.

13

Colonial New Mexican Chests: A Study of the Styles and Makers of the Valdez and Seven-Panel Chests

LANE COULTER

In August 1917, Burt Harwood walked down to Ledoux Street in Taos to look at an old chest offered for sale in the back of a horse-drawn wagon (fig. 13.1). The owner, José A. Valdez, was a seventy-two-year-old man from Velarde. Harwood decided to buy the chest and then asked Mr. Valdez, "Who made the chest?" Valdez then told him it was a family piece inherited through three generations of his family. Mr. Valdez, who was born in 1848, had inherited it from his father, Juan de Jesús Valdez, who was born in 1805, and he had inherited it from his father Francisco A. Valdez, whose father had made it. From the work of the historian and genealogical researcher José Antonio Esquibel, we now know that the maker was Manuel Lorenzo Valdez of

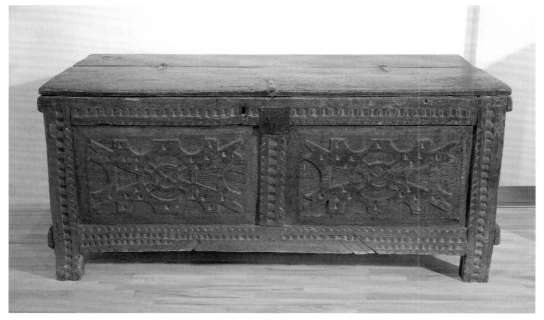

13.1. Manuel Valdez, chest, Velarde, New Mexico, late-eighteenth century. Pine, 26 × 71 × 33 in. Angle braces cut and legs shortened. Photograph courtesy of the author. Collection of the Harwood Museum of Art, Taos, New Mexico, 1980.83. Gift of Lucy Case Harwood.

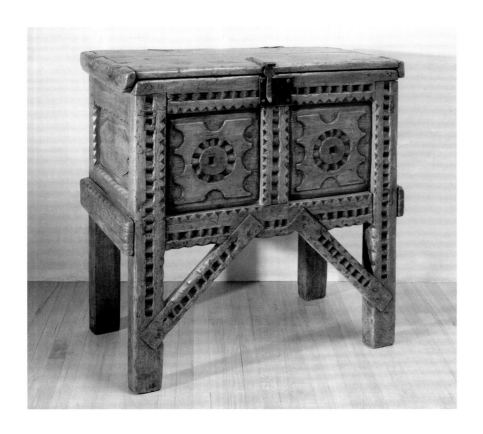

Velarde, who was born in 1752 and died in 1795.[1] Each of the family members that Mr. Valdez named represented the elder son in each generation. Harwood made written notes of this interaction and pinned it to the inside of the chest, where it remains today.

This chapter is intended to describe, enumerate, and illustrate representative examples of the two distinct groups of chests that form the bulk of existing decorated Colonial-era chests (figs. 13.2–13.3). Variants of the most typical examples of the two styles will be illustrated in sequence to connect to the primary examples. Additional work should lead to better ideas of the dating and the location of one of the groups. An attempt to note the *carpinteros* most likely to have carved and constructed the second group of chests is included here.

Examples of chests in museum collections studied for this chapter include those in the Museum of International Folk Art, the Spanish Colonial Arts Society (Museum of Spanish Colonial Art), and the School for

13.2. Typical Valdez chest, New Mexico, ca. 1780–1800. Pine, 29¼ × 28 × 16 in. Photograph courtesy of the author. Private collection, Houston, Texas. Formerly in the collections of Mabel Dodge Lujan and Frank Waters, Taos, New Mexico.

Advanced Research, all in Santa Fe. Other remarkable collections include the Harwood Museum of the University of New Mexico and the Millicent Rogers Museum, both in Taos. Regionally the Denver Art Museum and the Taylor Museum of the Colorado Springs Fine Arts Center both have extensive holdings of New Mexican furniture. A much-published example of a Valdez chest

13.3. Seven-panel heraldic chest, New Mexico, ca. 1780–1800. Pine, 18¾ × 45⅛ × 17½ in. Untouched condition, found in California, retains sales receipt from Spanish and Indian Shop, Santa Fe, 1946. Photograph courtesy of the author. Private collection, Taos, New Mexico.

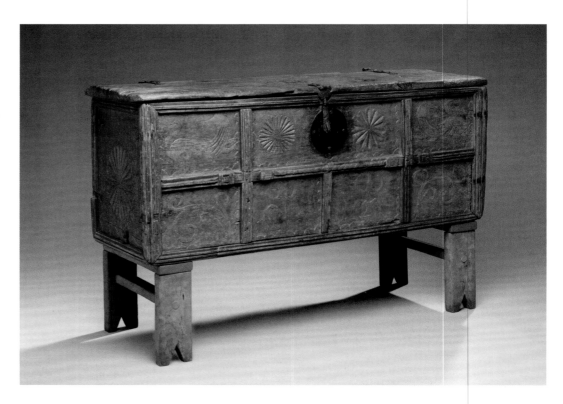

remains on view in the Art Institute of Chicago adjacent to a variant of the seven-panel chests.[2] The National Museum of American Art (Smithsonian) has in their collections a watercolor painting from the Works Progress Administration Federal Art Project, the Index of American Design, depicting a chest-on-stand attributed to the Taos area by the artist. This is one of a very few New Mexican furniture renderings that have ever been published from the project.

The chapter will disregard purely functional chests of six-board, dovetailed construction that have very little or no decoration. The two groups studied here differ completely in their construction techniques and decorative imagery, but not in function, size, or age.

Valdez Chests

The first group, now referred to as "Valdez chests," are built as framed chests with geometrically carved panels inserted within a framework of rails and stiles (fig. 13.4). In most examples, unless shortened at a later date, the stiles are elongated to form legs that support the body of the chest. These engineered braces provide a great deal of lateral strength and integrity to the whole form. The legs, stiles, and angled braces are decorated with chip-carved rows of accordion carving.

Many, if not all, Valdez pieces are signed with one or more incised asterisks on the back, the sides, or both.[3] With the exception of not noting or noticing these asterisks, Lonn Taylor and Dessa Bokides in their research on New Mexican furniture carefully studied this form and stated that they had located eighteen examples.[4] Since that project was completed and published, at least twelve more examples, including a few variants, have come to light, for a total of thirty.[5] All are relatively similar in that they are made in the standard residential storage size, with the exception of the four known *harineros* (grain chests) that are much larger and usually feature a small lid size that better protects the grain from rodents (fig. 13.5). These Valdez chests represent a rather large body of chests produced by a single family of *carpinteros* working in the late Colonial period. Of this specific style, art historian E. Boyd published one, Taylor and Bokides illustrated eight, and in 1977 Alan Vedder illustrated three.[6]

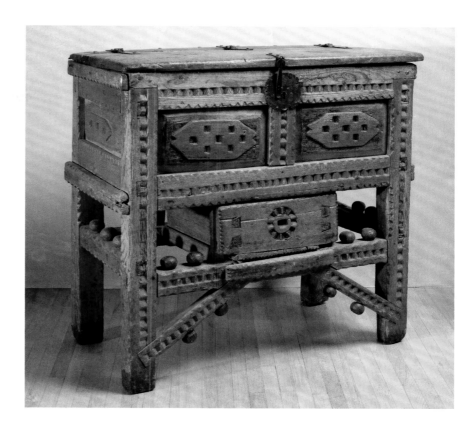

13.4. Valdez chest, New Mexico, ca. 1780–1800. Pine, 32 7/8 × 34 × 17 5/8 in. Highest quality, including drawer and fourteen carved-and-tenoned ball details. Photograph courtesy of the author. Collection of the Museum of Fine Arts, Boston, 2019.605. Formerly in the collections of Mabel Dodge Lujan and Frank Waters, Taos, New Mexico; and Lane Coulter and Jan Brooks, Santa Fe, New Mexico.

Variants on Valdez Style Chests

Two chests were also recorded that may be considered variants of the Valdez style. In the chest depicted in figure 13.6, most of the visual commonalities of Valdez designs are present, including the accordion carving and the panel layouts, but the lack of continuation of the rows of carving down the legs usually occurs only with the use of angle braces. The raised panel designs on the front are unlike any other examples. Also unusual is the chest's collection history. Apparently it was collected in Belen, New Mexico, south of Albuquerque, from the Chávez family.[7] Belen is some one hundred and forty miles south of Velarde, where the chests were produced. Historically

13.5. Manuel Valdez, *harinero* (grain chest), New Mexico, late-eighteenth century. Ponderosa pine, 29½ × 60½ × 19½ in. Museum purchase, National Cowboy and Western Heritage Museum, Oklahoma City, Oklahoma, 2018.18. © Dickinson Research Center. Formerly in the collection of the Millicent Rogers Family, Taos, New Mexico.

13.6. Valdez chest variant, New Mexico, ca. 1780–1800. Pine, 23⅝ × 40½ × 21¼ in. Collection of Casa San Ysidro: The Gutiérrez-Minge House, Corrales, New Mexico, gift of Ward Alan Minge and Shirley Jolly Minge, PC1997.51.19.

a trip of that sort would have taken almost two weeks by oxcart, an arduous and expensive trip at best.

Another example of a Valdez chest variant has been in the collection of the Wadsworth Athenaeum in Hartford since 1926, when it was gifted by J. P. Morgan Jr. from the early American furniture collection of New England entrepreneur, photographer, writer, and collector Wallace Nutting (fig. 13.7).

13.7. Valdez chest variant, New Mexico, ca. 1800–1850. Pine, 30¾ × 42 × 18 in. This is quite likely a second- or third-generation version; there are no angle braces or additional fancy carving within the panel. Two similar chests are known. Collection of the Wadsworth Atheneum, Hartford, Connecticut, 1926.301.

Seven-Panel Heraldic Chests

The second New Mexican decorated Colonial chest style is constructed as a rectangular six-board box, with the front face divided by handmade applied moldings, creating seven open-background areas that are then filled with low-relief carved images (figs. 13.8–13.11). These are now known as seven-panel heraldic chests. At least twenty-five examples of this style (including the variants) have been located. The panels are laid out in two horizontal rows across the face of the chest, with three panels at the top and four panels across the bottom. The top row of three has a larger panel in the center that also includes the lock plate and accompanying hasp (see fig. 13.10). Each of these seven panels has been decoratively carved with Spanish-based heraldic images related to those included in the coats of arms of the provinces of Leon and Castile, Spain, the geographic origin of many settlers in New Mexico. All of these examples include one or more small rosettes, two rather abstract lions facing away from each other (regardant), and a variety of plant-based images, including fruited pomegranates. The rosettes are invariably twelve-petal forms carved on the front in a small size. All heraldic images have direct links to designs brought from Spain to the New World in the sixteenth and seventeenth centuries that continued to be used in New Mexico well through the last half of the eighteenth century (for an example of a Spanish chest, see Gavin, fig. 11.11, this volume).[8]

It should be noted that no furniture made prior to the end of the Pueblo Revolt (1680–1696) still exists. Only one example from the second quarter of the eighteenth century may exist: an armchair collected by Tony Garcia of Alameda, New Mexico, in the 1950s at Taos Pueblo for the Minge Collection, now housed at Casa San Ysidro in Corrales, New Mexico. This armchair has been illustrated in Taylor and Bokides as well as in other publications.[9] It features an unusual strip of rawhide across the upper back rail that has been described as "in imitation" of a Spanish leather upholstery detail. There are unusual black outline and dot details painted in panels along the interior and exterior of the legs of this chair (black dot details are also known from one Valdez chest) representing some of the earliest decorative surface details used on New Mexican furniture, along with the large painted rosettes seen on the end panels of a few Colonial-era

13.8. Seven-panel heraldic chest, New Mexico, ca. 1780–1800. Pine. A primary example of the style. Photograph courtesy of the author. Private collection, Taos, New Mexico.

13.9. Seven-panel heraldic chest (detail of fig. 13.8), New Mexico, ca. 1780–1800. Showing carved lion regardant with crown.

13.10. Seven-panel heraldic chest (detail of fig. 13.8), New Mexico, ca. 1780–1800. Showing moldings, vines, and pomegranates.

13.11. Seven-panel heraldic chest (detail of fig. 13.8), New Mexico, ca. 1780–1800. Showing small twelve-petal rosette with hollow center.

13.9

13.10

13.11

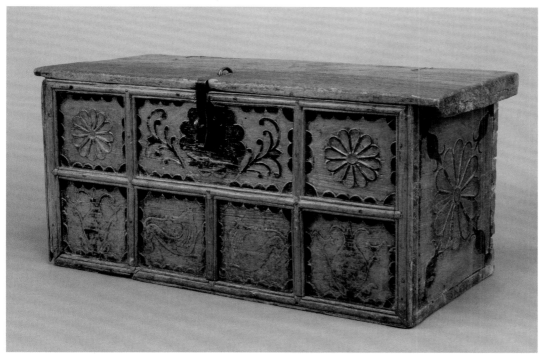

13.12. Seven-panel heraldic chest, New Mexico, late-eighteenth century. Pine, 20½ × 43½ × 19 in. One of the examples with integral cleats in which the whole center of the board of the lid was removed with an adze, leaving the full thickness at each end to create the cleats, a tremendous task. These are more typically found on a few Pueblo-made chests. Collection of the Museum of International Folk Art, Santa Fe, New Mexico, A.1960.20.1. Formerly in the collection of a Hispano family near Española, New Mexico.

chests (see fig. 13.11). The images seen carved on the front of seven-panel heraldic chests vary their positions from one panel to another in the various examples of these chests (fig. 13.12).

At least five examples of seven-panel heraldic chests have been discovered by dealers in southern California over the years. Due to the scarcity of Spanish Colonial-era furniture made in California, the chests had been shipped there from New Mexico in the early twentieth century to provide more authentic pieces for the Spanish Colonial Revival homes built following the Panama-California Exposition in San Diego in 1915 (see fig. 13.3).[10]

Variants on Seven-Panel Chests

In the recent search for seven-panel chests, approximately a dozen classic or typical examples ("type specimens") have been located. In addition to the two illustrated by Taylor and Bokides, important variant versions apparently produced by the same artisans have been found, also numbering at least a dozen. The closest relatives to these variants are those examples with frontal carvings of the readily recognizable lion images, usually accompanied by a version of the typical rosette, which invariably has a small outlined center circle with a hollow carved center (figs. 13.13–13.15).[11]

Other variations might include applied moldings around the face of the chest, with only two large rosettes for decoration. Most of these variant versions also utilize the large twelve- or twenty-four-petal rosettes on each of the end panels (see fig. 13.18). In another important variant style seen on both classic and variant examples, the face of the chest is outlined with compass-drawn crescent or scalloped borders and then the surface is entirely covered in complex vegetal forms of stems, leaves, and, occasionally flowers or fruit of the pomegranate (fig. 13.16). Visible scribed lines around the edges indicate that moldings are missing from the front and sides of this chest. In fact, the side moldings on many of these chests are often missing.

One variant chest illustrated in Taylor and Bokides features the same but more complex molding profile as that seen in figure 13.3 above (detailed in figure 13.17).[12] All the other "classic"

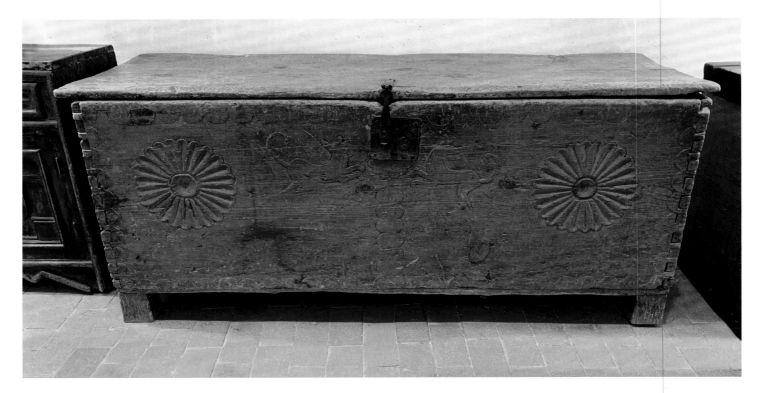

13.13. Seven-panel heraldic chest variant, New Mexico, late-eighteenth to early-nineteenth century. Pine. The designs here include scallop borders, two lions, and two large rosettes. Photograph courtesy of the author. Private collection, Taos, New Mexico.

13.14. Seven-panel heraldic chest variant (detail of fig. 13.13), New Mexico, late-eighteenth to early-nineteenth century. Showing two lions and scalloped borders and center motif.

13.15. Seven-panel heraldic chest variant (detail of fig. 13.13), New Mexico, late-eighteenth to early-nineteenth century. Note outlined and hollow center circle.

13.14

13.15

chests have the half-round molding profile, but the chest illustrated in Taylor and Bokides has six panels (with the bottom center panel being undivided) that are decorated with only horizontal gouged lines and include no scalloped outlines around the panels. The chest does have the expected large rosettes on each end panel.

Another simple variant chest found in Taos, New Mexico, dates to the end of the Colonial era and retains much of its original red-stained finish (fig. 13.18). At an early point the single-board lid split and was repaired by a blacksmith with two forged straps affixed to the top. In fact, many of these variant chests have received heavy wear and usage. The high survival rate represented by these decorated chests is a function of the preferences of collectors for those pieces that were more visually exciting. It is possible that Mabel Dodge Lujan may have owned at least six Valdez-made chests by the late 1930s.

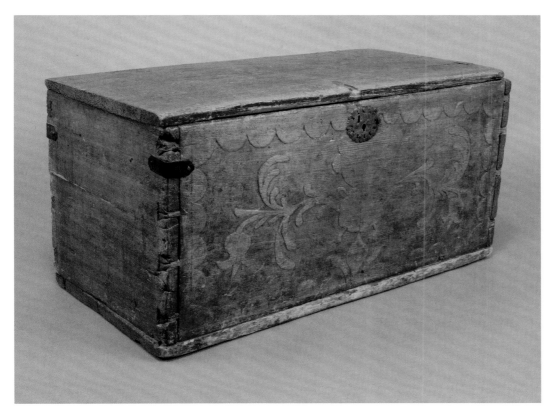

13.16. Seven-panel heraldic chest variant, New Mexico, late-eighteenth to early-nineteenth century. Pine, 16½ × 33 × 16 in. Unusual example showing scalloped border, vines, and fruiting pomegranates. Note the space bordering the scallops that indicates missing moldings. Inscribed lines around the edges indicate that moldings are missing from the front and sides of this chest. In fact, the side moldings on many of these chests are often missing (see fig. 13.8 details). Another simple variant chest found in Taos, New Mexico, dates to the end of the Colonial era and was repaired by a blacksmith with two forged straps affixed to the top. Collection of the Museum of International Folk Art, Santa Fe, New Mexico, A.5.1959.24. Formerly in the collection of Mary Cabot Wheelwright.

13.17. Seven-panel heraldic chest (detail of fig. 13.3), New Mexico, ca. 1780–1800. Showing carved rope molding.

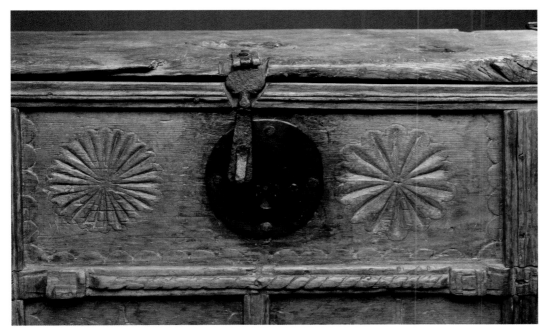

13.18. Seven-panel heraldic chest variant, New Mexico, ca. 1780–1800. Pine, 18 × 36 ½ × 17 in. Showing the typical large rosette end panels and scalloped borders. Photograph courtesy of the author. Private Collection, Taos, New Mexico (collected in Taos).

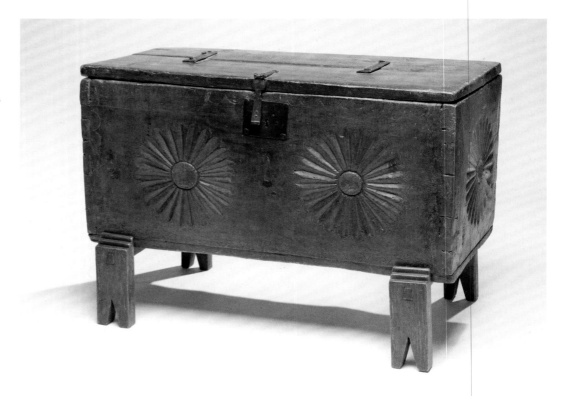

The History and Study of New Mexican Colonial Furniture

This large group of two unique styles of New Mexican Colonial-era chests suggests that they may have been made by as few as three early *carpintero* families.

The next step in the investigation, now that we know the Valdez chests are accurately identified, is to begin the process of identification of possible makers of the second group of Colonial-era chests, the seven-panel heraldic chests. Historians of early American decorative arts began to pin down information by looking at old articles published in *The Magazine Antiques* from the mid-1920s and 1930s. Historians looking at Pilgrim-era and American Colonial period furniture styles considered both the family provenance and the geographic location to identify a place of origin. Then they began looking at the cabinetmakers known to be working in that region at that time. Without early records of sale or production available to us in New Mexico, that method does not work. We can, however, look at the economy of the Colonial period in Santa Fe and Taos and at the number of cabinetmakers available to supply the demand.

By the time of the American centennial in 1876, at least a handful of collectors in New England were purchasing historic examples of furniture for their homes. In contrast, in New Mexico interest in the old Hispano material culture followed an earlier interest that had developed in Native American artifacts, particularly in the areas of Pueblo pottery and Navajo weaving. The advent of historic collecting in New Mexico was mostly initiated by late-nineteenth-century anthropologists who primarily focused on Native American material culture but with an occasional nod to the beginning of Spanish colonization. After the arrival of the railroad in 1880 in Santa Fe and then in Taos, curio shops occasionally offered Spanish *santos* (images of saints) along with their larger volume of Native American goods in the last few decades of the nineteenth century. But furniture was of no interest or value to tourists, due in part to the challenges of shipping.

Collecting New Mexican furniture really began around the turn of the century with the advent of the territorial-era Historical Society, which was dedicated to saving documents and

material culture of early New Mexico, and which housed its collection in the Palace of the Governors. The Society for the Revival of Spanish Arts founded in 1913 preserved and collected the early material and was a forerunner of the Spanish Colonial Arts Society founded in Santa Fe in 1925. Collecting Spanish Colonial material then became common among the well-to-do in Santa Fe and Taos. Taos pioneer artist Bert Phillips began collecting Hispano and Native American antiques by 1900 and with a partner opened the Taos Indian Curio Shop in 1902. He sold his interest only a few years later but continued collecting. Two early antique dealers, Ralph Meyers (beginning as early as 1910) and George Travis (beginning by the early 1920s) focused on local Hispano arts as well as Native American objects. In Santa Fe, Juan Olivas had opened a shop downtown by 1906, and the Spanish and Indian Shop, the Old Santa Fe Trading Company, and the Fred Harvey Shop in Santa Fe and in the Alvarado Hotel in downtown Albuquerque all sold both Hispano and Native American antiques.[13] Very little study of New Mexican Spanish Colonial furniture was published until E. Boyd's section in her final book *Popular Arts of Spanish New Mexico*, which was rushed into print in 1974 before her death a few months later. It represents an accumulation of her broad knowledge of the arts of historic New Mexico.

Predictably Boyd's first two examples shown in the section titled "Woodworking" were a front view of a seven-panel heraldic chest, and then a view of a chip-carved and angle-braced Valdez chest. These were then followed by a variant version of a dovetailed heraldic chest with lions and pomegranates.[14] A few years later, in 1977, Alan Vedder, a conservator and protégé of Boyd's, published his book, *Furniture of Spanish New Mexico*, the first that focused solely on that subject. Vedder included one previously unpublished example of a seven-panel heraldic chest as well as two examples of related variant versions, including one from the collection of the Wadsworth Atheneum that includes the scallop-border outlines and the large carved rosettes of Colonial pieces.[15]

Some six years later, in 1987, after years of study, Taylor and Bokides released what became the definitive volume: *New Mexican Furniture, 1600–1940*. The first ten pieces illustrated in their book are all examples of Valdez chests or slight variations of them. A few pages later, a section focused on the seven-panel heraldic chest is devoted to wonderful variant versions of these chests, but only a single classic example of these seven-panel heraldic chests was illustrated.

It is certainly time to focus attention and appreciation on these two remarkable surviving styles of Spanish Colonial chests. First, it is amazing that such a significant number of pieces, almost sixty, have survived over the past 250 years, given the harsh climate, population growth and movement, and cultural changes across the ages.

The Economy of Colonial New Mexico

Throughout most of the last two decades of the eighteenth century, New Mexico's economy expanded at a remarkable rate, greater than ever before. This was in response to the Spanish government's Bourbon Reforms as well as to a newly negotiated peace settlement with the Comanche tribe that allowed safer access to trade routes, primarily south to Chihuahua. Other changes included extensive growth in population and the resulting expansion along the river valley drainages east and west of the Rio Grande, opening large fertile areas for agriculture and resulting in tremendous production of grain, sheep, and to some degree cattle, mostly headed for the export trade.[16]

The dramatic increase in overland trade began to allow the development of a new upper-middle class of artisans, traders, and merchants. The sheer quantity of sheep produced, over thirty thousand annually at the time, and the tons of wool sheared, encouraged the work of numerous weavers, and their adjunct artisans, carders, and spinners. The result was the addition of a variety of textiles to the great volume of exports headed to northern Mexico. Thus, a much

more solid economy developed in New Mexico that positioned this new middle class to be able to afford the more elaborate products of its weavers, silversmiths, *santeros*, and, important to this study, *carpinteros*. We now know this was beginning to take place from Will Wroth's recent article on the painted chests from the workshop of the Laguna Santero (ca. 1770–1820), in which he illustrates an elegantly painted chest apparently collected by Bert Phillips from the Rancho de Taos Church.[17] The chest was made by the Valdez family of *carpinteros* and subsequently painted by the *santero*'s possible apprentice, Molleno.

The *Carpintero* Families

New Mexican *carpinteros* relied exclusively on a supply of ponderosa pine from the mountain forests of Northern New Mexico. They had to produce everything from finished lumber for builders to complex pieces of furniture. These included *trasteros* (dish cabinets), *bancos* (benches), *sillas* (chairs), and of course the most popular item, *cajas* or chests. In addition, they carved and decorated beams, corbels, and flooring. They also supplied their friends and neighbors who were *santeros* with boards in order to paint retablos and with wood blocks for carving *bultos*.

As many as sixteen *carpinteros* were working in Santa Fe in 1790, and most lived near the plaza and close by La Castrense Church located north of the river. They were not formally guild-trained in New Mexico but had experience, long-standing visions, and knowledge of construction details and decoration of Spanish furniture, whether from a few surviving pieces brought to New Mexico from Mexico or Spain, or those they had seen in Mexico before their journey north. The same is true for the few ironworkers, *herreros*, who supplied the carpenters with hinges, locks, and hasps as well as forged nails and spikes. They worked closely with the *carpinteros*, finishing the assembly of those pieces that required locks or hinges. Of course, unlike the *carpinteros*, who had a continual supply of timber from the mountains, ironworkers were reliant on either recycling the rare material or resupplying from the few annual caravans from mines as far as central Mexico. The *herreros*, judging by the surviving lock plates and hasps, simplified and limited as far as possible their use of the available iron. Many of the locks and hasps that were imported from Mexico were larger and fancier.

Two *carpintero* families stand out as the possible makers of the seven-panel heraldic chests, in part for their ages and the number of working family members, as well as additional skilled employees.[18] In 1790 each family had three trained woodworkers. First is the Lucero Family (often spelled Luzero) under the guidance of the father, Antonio Lucero, age sixty-seven, born in 1723. His two sons were Santiago Lucero, age forty-eight, born in 1742, and Antonio de Jesús Lucero, age thirty-two, born in 1758. One of only two known extant wooden pieces with a signature is a corbel in the Santuario de Guadalupe Church in Santa Fe signed by Antonio de Jesús Lucero, who may have also been known as Jesús the Carpenter in 1789.[19] The family's combined experience in woodworking would equal almost one hundred years. Additionally, another *carpintero*, Santiago Gallego, lived three doors down from Santiago Lucero, the son, and the noted *santero* José Rafael Aragón was a neighbor. Aragón's wife and the mother of his child was a Lucero.[20]

The other family of *carpinteros* was the Ortega family, brought to our attention by Marie Romero Cash in 1990, in reference to the only Ortega-signed piece of furniture: a signed and dated cradle in the collection of the Archdiocese of Santa Fe.[21] This miniature cradle, signed by Lorenzo Ortega and dated 1789, is decorated with traditional period carving of rampant lions, paste gemstones, and glitter-like material. The father was Juan Manuel Ortega, age sixty-three, born in 1727. His two sons were Lorenzo Ortega, age thirty-three, born circa 1757, and Jose Celedonio Ortega, age twenty-nine, born in 1761, who, unfortunately, was to die a short time after 1790. Their combined years of experience in 1790 totaled sixty-five to seventy. Two other

carpinteros lived just down the street from Juan Manuel Ortega: Manuel Trujillo, age thirty-nine, and Matias Sáez, age thirty-six. This suggests that all five of these men worked closely together, probably for many years. Juan Manuel Ortega's next-door neighbor was María Lucero, who was the *santero* José Casados's wife, and another neighbor, José Baca's wife, was also a Lucero, further connecting the two families.

These two rare examples of signed eighteenth-century woodworking, one by a Lucero and the other by an Ortega, highlight the importance of these two families as prominent artisans in Santa Fe. José Antonio Esquibel and Charles M. Carrillo, in *A Tapestry of Kinship*, have carefully explained the remarkable close local connections, laying out the family, *compadre* (close friend), *padrino* (godfather), and other support systems available to Hispano families at that time, which continue to some extent even today. This two-family group of *carpinteros* and their employees account for well more than half of the craftsmen producing furniture during this period in Santa Fe, New Mexico, according to the census. Thus, it is very probable that they produced most of the carved and decorated chests made during the late-Colonial period, with the exception of those made by the Valdez family. As a result, I can now assign the seven-panel heraldic chests and their variants to the grouping of the Lucero/Ortega family *carpinteros*, based on the quantity and similarity of work the two families and their coworkers must have produced.

While researchers always hope to find more exacting information to pin to any cultural object, we should thank Burt Harwood for asking the right question of the right person in Taos, some 102 years ago.

NOTES

1. As cited in Robin Farwell Gavin, "Carpinteros in Colonial New Mexico," in *Scholar of the City Different: Papers in Honor of Cordelia Thomas Snow*, ed. Emily J. Brown, Matthew J. Barbour, and Genevieve N. Head (Albuquerque: Archaeological Society of New Mexico, 2019), 76; Lonn Taylor and Dessa Bokides, *New Mexican Furniture, 1600–1940* (Santa Fe: Museum of New Mexico Press, 1983), 33, pl. 10.

2. See Judith A. Barter and Monica Obniski, *For Kith and Kin: The Folk Art Collection at the Art Institute of Chicago* (New Haven, CT: Yale University Press, 2012), 28–29, for a color photograph of a complex Valdez chest fitted with a drawer and carved decorative balls (one of only four known).

3. Ann Carson, personal communication, Albuquerque, 2004, discovered while inventorying the Minge Collection, now in the Albuquerque Museum collections.

4. Taylor and Bokides, *New Mexican Furniture*.

5. In addition to the eighteen examples found by Taylor and Bokides, other examples have been located in the collections of the Museum of Spanish Colonial Art: an *harinero* (2003.147) in the Luckett collection (see *American Furniture and Decorative Arts from Spain's Northern Colonial Frontier, 1700–1900, the Collection of Mr. and Mrs. Al Luckett, Jr.* [New York: Sotheby's, January 15, 1998], lot 229, cover, and lot 156); three in a private Santa Fe collection being dispersed; at least one other in a private Albuquerque collection; as well as a private collection in Houston (fig. 13.2); a private collection in Taos (fig. 13.3); the Boston Museum of Fine Arts (fig. 13.4); and an *harinero* in the National Cowboy and Western Heritage Museum (fig. 13.5).

6. E. Boyd, *Popular Arts of Spanish New Mexico* (Santa Fe: Museum of New Mexico Press, 1974), 248, fig. 144; Alan C. Vedder, *Furniture of Spanish New Mexico* (Santa Fe, NM: The Sunstone Press, 1977), 27–28; Taylor and Bokides, *New Mexican Furniture*, pls. 1–9.

7. The chest was undoubtedly collected by Tony Garcia, a picker from Albuquerque who supplied the Minge collection of Casa San Ysidro in Albuquerque with most of its material.

8. For more on New Mexican furniture motifs, see Taylor and Bokides, *New Mexican Furniture*; Donna Pierce, "Furniture," in *Spanish New Mexico: the Spanish Colonial Arts Society Collection*, ed. Donna Pierce and Marta Weigle (Santa Fe: Museum of New Mexico Press, 1996), 61–79; Donna L. Pierce, "New Mexican Furniture and Its Spanish and Mexican Prototypes," in *The American Craftsman and the European Tradition, 1620–1820*, ed. Francis J. Puig and Michael Conforti (Minneapolis: Minneapolis Institute of Arts, 1989, 179–201); and Vedder, *Furniture of Spanish New Mexico*.

9. Taylor and Bokides, *New Mexican Furniture*, pl. 102; William Wroth and Robin Farwell Gavin, *Converging Streams: Art of the Hispanic and Native American Southwest* (Santa Fe, NM: Museum of Spanish Colonial Art, 2010), 179, pl. 40; and Ward Alan Minge, *Casa San Ysidro: The Gutiérrez/Minge House in Corrales, New Mexico* (Santa Fe: Museum of New Mexico Press, 2017), 101, fig. 52.

10. James Jeter, personal communication, Santa Barbara, 2013.

11. For locales of seven-panel heraldic chests, including variants, see Taylor and Bokides, *New Mexican Furniture*, pls. 20, 22–23, 25–27, and 33; Boyd, *Popular Arts*, fig. 142; and Sotheby's, *American Furniture and Decorative Arts*, seven examples, four classic and three variants, lots 11, 19, 33, 102, 181, 231, and 249.

12. Taylor and Bokides, *New Mexican Furniture*, pls. 33–34.

13. New Mexico State Business Directory (Denver: Gazeteer Publishing Co.), various years, 1913–1932.

14. Boyd, *Popular Arts*, 247–248.

15. Vedder, *Furniture of Spanish New Mexico*, 41.

16. See Ross Frank, *From Settler to Citizen: New Mexican Economic Development and the Creation of Vecino Society, 1750–1820* (Berkeley: University of California Press, 2000), 100–128, for discussion of trade related to economic growth in the last quarter of the eighteenth-century, including change in family status. See also pages 189–195, for discussion of furniture production during the period.

17. William Wroth, "Painted Chests Attributed to the Laguna Santero," in Brown, Barbour, Head, eds., *Scholar of the City Different*, 225–243 and fig. 16. Wroth also notes (ibid., 225) that the Laguna Santero created seven altar screens in Santa Fe and five in Pueblo churches between 1796 and 1810, attesting to the growth of wealth in Northern New Mexico during this time period.

18. José Antonio Esquibel and Charles M. Carrillo, *A Tapestry of Kinship: The Web of Influence Among Escultores and Carpinteros in the Parish of Santa Fe, 1790–1860* (Los Ranchos, NM: LPD Press, 2004).

19. Gavin, "Carpinteros," 73.

20. See Esquibel and Carrillo, *Tapestry*, 11–25, for discussion of relationships between the *carpinteros* of Northern New Mexico.

21. Marie Romero Cash, "Santos of the Northern New Mexico Village Churches: A Documentation Project," *El Palacio* 95, no. 2 (Spring/Summer 1990): 24–29; Gavin, "Carpinteros," figs. 28–29.

Plates

The following plates represent artists whose work Will Wroth admired; fortunately he was able to make the selection himself. As in all his endeavors, Will was trying to bring forth different aspects of the rich and complex relationships among the many different peoples of the Southwest during the Spanish Colonial period and continuing through the centuries to the present day. The work of many of the chosen artists reflects this theme; for example, the buckskin shirt by Austin Box represents the conscious modern retention of traditional Native clothing and identity. The *santos* by various artists demonstrate the ongoing Hispano-Catholic tradition of religious imagery, still a part of local culture and life today. The mix of these cultural traditions can be seen in the *relicario* necklace by Michael Bird Romero as well as in the painting by Krissa López of the Virgin of Sorrows shown wearing a halo in the shape of a Native American stepped rain cloud (*tablita*). James Gavin's painting of railroad tracks symbolizes the modern introduction to the Southwest of people and commodities from outside the area, creating new possibilities, but also change, for better or worse. But the tracks also represent the ability of New Mexicans of any ethnic background to explore the outside world as well.

The work of Wroth's selected artists, as he said in his preface to this book, "reflect larger concerns that I believe are of vital importance in our world today: how can people of different cultures and histories living in close proximity coexist in harmony and productively interact with one another to lead meaningful, enriching lives? . . . Without glossing over clear disparities in power relationships, I believe that the long established Native American–Hispanic relationships in New Mexico since the beginning of the eighteenth century, while certainly not perfect, were for the most part amicable interchanges between these peoples, and can provide one example of healthier, more productive cultural interactions. They enrich my love of our past and give me hope for our future."

1. Michael Bird Romero, *Relicario Necklace*, Ohkay Owingeh, New Mexico, 2010. Silver, red trade beads, paper. Photograph by Blair Clark. Spanish Colonial Arts Society, Museum of Spanish Colonial Art, Santa Fe, gift of the artist, 2011.017.

2. Austin Box, *Man's Shirt*, Southern Ute, Colorado Springs, Colorado, n.d. Buckskin, paints, glass trade beads. Courtesy of the artist.

3. Charles Carrillo, *Altarscreen*, Santa Fe, New Mexico, 1991. Wood, gesso, paint, 88 × 40 ½ in. Spanish Colonial Arts Society, Museum of Spanish Colonial Art, Santa Fe, gift of Wayne E. Bingham, 2003.90.

4. James K. Gavin, *¿De Dónde, Adónde?,* Santa Fe, New Mexico, 2018. Oil on canvas, 11 × 14 in. Courtesy of the artist.

5. Kathleen Koltes, *Swallow,* Santa Fe, New Mexico, 2019. Stoneware clay and glazes, 9 × 8 × ½ in. Courtesy of the artist.

6. Arthur López and Bernadette Márquez-López, *Guadalupe,* Santa Fe, New Mexico, 2018. Natural and watercolor pigments, sterling silver and Kingman turquoise pendant with selenite and silver bead necklace, 3 ½ × 2 in. (pendant). Private collection.

7. Felix López, *San Francisco y Santo Domingo se Encuentran en el Campo,* La Mesilla, New Mexico, 2007.
Wood, gesso, paint, straw, 22 × 18 × 25 in. Photograph by Blair Clark. Spanish Colonial Arts Society,
Museum of Spanish Colonial Art, Santa Fe, Spanish Market Purchase Award, 2007.012.

8. Joseph Ascensión López, *San Rafael Arcángel*, La Mesilla, New Mexico, 2015. Aspen, pine, homemade gesso, natural pigments, beeswax, leather, 15 × 8 × ½ in. Private collection.

OPPOSITE

9. Krissa Marie López, *Our Lady of Sorrows,* La Mesilla, New Mexico, 2012. Pine, homemade gesso, natural pigments, beeswax, 17 × 11 in. Photograph by Blair Clark. Spanish Colonial Arts Society, Museum of Spanish Colonial Art, Santa Fe, 2012.014.

10. William Lumpkins, *Untitled*, Santa Fe, New Mexico, n.d. Watercolor on paper, 2 ¼ × 27 in. Photograph by Blair Clark. Collection of Will and Deborah Wroth.

OPPOSITE

11. Pat Musick, *El Cañoncito de La Madera*, Pueblo, Colorado, 2019. Poem by William Wroth. Photograph by Blair Clark. Enameling on copper, 12 × 9 in. Collection of Will and Deborah Wroth.

LA MADERA PEAK,
SACRED MOUNTAIN,
GUARDS THE NORTHERN
APPROACHES,
HAZY VALLEYS DRIFT
AWAY TO THE SOUTH.

IN THE MIDST
A SPRING OF PURE WATER,
DAWN MIST RISES OVER THE PONDS
IF THERE IS PEACE ON THIS EARTH
IT IS HERE.

"Looking at a vast perspective
of sea and cloud"
W. S.

Hale wind from the west
waiting for the ferry at Tarbert,
hale wind off the River Shannon
bringing cold rain in the face -
"the Shannon wading downward like a giant
into the sea"

The stars of Ireland breaking through
As we land in County Clare:
Killimer, Kilrush and warm glow of Mrs.Crotty's pub.
McGreevy's Mal Bay, Spanish Point, Hag's Head,
and the Cliffs of Moher -
"rising out of the mist"
dropping off to dark boulders,
sea birds, the open sea.

West wind and rain cutting through
like tissue paper:
Light and darkness collide,
a fruitful collision -
"nights full of green stars from Ireland,
Wet out of the sea, and luminously wet."

With Wallace Stevens
in County Clare

by William Wroth

12. Timothy O'Neill, *With Wallace Stevens in County Clare*, Dublin, Ireland, 2019. Poem by William Wroth. Gouache and ink on paper made by Tom Leech, 12 × 18 in. Collection of Will and Deborah Wroth.

OPPOSITE
13. Eulogio and Zoraida Ortega, *San Miguel*, Velarde, New Mexico, n.d. Wood, gesso, water-based paint, 32 ¾ × 12 × 9 in. Photograph by Addison Doty. Spanish Colonial Arts Society, Museum of Spanish Colonial Art, Santa Fe, gift of Nancy Reynolds, 1999.47.

14. Vicente Pascual Rodrígo, *Untitled,* Bloomington, Indiana, and Zaragosa, Spain, n.d. Acrylic on paper, 26 ½ × 37 ½ in. Photograph by Blair Clark. Collection of Will and Deborah Wroth.

OPPOSITE

15. Horacio Valdez, *Cristo Crucificado,* Dixon, New Mexico, 1986. Wood, gesso, water-based paint, 39 × 23 ½ × 7 ¼ in. Photograph by Addison Doty. Spanish Colonial Arts Society, Museum of Spanish Colonial Art, Santa Fe, 2000.073.

16. Martha Varoz Ewing, *Capilla de Nuestra Señora del Rosario*, Santa Fe, New Mexico, 2005. Pine, water-based paints, cornhusk, oat and wheat straw, commercial satin finish, 18 × 16½ × 17 in. Photograph by Blair Clark. Spanish Colonial Arts Society, Museum of Spanish Colonial Art, Santa Fe, 2005.021.

OPPOSITE
17. María Vergara Wilson, *Weft Ikat Blanket,* La Madera, New Mexico, 1979. Wool, indigo dye, 50 × 36 in. Photograph by Addison Doty. Spanish Colonial Arts Society, Museum of Spanish Colonial Art, Santa Fe, 1979.12.

Part III
Modern Expressions and Politics

14
Cleto Yurina, Folk Artist and Entrepreneur

JONATHAN BATKIN

Starting around 1885, Cleto Yurina of Cochiti Pueblo carved figurines from stone and sold them as ancient "idols," which he claimed to have recovered from ancestral ruins near the pueblo. His scheme was inspired by a vast market for Native American artifacts, in which women potters of Cochiti played a significant role. Not only would Yurina have witnessed the marketing of pottery to curio dealers in Santa Fe but he was also familiar with the most prominent of those dealers.

Yurina sensed opportunity, invented an artifact type, and created desire through brilliant storytelling. His most acquisitive clients were New Mexico governor LeBaron Bradford Prince (1889–1893) and his wife Mary, who purchased more than sixteen hundred pieces directly from him (fig. 14.1). The Princes sensed opportunity as well, and believed they were acquiring priceless antiquities for a song.[1] In 1900 the Princes began offering their collection for a huge profit, but the effort failed. Before long, Yurina's idols were proclaimed fake, and most of his work was discarded or destroyed.

Several events in the lives of Yurina and his family are documented in government and church records, and other details are in the papers of linguist John P. Harrington, who conducted fieldwork at Cochiti in 1909 while working for the School of American Archaeology in Santa Fe. By that time, many ethnologists doubted the "authenticity" of the idols Prince acquired, and Edgar Lee Hewett, the director of the school, asked Harrington to study the matter. Harrington's report, which declared the idols fake, was suppressed for decades.[2]

Born about 1850, Cleto Yurina was one of at least three children of Juan Rosario Yurina and Maria Teodora Romero. The surname Yurina was a Spanish corruption of a Keres word translated by Harrington as "that which shakes." Harrington was told that Juan Rosario earned the name because "he was a man quick to move about, [who] never kept still."[3]

Cleto married Reyes Archibeque on November 28, 1874, in the church at Peña Blanca, about two and a half miles south of Cochiti. Reyes's father was Francisco Archibeque. Her mother was also named Reyes but her surname was not recorded. Of at least five children born to Cleto and Reyes, only two sons survived childhood: Anastacio, born April 2, 1876, and Sebastián, born January 20, 1890.[4]

The last known mention of Cleto was in a letter from Anastacio to Bradford Prince, dated March 13, 1901. Anastacio asked for money to help with his upcoming marriage: "[If] you will

OPPOSITE

14.1. "Idols" by Cleto Yurina, some possibly made in collaboration with his son Anastacio or wife Reyes, on display in the Palace of the Governors, Santa Fe, ca. 1895. These pieces are presumably from the collection of LeBaron Bradford Prince and his wife Mary, who loaned hundreds of Yurina's pieces to the Historical Society of New Mexico for display. The Historical Society owned only a few small pieces by Yurina, so most or all of the pieces displayed on shelves in the room were from the Prince Collection. Photograph by Charles C. Pierce. University of Southern California Digital Library, California Historical Society Collection.

send me five dollars ($5) you will greatly oblige me, and please send the money by my father, I want it very much." Based on what Harrington was told, Cleto may have passed away in September 1901; Reyes passed away in about 1897.[5]

Anastacio attended school in Albuquerque from 1886 to 1888. He later worked with his father and was well versed in the lore of their idols. He married three times. His first wife was Dominga Benado. Their daughters Demalia, age two, and Trienda, age one, were named in the 1898 census but had died by June 1899. Dominga was counted in the 1900 census but died shortly afterward.[6]

The marriage for which Anastacio asked Bradford Prince for support was to Inez Cordera, daughter of Teodosio Cordero and Juanita Podaca. They were married at Peña Blanca on April 15, 1901. Like Dominga, Inez died shortly after they were married. Anastacio married his third wife, Victoria Ortiz, on February 19, 1903. Victoria was the daughter of Miguel Ortiz and Juana Quintana.[7]

Anastacio's and Victoria's only child, Luis, was baptized at Peña Blanca on November 20, 1904. Anastacio also died young, and it is unclear whether he lived to see his son baptized.[8] Harrington described Luis as "a cute little boy and bright as can be." In 1906, he was living with Victoria, her widowed mother Juana, an older daughter of Victoria named Agripina, and other relatives.

At the same time, Sebastián was living with Miguela Arquero and her husband, Luis Romero. Miguela, daughter of Cleto's older sister Juana, was born in 1881; her father was Toribio Arquero. By 1897, Miguela was an orphan living in Cleto's home, and in 1906, Sebastián was identified as her brother; clearly they were close.[9]

After Cleto and Anastacio died, ownership of Cleto's home, a single room of about seventeen by nineteen feet, passed to Luis and Sebastián. Sebastián eventually sold his share in the house to Marcial Quintana in exchange for a Navajo blanket. Marcial's wife was Agripina Ortiz, the older daughter of Victoria, and they moved into the house with their two children.[10]

In 1909, Sebastián went to work at Rocky Ford, Colorado, and he was away from the pueblo when Harrington did his fieldwork. By March 1910 he had returned, and he lived there through at least 1932. He did not marry, and Luis lived with him for several years. Sebastián's Keres name referenced an evergreen, and apparently even while still residing at Cochiti, he traveled and performed as a bird and animal imitator under the name Chief Evergreen Tree. Charles Lange noted that Sebastián eventually "moved to Wisconsin Dells, Wisconsin, where he took an Anglo wife." He died on October 7, 1972, after a much longer life than any other member of his family.[11]

Cleto and his sons were active in the religious traditions of the community. He and Anastacio were members of the Kwe´rena Society; Anastacio was also a member of the Shi´kame Society; and Sebastián was a member of the Ku-sha´li Society. Like all or most other men from Cochiti, Cleto farmed a small plot of land, and he and his family observed some traditions of the Catholic Church.[12]

Cleto Yurina's career as a carver evolved against this backdrop of traditional life, extreme poverty, the heartbreak of high infant mortality, and other challenges of life in New Mexico in the nineteenth century.

Adolph Bandelier's journal entry for March 28, 1882, includes the first mention of Cleto Yurina by an outsider: "I went to Jacob Gold's in the morning and met two Cochiteños, Toribio and Salvador Arquero. Before them, Cleto, another one, had been in and had given to Gold a little dust or soil, telling him it was good to keep out the wind and prevent storms. The other Indians looked at it and laughed, saying it was *Ha-atze*, earth, and used also [the] word *Q'ashia*, white."[13]

Jake Gold opened his curio business in about June 1881, and Bandelier had visited it earlier in March 1882, noting in his journal, "Jac. Gold has a magnificent collection of Indian goods."[14] Gold became famous as a master salesman. An article by Henry Russell Wray published in the *Philadelphia Ledger* in 1894 described the experience of being drawn into Gold's shop, where you could

buy "the last pair of trousers worn by Columbus, the sword De Soto wore, the hat of Cabeza de Baca or the breastplate of silver worn by Cortez; that is, if Jake thinks you want any of these things after hearing you talk, and 'sizing you up,' he will call into play an eloquence so convincing and an indifference about selling that you fain would believe."[15]

Jake Gold, and his older brother Aaron before him, built their curio businesses on Pueblo pottery and relied on potters of Cochiti and Tesuque—the two Pueblo villages nearest Santa Fe—for a steady supply. In the 1880s, potters at Cochiti made human figurines as well as figurative pitchers and other forms, all unprecedented in the pueblo's ceramic tradition. Potters at Tesuque invented entirely different humanlike figurines, and there is little doubt that the Golds had a role in their evolution and eventual standardization.[16]

Gold sold Tesuque figurines in his shop and wholesaled them to other curio dealers. The first to offer them by mail was H. H. Tammen of Denver, who in an 1882 catalogue illustrated two, of which he said, "They are looked upon by the Indians as gods, such names as the God of War, God of Pain, God of Hunger, God of Plenty, etc., being given them." The naming of Tesuque and Cochiti figurines was common, but it did not originate with Tammen. Jake Gold still referred to Tesuque figurines as "idles" after 1900, and the practice of naming them may have originated with him or Aaron.[17]

Cleto Yurina witnessed and absorbed all of this—the invention of a type of artifact, the naming of individual idols, a compelling style of storytelling, and bartering. He spoke little or no English, though he was fluent in Spanish, as evidenced in Mary Prince's and other people's correspondence.

By 1885, Cleto was carving humanlike and animal figurines from stone, including volcanic tuff and pumice.[18] Those materials were laid down by the eruption 1.14 million years ago of the volcano that survives as the Valles Caldera. An estimated seventy cubic miles of volcanic ash was blown from the volcano, settling deep over a large area in the Jemez Mountains near Cochiti Pueblo. Tuff and pumice are easily worked, and Harrington said that Cleto did all of his carving with a hatchet, though he used other tools, including rasps and pump drills.[19]

Informants told Harrington that Cleto and Reyes worked secretly in a place that today is called Hondo Canyon, which drains into the Rio Grande eight miles north of the pueblo. They said that Yurina's route from there to Santa Fe was overland to Alamo Canyon, the next drainage to the north, then down to its mouth on the west bank of the Rio Grande. They forded the river at that point, hiked to the top of the plateau called the Caja del Rio, and walked east toward the village of Agua Fria.[20]

Yurina, whose idols stood up to 42½ inches tall, used burros as pack animals, as documented in an 1895 letter from H. A. Montfort of Albuquerque to Bradford Prince. Montfort purchased five pieces, probably from Yurina, which he later sold. Prince became aware of this after the fact and asked Montfort for details of the acquisition:[21] "I cannot really give you no information regarding them. The Indians from whom I purchased the Images came in here with several Burros loaded with them, said they had come from a long distance, said they Knew you. Mentioned your name, but I could understand but few words they said, and gained no important information from them[.] [B]ought the images. More as a curiosity than anything. The Idea I received was they had been dug up from some ancient Ruins, but I could not locate the place."[22] Harrington provided another description of Yurina's pack animals: "One time J. D. [John Dixon] caught up with Cleto descending to [Bocandos]. He had 3 burros loaded with sacks on each side & on top. J. D. was riding horseback & did not know what the load was. Cleto & his wife were walking along behind the burros. Loaded like watermelons."[23]

Cleto claimed that he had recovered his idols from ancient ruins on Cochiti land, and the people of Cochiti were aware that Cleto gave them names, just as curio dealers did. Harrington

wrote, as if surprised by the revelation, "It is rumored about the pueblo that Cleto gave each one a separate name, claiming it to be some divinity." Some of Cleto's names, such as El Gran Capitan, were recorded by the Princes and recur in their descriptions.[24]

Yurina's salesmanship was clever and rehearsed, and he sold directly to the Princes. How he managed to make that connection is unknown, though Pueblo potters peddled their wares door to door in Santa Fe from early Colonial times to the early 1900s. Some authors have said that Jake Gold sold Yurina's idols, but no evidence supports that.[25]

The earliest documented encounter between Yurina and Mary Prince is described in a letter from her to Bradford, dated March 5, 1886. Like all of her letters, it is loving and covers family and social news. It is also overflowing with Yurina's storytelling, his testing to ensure that Bradford Prince is not onto him, his preparations for future interactions, his bargaining power, and Mary Prince's uncontrollable desire to own:[26]

> A postal from Newton, Kansas, came this a.m. and, what do you think has happened? Why, Cleto has been here! He came before I was up this morning, weary & worn. He rec'd your first note last Sat'y & the other on Sunday. His wife has a baby six weeks old and he had to help her. He is constantly watched by the people in the Pueblo, and received fifty lashes on his bare back. Kneeling with his arms folded, hands under the arm pits for selling that lion or bear which you have east with you. "Jakie Gold told some men from Cochiti that Cleto sold it and they whipped him taking him first to a hill." So he waited until after dark and then came on foot, resting a little by the way. The weight was more than I could lift. He carried it on his back.

Cleto told Mrs. Prince that he understood that Jake Gold had said that Bradford Prince "tho't all the things [Cleto] brought were new ones and didn't want anything more to do with him." Cleto said he was not going to visit again, but he changed his mind after receiving the letters from Prince. Mary Prince continued with details of his work and his bargaining:

> He brought . . . six of the most remarkable things I have ever seen! An idol larger than our best one with large folded arms. . . . 2nd One about the size of our former best one with chalchuitl [turquoise] mouth and curious light gray eyes—3rd smaller—very curious—of stone to hold in the hand like Folly's clown on a stick—all three have fine necklaces. Then 3 pure white stone articles—two shaped like whales' teeth—and one just like an eels head[,] turquoise eyes[,] red mouth & dark nostrils. I have never seen anything so wonderful. The last three & stones he gave to me for a magnet which I gave him last summer (in exchange)—The others, the idols, he said were worth $5.00 each, but if I would promise to pay him $10.00 for two ($5.00 each) . . . he would let me have two idols for $3.00 each & one for $2.50 and give me everything else he brought.

Mrs. Prince describes making partial payment in cash, and part in clothing ("an old wool coat of yours"), breakfast, food for his dinner, apples, an old doll, and a rattle for the baby.

> In all the money paid for all—and they are wonderful things—was $5.65. I must have $10.00 when he comes in "ocho dias or doce dias" with the other things. He begged me not to say "Cleto nor Cochiti" & I shall neither speak of nor show anything till you return. . . . He says there is a wonderful lion & bear in the estufa [the kiva; of the ruin he claims is the source of the idols] with turquoise tails & eyes—looking over their shoulders heads turned—which he will get some time. He is going to bring everything

to me. I wrote down the names of the idols very hastily, so do not lose the paper I enclose. The Indian names are pronounced as English letters. I wrote them according to the sounds he gave me.

She closes with, "Tell me you are delighted about Cleto! I tell you, dear, things are looking up—for just think what those idols are worth."[27]

This is the richest surviving letter. Others show that Cleto was sometimes accompanied by Reyes; on one such occasion, "Cleto and wife were here 4 or 5 hours—You know how long they keep one. . . . I paid but $10.00 for 18 & gave an old shirt, pants, shoes, a few collars & old suspenders. He wants other shoes & a hat." On another occasion, Reyes and Anastacio "brought 2 remarkably fine idols," and on still another, Cleto said that nine of the idols they offered were his mother's, to suggest that she had collected or owned them.[28] And in a letter of June 26, 1888, Mary wrote, "I did not dare fail to take them for eleven days ago 'Adolfo' [Adolph Bandelier] was at Cleto's house & 'begged & pleaded offered much money if he would take him to the Cañada de Cochiti for idols.' Cleto did not know anything about them [the idols he offered on this occasion]. He is honest with us—I think."[29]

Like Cleto's story of Jake Gold telling men of Cochiti about his selling of idols and being whipped for it, this story about Bandelier was invented to reinforce the cultural importance of the objects, the importance of the transactions, and the need for confidentiality. For months leading up to the date of this letter, Bandelier was in Santa Fe, writing, corresponding, and visiting the Tewa pueblos. He did not go to Cochiti during this period, and in fact Bandelier never mentioned in his exhaustive journals speaking to Yurina about idols.

Another remarkable document is Prince's notes of a conversation with Anastacio on February 28, 1892, when Anastacio was fifteen. Prince notes that Anastacio "Brought belt, armlets & knee 'musica' [rattles?]." Anastacio tells Prince, "These 'armlets' are what the cacique wears when he makes the idols dance. He puts these on. He puts on this belt. He has three of these belts. We got them out of the place (the inner estufa)." Prince continues as follows:

Q[uestion]—Have you seen the idols dance yourself?

A[nswer]—Yes. I am now old enough to be there. The people do not stand near the idols. They stand off on the other side to look. The cacique throws something (motion as of man sowing grain).

Q—Is it meal?

A—I do not know[;] he throws something that way. He wears these things. We got them out. We have got a copy of one of the keys.

Q—You must be very careful.

A—Yes—we saw the place where those dead men are buried. We saw the earth loose.

Q—Do those idols get up to dance?

A—Yes—these one (animals) get up this way (horizontal). These others (men) get up straight.

[rule]

They (5 men, 7 animals) came from 2 miles from Pueblo, on this side River.[30]

Harrington suggested that Cleto Yurina carved all of his idols between 1886 and 1888, while Anastacio was away at school in Albuquerque. However it is clear that the Princes began collecting them by 1885, and evidence shows that Cleto continued carving into the 1890s.[31] In 1890, Prince began promoting the collection through gifts and loans, including an idol he sent to president Benjamin Harrison.[32]

Prince's next loan was to the World's Columbian Exposition, where he sent 99 idols for display. At least some were conspicuous in one of the state's displays (fig. 14.2).[33] As New Mexico's executive commissioner T. B. Mills wrote,

> The exhibit of Gov. Prince's idols attracts considerable attention . . . and [it] is quite amusing to hear Shed Ellsworth, our janitor, explaining the same to the visitors in the following language: "These idols antidate [*sic*] the discovery of America by Columbus, and the period when they were made is so remote that it is not known to man. The ancients to whom they belonged worshiped them with the greatest zeal. . . . Here is the God of love, where the maiden is wooed by her lover. This is the god of rain, here is the god of fortune. . . . They are not the gods of the Aztecs, nor the Pueblos, nor the Cliff Builders, nor the gods of the people of New Mexico, but they are the gods of our worthy ex-Gov. L. Bradford Prince."[34]

Prince also loaned ten idols for display at the Louisiana Purchase Exposition in 1904, and between the expositions, he loaned pieces to the Metropolitan Museum of Art, New York, and to the Smithsonian Institution. Although pieces he loaned to the Met were put on display, the Smithsonian never exhibited any.[35]

14.2. Bradford Prince loaned ninety-nine idols, probably all made by and purchased from Cleto Yurina, for display at the World's Columbian Exposition in Chicago. Some were exhibited in a room with agricultural products from New Mexico, as seen in this detail of a photograph published in *World's Columbian Exposition Illustrated* from December 1893.

In November 1900, Prince wrote Otis Jones of Chicago, "I hereby empower you to dispose of my collection of Idols amounting in number to about sixteen hundred and fifty including the collection at the Metropolitan Museum of Art in New York for Thirty five thousand Dollars. The price should be, as I have stated[,] fifty thousand dollars, but I desire to make immediate disposition of them and hence make this great reduction with the hope that it will secure a quick sale of them."[36]

In 1901, Frederic Ward Putnam of the American Museum of Natural History declined an offer of the collection for thirty thousand dollars, stating that "it would be interesting if Mr. Prince would have a very careful account of the collection published giving with figures of the specimens the data as to the finding of the specimens, and the exact conditions under which they were obtained. That would place his collection on a good scientific basis, and then he would have a better chance of disposing of it."[37]

Putnam was not the first to be suspicious of the idols. In 1893, major John Wesley Powell dismissed Prince's offer to sell one hundred idols to the Smithsonian for fifteen hundred dollars for display at the Columbian Exposition, telling associates that because Prince would not provide collection data, the pieces were "valueless."[38] In her article on Prince and his collection, Patricia Fogelman Lange quoted from Frederick Webb Hodge's unpublished journal, in which he described his encounter with the Prince collection in 1899:

After examining the Prince Coll'n with care I came to the conclusion that very few of them were ancient and that many if not most were made recently & probably for purposes of sale. My surmise was later substantiated by A. F. Spiegelberg [a curio dealer of Santa Fe] who informed me that probably all of them were manufactured by a man named Kleto of Cochiti who has a son named Anastasio. Some of the specimens in the Hist. Soc. rooms are of gypsum, smeared with red paint[,] but are fresh & new where the paint did not penetrate the interstices; these also show undoubted file or rasp marks as well as evidences of fresh metal tool marks. One group has embedded as eyes modern shell beads of native manufacture with small holes drilled with a metal instrument & fastened with fresh gum to which wool fiber adheres.[39]

Suspicion and rumors about Cleto Yurina were prologue to Harrington's probing at Cochiti. Harrington established some facts about Yurina, but in his effort to discredit him, he wove a handful of incidents and comments from some informants into the conclusion that "Cleto, the Indian idol-faker" was an "uneducated Indian," was shunned within his community, "was not a man to do much farming," and "played cards."[40]

A fraud so unique in its nature and conducted on such gigantic scale was never before perpetrated in the history of American archaeology. The idea of forging the "idols" originated in the mind of an erratic Indian named Cleto Yurina, who preferred to associate with Mexicans rather than with his fellow tribesmen and was in need of money for gambling and drinking purposes. Assisted only by his wife, this Indian hacked the images out of stone, working secretly in a wild dell in the mountains north of Cochiti, and smuggled them into Santa Fe on burro back, where he disposed of them to the number of many hundred. The story of the manufacture of the objects is a matter of common gossip among the Indians of Cochiti and among Mexicans living in the vicinity of that pueblo and at Agua Fria, a hamlet situated between Cochiti and Santa Fe. These gossipers consider "idols" too dignified a term to bestow upon the fake images, and commonly dub them "monos," meaning in Spanish "monkeys."[41]

Harrington, in conclusion, stated that the Indians "regard the manufacture and successful passing off of these fakes as the greatest joke ever played by an Indian on the Americans."

Edgar Lee Hewett did not release Harrington's report, which he "never thought best to publish, especially as the collection practically disappeared many years ago, and no contention has been made as to its authenticity." This would have been wise for other reasons, since Hewett was deeply involved in the development of cultural institutions in Santa Fe, and Bradford Prince remained one of the state's most influential citizens.[42]

As late as 1914, Hewett enabled Bradford Prince to cling to his convictions about his idols. In October of that year, the International Congress of Americanists met in Washington, DC. A two-week "postsession excursion" following the conference was planned to take attendees to several cities to visit museums and archaeological sites, ending in Santa Fe. A preliminary agenda for the program in Santa Fe, planned by Hewett and announced in May, included a presentation by Bradford Prince on "Idols and Fetiches of New Mexico."[43]

It was 1916 before the secret knowledge of Yurina's ruse was revealed to the Princes. In a letter of May 2 to Bradford, Mary Prince opened with the fact that she had "Read about the Indian Museum and *return.*" She continued, "Let us sell *all* of our Indian Collections if possible. Mrs. Bandelier will help. I shall try hard about the Idols. *Be sure* & bring on all the Photos of Idols. They are in old trunk in a package. The Idols I should have piled up in our Idol rooms—& the old papers in our own back kitchen. Please take them from the university[.] They will be stolen.

I do not see how the archlog'l people had any right to take them out of the Historical Soc'y rooms. I am feeling better, but *very* nervous."[44]

What Mary Prince read is unclear, but it may have been a letter or telegram, as the matter was not divulged in the press. After this, Yurina's idols suffered several different fates. The collection of the Historical Society of New Mexico (fig. 14.3), which had been exhibited in the Palace of the Governors, was said to have been tossed down a well in the palace courtyard. The Prince collection, much of which was on loan to the historical society, was first moved "under dark of night" to old barracks that were to be demolished for construction of the art museum, which opened in 1917, and promptly moved again to a building in the rail yard that belonged to the University of New Mexico.[45]

When the Smithsonian contacted the Prince's son, William R. Prince, in 1932 regarding the disposition of the old loan, he said, "The only practical use I have found for these Idols is to sell a pair of them to Easterners who come out here and build 'Spanish-Indian' houses, and try to make them look as odd as possible; they have been plastered in on each side of a fire place, or sometimes at the sides of a gate or driveway."[46]

In February 1932, in response to a letter from Alexander Wetmore, William Prince stated that he had no use for his father's loaned idols and did not want them. The museum subsequently destroyed all but three.[47]

14.3. In 1896, the Historical Society of New Mexico published *The Stone Idols of New Mexico*, a small catalogue in which fifteen of the twenty pieces in the society's collection were illustrated. Most of the idols appear to be by a single hand and are more rudimentary in execution than those exhibited at the Columbian Exposition in 1893. They were probably purchased for the society by Bradford Prince from Cleto or Anastacio Yurina.

Perhaps fewer than thirty examples of Yurina's work survive in museums. In Santa Fe, a few are among a collection of stone idols donated by W. Paul Zundel to the Laboratory of Anthropology in 1984. Most others in Zundel's collection appear to be inconsistent with Yurina's work. Some may be the work of Anastacio or Reyes, but evidence suggests that others at Cochiti made idols for sale, including Francisco Semilla, who was cacique between 1886 and 1890.[48]

There is little doubt that Yurina was unusual. Even Bandelier's description of him leaving some earth for Jake Gold hints at that. Marcial Quintana, who ultimately owned and lived in Cleto's home, described Yurina as "muy desvariado" (raving, nonsensical). However, in his business he was crazy like a fox. Harrington dwelled on the fact that Yurina never rose into a higher religious society in the pueblo and did not learn to "doctor," but he was told that Yurina had cured people outside the pueblo, among them the wife of the judge in Peña Blanca.[49]

Harrington concluded that Anastacio had no role in the making of the idols, but this was certainly incorrect. Anastacio was described by several as Cleto's assistant, and Edgar Lee Hewett, who claimed to have known Cleto and Anastacio, said that they made "practically all of the idols in the Prince collection."

The secret workplace in Hondo Canyon is illogical. According to J. Michael Bremer, heritage program manager and archaeologist for the Santa Fe National Forest, the described route from there to Agua Fria would have been "miles and challenging terrain away from any habitation." Contrary to what Harrington was told, Edgar Lee Hewett "knew their workshop under the big cottonwood tree only a few minutes' walk from the pueblo." If that were the case, then instead of taking a long, rough overland route, Cleto would have traveled like all others from the pueblo, going to La Bajada, then north to Agua Fria, where many people from the pueblo had acquaintances who would feed them and even put them up for the night.[50]

One is left to wonder if Harrington's informants were honest with him; certainly Harrington was selective about what he heard. Harrington worked hard to learn how Cleto transported the idols over a hidden and tortuous route, even drawing maps to understand the landscape that his informants described. But well before writing his report, he noted, "Indians merely met him going with them to Agua Fria." Smuggling made for a better story.[51]

What makes Cleto Yurina's idols fake? Did anybody in the late nineteenth or early twentieth century consider Cochiti or Tesuque pottery figurines "fake"? Did anybody believe that the women who made those pieces were "erratic" and attack them for being "uneducated"? Were the dealers who named the potters' figurines "gods" attacked for misleading the public? Jake Gold and, later, his successor J. S. Candelario, were celebrated in the press for their outrageous fabrications about their goods, so why wasn't Yurina seen as a genius for succeeding with the same practice?[52]

The dismissal of Yurina's work has more to do with the embarrassment of the wealthy, the influential, and the scientific than it does with fakery, and Harrington's character assassination is an attempt to excuse gullibility and greed. Harrington described Yurina as a lazy farmer, but he worked hard. Like his father, he never kept still. His idols are not ancestral Puebloan, but they are compelling.

When the archaeologist Marjorie Lambert excavated a well in the courtyard of the Palace of the Governors in Santa Fe in 1956, she did not find any of Yurina's pieces, though she anticipated that she might. She was aware of the folklore surrounding the disposal of the historical society's collection in 1916, as well as all the controversy surrounding Cleto Yurina.[53] To her is owed credit for being the first to recognize Yurina's work as the "folk art" of an "enterprising Cochiti man." She also teased at the preoccupation with authenticity, describing Yurina's idols as "the so-called genuine Indian-made fakes and forgeries."

Yurina is one of the earliest Native American artists from the Southwest whose name we know, and he is to be honored, not condemned.[54]

NOTES

1. Prince was governor from 1889 to 1893. The reader is encouraged to consult an article on the Prince collection and Cleto Yurina's idols by the late Patricia Fogelman Lange, whose approach to the subject was different from that taken here. See Patricia Fogelman Lange, "Cultural Collecting Fever in New Mexico: Figurines and Governor L. Bradford Prince," *Journal of the Southwest* 40, no. 2 (1998): 217–242.

2. Harrington's field notes and the manuscript for his report contain details omitted from his final typescript. John P. Harrington, "The 'Stone Idols' of Cochiti: A [R]emarkable Archaeological Forgery," Santa Fe, NM, unpublished typescript [ca. 1909]. See National Anthropological Archives, "John Peabody Harrington Papers: Cochiti 1909," which can be downloaded as a PDF, https://collections.si.edu/search/detail/edanmdm:siris_arc_363481. This includes field notes, a census taken at Cochiti in 1909, and both versions of Harrington's report. These are cited in the following notes as "NAA" with the image number of the PDF.

3. Census of the United States, 1850; Free Inhabitants, Santana [Santa Ana] County, New Mexico, January 1, 1851, household 873, family 873 [spelled Urino]. Juan's age is given as fifty and Teodora's as forty-seven, the latter being unlikely given the age of the children: Vicento, male, seven; Maria San Juana, female, four; and Antonio Clito, male, one. There is no separate census of Cochiti for 1850, and this portion of the census includes several unidentified communities among which, based on surnames, are Jemez and Zia Pueblos. Harrington noted that Juan Rosario's name was "Huero" (Guero) Yurina, adding that it was a nickname meaning "brown," which is not a recognized meaning, even in slang, today. See Harrington, "'Stone Idols' of Cochiti," 2. *Guero* today often refers to light-skinned individuals but can also be a reference to pale eyes, including light brown.

4. Archives of the Archdiocese of Santa Fe (AASF), Our Lady of Guadalupe Church, Peña Blanca, Microfilm reel 80-A, marriages 1863–1955, 1874, 78. Charles H. Lange, in *Cochiti: A New Mexico Pueblo, Past and Present* (Austin: University of Texas Press, 1959), 517, incorrectly gave the date of marriage as September 28, 1874; he added that both were of the Water Clan. Reyes's mother's surname was also omitted from the

marriage record of her sister, Maria Ignacia (AASF, Microfilm reel 80-A, marriages, 1874, 75). The 1885 Pueblo Agency census gives Cleto's and Reyes's ages as thirty-five, placing Reyes's birth also around 1850. The dates of Anastacio's and Sebastián's births are given by Lange (*Cochiti*, 512, 514). They are in AASF, Peña Blanca, Microfilm reel 78-A, baptisms, 1841–1909, 1876, 319 and 1890, 75. Lange calculated the birthdates by counting back from their ages as stated on the days of their baptisms. Three sons who died in infancy or childhood are José, born about 1880 and named in the census of 1885; Lorenzo, baptized on March 12, 1882, when ten days old (AASF, Microfilm reel 78-A, 1882, 439); and Juan Felipe, born about 1885. I construe Juan Diego, said to be one year of age in the 1886 Pueblo Agency census, and Juan Felipe, said in Pueblo Agency censuses to be age two in 1887 and age four in 1889, to be the same.

5. Anastacio Yurina to Bradford Prince, March 13, 1901. Anastacio signed his name Anastacio Urino. This etter is in New Mexico State Records Center and Archives, Santa Fe, Prince Collection, Historical Notes and Events, Cochiti Idols 1886–1903, folder 4, 14020. In subsequent endnotes, this folder is cited as NMSR-CA. Reyes is not in the census of September 28, 1897. See Frederick Starr, "A Study of a Census of the ueblo of Cochiti, New Mexico," *Proceedings of the Davenport Academy of Natural Sciences* 7 (1897–1899): 33–44. Harrington was told that Reyes and Cleto died about two years apart, and the fact that Cleto was still living in early 1901 suggests that she couldn't have passed away much before 1897. He noted that Cleto "died in 1900 or 1901, in summer, about in Sept." (NAA, field notes, PDF image 88). On the same page, he gave Cleto's and Reyes's Keres names.

6. Anastacio presumably attended the Albuquerque Indian School (see NAA, field notes, PDF image 218). I found no marriage record for Anastacio and Dominga, identified as Dominga Yurina in the 1898 and 1899 Indian Agency censuses. In the 1900 federal census, Anastacio is shown living in dwelling 27 with Dominga Benado, said to have had no children. He is also shown living in dwelling 50, Cleto's house, with Dominga Quintana, who is said to have had and lost three children. Entries in the 1898 and 1899 censuses for both Dominga Quintana and Dominga Yurina make it clear that Dominga Yurina and Dominga Benado are one and the same. Otherwise the facts are irreconcilable. According to Lange, monogamy was universal and not violated at Cochiti. See Lange, *Cochiti*, 367, 411. Harrington's informants told him that Anastacio's first wife died shortly after their marriage (NAA, field notes, PDF images 172, 205).

7. AASF, Peña Blanca, Microfilm reel 80-A, marriages 1863–1955, 1901, 239. The different spellings, Cordera for Inez and Cordero for her father, are as stated in the marriage record. That Inez died is in NAA, field notes, PDF images 172, 205. The marriage to Victoria (also Vitoria) is on Microfilm reel 80-A, marriages, 1903, 248.

8. Luis was said to be ten days old at the time of his baptism (AASF, Peña Blanca, Microfilm reel 78-A, baptisms, 1841–1909, 1904, 367). According to Harrington, Anastacio died shortly after his father; he was counted in the 1904 Indian Agency census, but there is no further evidence of him. The census is undated, though in most years the count was taken by midyear.

9. Description of Luis in NAA, MS of report, PDF image 269. Inhabitants of the households are from the Indian Agency census of Cochiti, 1906. Miguela was baptized at Peña Blanca on June 4, 1881, when she was said to be eleven days old (AASF, Peña Blanca, Microfilm reel 78-A, baptisms, 1841–1909, 1881, 128). Cleto's household and Miguela's status as an orphan are in Starr, "Study of a Census," 40.

10. NAA, field notes, PDF image 60; MS of report, PDF image 269.

11. According to Starr, Sebastián's name meant "Great Pine" ("Study of a Census," 40); according to Harrington it meant "Douglas Spruce" (NAA, MS of report, PDF image 268); and according to Lange it meant "Evergreen" (*Cochiti*, 512). Harrington learned that Sebastián had left to work at Rocky Ford (NAA, MS of report, PDF image 172). Given the fact that Sebastián lived at the pueblo from 1910 to the 1930s, one wonders whether he went to Colorado to avoid Harrington. He probably left the pueblo permanently by 1939, when he was listed as an addition to the census and identified for the first time as married. See Lange (*Cochiti*, 512) regarding his wife. For his death, see findagrave.com, entry number 111337602 (accessed September 25, 2019). When grown, Luis adopted the spelling Louis.

12. For information on these societies, see Lange, who documented their membership (*Cochiti*, 512–514). Harrington also mentions that Cleto was a member of the Kwe´rena Society (NAA, field notes, PDF image 94). I have spelled the societies' names as in Lange (*Cochiti*); they do not conform to contemporary Keres standards.

13. Adolph F. Bandelier, *The Southwestern Journals of Adolph F. Bandelier, 1880–1882*, ed. Charles H. Lange and Carroll L. Riley (Albuquerque: University of New Mexico Press; Santa Fe: School of American Research and Museum of New Mexico Press, 1966), 244.

14. Jonathan Batkin, *The Native American Curio Trade in New Mexico* (Santa Fe: Wheelwright Museum of the American Indian, 2008), 29. Bandelier, *Southwestern Journals*, 238.

15. Wray's article, "A Gem in Art," was reprinted in the *Weekly New Mexican Review*, June 21, 1894.

16. For information on the curio trade in Santa Fe, the figurative ceramics of Cochiti and Tesuque, and the marketing and standardization of Tesuque figurines, see Jonathan Batkin, "Tourism Is Overrated: Pueblo Pottery and the Early Curio Trade, 1880–1910," in *Unpacking Culture: Art and Commodity in Colonial and Postcolonial Worlds*, ed. Ruth B. Phillips and Christopher B. Steiner (Berkeley: University of California Press, 1999), 282–297; Batkin, *Native American Curio Trade*; and Jonathan Batkin and Patricia Fogelman Lange, "Human Figurines of Cochiti and Tesuque Pueblos, 1870–1920: Inspirations, Markets, and Consumers," in *Clay People: Pueblo Indian Figurative Traditions*, ed. Jonathan Batkin (Santa Fe, NM: Wheelwright Museum of the American Indian, 1999), 40–63.

17. H. H. Tammen, *Western Echoes: Devoted to Mineralogy, Natural History, Botany, &c, &c.* (Denver: H. H. Tammen, 1882); Batkin, *Native American Curio Trade*, 56.

18. Bandelier reported, "A very interesting find was made at this pueblo in 1885, by Governor L. Bradford Prince of New Mexico, who obtained a number of stone idols, rudely carved human figures, some of them of large size, belonging to the kind called by the Queres Yap-a-shi." See Adolph F. Bandelier, *Final Report of Investigations among the Indians of the Southwestern United States, Carried on Mainly in the Years from 1880 to 1885: Part II, Papers of the Archaeological Institute of America* (Cambridge, MA: J. Wilson and Son, 1892), 152. In 1886, Bandelier borrowed some of Prince's idols to paint them for his monumental history of the colonization and conversion of the Native peoples of the Southwest. See Bandelier, *Southwestern Journals*, 138–140. For his history, see Adolph F. Bandelier, *A History of the Southwest: A Study of the Civilization and Conversion of the Indians in Southwestern United States and Northwestern Mexico from the Earliest Times to 1700*, ed. Ernest J. Burrus, SJ, vol. 1, *A Catalogue of the Bandelier Collection in the Vatican Library* (Rome: Jesuit Historical Institute, 1969). See also note 48 below.

19. Harrington, "'Stone Idols' of Cochiti," 7.

20. Ibid., 8. Based on his informants' input, Harrington insisted that only Reyes assisted Cleto, but others stated categorically that Anastacio helped. The coordinates of Hondo Canyon at its mouth on the Rio Grande are N 35.694247°, W -106.298673°. The coordinates of Alamo Canyon at its mouth are N 35.715825°, W -106.291245°.

21. For the fact that Montfort acquired five pieces and later sold them, see Historical Society of New Mexico, *The Stone Idols of New Mexico: A Description of Those Belonging to the Historical Society* (Santa Fe: New Mexican Printing Company, 1896), 9. A figurine in the Prince collection said to be 42½ inches tall is described in the same publication (ibid., 15). In a small manuscript catalogue of their collection written in 1886 (in NMSRCA), the Princes described other pieces as tall as 30 inches, though many were much smaller. Montfort, an undertaker and embalmer, converted some of his business space to the selling of Indian curios in 1888 (Batkin, *Native American Curio Trade*, vii).

22. Montfort to Prince, May 15, 1895, NMSRCA.

23. NAA, field notes, PDF images 92, 130. John Dixon's Spanish name was Juan de Jesus Pancho. He was one of two young men from Cochiti who went to Carlisle Indian Industrial School in Pennsylvania in the early 1880s. The other was Santiago Quintana. At Carlisle they were assigned the names John Dixon and Cyrus Dixon, though they were not closely related (Lange, *Cochiti*, 30). Harrington stated that Bocandos was just west of Agua Fria, and that Cleto would have encountered the first Mexican dwellings there while crossing the Caja del Rio. The name does not survive, and its location is unknown. Harrington was told that "some Mexican families used to live at Bocandos and plant corn there," and that the name meant "two (cañadas) have their mouths" (NAA, field notes, PDF image 175; NAA, MS of report, PDF image 276).

24. NAA, MS of report, PDF image 278. Various lists of idols are in NMSRCA. Yurina also assigned Keres names to some idols that he sold to the Princes, which they recorded phonetically.

25. On Pueblo potters peddling their wares in Santa Fe, see Jonathan Batkin, *Pottery of the Pueblos of New Mexico, 1700–1940* (Colorado Springs, CO: The Taylor Museum of the Colorado Springs Fine Arts Center, 1987), 25. Lange states that the 1886 manuscript catalogue of the Prince collection identifies Gold as one of their sources ("Cultural Collecting," 223–224). A single entry references a piece acquired in July 1886, "From Jose Arquero via J. G.," which suggests that the piece was not by Yurina.

26. Mary Prince to Bradford Prince, March 5, 1886, NMSRCA.

27. Ibid.

28. Mary Prince to Bradford Prince, June 19 or 29 (year not indicated); July 7, 1888; and September 8, 1887, NMSRCA. Cleto's mother Teodora is listed as living with Cleto and Reyes in the 1886 Pueblo Agency census.

29. Mary Prince to Bradford Prince, June 26, 1888, NMSRCA.

30. Bradford Prince, notes of interview with Anastacio Yurina, February 28, 1892, NMSRCA.

31. Harrington, "'Stone Idols' of Cochiti," 6. See note 18, above, for Cleto's work made as early as 1885. In September 1892, A. F. Spiegelberg, a curio dealer in Santa Fe, wrote H. W. Henshaw of the Bureau of Ethnology, stating that he "might be able to obtain some stone idols for $5.00 each if interested" (Lange, "Cultural Collecting," 238n21). Spiegelberg later told Frederick Webb Hodge that "probably all" of the pieces in the Prince collection were made by Cleto and Anastacio (ibid., 226).

32. Receipt of the idol and Prince's accompanying letter was acknowledged by Harrison's personal secretary, Elijah W. Halford, in a letter to Prince on Executive Mansion letterhead on February 14. It is not explicitly stated that the idol was a gift, but it is presumed to have been one.

33. This image was printed in the magazine World's Columbian Exposition Illustrated 3, no. 10 (1893): 262. It was later printed in Campbell's Illustrated History of the World's Columbian Exposition (Chicago: N. Juul, 1894), 461.

34. "The World's Fair: Executive Commissioner T. B. Mills Writes of the New Mexico Exhibit at the Great Exposition," Santa Fé Daily New Mexican, June 26, 1893, 1.

35. Bradford Prince's loans are documented in correspondence throughout his papers in NMSRCA. Harrington stated that the Smithsonian never exhibited any of the idols from Prince (NAA, MS of report, PDF image 280). Lange states that the consul general of Spain requested that Prince lend his collection of "Gods" to the Madrid Exposition, which is correct (letter from Calvin D. Van Name, New York, to Prince, February 10, 1892, NMSRCA), and that fifty-eight were exhibited there, which is incorrect. There is no evidence in any reports of the Columbian Historical Exposition that idols from the Prince collection were exhibited in Madrid, and there is no document suggesting that in NMSRCA. Lange apparently misconstrued Prince's notes on letterhead of the World's Columbian Exposition Managers of New Mexico, which was the local organizing committee for the Chicago exposition, as an inventory of pieces for display in Madrid. Lange cites fifty-eight pieces, which constitute the total on the first of two pages of idols listed by Prince for his loan to Chicago.

36. Autograph draft written on letterhead of Palmer House, Chicago, November 24, 1900, NMSRCA.

37. Frederic Ward Putnam to Joseph R. Putnam, President of Board of Trustees, Chicago Academy of Sciences, March 12, 1901, NMSRCA.

38. Lange, "Cultural Collecting," 238n21.

39. Lange locates the journal in Hodge's papers at the Southwest Museum, now the Autry National Center (ibid., 226).

40. Harrington also went on at length about Yurina failing to gain membership in a higher religious society at Cochiti, though he didn't establish that Cleto sought membership. NAA, field notes, PDF image 93; NAA, MS of report, PDF images 261–265.

41. Harrington "'Stone Idols' of Cochiti," 1–2.

42. Ibid.; and Edgar Lee Hewett to Lansing Bloom, 1938, quoted in Lange, "Cultural Collecting," 227.

43. "People from All Nations to Come: Santa Fe Expects a Unique Gathering at Congress of Americanists," Las Vegas Daily Optic, May 23, 1914, 2. It is unclear whether events in Santa Fe played out as planned.

44. Mary Prince to Bradford Prince, May 2, 1916, NMSRCA. I was unable to determine what Mary Prince read about the return of idols, but it may have been a communication from the Historical Society of New Mexico.

45. It is unlikely that disparagement of the Prince collection would have appeared in the press, and I have found no evidence of it, though the Santa Fe New Mexican for April 30, 1916, is lacking in the run of the paper held by the Fray Angélico Chávez History Library. That run is the source of microfilm nationwide, and no other institution has issues of the paper from April 1916. Lambert describes the "folklore" regarding the collection in the well; see Marjorie Lambert, "The Wells in the Palace of the Governors Patio and the Excavation and Repair of Well I. LA 4451," in Southwestern Culture History: Collected Papers in Honor of Albert H. Schroeder, ed. Charles H. Lange (Albuquerque: Archaeological Society of New Mexico, 1985), 221. Lange

misread Lambert, stating that the well she excavated is the one into which the collection was thrown, that she excavated it in 1971, and that she found some of Yurina's pieces and returned them to the well ("Cultural Collecting," 228). All of those assertions are incorrect. Lambert excavated one of two wells in the courtyard in 1956. She found no stone idols and explained that if the story were true, the pieces were tossed into a much larger and earlier well in the courtyard, which has never been excavated. See Lambert, "Wells in the Palace," 221. As of 1896, the historical society's own collection included twenty pieces, and they held on loan "a considerable portion" of the Prince collection, "available for public inspection (Historical Society of New Mexico, *Stone Idols*, 8–9). Harrington stated that the loan included hundreds of Yurina's pieces (NAA, MS of report, PDF image 261). Lange cites a 1932 letter from Jesse Nusbaum to Neil Judd, in which he describes being ordered by Hewett to move the pieces from the historical society's exhibits at night, and moving them twice ("Cultural Collecting," 230). It is unclear how long before Mary's letter to Bradford the collections were moved.

46. Lange, "Cultural Collecting," 230–231. She suggests that in his letter to Judd, Nusbaum claimed that some of the pieces were stolen from the university building and used as William Prince described.

47. Ibid., 238n21. Lange states that all of the idols were destroyed but illustrates two pieces in the museum's collection. Robert Pruecel states that of the pieces sent by Prince to the Smithsonian, all but three were destroyed. See Robert W. Pruecel, "Manufacturing Desire: Cleto Yurina and His Cochiti Figurines," *Contexts: The Annual Report of the Haffenreffer Museum of Anthropology* 41 (2016): 16.

48. Zundel claimed his pieces were from the Prince collection, though he acquired them over a period of many years and did not provide substantiating documentation; several are heavily abraded or eroded. Several of Yurina's idols are in Brown University's Haffenreffer Museum (Pruecel, "Manufacturing Desire"). Lange, who also felt that many pieces in the Zundel collection were not by Yurina, named museums where she located his work ("Cultural Collecting," 230). In 1886, Adolph Bandelier showed one of his paintings of idols from the Prince collection (see note 18, above) to a man from Cochiti, who told him the idols were "medicine gods which they use in case of sickness. The cacique keeps them" (Bandelier, *Southwestern Journals,* 138–140). Another informant gave the same Keres name for the idols, telling him that the "cacique used them for curing and is manufacturing them at Cochiti for sale!" (Bandelier, *Southwestern Journals*, 153). Cleto Yurina identified Francisco Semilla as that cacique, also telling Bradford Prince that Semilla's son was named Rafael ("Cleto, June 30, 1898," NMSRCA). Harrington also stated that Rafael was the son of Francisco (Harrington, NAA, field notes, PDF images 222–233). Lange (*Cochiti*, 457) identified Rafael as a cacique, but the earliest cacique he could identify was Guadalupe Romero, who assumed the position in 1890. Semilla was Romero's predecessor (NAA, field notes, PDF image 222).

49. Marcial's comment is in NAA, field notes, PDF image 168. The judge's name was apparently Luterio Leyba (NAA, field notes, PDF image 167). In the 1880 federal census of Peña Blanca, a Luterio Leyba, age eleven, is named. The 1890 federal census does not exist, and Leyba is not named in the 1900 census. However it is conceivable that this person was a judge by the mid-1890s. Harrington was also told that "Cleto once treated Juan Antonio Lucero, a Mexican residing in the Cañada de Cochiti, and cured him of acute stomach trouble, making him vomit two gobs of black-looking stuff, which gave the patient immediate relief" (NAA, MS of report, PDF image 265).

50. Both quotes from Hewett are from a 1938 letter to Lansing Bloom (Lange, "Cultural Collecting," 227). Bremer's comment is from a personal communication, October 2, 2019. According to Harrington, "The Indians all have certain 'amigos' at Agua Fria, at whose houses they often become guests . . . [they] will stop to get a meal of victuals, warm themselves at the fire . . . or perhaps stop to feed their horses, or perhaps stay over night" (NAA, MS of report, PDF image 265).

51. NAA, MS of report, PDF image 262; NAA, field notes, PDF image 167.

52. On Candelario, see Batkin, *Native American Curio Trade*, 60, 75.

53. See note 45, above.

54. Nobody with the name Yurina is at Cochiti today, and Cleto's story is forgotten. Personal communication from Robert Pruecel, October 27, 2019, based on a conversation he had with Joseph Suina of Cochiti in about 2014.

15

Conquest, Reconquest, Deconquest: Colonial and De-Colonial Imaginaries along El Camino Real de Tierra Adentro

TEXT BY ENRIQUE R. LAMADRID

PHOTOGRAPHS BY MIGUEL A. GANDERT

Cultural Memory on the Plaza

For four centuries along El Camino Real de Tierra Adentro, the Native and mestizo peoples of northern Mexico and New Mexico have dramatized their political and cultural struggles in festival and ritual display (fig. 15.1). Conquest and reconquest, resistance and capitulation are recurring themes in the intangible cultural heritage of the vast region. Victory and morality plays, ritual dance, and even contemporary civic "fiesta" parades utilize mimetic portrayals of cultural selves and others, including Christians, Muslims and Jews, Aztecs and Comanches, Spaniards and Anglos.[1] Alterity, hybridity, and identity are negotiated on the plaza and in the cultural imagination. To read cultural narratives and metaphors more deeply, we must follow them beyond the documents of history and literature and into choreography, costume, ritual, and song. Collective memory is profound in a contested region at the edges of empire, where conquerors are conquered in turn, and where discourses of power morph into discourses of survival. Indo-Hispano cultural knowledge has much to contribute to a global conversation about the limits of empire in our own times.

OPPOSITE

15.1. *Santiago Matamoros y su gente* (Saint James and his people), Jesús María de los Dolores, Aguascalientes, México, 2009.

Ritual Inventories

From over a decade of fieldwork on the *fiestas* (feast days), devotions, and pilgrimages of the Camino Real de Tierra Adentro, five types of celebrations have emerged. In this chapter, the first two will be discussed in the cultural context of two of the saints from the Devociones section below, San Juan Bautista (Saint John the Baptist) (fig. 15.2) and Santiago (Saint James).

Morismas: Teatro de la Reconquista (**Theater of the Reconquest**)

First documented in Coatzacoalcos on the Gulf of Mexico in 1524,[2] sixteenth-century pageants of Moros y Cristianos (Moors and Christians) were commemorative events with titles such as

257

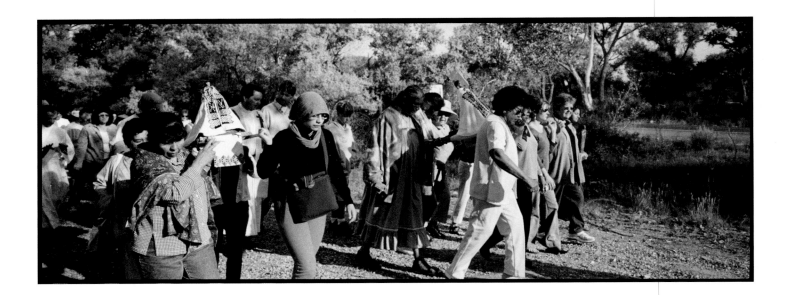

15.2. *San Juan en el sendero al Río Grande* (Saint John on the path to the Rio Grande), San Juan/Ohkay Owingeh Pueblo, Nuevo México, 2005.

"The Conquest of Rhodes" (Mexico City 1539) and "The Conquest of Jerusalem" (Tlaxcala 1939). In the latter, fifteen hundred or more Tlaxcalan warriors reveled in the role of Christian soldiers, liberating the "Holy City" from the invading Turks who occupied it. The spectacles featured boisterous combat and battle harangues, and ended with scenes of conversion and baptism. They were meant to demonstrate Spanish dominion but could easily be read as allegories of liberation by the Natives.[3]

After many months of delays on the trip north from Zacatecas in 1598, the colonizing expedition of don Juan de Oñate performed its own specially composed version of Moros y Cristianos twice: once after crossing the Rio Grande and entering Nuevo México near El Paso in April, and again in September at San Juan (Ohkay Owingeh) Pueblo, the first capital of the kingdom.[4] Native audiences did not fail to notice that the mock battles were harmless and the enemies of Spain were accepted as brothers if they repented and were baptized.

In subsequent centuries, the *morismas* were appropriated and ritualized and performed on religious feast days by indigenous and mestizo communities as emergent, evolving expressions of cultural resistance and militancy (see fig. 15.1).

Matachines: Danza de la Reconquista (**Ritual Dance of the Reconquest**)

The greater Mexican tradition of the morisca (Moorish) dances dramatizes the interactions of Christianity and Native religion, and is part of the "culture of conquest."[5] Cultural historians and dance ethnographers have identified three styles of matachines: *la danza de la pluma* (dance of the plume), performed in southern and central Mexico;[6] *la danza de la flecha* (dance of the arrow), performed in northern Mexico as far north as Tortugas, New Mexico;[7] and *la danza de la palma* (dance of the palm), performed from the Sierra Tarahumara of Chihuahua north to Northern New Mexico.[8]

Characters in the dance dramas include twelve militant spirit dancers; grotesque ancestral guardians called *abuelos* and *viejos* (grandfathers and old men); the *toro* (bull), totem of Imperial Spain, often infantilized as a *torito* (little bull) played by a little boy; and La Malinche, the little girl who represents the first Christian convert.

La danza de la pluma (fig. 15.3) is named for the plumed headdresses dancers wear. *La danza de la flecha* is named for a percussion instrument that resembles a bow and arrow, and features colorful reed-laced skirts and the animated interaction of the ancestral *viejos* with multiple *malinches*.

15.3. *Danzantes de la pluma* (Dancers of the feather), Bracho, Zacatecas, México, 2008.

Named for the trident wand carried by dancers, *la danza de la palma* includes all of the characters plus the *monarca* (king), associated with Moctezuma, and features the pursuit and death of the *toro* at the hands of a single *malinche* and the *abuelos*.

Pastorelas: A Cycle of Traditional and Contemporary Shepherds' Plays

Called upon by San Miguel Arcángel (Archangel Saint Michael), the *pastores* (shepherds) travel to Bethlehem in search of epiphany, the metaphor for the tribulations of all humanity, allied with angels and besieged with devils. San Miguel defeats *el demonio* (the devil), clearing the road for the shepherds. In these plays, the Jewish cultural other and its implied Native counterpart resist then embrace the prophet child destined to become the new Messiah.

Comanches: Commemoration of the Comanche Wars of the Eighteenth Century

This ceremonial complex includes ritual mimetic dance in all the eastern and western Indian Pueblos and in many Nuevomexicano communities, including the *genízaro* (janissary) community of Ranchos de Taos (fig. 15.4).[9] One of the major themes is the redemption of captives.

In the Comanches' Nativity play, a wandering group of Comanches stumbles across a village where the Noche Buena (Christmas Eve) vigil is being celebrated. The wary hosts invite them inside, where they dance for the Santo Niño (Holy Child). As they dance, they fall in love with him, take him captive, and attempt to flee, pursued by the hosts.[10]

In addition to dance and Nativity plays, a spectacular equestrian drama titled *Los Comanches* employs the same plot structure of Moros y Cristianos to portray the 1779 military defeat of the seemingly invincible Comanche war chief Cuerno Verde (Green Horn), paving the way toward a diplomatic settlement with the Comanches (fig. 15.5).

Devociones: The Santos (Saints) of the Camino Real

This constellation of saints reflects the cultural and religious history of northern Mexico and New Mexico. Marian devotions include the Guadalupe, reminder of the journey from *castizo* (pure Spanish caste) to mestizo (mixed blood caste) consciousness, and Nuestra Señora de los

15.4. *La rueda: Baile de los cautivos* (Circle dance of the captives), Ranchos de Taos, Nuevo México, 1995.

15.5. *La última batalla del jefe de guerra Cuerno Verde* (Last battle of war chief Green Horn), Alcalde, Nuevo México, 1999.

Dolores (Our Lady of Sorrows). Devotions to the Christ include El Señor de Mapimí (the Lord of Mapimí), a crucified Christ portrayed as victim of and protector against Indian attack; El Señor de Esquipulas (the Lord of Esquipulas, Guatemala), crucified on the tree of life; and the contemplative Jesús Nazareno (Christ the Nazarene), tried, bound, and crowned with thorns in the midst of his passion. On the northern frontier, the suffering Christ becomes a reminder of the hardships and heroics of subsistence in the desert, a metaphor for transcendence and survival. Notable also is the emergence of a broad-based devotion to the Santo Niño de Atocha (Holy Child of Atocha), the miraculous Christ child who embodies emancipation from the

Moors in Spain, and liberation from Spain in Mexico. Evangelization and conquest are mediated by San Juan y Santiago (Saints John and James). San Francisco y Antonio (Saints Francis and Anthony) are the guardians of the Franciscan missionary provinces of the north. And San Lorenzo (Saint Lawrence) is protector and redeemer in the Indian wars and huge rebellion of 1680 that engulfed not only New Mexico but also the entire northern frontier. A large complex of devotional practices includes the ubiquitous Holy Week and Christmas, saints' day festivals, and the processions and pilgrimages that bind together a geographical area the size of Europe.

Strategies of Conquest: Sangre y Fuego versus a Theatre of Persuasion

Festival and ritual are persistent but never static. Changes reveal much about people adapting to new human and physical landscapes. With time and forbearance, even invaders can eventually become indigenous to a place. Evolving devotions to San Juan and Santiago are a case in point.

In the summer of 1598, the exhausted and grateful families of the Oñate expedition were treated to the food and fellowship of traditional Tewa hospitality at the Pueblo of Ohkay Owingeh near the confluence of the Río Chama and Río del Norte. When don Juan named the pueblo San Juan de los Caballeros (St. John of the Knights), historians have always assumed it was in gratitude for the generosity of the Indians that the poet Gaspar Pérez de Villagrá praised in his epic poem *La verdadera historia de la conquista de la Nueva México* (The true history of the conquest of New Mexico), published in Madrid in 1610.[11] The naming of Nuevo México's first capital is actually part and parcel of a larger devotion to the saint who baptized Jesus and became the first minister and martyr of his cousin's new religion. Oñate and his knights were members of a *cofradía* (confraternity) called Caballeros de San Juan that they brought north from Zacatecas. They celebrated their first *fiesta* of the Baptist Saint on June 24, with a spirited round of *juego de cañas* (game of reeds), a mounted jousting game with reed lances.[12] In September, after a makeshift church was finished, they celebrated with a complete equestrian play written by Captain Farfán de los Godos in the style of the equestrian games of Moros y Cristianos. The script did not survive, but a description of the production is in Villagrá's poem. The poet noted that in front of an audience of amazed Indians, the horses galloped and firearms exploded. Beyond flash and fury, shock and awe, the main lesson gleaned by viewers was that, impressive as they were, the cannons and harquebuses caused no harm. Ironically, only four months later, in the rebellion and tragic siege of Acoma Pueblo in January of 1599, scores of warriors fell to gun and cannon fire as they charged the Christian soldiers, unafraid.

In the twentieth-century performances of Moros y Cristianos in Alcalde and Chimayó, New Mexico, after a furious battle with "fifty thousand soldiers" represented by about twenty mounted actors, nobody is killed either. The Christian King Alfonso refuses to pay ransom for the cross that the Moors have stolen and wins it back, along with the soul of the *sultán* after the battle (fig. 15.6). In this wishful scene, he has had many names across the centuries, including Boabdil, Ozmán, Suleiman, Selim, and more lately, Saddam and Osama. The *sultán* embraces the cross and pleas for mercy:

Cristiano, ya tu valor Christian, your valor
me tiene a tus pies postrado, has me prostrate at your feet,
te pido por vuestra cruz I ask you by your cross
y por tu Dios venerado, and for the God you venerate,
que me des la libertad that you give me my liberty
que yo estoy desengañado, for I have seen the light,
que solo tu Dios es grande for only your God is great
Mahoma todo engaño. Mohammed all deception.[13]

15.6. *Conversión del Gran Sultán* (Conversion of the Great Sultan), Chimayó, Nuevo México, 1993.

15.7. *La conversión y bautizo de Argel de Ozmán* (Conversion and baptism of Argel de Ozmán), Bracho, Zacatecas, México, 2006.

He repents, renounces Mohammed, and is welcomed as a new convert to Christianity. The "public transcript" in the minds of the settlers is all about the propagation of the faith. The "hidden transcript" in the minds of the Indian audience is more practical: embrace the cross and your lives will be spared.[14]

Twelve hundred miles down the Camino Real in Zacatecas, another quite different performance of Moros y Cristianos is celebrated, La Morisma de Bracho. The Cofradía de San Juan Bautista in Zacatecas, which numbers over fifteen thousand members, stages a *sangre y fuego* (blood and fire) production, the metaphor for military campaigns of no quarter. The performance of La Morisma takes three days, involves eight thousand costumed participants, and

15.8. *Armando de Guzmán y la cabeza de Ozmán* (Armando Guzmán and the head of Ozmán), Bracho, Zacatecas, México, 2006.

culminates on August 28, the feast day of La Degollación de San Juan, the martyrdom and decapitation of John.

The voluminous script begins with Charlemagne, Roland, and the Twelve Peers of France, and ends eight centuries later with the defeat of the Ottoman Empire in the Battle of Lepanto. Much blood flows, and clouds of gunpowder smoke hang over the battlefield littered with "corpses" after each engagement. In the last scene, within the last fifteen minutes, *sultán* Argel de Ozmán is defeated in battle by Armando de Guzmán, repents, converts to Christianity, is baptized, and is then beheaded (fig. 15.7). In a triumphal procession, his head is paraded around the battlefield impaled on a lance. The iconographic counterpart in the *fiesta* is the severed head of John the Baptist displayed in niches in local churches (fig. 15.8).

Why are the two *morismas* so different? In Zacatecas the emphasis and the "public transcript" is on suffering, victory, and martyrdom. There seems to be no "hidden transcript" because there are no Indian viewers. The population of Zacatecas is almost entirely mestizo, since the local Indians were eliminated in the Chichimeca wars of the sixteenth century. They play all the roles, including Christians, Moors, and Turks (fig. 15.9).[15]

In New Mexico, where there were and are Indians present, a different aspect of San Juan is observed with his patronal feast on June 24, where he presides as the lord of the summer solstice, a solar feast common to world religions. In recent years, the New Mexican Moros y Cristianos has been celebrated on the feasts of Santa Cruz (the Holy Cross) on May 3, and Santiago on July

15.9. *Vanguardia de los Turcos* (Vanguard of the Turks), Bracho, Zacatecas, México, 2006.

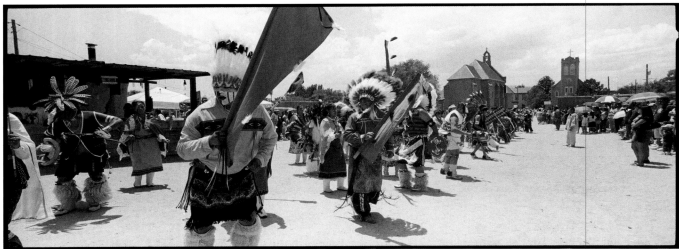

15.10. *Comanches de verano, Fiesta de San Juan* (Summer Comanches, Saint John's Feast Day), San Juan/ Ohkay Owingeh Pueblo, Nuevo México, 2005.

25. What began as a triumphalist display of power in Colonial times has evolved into a discourse of resistance for Nuevomexicanos reclaiming the Spanish language and expressing pride in culture and homeland now dominated by Anglo Americans. Across the valley in San Juan (Ohkay Owingeh) Pueblo, their patron saint, John the Baptist is honored with ritual bathing, processions, and Summer Buffalo and Comanche dances (fig. 15.10).

De-Colonial Moments: Santo Niño Cautivo, Postmortem Castration, and the Transfiguration of Santiago

Where *morisma* narratives are rich with scripted texts, other celebrations, such as the Matachines dances and all of the saints' festivals, are rich with choreography and a kinetic play of symbols. Words become contextual and hover at the edges of the festivals. In several key fiestas, dramatic actions conspire to contest and dismantle the colonizing visions of signification and submission they were assembled to transmit.

Los Cautivos, Silence, and Power

The wars of the Reconquista, in Spain, New Spain, Mexico, and New Mexico, were as much about the taking of captives as they were about securing borders or territory. In the *morismas* that represent them, *cautivo* (captive) characters are seen on the sidelines of the battles fought over them. In *Los Comanches* the equestrian play, several astonished captive Pueblo girls watch the fray in silence, knowing they are the cause of it. In *Los Comanches* the Christmas play, even though the newborn is closely watched almost all night, the adoring Comanches, who manage to distract the infant's guardians, take him captive. The Santo Niño Cautivo is transformed by his captivity and is instrumental in mediating conflict and strife (fig. 15.11).

After the roar of battle dies down during La Morisma de Bracho, multiple hostage Holy Children appear among the ranks of soldiers. The Turkish soldiers tenderly display the Santo Niño Cristiano they have captured. When Christian soldiers redeem and recapture the child, his clothing is the sign of his transformation. He has become El Santo Niño Moro (the Moorish Holy Child), and his new clothing is emblematic of his transformative work among the Muslims—all in silence (figs. 15.12–15.13).

El Torito: The Bull of Empire Infantilized and Castrated

In the Matachines dances performed in the upper Rio Grande Valley, from Las Cruces to Northern New Mexico, apart from the situational comments of the crowd, the only words in evidence refer to characters, moments in the dance, and details of the costumes. The various movements of the dance, each with distinctive violin and guitar music, are named for choreographic elements or for the main character featured. La Entrada (The Entry) is the first movement, and La Cruz (The Cross) features the dancers in a cruciform formation. El Monarca (The Monarch) features the animated dancing of the king, also known as Moctezuma, while La Malinche highlights the criss-cross journey between the lines of dancers of an angelic little girl dressed in white said to be the king's bride or daughter. She shares her name with the consort of Cortés, but she plays the role of angel, not traitor. In Mesoamerican ritual, La Malinche is a powerful female teacher who presides over great changes.[16] The movement called El Toro features the defeat, death, and

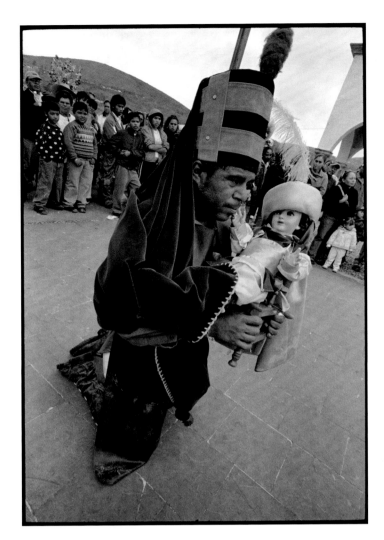

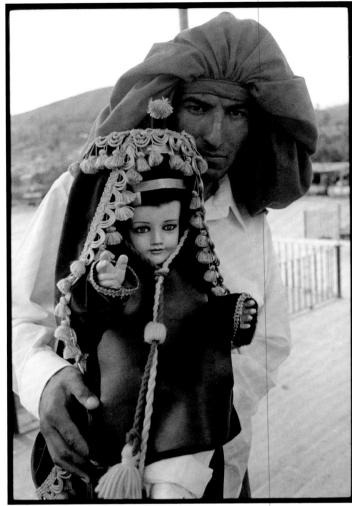

15.12. *Soldado cristiano con Santo Niño Moro* (Christian Soldier with Moorish Holy Child), Bracho, Zacatecas, México, 2006.

15.13. *Soldado turco con Santo Niño Cristiano* (Turkish soldier with Christian Holy Child), Bracho, Zacatecas, México, 2006.

castration of the bull by the *abuelos*, or masked ancestral clown spirits. The *matachines* or *danzantes* (ritual dancers) are spirit warriors ten or twelve in number said to represent the Disciples of Christ or the tribes of Israel or Mexico. Their costumes include a headdress decorated with saints and fringe, which hangs down the back with ribbons, and a crown shaped like a bishop's mitre. The term for it is *cupil*, the Nahuatl word for "crown," for it is constructed not like the mitre but like the crowns that Aztec nobles wore as pictured in the codices, with a curved front piece attached to a headband. The *guaje*, or gourd rattle, they carry in the left hand is another word of Nahuatl origin, further evidence of mestizo or Native origins. In the right hand dancers carry a *palma*, literally a palm frond or trident sword said to represent the Holy Trinity that they swirl in elegant arabesques. In iconographic terms the palm is also a symbol of martyrdom. Early in the dance, while the dancers kneel as if dead or in another dimension, a seated *monarca* lends his *palma* to La Malinche, who passes it in mysterious circular motions around his outstretched hands in a moment often called La Conversión de Moctezuma (the Conversion of Moctezuma) to commemorate the moment he became a Christian, not long before his death.

People mostly watch in silence or laugh at the antics of the *abuelos*. They will also offer observations about the struggle between good and evil, said to be represented by the bull. Occasional comments can be poignant hints at deeper meanings, such as this comment a child made to his father at the Alcalde, New Mexico, Matachines in 2009 (fig. 15.14): "Papá, ¿por qué le cortan los huevos al torito, si ya está muerto?" (Dad, why do they cut the balls off the little bull if he's already dead?)

15.14. *El Abuelo capa al Torito* (The grandfather castrates the little bull), Alcalde, Nuevo México, 2008.

No response. It is obvious that the normal practices of animal husbandry do not include the castration of animals after their death. There are symbolic dimensions in evidence here, since the bull is the totem animal of Spain, brought during the conquest and associated with the conquest in the Native imagination. The choreographic narrative and "hidden transcript" of the Matachines is complex indeed, representing spiritual encounters, the coming of Christianity, and its adaptation to a new cultural and spiritual context.

The *danza de la flecha* (fig. 15.15) or Chichimeca style of Matachines features a cast of fewer characters, less complicated choreography, and lively, more frenetic music with loud drums and occasionally a violin. The *danzantes* are brightly dressed, usually in red, with distinctive *nagüillas*, or kilts, hung with reeds that jangle with the movements of the dance. The Virgin of Guadalupe is often embroidered on the back of shirts or vests, or present on *paños* (kerchiefs) worn draped from the shoulders. A gourd or metal rattle marks the tempo, along with a stylized clacker that resembles a bow and arrow and is aimed and shot. The arrow, however, is fixed and never takes flight. Headgear is either a headband or stereotypical Plains-style feathered war bonnets. Dance leaders are called *capitanes* (captains) or sometimes *comanches*. Young girls also dressed in red play La Malinche, and there can be as many as three or four in a dance. The ancestral *viejos* (old men) of the dance wear terrifying simian masks, carry whips, interact with *malinches* and crowd, and are eventually overpowered and "killed" by the dancers with their arrows.

15.15. *Danza de la Flecha-Matachines de Guadalupe* (Dance of the Arrow-Matachines of Guadalupe), Tortugas, Nuevo México, 2008.

The movements of the dance are varied, often named after animals, and are combined in varied ways, depending on the symbolism or iconography of the feast day. Crowds watch in silence or laugh at the *viejos*. Peripheral comments are often revealing. While watching the Matachines at the Feast of San Juan in San Juan del Valle, Chihuahua, on June 24, 2009, an audience member observed how and why particular movements of the bow and arrows resembled wings beating: "Hacemos la danza del gavilán para honrar el águila de San Juan" (We do the dance of the dove hawk to honor the eagle of Saint John). The symbolism of the dance is not esoteric, but is also not always specifically articulated. The eagle totem of San Juan Evangelista here is called up to honor San Juan Bautista on his feast.

Santiago Matamoros a Santiago Redentor (Saint James the Moorslayer to Saint James the Redeemer)

One of the most notable decolonizing transformations, not only in greater Mexico but in all of the Americas, is the indigenous appropriation of Santiago, the patron saint of Spain and the Iberian Reconquest. When the warrior saint comes to the New World, his epithet changes from Matamoros to Mataindios, from the Moorslayer to the Indian Killer. Associated with horses and with the primal force of thunder, by the end of the Colonial period he becomes the special protector of Natives in a symbolic reclamation that varies from group to indigenous group.

Santiago's first appearance in New Mexico is literary. The epic poet Villagrá places him and the Virgin herself at the bloody battle of Acoma in January of 1599. A three-day siege breached the almost impregnable fortress pueblo, perched high on a sandstone mesa. Six to eight hundred of the defenders and their families were slaughtered, and survivors were mutilated and taken into servitude in the most grievous violation of human rights in the history of New Mexico. Don Juan de Oñate was charged and tried for his abuse of power, and punished with exile to Spain. Although there is no memory among the Acoma people of Santiago at the tragic battle, as in other Queres Pueblos, he is transformed into Santiak, a hobbyhorse dancer who playfully and powerfully represents the mounted saint on his July 25 feast day.[17]

15.16. *Los Chicahuales, soldados de Santiago* (Chicahuales, soldiers of Saint James), Jesús María de los Dolores, Aguascalientes, México, 2009.

One of the most symbolic transformations of Santiago takes place the same day in the village of Jesús María de los Dolores, twelve kilometers north of Aguascalientes, the next stop on the Camino Real south of Zacatecas. Unlike the historically costumed Moros y Cristianos of Zacatecas, those of the village of Jesús María de los Dolores all wear wooden masks, except Santiago himself and the only female character in the play, Toci, the wife of the Aztec sun god Huitzilopochtli. With masks and indigenous characters, this *morisma* is profoundly Mesoamerican in character. The grey-masked, turbaned Moros are mounted on horses and enjoy a military advantage over the white-faced Cristianos, who wear extravagant straw hats decorated with colored tassels. El Rey Cristiano (the Christian king) wears a large elaborate mask with a long, carved beard. His soldiers are called Chicahuales, a term of Nahuatl origin meaning strong and determined (fig. 15.16). They are dressed in *huaraches* (sandals) and *calzones* (white pajamas), emblematic of their indigenous origins, despite their masked transformation into white or mestizo Christians.

In stark contrast to the almost endless *parlamentos* (scripted speeches) of Zacatecas, there is no dialogue at all, only a series of *escaramuzas* (skirmishes), ringing with the sounds of the steel *machetes* of the Moros clashing with the hardwood swords of the Chicahuales. Not a single character speaks, but everyone in the crowd, including children, already knows the narrative, which they gladly summarize for visitors:

> Seated on his throne in Heaven, God notices the wars and pitched battles that are taking place below on the earth. The Rey Cristiano (Christian King) has been grievously wounded and is near death in a coma. Disturbed with the mayhem, God calls Santiago to his side and orders him to descend to earth to make peace. Santiago appears to the Rey Cristiano in a dream and tells him the plan. He will come to earth to heal him and help him prevail in the battle. The warrior saint comes down to earth on his white horse and defeats the Moros, one by one. They lie on the ground either dead or agonizing. Santiago returns to heaven and is scolded by God, who tells him, "I wanted peace on earth, not death and destruction. I need the Moros alive." He then announces to Santiago, "Now I am giving you the power that only I and my son Jesus have: the power to resurrect the dead. Now go and bring them back to life."[18]

15.17. *Santiago Redentor* (Saint James the Redeemer), Jesús María de los Dolores, Aguascalientes, México, 2009.

Santiago descends to earth again and carefully rides his white horse three times over the bodies of the Moros. On the third pass, he touches each one, and they come back to life one by one.

The rest of the celebration is a joyful Juego de Moros y Cristianos at its best. The Moros ride back and forth for an additional hour by the line of Chicahuales, clashing swords, not in combat but in celebration. The next day the spectacle is repeated, but a new character appears: Toci, the wife of Huitzilopochtli, who rides among the Chicahuales and dispenses food from her basket to keep them strong.

The most significant aspect of this fiesta is the transformation of Saint James himself, from Santiago Matamoros, the merciless Moorslayer, to Santiago Redentor, the Redeemer (fig. 15.17). In most areas of Latin America, the transformation is never this overt or explicit, and never so boldly dramatized. In one afternoon, Santiago is transformed from the most formidable enemy and worst nightmare of the Natives into their redeemer and protector.

Disorientalization: Toward a New Paradigm for Global Conversations on Judaism, Christianity, and Islam

In observing the festivals of the Camino Real de Tierra Adentro, visitors are struck with the persistence of cultural memory and wonder about the continuing resonance of events that happened so long ago. Are these dramas some kind of bizarre antiquarian pursuit? How can

they seem to speak so profoundly to contemporary people? Can the study of these traditions transcend anecdotal description and begin to theorize exemplary cultural processes instrumental in understanding cultural and political dilemmas of the present day? These community rituals revisit Europe's millennial antagonisms with Islam and Judaism that have forged cultural habits with grave political consequences. The dreamlike ideas and representations of Oriental and Indigenous others are distorted and essentialized in art, literature, and academic disciplines, creating a legacy of troubling discourse that the great Palestinian Christian scholar Edward Said identifies as Orientalism.[19] With the defeat of Islam in Spain in 1492, a supercharged social imaginary is born that traps the West in a globalizing and colonizing impulse that does not allow us to think about what is best for others without projecting or forcing our values onto them.

This is not a clash of civilizations as some have characterized it, for Islam, Christianity, and Judaism are faces of the same monotheistic civilization. Said's student, the Moroccan Anouar Majid, asserts that the political turmoil that surrounds us is rather a deadly clash of messianic fundamentalisms. His quest to develop a theory and practice of disorientalization has led him to revisit the Iberian Reconquest and the era of Convivencia (living together) or cultural tolerance that preceded it in search of a broader paradigm of cultural and political relations. Majid also makes a call for scholars to reconsider the cultural arena of greater Mexico, where Native Americans were forced by a new conquest to join in the global conversation.[20]

We believe a new disorientalizing prototype can be identified in the Indo-Hispano rituals that evolved after the conquest of Mexico. These photographs and this discussion can help visualize this liberating paradigm of the embodied cultural knowledge enacted on plazas and in the imagination of mestizo peoples as they dramatize their own destiny and place in the world.[21]

NOTES

*A preliminary sketch of this study appeared in *Chronicles of the Trail* 6, no. 1 (Winter 2010): 7–15, a newsletter of El Camino Real de Tierra Adentro Trail Association.

1. In this ethnographic project, the term *fiesta* signifies the traditional religious feast days of the annual calendar. Civic *fiestas* are promotional events organized by municipalities, state governments, and chambers of commerce.

2. Max Harris, *Aztecs, Moors and Christians: Festivals of Reconquest in Mexico and Spain* (Austin: University of Texas Press, 2000), 118.

3. Ibid., 132–147.

4. Gaspar Pérez de Villagrá, *Historia de la Nueva México, 1610*, trans. and ed. Miguel Encinias, Alfred Rodríguez, and Joseph P. Sánchez (Albuquerque: University of New Mexico Press, 1992), 131, canto 14, versos 317–321, and 150, canto 16, versos 100–116.

5. On *"danza de la reconquista,"* see Enrique R. Lamadrid, "Colonial and De-Colonial Choreographies in Ritual *Danzas* and Popular *Bailes* of Greater Mexico," in *Routledge Handbook in Chicana/o Studies*, ed. Francisco A. Lomelí, Denise Segura, and Elyette Benjamin-Labarthe (New York: Routeledge, 2018), 379–410. On the interactions of Christianity and Native religion, see Gertrude P. Kurath, "Mexican moriscas: A Problem in Dance Acculturation," *Journal of American Folklore* 62, no. 244 (1949): 87–106. On the "culture of conquest," see George M. Foster, *Culture and Conquest: America's Spanish Heritage* (Chicago: Quadrangle Books, 1960).

6. J. H. Cohen, "Danza de la Pluma: Symbols of Submission and Separation in a Mexican Fiesta," *Anthropological Quarterly* 66 (1993): 149–158.

7. Deidre Sklar, *Dancing with the Virgin* (Berkeley: University of California Press, 2001).

8. Sylvia Rodríguez, *The Matachines Dance: Ritual Symbolism and Interethnic Relations in the Upper Rio Grande Valley* (Albuquerque: University of New Mexico Press, 1996).

9. In Nuevo México, *genízaros* are indigenous captives and their descendants taken from enemy Indian groups, who are adopted into Hispano families, acculturated, and freed.

10. Enrique R. Lamadrid with Miguel Gandert, *Hermanitos Comanchitos: Indo-Hispano Rituals of Captivity and Redemption* (Albuquerque: University of New Mexico Press, 2003), 80–134.

11. Villagrá, *Historia*, 148, canto 16, versos 16–18.

12. Ibid., 143, canto 15, versos 180–192.

13. This manuscript of *Moros y Cristianos* was originally collected and published by Aurora Lucero White-Lea as *Literary Folklore of the Hispanic Southwest* (San Antonio, TX: Naylor, 1953), 107–112, and became this script of the play used by the Chimayó production. It is excerpted in Enrique R. Lamadrid, Jack Loeffler, and Miguel Gandert, *Tesoros del espíritu: A Portrait in Sound of Hispanic New Mexico* (Albuquerque: Academia/El Norte Publications, 1994), 10.

14. James Scott in *Domination and the Arts of Resistance: Hidden Transcripts* (New Haven, CT: Yale University Press, 1990) develops the interpretation of "public vs. hidden transcripts," which Max Harris (*Aztecs*) applies to the *fiestas* of Mexico and New Mexico.

15. *Chichimeca* is a Nahuatl word roughly equivalent to "barbarian," the nomadic inhabitants of the deserts of northern New Spain.

16. Max Harris, "Moctezuma's Daughter: The Role of La Malinche in Mesoamerican Dance," *Journal of American Folklore* 101, no. 432 (Spring 1996): 149–177.

17. Enrique R. Lamadrid, "Santiago y la Cruz Emplumada / St. James and the Plumed Cross: Indo-Hispano Artifacts of Resistance and Redemption," in *Converging Streams: Art of the Hispanic and Native American Southwest*, ed. William Wroth and Robin Farwell Gavin (Santa Fe, NM: Museum of Spanish Colonial Art, 2010), 147–155.

18. This is not a written script but a compilation of oral excerpts from comments taken down in field notes. Popular summaries of the legendary Battle of Clavijo, fought near Logroño, Spain, in the year 844 are the source of the narrative, plus local interpretations and additions. In it, Santiago descends from heaven, mounted and fully armed, to secure the outcome of the battle; Clifford J. Rogers, ed., "Battle of Clavijo," in *The Oxford Encyclopedia of Medieval Warfare and Military Technology* (Oxford: Oxford University Press, 2010).

19. Edward Said, *Orientalism* (New York: Pantheon Books, 1978).

20. Anoar Majid, *We Are All Moors: Ending Centuries of Crusades against Muslims and Other Minorities* (Minneapolis: University of Minnesota Press, 2009).

21. Guillermo Bonfil Batalla, *México profundo: Una civilización negada* (México: CIESAS, 1987); Miguel Gandert and Enrique Lamadrid, *Nuevo México Profundo: Rituals of an Indo-Hispano Homeland* (Santa Fe: Museum of New Mexico Press, 2000).

16

Manitos and the Struggle for Self-Identity in the Hispano Homeland

ORLANDO ROMERO

From the onset of Spanish settlement in the New World, many Hispanos suffered a cultural identity crisis and a form of neurosis that would follow them to the present. The origin of the crisis lay with the Spanish themselves and with the desire of those in Spain to prove *pureza de sangre*, that is, purity of blood.[1] What we generally term "Anglo Saxons," or simply "Anglos" in the settlement of the East Coast of the United States, for example, had to some degree a racial measure to distinguish themselves from Indians or Blacks, but not from each other until other Europeans, such as Germans, Irish, Scots, Italians, and so on, began to migrate to the United States. With time, prejudice and bias against other immigrants, even if they were also Europeans, became evident.[2] Prejudice against the Irish, for example, is well known and documented in the annals of American history.[3]

Prejudice and bias due to ethnic, political, religious, and cultural differences are not new among many groups, including Hispanos and Anglos. There is a cultural and identity crisis and neurosis among *manitos* in the homeland. According to Rubén Cobos, in his *Dictionary of New Mexico and Southern Colorado Spanish*, *manito* is "a term applied by Mexican immigrants to New Mexican Hispanics."[4] At this point it would be useful to delve into the nomenclature of terms such as *manito*, "Hispanic," and "Spanish American."

In William deBuys's *Enchantment and Exploitation*, the cultural identity crisis and neurosis that affects many Hispanics today is revealed in the conversation of Eloisa Romero:

> "I don't know what we are supposed to call ourselves now," she says. "I never heard that word *chicana* when I was a girl, so I guess I cannot be one now. What do you think, Jacobo?"
> The old man shrugs. "If you ask Juan de Dios," he says, "he will tell you we are Spanish."
> "But we are not Spanish; the people in Spain are Spanish, not us."
> "Well, we have to be something, and so I guess I will be a Mexican."
> "No, you are no Mexican either, old man. A Mexican is one of those boys who comes from Juárez or Chihuahua to make adobes."

"Well then if I am not a Mexican, and I am not Spanish," he says, savoring the riddle,
"what am I?"

She puts her hands on her hips and appraises him with a cattle buyer's squint. "I am not too
sure what you are, old man, but I suppose you are probably some kind of an old Manito."[5]

This conversation illustrates the quandary or situation in which a Hispano, particularly one from Northern New Mexico, finds himself in when trying to explain his cultural identity in relation to his self-identity and his homeland. One of the most intriguing aspects of self-identification is that in relation to Jacobo's comment that he is Spanish he is told that he is not, because "the people in Spain are Spanish," and he is not from Spain, so he cannot be Spanish. Yet every year Saint Patrick's Day is celebrated by thousands of Irish Americans who identify as Irish but have not lived in Ireland for hundreds of years. The question is, When is an Irishman not an Irishman? After how many years of living in another country is it still valid to call yourself Spanish, Irish, Italian, and so on? Or does it really matter?[6]

Kevin Laughlin, a twenty-seven-year-old attending New York's Saint Patrick's Day Parade, said, "I've always been so proud to be an Irish American, and that's what today is about, it's more than just one big party, it's about celebrating our freedom."[7]

Yet if a *manito* from Northern New Mexico says he's Spanish American, Chicano academics attack and accuse him and his culture of living in the romantic past and denying his Mexican-ness, or his *mestizaje*, that is, mixture with Indians. Chicano academics add to the cultural identity crisis and neurosis by creating their own standard, their own "purity of blood," and denying the *manito* the right to self-identify himself in the same way as the "Irish" person at the Saint Patrick's Day Parade, whom no one accuses of not being Irish.

That external factors create cultural identity for Hispanos is nothing new. As Doris Meyer points out, "The gap of the letter of the law and the practical experience of intercultural exchange became painfully evident as the New Mexican territory grew and prospered. At stake for Neomexicanos by the late 1800s and well into the 1900s was just not the issue of legal entitlements but *the vindication of their identity as an ethnic community.* In essence, the circumstances in which they found themselves had the dimensions of *a cultural identity crisis, not arising from within the ethnic community but rather from factors external to it*" (emphases added).[8]

This cultural identity crisis is part and parcel of identification with the Hispano homeland. The Hispano homeland is not just a geographical location but also a *querencia. Querencia* as defined by Hispanos is a village, a place, a people, where the heart is.[9] You cannot have a place where the heart is, or even where memories remain, without this piece of homeland. As deBuys explains, "It has been said that to be Hispanic in Northern New Mexico is to be of a village, and Las Truchas and Las Trampas are quintessential Hispanic villages of the region. Born in adversity and isolated by the ruggedness of their environment, they were places where sufficiency gave easily to suffering and where arduousness and danger were the common conditions of life. The people who settled them were a resilient breed. Passionately Spanish and Catholic in their cultural orientation, they were descendants as much of the New World as of the Old."[10]

The Neomexicanos or *manitos* were so adamant about their homeland that they fiercely defended even the name of their state: "Eastern Anglos rarely understood that those who called themselves neo (or Nuevo) mexicano felt that their identity was inextricably tied to their Southwestern homeland. Noting efforts had been made in other states to preserve the names of indigenous people, such as in the naming of the Mississippi, Dakota, Wyoming, and Tennessee, the newspaper editor asked: 'se nos ofrece a nosotros, lo de la raza hispana, menos consideración que á los tribus de indios errantes que habitaban estos países?' [are we, those of the Hispanic race, being offered less consideration than the wandering Indian tribes who lived in these lands?]"[11]

Harsh, hardscrabble, and unpredictable as survival may have been in this land of both extreme beauty and extreme conditions, the *manito* survived drought, famine, Indian attacks, and later, the federal government's corrupt takeover of Spanish land grants, which diminished the *manito*'s ability to survive in a land that they had come to know as their own.

"Nueve de invierno y tres de infierno" (Nine of winter and three of hell) was an adage used by Enrique Romero of Nambé that is still used to describe the province of Extremadura, Spain, today. Harsh as this homeland may have been for these early *manitos*, they fully recognized that "nosotros se los quitamos a las Indios y los Americanos nos los quitaron a los dos" (we took it from the Indians and the Americans took it from both of us).[12]

Nothing exemplifies this battle for the homeland by both Hispanos (*manitos*) and Natives better than the Taos Revolt in 1847, when they joined forces to repel the occupation of New Mexico by American forces. At the core of the revolt, Carlos R. Herrera has written, "It seems more likely that the insurgents detested the idea of conquest and planned to revolt in order to regain control of their homeland."[13] The revolt proved to be costly to both *manitos* and Indian Pueblo Natives, as approximately two hundred New Mexicans died in battle against US forces under major general Sterling Price.[14]

In his article "New Mexico Resistance to U.S. Occupation," Herrera claims, "Careful analysis of U.S. sources and military accounts, however, does indicate that the two rebellions were part of a larger New Mexican movement to reject U.S. occupation of their homeland. How can one claim that the Taos revolt was an act of revenge on the part of irate Indians and Mexicans when hundreds of their comrades died while opposing the American forces? As for Mora [a village in Northern New Mexico], the fact that all the communities of the region but two supported the revolt indicates that this uprising was not simply the result of mob hysteria."[15] However, this was not the first uprising by *manitos* in defense of their homeland.

In 1837, some sixteen years after Mexico attained its independence from Spain, an armed clash erupted in Northern New Mexico that ended with the murder of the incumbent governor and sixteen of his officials. Two years earlier, this governor, Albino Pérez, a polished, military-trained patrician with a background totally opposite from the poor Hispano and Indian farmers wresting a living from the unforgiving land, had come to the region from far off Mexico City to assume his duties. Pérez brought with him a constitution, a revised tax structure, and an attitude that won him few friends with his constituents.[16]

The clash, which was referred to as the Chimayó rebellion, was a "response to the arrogance and excesses of Governor Pérez. . . . The protesters beheaded the governor, desecrated his remains, and for a time refused to allow the body to be buried."[17] Needless to say, the subsequent reign as governor of José Gonzales, one of the leaders of the revolt, from Taos, was short-lived. The rebels were finally defeated by the soldier Manuel Armijo when he installed himself as governor.

The act of resistance by New Mexican *manitos* in the preservation of their homeland is well documented as late as the 1890s. The history of the Gorras Blancas (White Caps) is evidence of that fact. Anselmo Arellano has written, "As an organized group, the Gorras Blancas were probably the most secretive and closely knit association of men to ever exist in the territory of New Mexico. Their protest against the encroachment upon and theft of their lands began in 1889, and by the end of 1890, their notoriety had spread throughout the territory and reached the eastern states."[18] Their activities—tearing down fences, barn burning, and so on—may have been seen as lawless by the establishment but showed their passionate defense of their homeland against aggressors that threatened their way of life.

And while resistance continued in the 1960s with the advent of Reies López Tijerina and the land grant movement, there is little doubt that *manitos*, particularly in the Northern New Mexico

homeland, were a distinct group of people who not only cherished their homeland but also fought to the death to defend it. What I disagree with, as a native of a Hispano village who has documented many of our traditions, not only of my village of Nambé but also of other villages, is the negative reaction by academics when Richard Nostrand published his provocative *Hispano Homeland*.[19] Academics sitting in their university ivory towers who had never lived in a Hispano/manito village, much less experienced a *limpia de acequias*, a *santo encuentro*, *el coro de La Sagrada Familia*,[20] or many other distinct *manito* traditions, blasted Nostrand, basically saying that we *manitos* are not distinct in any way, and even questioned whether Northern New Mexico was our homeland. Some went as far as to claim that Nostrand was supporting an elite "Spanish" class that was nothing more than a myth.[21]

Interestingly enough, no one ever questioned the reality of Aztlán, the ancestral home of the Aztecs, or its borders, nor the myth of the Aztecs and their conquest of and brutality toward other Native peoples.

I and many other *manitos* in Northern New Mexico are indeed a distinct group, and we will, as we have in the past, self-identify ourselves as we see fit—as Hispano, *manito*, and so on. Our self-identification and struggle for that self-identification is our birthright, our *querencia*, in our own homeland, and is not to be determined by academics far removed from the realities of a homeland they never experienced.

NOTES

1. "The subordination of state to church and the ideology of *limpieza de sangre* (purity of blood)—where the absence of Jewish or Muslim blood defined an honorable 'Old Christian' were factors in Spain's hierarchically organized society." See Ilona Katzew, *Casta Painting: Images of Race in Eighteenth-Century Mexico* (New Haven, CT: Yale University Press, 2004), 39.

2. The English in America considered themselves "neither Europeans nor the descendants of Europe, but a new race of men." Also, Joel Barlow, the first poet of independent America, hailed them as "call'd from slavish chains a bolder race." For both quotes see Felipe Fernandez-Armesto, *Our America: A Hispanic History of the United States* (New York: Norton, 2014), 103.

3. "The killing of Indians by Spaniards became (to the English) 'atrocities' or 'ruthless extermination'; but when Englishmen ran Irishmen to death by the thousands in their own bogs, or slaughtered them after surrender, this was called 'the Irish Problem.'" See Philip Wayne Powell, *The Tree of Hate: Propaganda and Prejudices Affecting United States Relations with the Hispanic World* (Albuquerque: University of New Mexico Press, 2008), 12.

4. Rubén Cobos, *A Dictionary of New Mexico and Southern Colorado Spanish* (Santa Fe: Museum of New Mexico Press, 1983), 105.

5. William deBuys, *Enchantment and Exploitation: The Life and Hard Times of a New Mexico Mountain Range* (Albuquerque: University of New Mexico Press, 2015), 186.

6. Orlando Romero, "The Irish in New Mexico," in *The Encyclopedia of the Irish in America*, ed. Michael Glazier (South Bend, IN: University of Notre Dame Press, 1999), 676–677.

7. Sabrina Caserta, "Irish Pride and Politics at St. Patrick's Parade," *Associated Press*, March 17, 2019.

8. Doris Meyer, *Speaking for Themselves. Neomexicano Cultural Identity and the Spanish Language Press* (Albuquerque: University of New Mexico Press, 1996), 92.

9. "La Querencia: A Homeland Facing Change," documentary by Judy Goldberg, Santa Fe, New Mexico, 1984.

10. deBuys, *Enchantment*, 57.

11. Meyer, *Speaking for Themselves*, 183.

12. Interview with my grandfather, Enrique López Romero of Nambé, 1973. Romero Archives, author's private collection, Nambé, New Mexico.

13. Carlos R. Herrera, "New Mexico Resistance to U.S. Occupation during the Mexican-American War of 1846–1848," in *The Contested Homeland, A Chicano History of New Mexico*, ed. Erlinda Gonzales-Berry and David R. Maciel (Albuquerque: University of New Mexico Press, 2000), 31.

14. Ibid., 33.

15. Ibid.

16. James A. Crutchfield, *The Revolt at Taos: The New Mexican and Indian Insurrection of 1847* (Yardley, PA: Westholme Publishing, 2015), 64.

17. Ibid.

18. Anselmo Arellano, "The Peoples Movement: Las Gorras Blancas," in Gonzales-Berry and Maciel, *Contested Homeland*, 63.

19. Richard Nostrand, *The Hispano Homeland* (Norman: University of Oklahoma Press, 1992).

20. *Limpia de acequias*: cleaning of the ditches. *Santo encuentro*: The encounter of Mary and Joseph during a Penitente procession occurring during Holy Week. *El coro de la Sagrada Familia*: a membership of mostly Hispanic families that receive a holy and blessed three-dimensional image behind glass in a wooden display case representing the Holy Family. Many Hispanic villages originally assigned to the Holy Family parish of Santa Cruz de la Cañada still carry on this once-a-month visit by this portable shrine before it is passed to another family.

21. J. M. Blant and Antonio Rios-Bustamante, "Commentary of Nostrand's 'Hispanos' and Their Homeland," *Annals of the Association of American Geographers* 74, no. 1 (March 1984): 157–164.

17.1.

17.2.

17.3.

17
Rewilding Consciousness

JACK LOEFFLER

An early morning walk in mid-May, the ground cover as green as I've seen in years. Indian paint-brush otherwise known as Prairie fire splashes vermillion amid the green. Clusters of yuccas abound, many sprouting phallus-like stalks that will soon yield white flowers that will attract yucca moths, pollinators specific to these beautiful and varied species that thrive in the arid Southwest. I walk through this piñon-juniper grassland opening my mind to so many different life forms that make their home in the arid high country of what is presently known as Northern New Mexico.

And then it dawns on me that I'm part of the wildlife, or would be if my cultural perspective didn't attempt to set me apart from all these other species. I have to stop and think about this. How long have I actually understood that I am an animal? That my species—the human species—is part of the animal kingdom? A multicellular eukaryotic organism that eats and breathes and performs the biologic functions that characterize my species, which has wandered this planet since we evolved from other species of hominids two to three hundred thousand years ago?

I realize that I am actually thinking these thoughts as I walk along the trail, and that my ruminations are shaped by my abiding love for the natural world, tempered by my fascination with science, yet tickled by an intuition of something far greater that has to do with the mystery of life and consciousness. I consider that my maternal grandmother also loved the natural world, but that her thinking was held in thrall by her Presbyterian Christian upbringing, which she attempted to pass along to me.

This leads to the profound realization that all our wondrously conscious, intelligent fellow humans have each been shaped by the cultures into which we were born, cultures that emerged over the millennia in response to environmental conditions, spiced by notions about the great mystery, held in place by language and the commonality of stabilizing beliefs, ever suspicious of anything at all alien on any level.

Time to sit down beside the trail and meditate on this. I glance around for red ants or a rattlesnake. So far, I've been spared a rattlesnake bite, but red ants are another matter. I sit down and settle into this place. I hear finches and thrashers singing, the occasional distant call of a scaled quail, the persistent utterances of ravens. I look at the long dead cholla cactus on the far side of the trail that was young and healthy when I first began to sit here many years ago.

I've long wondered what it would be like to go feral, to resign from my cultural coordinates, let language languish, be rid of the melodies that play through my mind's ear constantly, and rely on my wits to subsist within the wilderness. But one can't really go feral after one's first few months on the planet. Language, mores, and cultural coordinates become fixed, and remain inescapable short of personal systemic breakdown.

And yet, I feel such affinity with the flow of Nature, with my fellow life-forms, and the geophysical cradle that sustains us all—our planet Earth—that I find myself seeking a return to a more primeval state of mind guided at least as much by intuition as intellect. This feeling is strengthened when I pay even modest attention to the news of today, and realize yet again what a paltry perspective our culture is exposed to and forced to participate within, and that, indeed, we are all but shorn of our roots in Nature.

To my great good fortune, I have found a way to support myself that has allowed me the opportunity to explore other cultural perspectives that are more in tune with our rootedness in Nature. I've wandered with recorder, microphones, pad, pen, and canteen through many Native American homelands and have been granted permission to record conversations with many who still regard habitat as sacred, who continue to perceive divinity in homeland.

One of my true friends of this lifetime was a great lady named Rina Swentzell, who was born into the Naranjo family at Santa Clara Pueblo west of the Rio Grande just south of Española, New Mexico (fig. 17.1). Sometime during the 1980s, Rina asked if I would record her mother singing Tewa children's songs at their home in the pueblo. I was honored, and shortly thereafter, Rina and I drove to Santa Clara, where I spent a wonder-filled day meeting many members of the Naranjo family and recording traditional music. Thereafter, Rina Swentzell and I had many conversations wherein she provided me with great insight into Puebloan cultural perspective as well as her own take on contemporary monocultural obsessions that prevail throughout America and beyond. I recall a conversation with Rina that I recorded in 2010 at her home near the base of T'si-ku-mu Peak just west of Santa Clara Pueblo. She had recently moved back to Santa Clara from Santa Fe after the death of her husband, Ralph Swentzell, who had been a tutor at St. John's College.

Rina Swentzell: I walk these hills for six hours at a time nonstop just to be here. I go work in the yard just to be here, just to open myself up to this place. I want to know where the wind comes from. I want to know exactly where on those mountains that the sun is, traveling back and forth. And I want to know where the clouds are forming and how they're moving in this particular spot, because this spot is very different than in Santa Fe. The sense of the place is so different. It's so different not only because I know that my ancestors walked right here, formed right here, lived right here all around me. There's something even larger than that, and that's the sense of knowing the wind and the water and the sun patterns and the moon, the whole thing.

The notion of ancestors. People think I moved back here because I wanted to be where my people came from. It's very important, but I think even more important for me is to see how the place works right here in this tiny, tiny piece of land, on this tiny piece of land. How is it that the energy swirls right here? How can I be a part of the swirl of this place right here, this tiny place right here? I get this from my grandmother. I think that if you can feel how a place works, how the tiny place that you're a part of works, then you don't have to worry about what the guy next door is doing. I think of getting intensely focused on being a part of what you know you're a part of anyway. I don't own the land. We don't own the land. My grandmother was very adamant about that. Never think that you own the place. We don't own the place. How do we walk here, how do we breathe here so that we become this place itself? How do I become this place in the best way I can become one with it? How do you bring that into more awareness is what I'm trying to say. Because we are already one with it. How do I become more aware of that?

Jack Loeffler: One of the things that I ponder is about people who have that sense of being indigenous to a place, and how can we communicate that to people who have lost their sense of indigeneity?

RS: I think part of the problem there is that we've put so much focus on human indigeneity, and that's why I talked about ancestors before, because a lot of people will assume, especially in the non-Indian world, "Oh, you've gone back home again." In a way I have, but not in the way they mean—that I'm not here to connect only with the people, with humans, other humans here, even those who have gone before, which is very important. But for me, I feel that to be the best person I can be, I can't be anything until I am one with more than the human place. The Pueblo social world is great as communities go, but it doesn't get close to my sense of well-being, being a part of just the tiny place that I'm a part of.

If I'm that healthy inside, I don't have to worry about any threat from anybody else. I think it's when we're fearful, when we feel threatened, that we want to have power over somebody else. I think that's happening in our political world right now. We become so frightened of each other. That's because we're not rooted ourselves.

JL: Even the notion of being rooted in the Earth wherever on the planet one happens to be, that's really critical. But how do we reinvigorate the kind of political will it would take in a bigger sense?

RS: I think it's almost an impossible thing unless people do go to that place that only the individual can take himself or herself to. And the desire doesn't seem to be there to do that. It's so fast-moving. And if you're moving as fast as the world wants you to move right now, don't you think it's less likely that it can happen that you can be rooted in a quiet place where you can begin to take a deep breath and feel like, "Ah, I am in a place and the place loves me and I can love the place, and now I can interact with everybody around me."

JL: We have the opportunity to straighten up our collective act here in the Southwest and create a sort of model for looking at commons from other places within the larger mosaic. There may be levels of competition and drive to survive, but everything is interrelated. How to reinvigorate that sense of interrelatedness within our own species?

RS: I think we're on a track that's going to break. I don't know where it breaks. You look at the Mexican border and the whole border issue, immigration issue, we've got going right now where people draw a line and say, "You stay on that side and we stay on this side and don't you climb over the fence or we'll shoot you." I see it just moving more and more in that direction right now and I think it'll keep going until something very drastic happens and I don't know what that point is.

It seems like we're bound to collapse. We're in such a fast lane that it's got to collapse at some point. Maybe we just wait for the collapse to come and it becomes the beginning of something new. And that's another Pueblo thought, you know, that this is a cycle. The wind starts blowing and it gets bigger and bigger and it keeps going and there's no way to stop it. There's absolutely no way to stop the swirling of the wind when it picks up on itself. We aren't too much different from the wind in that sense. We become part of a cycle of thinking, of action, that we've taken on. Then what happens to the wind? How does it stop? We certainly can't stop it. But how does it stop? We try and stop the water with dams, and that works for some time. But if there's enough water behind it, the water just goes over and floods down south again, going over the banks.

It's all very interesting phenomena that I think that we don't identify with enough. We don't identify with being a natural force, and we humans are a natural force. Maybe we acknowledge

just who we are. Wind can be very destructive. Water can be very destructive. So can we. I don't know if we get to that point of thinking of ourselves as natural forces.

JL: I sure do. I feel like our species is a force of Nature at this point. We still have the means to curtail our ability to cause habitats and species to go down. But we have to find the collective will to turn this thing around. It seems to me that it's going to require more than just an intellectual event. It requires feeling.

RS: That's right. And how do you get people from Wall Street, for instance, to feel it? People who spend their days in a box, as it were, with this clicker noise going on. I have no idea what goes on in there, but I see them throwing paper around and stuff. But where is the need for connection there except the numbers going by? I don't want to be just pessimistic about it, but I don't know how one breaks that cycle. How does one break that cycle of people wanting more and more and more of whatever they have already?

JL: To me the great enemy right now is our economic paradigm. That's symbolic of where we've gone askew on a global level.

RS: And talk about commons, you know, the economics—money has become such a common commodity for the world. Everybody works off of money anymore. That's a commons, as it were. And how do we think about it, or do we, is it our challenge to think about it in a positive way as commons? Do we redefine commons? What do we do?

JL: I'm beginning to look at consciousness as a commons, human consciousness, and then extending beyond human consciousness into other species' collective levels of cognition. I know that the whole worldwide system of economics on the planet really is a commons, as you say. It's a common denominator. It's a model for human conduct that seems to me to have gone totally awry. Subsequently the question is how to turn that back around and realize that part of that paradigm is founded on turning habitat into money, which seems to be an erroneous point of view.

RS: I totally, totally, completely agree with you. I think it's totally erroneous. But I do feel that I don't have any power to do anything about it except to make **do** with what I have. Pueblo philosophy would say, "No, you don't have even the right to do that." You do what you can do. That's why we have all these center places, because we know those people over there are going to be doing something different than what we're doing. You take care of what you can take care of, and you do it in the best way that you can do it. If you take that other model, like saying I want to go and turn some politician's head around, there's no hope. I've just lost myself. I've lost my center then. If I go and do that, then I become that politician.

That conversation with Rina Swentzell ever lingers in my memory. She reveals that Puebloan cultural perspective is aligned with the ancient Chinese Taoist notion of wu wei—the realignment of the mind and spirit with the flow of Nature, as I conceive of it.

After I complete my meditation on that conversation with Rina, I glance at the shadows and note that the sun has moved a bit since I sat down. I stand up, brush the dust off the seat of my pants, and head back up the trail toward home. I round a bend, and there to the northwest I see T'si-ku-mu Peak, Rina's homeland. Rina's spirit departed her body a few years ago, and I always look to see if I can recognize her in the clouds around T'si-ku-mu. I say "Hello."

I spot a piece of chipped obsidian along the trail, a remnant of an earlier time when pre-Columbian Natives trod this path. I think of Lyle Balenquah, a Hopi friend who became an archaeologist yet still adheres to his people's cultural traditions (fig. 17.2). I remember another day in 2010 when I was in Hopi country, and recorded my friend Lyle Balenquah reflecting on the importance of homeland in shaping his own worldview.

Jack Loeffler: The concept that I'm really trying to develop in my own mind has to do with cultural perspective as shaped by habitat. Is that something you've thought much about with regard to the Hopi people?

Lyle Balenquah: I think it's there every day. We as Hopi always talk how we've come to be who we are as a direct result of the land that we have inhabited. We chose the place where we ultimately ended up because it was hard, because it was a harsh landscape. There's multiple stories out there about how Hopi came to be where they're at now. But it was with the understanding that it wasn't going to be easy, that we live in a desert landscape, that to make a living there was going to test one's physical, spiritual, emotional side of yourself and really push you to understand the intricate fluctuations of living in such a landscape. It's not guaranteed that it's going to rain every year or snow every winter.

So yeah, for Hopi our natural landscape, our habitat, has directly influenced our lifestyle, or at least our traditional lifestyle. Of course we're impacted now by modern society just as everyone else is. But the core foundation of what Hopi is supposed to stand for is to not forget what it takes to live in that landscape. All of our ceremonies, or a good portion of them, are centered around that idea of moisture, asking moisture to come. It's that different kind of cultural perspective of, well—it's not weather patterns, it's not the jet stream bringing clouds and moisture and the changing of the seasons. It's a direct manifestation of your spiritual interaction with the natural environment, asking, drawing upon your own individual and group energies to harness the natural forces out there: the wind, the rain, the snow. I think sometimes because we are exposed so much to the scientific side of things, the traditional part may get lost in the shuffle. But I think it's very evident to a lot of people out at Hopi that we are who we are because of where we are. We wouldn't be Hopi if we were somewhere else. It was just the Promised Land, the destiny. It was supposed to happen this way.

So yeah, we pray for the moisture to come to provide the life-giving force to the crops that sustain us. The water that we drink or traditionally used to drink from the springs comes from some other place. It's not necessarily because of us that water's there. There's greater forces at work here, I guess you come to understand, and I think in order to maintain that perspective you have to maintain your connection to the landscape. Once you break your relationship with the natural world, then it just becomes something that you can go to the store and purchase. It becomes that easy, that kind of simple interaction. It's not that simple once you really start to be involved with the natural world. So being out there, whether we're farming or ranching or just out and about exploring, whether we're gathering plants for medicinal purposes or arts and crafts, there's all of these opportunities that Hopis have to be out there on the landscape. Participating in those events or those kinds of routines gives you that opportunity to remember a lot of what has been taught to us.

I'm fortunate because being an archaeologist and sometimes river guide I'm outside constantly and not just at Hopi but throughout the Four Corners region. So you see changes even year to year and season to season. So I think it's important, coming from my Hopi perspective, to maintain that perspective, that relationship. It's also important for the society in general to not forget that. For many Americans—when I'm on a river trip I tell the Anglo kids, "Not more than two or three generations ago your forefathers, your grandparents, your grandmothers were struggling out here on the landscape to make a living to sustain themselves. It's not that far removed from you. It's not something that is three, four hundred years ago. It's a hundred years ago." Maybe for some people that's a long time, but I think maybe as you get older you tend to not view a hundred years as being too long. Here we are in 2010 already, and a lot has happened just in the past ten years. The way things are going, it could get a lot worse if we don't make a change.

So I think it's important from a Hopi perspective that we continue to remember that our culture is directly tied to our habitat, our scarcity of water, you could say scarcity of precipitation. And yeah, it hasn't been easy. It's not easy. We don't have to farm to sustain ourselves. It's a tradition that maintains itself, that maintains our culture. So it looks like we need to continue those types of things so that we don't forget how hard it can be and how hard it was.

Who is to say that there isn't going to be a world catastrophe, that all of a sudden we're all going to have to revert back to a more sustainable lifestyle forced upon us not by choice but because we have to. And I think if Hopi can continue to maintain their traditions, not only will we have the means to do it, but we have the longevity, the philosophical and mental genetic makeup to know that we can survive something. That's a huge "what if," but it's still a deep sense of pride, I think, for a lot of the Hopi farmers to go out there year after year, put your seed in the ground, and have faith that something will come of it. It's not an automatic return. There's a lot of effort and a lot of hopeful gazing at the landscape that something will happen. A lot of it is solitary. I know a lot of Hopi farmers look at their farming, their tending the fields, as somewhat of a therapy session, of releasing the daily stresses that we all experience having to be in this modern society. So you look at the landscape as kind of a sponge—it's always there to lend you some sort of support, whether it's your corn that you're going to eat or you sustain your family with, or just as a means for you as an individual or group of individuals to relieve stress and think about some of the bigger issues in life.

The wind is picking up, the wind that I love coming in from the northwest. I'm mostly headed into the wind, where I've been, metaphorically, my whole life long. I step off the trail and onto the path that leads across that piece of land to which we have a deed, my wife and I. We don't own the land. No one owns the land, regardless of the concept of land ownership brought to us by the sons and daughters of Europe. But so many of my Native American friends are guided by traditions that seem to me considerably more sane, more in harmony by far than the legislated concept of reality that violates natural law and has come to prevail on this continent over the last four centuries or so.

I finally sit down on the chair outside the western door of my studio. It feels good to rest my body. In earlier decades, I'd walk all day in a state of quiet joy. Walking has always been my way. I give thanks to the flow of Nature for providing me with the wherewithal to continue to walk even after over eighty years on this beautiful, living, planet Earth. I reflect on the words of my old friend Camillus Lopez, a Tohono O'odham lore master whose homeland is that part of the Sonoran Desert now sundered by an international boundary (fig. 17.3).

Camillus has revealed to me many important aspects of Tohono O'odham cultural perspective. Part of his role among his people is to preserve the old stories that reveal the old ways that still prevail in this ancient desert culture that evolved as the desert itself evolved over the centuries, the millennia.

Camillus Lopez: In O'odham there's no categorizing, no science, math language. Everything is the same, so when you go to a person, you go to them with the whole of everything. If you go there for a reason, to talk to somebody for this reason, you're bringing everything else. I've noticed that in O'odham culture everything is cold or hot, or dark or light. But in the Western culture there's a lot of numbers and degrees and miles and those things. When in O'odham something's far, then it's far. If it's cold, it's cold. I hear a lot of times with Westerners that I work with, if it's cloudy they'll say something like "Oh, this is strange weather for June." In O'odham if that's the way it wants to be, then go with it. So everything's based on the outside because it's affecting the inside. When you live as part of an environment, I guess you become it, and

everybody else around you is it. There's no change of thinking when you go to talk to somebody and you go to somebody else. In Western culture if you were talking to a politician your words would change because that's the way the understanding is. If you're talking to a baker, a policeman, you know, a drunk, whatever. Your words change according to circumstances in Western culture. But it's not like that in O'odham, where it's basically the same thing all over, the same kind of attitude towards everybody.

In O'odham, long before, you weren't walking through the desert to take a walk. You didn't walk through the desert to go from here to there. You actually were meeting all these trees. So it's actually like a high reverence where you could stop and pick a berry from a tree and at the same time you're talking to the tree, saying you've been standing here and these berries are good for me and I'll use them right. So it's not where you're just taking a walk. But they're always remembering that things are alive and that you're not alone.

Jack Loeffler: That's the kind of thinking that really needs to happen with everybody. Say you're walking through the desert. When you see a paloverde or any kind of a tree, do you think of the story of that tree, or is that feeling with you?

CL: I walk through the desert, if I see a paloverde tree—I look at it and see that they're yellow, they're pink, or whatever the leaves are, then I think that's the time of the year it is. So you recognize it as you recognize a person walking by. Two O'odham in the middle of the desert coming together and they start talking, they're not talking just to themselves. It's kind of like you're being overheard by all this other stuff around. So it's always been like that kind of reverence. If you see a paloverde tree standing there and you come by, you notice it. Then it's kind of like both people know where you're at. So it's not just singing or talking to the trees as you're walking along but keeping in mind that you're there with them and that they're just as much alive as you are. But I think trees sense more of that than humans do.

I know that there was a time when I saw an old man, he was talking among these trees and I was wondering what he's doing, so I kind of came up on him and I said, "You're talking to yourself." He looked around and he said "Oh, you know. There's an audience." Later, we were talking about something else, and I was getting ready to leave, and he said that the words that I'm saying are out there and it'll land on somebody's ear if they're willing to hear it. That it's now said and it's floating out there someplace, and if your mind and your heart and your whole life are open to it, you'll be able to accept these good messages that I'm saying.

I digest these thoughts as I sit here resting after my walk, in harmony with the juniper tree, the grasses, the Indian paintbrush, the yuccas, the birds, the insects. Clouds are appearing over the mountains. I feel at home in the flow of Nature, and recall yet another thought that Camillus Lopez once shared with me: "If you look at Nature and can't see yourself in it, then you're too far away."

I am honored to contribute a chapter to this anthology commemorating the life and perspective of my old friend, Will Wroth. Will and I share many spheres of reference, including an abiding love of the flow of Nature, both of us having lived out in it for extended periods of time. We also share deep respect for cultures indigenous to their respective homelands—their art, their music, their cultural and individual purviews. With that in mind, I present this chapter in the hope that the points of view expressed here will resonate with folks of all cultural persuasions. And in the spirit of enduring friendship, I offer this to Will Wroth with great admiration, respect, and affection.

Part IV
The Life of William Wroth

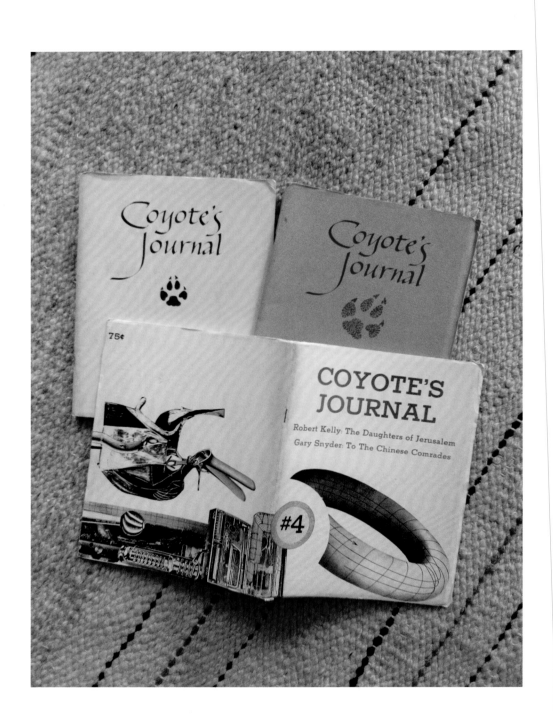

18
Will Wroth, Poet

JOHN BRANDI

Will Wroth's contributions as scholar and historian are well known, but perhaps less known is his parallel life as a poet, and his involvement in the alternative press movement.

A good place to begin is the year 1960, which ushered in the heyday of the small-press literary movement. Mimeographed publications, hand-sewn chapbooks, and handset letterpress broadsides were the fashion. These offered quick, no-frills ways to get poetry onto the streets, especially during the rising political confrontations around the American war in Vietnam. A vigorous literary movement was underway, propelled by younger poets who largely rejected the standards of academic verse, as well as the confines of mainstream publishing.

In 1962, while in grad school at the University of Oregon in Eugene, Will Wroth was invited to serve as managing editor of the university's *Northwest Review*. In an interview I conducted with Will in spring of 2019, he said the magazine "had been publishing mostly regional academic-oriented poets, maybe the best of whom was William Stafford."[1] Perhaps taking his cue from *The New American Poetry*, an anthology edited by Donald Allen in 1960, Will's suggestions on whom to publish helped to transform the *Northwest Review*. Gary Snyder, Margaret Randall, and Ed Dorn were a few of the contemporary poets whose work was included in the summer 1963 issue, which also featured a review of Robert Creeley's *For Love* by David Bromige.

Under Will's revitalization, the *Review* was on a new roll, and by autumn it went to press with contributions from Philip Whalen, Charles Bukowski, and a translation of Antonin Artaud's *Pour en finir avec le jugement de dieu* by Guy Wernham. According to Will, "The Fall 1963 issue . . . caused an uproar among the rightwing watchdogs of the university, not only because of what they called obscene content, but also for the interview with Fidel Castro by progressive former US Representative Charles O. Porter." In June 1964 the university fired the editors and the *Northwest Review* ceased to be.

Before the magazine met its fate, Will was introduced to Jim Koller, who had been hired by *Northwest Review*'s editor-in-chief, Ed Van Aelstyn, to be the poetry editor. Given that the *Review* was dead, and a stack of new contributions had already been accepted for future issues, the three editors met to discuss how to proceed. The answer: create a new venue. As Will explained, "Ed and I met with Jim to plan a new magazine. He suggested the name *Coyote's Journal*, to which Ed and I enthusiastically agreed. It seemed especially fitting in terms of what had just transpired!" *Coyote's Journal* was to become one of the most respected poetry venues in the 1970s and 1980s,

OPPOSITE

18.1. *Clockwise from upper left: Coyote's Journal* No. 2, published by former editors of *Northwest Review* James Koller, Edward van Aelstyn, and William Wroth in Eugene, Oregon, 1965; *Coyote's Journal* No. 1, published by James Koller, Edward van Aelstyn, and William Wroth in Eugene, Oregon, 1964; *Coyote's Journal* No. 4, published by James Koller, Edward van Aelstyn, and William Wroth in Eugene, Oregon, 1965.

anOthERfiNeMesS Number 9 • September, 2012

An amalgam of poetics & print published occasionally at the Palace of the Governors in Santa Fe, New Mexico.

Rebirth of Song

When the oil ran out
years of calamity and chaos
the ones who survived
had to return to hand work, farming,
hard sweat of the physical—
who remembered it?
The derelict refineries
hovering ghosts across the fields,
empty factories, useless goods
moldering in storage.
And a strangely silent world
no more relentless noise
only the quiet *slice-slice* of the sickles,
voices calling softly back and forth,
and finally, song.

Rebirth of Song by William Wroth • *Cantus* by Patricia Musick
Handmade paper by Tom Leech • Printed at the Palace Press

18.2. William Wroth, *Rebirth of Song*; Patricia Musick, *Cantus*; Tom Leech, handmade paper. *Another Fine Mess Broadside Series*, No. 9, September, 2012. Printed at the Press at the Palace of the Governors, Santa Fe, New Mexico.

especially for outrider poets of the Beat and post-Beat movement, myself included. It was well out of the loop of fussy, academic literary magazines confined largely to university audiences. *Coyote's Journal* reached both the backwoods and inner-city circles (fig. 18.1).

Recalling some of the poets that appeared in the first four issues of the new journal, Will mentioned Diane Wakoski, Clayton Eshleman, Charles Olson, Larry Eigner, Cid Corman, Anselm Hollo, David Meltzer, and Ron Loewinsohn. "We also began a series of Coyote Books— Phil Whalen's *Every Day*; William Brown's *In Honeytown*, Douglas Woolf's *Signs of a Migrant Worrier*, Theodore Enslin's *New Sharon Prospects and Journals*."

Will dropped out of the role of coeditor of *Coyote's Journal* in 1966 when he moved to the Bay Area. Koller continued as sole editor into the 1980s and 1990s, until he could no longer afford

the cost of printing and began publishing the magazine online. A selection of Wroth's poetry was part of that online publication, but—for as many people as it reached—the medium did not quite suit the author. In 2008 Will decided to self-publish it as a limited-edition, hand-sewn chapbook. *All Worlds in One: Poems by William Wroth* can now be held in the hand; personal, tactile, cozy—it can be enjoyed from a rucksack, savored after a swim, and opened at the fireside or while waiting for the dentist to call you in.

Will described the book's production with the excitement familiar to any small-press advocate: "I had the text printed offset at a local print shop, and Tom Leech at the Press at the Palace of the Governors hand-printed the covers on quality stock." Sewing the pages between the covers extended the intimacy of the book production. "It became a family affair with all of us taking a hand in the binding."

Will followed up with two other chapbooks in this tradition, though without the letterpress covers and sewn bindings: *Some Recent Poems for Christmas* (2013) and *Cedar Beach Poems* (2017). These had limited distribution, a few for family members and friends. I was fortunate to receive copies, a pleasure to hold and slowly savor. As I reexamine them, I'm reminded of the Greek poet Constantine Cavafy whose *Waiting for the Barbarians* is one of the most widely anthologized poems in Western literature. Cavafy offered his poems to friends and relatives as self-printed pamphlets or broadsheets. That was his method of distribution. During his lifetime he never offered a volume of poetry for sale.

This leads me to address the publication of Will Wroth's poem "Rebirth of Song," issued as a broadside by Tom Leech, who set the poem in twenty-four-point Bembo, and printed it in two colors on twelve-by-eight-inch handmade paper with an illustration by the artist Patricia Musick. It appeared in an exhibit at Santa Fe's El Zaguán in April 2019, along with fifty broadsides and books printed over a fifteen-year period by Tom Leech and James Bourland at the Press at the Palace of the Governors (fig. 18.2).

A letterpress broadside—printed in a limited, numbered edition—is, in a sense, ephemeral. When the numbers are exhausted, the edition is done. The text is not to be reprinted, at least not in its original form. It may end up between the pages of a book or in an anthology—but that is a far cry from the hand-printed twelve-by-eight-inch poem, framed on the wall, to be viewed at one's pleasure.

Rebirth of Song

When the oil ran out
years of calamity and chaos
the ones who survived
had to return to hand work, farming.
hard sweat of the physical—
who remembered it?
The derelict refineries
hovering ghosts across the fields,
empty factories, useless goods
moldering in storage.
And a strangely silent world
no more relentless noise
only the quiet slice-slice of the sickles,
voices calling back and forth,
and finally, song.

Commenting on the poem, Wroth said it was written "in response to the seeming unending dominance of exploitive industries in the US, as though there is no end to resources like oil, minerals, clean air and water . . . and depicts a return to handwork and revival of culture coming from people, not from the media barons."

As translator, Will Wroth has focused on the work of the late poet and visual artist Vicente Pascual Rodrigo, who was born in 1955 in Zaragoza, Spain. My first introduction to Pascual's work was during an early visit to Will and Deborah's house, where I noticed the glow of an abstract, rather metaphysical painting on the wall (see plate 14). Will said it was painted by Vicente Pascual Rodrigo, whom he had met at Indiana University in the early 1990s when Pascual was visiting friends in the Spanish Department. "I immediately liked his paintings, and gave Vicente and Ana advice on things to do in New Mexico on a trip they took to Santa Fe, where he had an exhibition at the Santuario de Guadalupe Church."

As their friendship continued, Vicente informed Will that he was writing poems. "I asked to see them and said I would like to translate them. By this time Vicente and his wife had moved back to Spain, so we corresponded by email as he sent me poems and I sent back translations." Vicente died in 2008 and, as of June 2019, Will continued his translations, aided by Susana Marin, a native Spanish speaker from Spain. A small bilingual publication has been planned, but until then a glimpse of Vicente's poems in English may be had in Will Wroth's essay "In That Luminous Darkness: The Poetry of Vicente Pascual Rodrigo," which appeared in *Spiritus* magazine. Here is an excerpt from the essay, with translations:

> At a time when much poetry is self-concerned, topical, or mundane—or worse, lacks meaning or means of access, Vicente Pascual Rodrigo's work is . . . a refreshment to the spirit and the soul. In Pascual's work one may find a teaching which contemplates the most elemental questions of life, love, and death—yet it is neither didactic nor sectarian. Through his evocative and musical language, he communicates these timeless human issues which concern all of us regardless of language or culture.

Y este ego.	And this ego.
¡Cómo se hincha! Cuánto manda!	How it puffs itself up! How much it demands!
Cuando olvida.	When it forgets.
Que mis huesos se evaporen	May my bones vanish
en el aire muy inmenso.	in the immensity of air.
Que mis carnes alimenten	May my flesh be food
muy menudas criaturas.	for the smallest creatures.
Y ojalá que este romero	And may this pilgrim
en muriendo siempre, encuentre	by always dying, find
el sendero de retorno.	the path of return.

In this powerful meditation on impermanence and self-naughting, [Pascual] first dispenses with attachment to the physical body. Then in a brief prayerful stanza he encapsulates the essence and final purpose of spiritual practice: dying to the things of this world—even those as intimate as bones and flesh—he prays will lead to the path of return. By inviting us to embrace "the luminous darkness," the poet encourages us to open our

hearts and set aside the mask. His invitation is the beginning of the journey, the search for the path of return.[2]

While fine-tuning his translations of Pascual's poems, Will was at the same time contemplating a collection of his own poetry, edited from years of work stored on his computer. When I asked about what personal reward he receives from hand-sewn, limited editions versus going for what many aspiring poets call "the real thing," a mainstream publisher's six-by-nine glossy-cover book, his answer was candid: "I'm happy for poets whom I like to get that kind of distribution and hopefully recognition (if that is what they want), but so few mainstream poetry books have anything to distinguish them from the next poet's book. There is little or no imagination in the book design, seldom any illustrations. Good poems are intimate and deserve the intimate presentation of a hand-printed/handmade book."

This final sentence pays tribute to the long-standing practice of poets, papermakers, printers, and binders who insist on bringing words into the world with utmost attention. It is to this dedicated circle of artisans that Will Wroth belongs as poet, editor, translator, and crafter of the small-press book.

NOTES

1. Will Wroth, interview by John Brandi, April 2019, Santa Fe. All subsequent Wroth quotes are from the same interview.

2. *Spiritus* 15, no. 1 (Spring 2015): 61–72.

Books

Translator, with Susana Marin. *In That Luminous Darkness: Selected Poems by Vicente Pascual Rodrigo*. London: The Matheson Trust, 2020.

Editor, with Robin Gavin, and contributor. *Converging Streams: Art of the Hispanic and Native American Southwest*. Santa Fe, NM: Museum of Spanish Colonial Art, 2010.

Editor, rev. ed. Ananda K. Coomaraswamy. *Figures of Speech or Figures of Thought? The Traditional View of Art*. Bloomington, IN: World Wisdom Books, 2007.

Editor and contributor. *Ute Indian Arts and Culture from Prehistory to the New Millennium*. Colorado Springs, CO: Colorado Springs Fine Arts Center, 2000.

The Mexican Sarape: A History. St. Louis, MO: Saint Louis Art Museum, 1999.

Images of Penance, Images of Mercy: Southwestern Santos in the Late Nineteenth Century. Norman: University of Oklahoma Press, 1991.

Editor and contributor. *Russell Lee's FSA Photographs of Chamisal and Peñasco, New Mexico*. Santa Fe, NM: Ancient City Press, 1985.

Editor. *Weaving and Colcha from the Hispanic Southwest*. Santa Fe, NM: Ancient City Press, 1985.

Editor. *Furniture from the Hispanic Southwest*. Santa Fe, NM: Ancient City Press, 1984.

Christian Images in Hispanic New Mexico. Colorado Springs, CO: Colorado Springs Fine Arts Center, 1982.

The Chapel of Our Lady of Talpa. Colorado Springs, CO: Colorado Springs Fine Arts Center, 1979.

Editor and contributor. *Hispanic Crafts of the Southwest*. Colorado Springs, CO: Colorado Springs Fine Arts Center, 1977.

Articles

"Engaging the Senses: The Pilgrimage Shrine of Santuario de Chimayó in Northern New Mexico." In *Aesthetic Theology in the Franciscan Tradition: The Senses and the Experience of God in Art*, ed. Xavier Seubert and Oleg Bychkov. New York and London: Routledge Press, 2020, 315–353.

"Painted Chests Attributed to the Workshop of the Laguna Santero." In *Scholar of the City Different: Papers in Honor of Cordelia Thomas Snow*, ed. Emily J. Brown, Matthew J. Barbour, and Genevieve Head. Papers of the Archaeological Society of New Mexico, vol. 45, Albuquerque: Archaeological Society of New Mexico, 2019.

"'In That Luminous Darkness': The Poetry of Vicente Pascual Rodrigo." *Spiritus* 15, no. 1 (Spring 2015): 61–74; including translations.

"Bernardo Miera y Pacheco and the New Mexico Santeros of the Nineteenth Century." In *The Art and Legacy of Bernardo Miera y Pacheco*, ed. Josef Diaz. Santa Fe: Museum of New Mexico Press, 2013.

"Barrio de Analco: Its Roots in Mexico and Role in Early Colonial Santa Fe." In *All Trails Lead to Santa Fe*. Santa Fe, NM: Sunstone Press, 2010.

"The Meaning and Role of Sacred Images in Indigenous and Hispanic Cultures of Mexico and the Southwest." In *Converging Streams: Art of the Hispanic and Native American Southwest*, ed. William Wroth and Robin Gavin. Santa Fe, NM: Museum of Spanish Colonial Art, 2010.

"Buffalo Soldiers in New Mexico." In *Telling New Mexico: A New History*, ed. Marta Weigle. Santa Fe: Museum of New Mexico Press, 2009.

Thirty-one essays on nineteenth-century New Mexico cultural history. State of New Mexico Office of the State Historian, 2006. https://newmexicohistory.org/?s=William+Wroth.

"Exhibiting Native American and Hispanic Arts in Cultural Context." In *Preserving Western History*, ed. Andrew Gulliford. Albuquerque: University of New Mexico Press, 2005.

Encyclopedia of American Folk Art. New York: Routledge, 2003.

"Mountain-Family-Spirit: The Arts and Culture of the Ute Indians." *American Indian Art Magazine* 27, no. 4 (Autumn 2002): 66–96.

"Some Sources for the Ideas of Frank Applegate: The Role of Ananda Coomaraswamy." In *Frank Applegate of Santa Fe: Artist and Preservationist*, ed. Daria Labinsky and Stan Hieronymus. Albuquerque, NM: LPD Press, 2001.

"Ute Civilization in Prehistory and the Spanish Colonial Period." In *Ute Indian Arts and Culture from Prehistory to the New Millennium*, ed. William Wroth. Colorado Springs, CO: Colorado Springs Fine Arts Center, 2000.

"New Mexican Santos and the Preservation of Religious Traditions." *El Palacio* 94, no.1 (Summer-Fall 1988): 4–17, reprinted in *Critical Issues in American Art*, ed. Mary Ann Calo. Boulder, CO: Westview Press / HarperCollins, 1998.

"Miraculous Images and Living Saints in Mexican Folk Catholicism." In *Folk Art of Spain and the Americas: El Alma del Pueblo*, ed. Marion Oettinger Jr. New York: Abbeville Press, 1997.

"The Hispanic Crafts Revival in New Mexico." In *Revivals! Diverse Traditions, 1920–1945: The History of Twentieth-Century American Crafts*, ed. Janet Kardon. New York: Abrams Art Books, 1994.

"Crafts: The Spanish Borderlands." In *Encyclopedia of the North American Colonies*. New York: Charles Scribner's Sons, 1993.

"Arte Popular Cristiano." In *Religiosidad Popular: Las imagenes de Jesucristo y la Virgen María en América Latina*. San Antonio, TX: Instituto de Liturgia Hispana, 1990. Translation of chapter 2 of *Christian Images in Hispanic New Mexico*.

With Alan M. Fern. "'Taking Pictures of the History of Today': Russell Lee's Photography." In *Russell Lee's FSA Photographs of Chamisal and Peñasco, New Mexico*, ed. William Wroth. Santa Fe, NM: Ancient City Press, 1985.

"La Sangre de Cristo: History and Symbolism." In *Hispanic Arts and Ethnohistory in the Southwest: New Papers Inspired by the Work of E. Boyd*, ed. Marta Weigle and Claudia Larcombe. Santa Fe, NM: Ancient City Press, 1983.

"New Hope in Hard Times." *El Palacio* 89, no. 2 (Summer 1983): 22–31.

"An Account of the Taos Society of Artists: 1883–1966." In *A Western American Vision*. Pueblo, CO: The Sangre de Cristo Art Center, 1982.

"Hispanic Southwestern Craft Traditions and the Taylor Museum Collections." In *Spanish and Mexican Land Grants in New Mexico and Colorado*, ed. John R. Van Ness and Christine M. Van Ness. Manhattan, KS: Sunflower University Press, 1980.

"The Flowering and Decline of the Art of the Santero: 1780–1900." In *New Spain's Far Northern Frontier: Essays on Spain in the American West*, ed. David J. Weber. Albuquerque: University of New Mexico Press, 1979.

"Southwestern Indian Jewelry: History, Myth and Ritual." In *Enduring Visions: 1000 Years of Southwestern Indian Art*, by Philip M. Holstein and Donnelley Erdman. Aspen, CO: Aspen Center for the Visual Arts, 1979.

Plate captions in Ron Tyler, ed. *Posada's Mexico*. Washington, DC: Library of Congress, 1979.

"Jewelry in Spanish New Mexico: Some Thoughts on the Art of the *Platero*." In *Hispanic Crafts of the Southwest*, ed. William Wroth. Colorado Springs, CO: Colorado Springs Fine Arts Center, 1977.

"Traditional Ways in New Mexico Villages." *Journal of the New Alchemists* 1 (1973): 61–64.

"Dr. G. T. Wrench: Pioneer of the Organic Movement." *Organic Gardening and Farming* 19, no. 12 (December 1972): 110–115.

Poetry

All Worlds in One: Poems by William Wroth. Brunswick, ME: Coyote Books, 2008.

Poems published in *The Wallace Stevens Journal* (2016), *Spiritus* (2014), *Malpais Review* (2012–2013), *Runes: A Review of Poetry* (2006), *Wild Dog* (1964), *Northwest Review* (1963), *Yale Literary Magazine* (1960), and other journals.

Founding editor, with James Koller and Edward van Aelstyn, of *Coyote's Journal* (1964).

William Wroth

Selected Exhibitions

Guest curator, with Robin Gavin. *Converging Streams: Art of the Hispanic and Native American Southwest*. Museum of Spanish Colonial Art, Santa Fe, New Mexico, 2009.

Guest curator. *Ute Indian Arts and Culture from Prehistory to the New Millennium*. Colorado Springs Fine Arts Center, Colorado Springs, 2000; Anasazi Heritage Center, Dolores, Colorado, 2001; Autry Museum of Western Heritage, Los Angeles, 2001–2002; Buffalo Bill Historical Center, Cody, Wyoming, 2002.

Guest curator. "Hispanic Crafts Revival" section in *Revivals! Diverse Traditions, 1920–1945*. American Craft Museum, New York City, 1994–1995.

Guest curator. *Images of Penance, Images of Mercy*. Colorado Spring Fine Arts Center, Colorado Springs, 1991; Walters Art Gallery, Baltimore, Maryland, 1991; University of Oklahoma Museum of Art, Norman, Oklahoma, 1992; McMichael Canadian Art Collection, Kleinberg, Ontario, 1992.

Guest curator, with Jonathan Batkin. *Sacred Land: Indian and Hispanic Cultures of the Southwest*. Colorado Springs Fine Arts Center, Colorado Springs, 1992.

Guest curator. *Familia y Fe / Family and Faith*. Long-term exhibition. Hispanic Heritage Wing, Museum of International Folk Art, Santa Fe, New Mexico, 1989–2008.

Recreation of the interior of the Chapel of Our Lady of Talpa. Long-term exhibition. Taylor Museum of the Colorado Springs Fine Arts Center, Colorado Springs, 1979.

Hispanic Crafts of the Southwest. Colorado Springs Fine Arts Center, Colorado Springs, 1977.

Jonathan Batkin recently retired as director of the Wheelwright Museum of the American Indian, Santa Fe. Batkin began his career in museums as a graduate student, working at the Denver Art Museum in the 1970s. In 1990, Will Wroth hired him as assistant curator of the Taylor Museum, a department of the Colorado Springs Fine Arts Center. With Wroth's encouragement, Batkin studied historic Pueblo pottery and published an influential book and several articles on the subject. Much of his research and writing since 1990 has been on the Native American curio trade in the Southwest, specifically the production and marketing of Native arts for a non-Native audience. His interest in Cleto Yurina is rooted in the fact that Yurina's story is the earliest known and most thoroughly documented example of the inverse—the acquisition of the work of an artist from the Southwest.

John Brandi is an ardent traveler who continues to seek source and renewal in the geographies of the Southwest and abroad. His multiple publications include poetry, prose, haiku, and *haibun*. His honors include a National Endowment for the Arts Poetry Fellowship, a Touchstone Distinguished Books Award for his translations of Masaoka Shiki's haiku, and several grants from the Witter Bynner Foundation to teach poetry in the Santa Fe schools. He has made New Mexico his home for fifty years.

Klinton Burgio-Ericson is an artist, art historian, and educator. He employs an interdisciplinary approach to the material record, exploring diverse agencies of historical actors in the Colonial Americas, and the lasting implications of these interactions to anthropology, museums, and Native communities today. Burgio-Ericson has been a postdoctoral fellow in Southwestern archaeology and museum studies at the University of New Mexico, a Tyson Scholar at Crystal Bridges Museum of American Art, and a Peter Buck Fellow at Smithsonian Institution's National Museum of Natural History. He completed his PhD in art history at the University of North Carolina at Chapel Hill in 2018, with a study of cultural encounters and missions in seventeenth-century New Mexico.

Lane Coulter trained as a silversmith, first on the Eastern Cherokee Qualla Boundary, North Carolina, later at the University of Illinois at Urbana–Champaign. He has taught at the College of Architecture, Texas A&M University (design, communications); the School of Art, University of Oklahoma (design, metalwork, Native American art history); and the Institute of American Indian, Alaskan and Hawaiian Native Arts (metalwork, design). His publications include "Folk Art Images" in *Oklahoma Folk Art* (1983); *New Mexican Tinwork, 1840–1940* (coauthor, 1990); *Navajo Saddle Blankets: Textiles to Ride in the American West* (editor and contributor, 1993); and "Early Jewelry of the Pueblos, Navajos and Hispanos of New Mexico," in *Converging Streams, Art of the Hispanic and Native American Southwest* (2010).

José Antonio Esquibel is a genealogical researcher, historian, and author of articles and books related to New Mexico's Spanish Colonial-era history. With Marc Simmons, France V. Scholes, and Eleanor B. Adams he is coauthor of *Juan Domínguez de Mendoza: Soldier and Frontiersman of the Spanish Southwest, 1627–1693* (2012). In 2009, Juan Carlos II, King of Spain, inducted Esquibel to the knightly Orden de Isabel la Católica for his dedication to uncovering and preserving the history of Spain and Spanish heritage in New Mexico.

Richard I. Ford is an emeritus professor of anthropology and botany at the University of Michigan, and he continues as the Arthur F. Thurnau endowed professor. He currently is also a research associate at the Museum of Indian Arts and Culture, Santa Fe. Beyond his rock art research, he is also an expert witness for several Pueblos for their water rights and land claims.

Miguel A. Gandert is an award-winning documentary and fine art photographer and filmmaker. Distinguished Professor Emeritus of Communication and Journalism at the University of New Mexico, he has taught courses in photography, multimedia journalism, ethnography, media theory, and intercultural communications. His work explores contrasts between Hispanic life in Spain, Latin America, and Old and New Mexico. He works primarily in black-and-white photography and sees documentary photography as both a form of art and a way of understanding complex cultural relationships. A primary focus of those stories is Gandert's mestizo heritage and the fusion and tension of the relationship between Spanish and Native cultures of the Americas.

Robin Farwell Gavin has worked in the field of Spanish Colonial art history for over thirty years. After working as an archaeologist for the Museum of New Mexico's Office of Contract Archaeology, she switched her focus to art history and the traditional Hispano arts of New Mexico. She served as curator of Spanish Colonial art at the Museum of International Folk Art and as chief curator at the Museum of Spanish Colonial Art, both in Santa Fe. Her publications include *Converging Streams: Art of the Hispanic and Native American Southwest* (with William Wroth) and *Cerámica y Cultura: The Story of Spanish and Mexican Mayólica* (with Donna Pierce and Alfonso Pleguezuelo).

Cristina Cruz González is an associate professor of art history at Oklahoma State University. She studied at Yale, Austin, and Cambridge prior to receiving her PhD in art history from the University of Chicago. A specialist in the visual culture of Latin America, and a past Getty Research Fellow, her work has appeared in numerous publications, including *The Art Bulletin* and *Res: Anthropology and Aesthetics*. She has written on Franciscan image theory in New Spain, the art of Mexican confraternities, and the female imitation of Christ in Spanish America. Her work engages the borders and frontiers of the Spanish empire, and the popular devotions emerging in these areas.

Rick Hendricks is the New Mexico State Records administrator. He was the state historian for nine years before accepting his present position. He received his BA from the University of North Carolina at Chapel Hill in 1977. He attended the Universidad de Sevilla in Spain. He received his PhD in Ibero American studies from the University of New Mexico in 1985. He is a former editor of the Vargas Project at the University of New Mexico. After the conclusion of the Vargas Project, he worked at New Mexico State University (NMSU), most notably on the Durango Microfilming Project in the Archives and Special Collections Department. At NMSU Rick also taught courses in Colonial Latin America and Mexican history. He has written extensively on the history of the American Southwest and Mexico.

Victor Dan Jaramillo is a resident of Chimayó, New Mexico, and a descendant of its original settlers. His interest in the history and culture of his native land began at a very young age. His extensive collection of research, oral histories, and photographs allowed him to publish his first book, *Los Chimayosos: A Community History*, in 2018. Dan is a founding member of the Chimayó Cultural Preservation Association and the curator of the Chimayó Museum.

John L. Kessell who never set out to be a historian, wishes to acknowledge a few of the engaging personalities he met along the way on both sides of the great divide: Diego José de Vargas Zapata y Luján Ponce de León y Contreras, Rick Hendricks, Meredith D. Dodge, and Larry D. Miller (*The Journals of don Diego de Vargas, 1691–1704*, 6 vols., 1989–2002), and the likes of Bernardo Pasqual Joaquín de Miera y Pacheco (*Miera y Pacheco: A Renaissance Spaniard in Eighteenth-Century New Mexico*, 2013). No le han dejado impasible.

Enrique R. Lamadrid is Distinguished Professor Emeritus of Spanish at the University of New Mexico, who has taught folklore, literature, and cultural history there since 1985. His research interests include traditional culture and bioregionalism, ethnopoetics, and folklore. His book *Hermanitos Comanchitos* (2003) won the Chicago Folklore prize, and he now edits the *Querencias* series for UNM Press. *Querencia* is a popular term in the Spanish-speaking world used to express love of place and people. This series promotes a transnational, humanistic, and creative vision of the US-Mexico borderlands, based on all aspects of expressive culture, both material and intangible.

Jack Loeffler is an aural historian, radio producer, and author who has lived in New Mexico since 1962. His radio series have been broadcast over Community Public Radio stations both nationally and regionally. He has written many books concerning cultural and environmental issues, including his current book, *Headed into the Wind: A Memoir*. Loeffler concludes that diversity of cultural perspective is vital to human sustainability. He shares points of view of Native Americans, scientists, writers, counterculturalists, and environmentalists through his comments and by playing excerpts from recorded conversations that have become the basis for his radio series, books, and essays.

Scott G. Ortman is an associate professor of anthropology at the University of Colorado Boulder, a research affiliate of the Crow Canyon Archaeological Center, and an external professor at the Santa Fe Institute. He is author and coauthor of numerous articles on ancestral Pueblo historical anthropology, and on complex systems approaches in archaeology. His published works include *Winds from the North: Tewa Origins and Historical Anthropology* (2012); *Painted Reflections: Isomeric Design in Ancestral Pueblo Pottery* (with Joseph Traugott, Museum of New Mexico Press, 2018); and *Re-Framing the Northern Rio Grande Pueblo Economy* (editor, 2018).

Donna Pierce, former Frederick and Jan Mayer Curator of Spanish Colonial Art and head of the New World Department at the Denver Art Museum, holds BA and MA degrees from Tulane University and a PhD from the University of New Mexico. She served as curator at the Museum of Spanish Colonial Art, the Palace of the Governors, and the Museum of International Folk Art in Santa Fe and collaborated on exhibitions and publications at the Metropolitan Museum of Art, the Brooklyn Museum, the Minneapolis Institute of Art, the Santa Barbara Museum of Art, the Museum of Fine Arts Houston, and the Museum of Fine Arts Boston. She has published extensively in the field and coauthored *Cerámica y Cultura: The Story of Spanish and Mexican Mayolica* (2003), *Painting a New World: Mexican Art and Life* (2004), and *Transforming Images: New Mexican Santos in-between Worlds* (2006).

Orlando Romero is the retired director of the Fray Angélico Chávez History Library. He was a columnist for two different newspapers for almost thirty years and has written for numerous other publications. He is the author of two books and has completed a third. He has received numerous awards, among them a National Endowment for the Arts creative writing fellowship; was named Eminent Scholar by the Department of Higher Education; and has been knighted by the King of Spain as Sir Orlando Romero in the Order of Isabela of Spain. He has lectured throughout the United States and Europe.

David L. Shaul is adjunct associate professor in the Department of Anthropology at the University of Colorado Boulder. His latest major works include *A Prehistory of Western North America: The Impact of Uto-Aztecan Languages* (2014). Recent works include *Esselen Studies: Language, Culture, and Prehistory* (2019) and *Salinan Language Studies* (2020), both with Lincom Europa (Munich). He is currently at the Center for the Study of Origins, University of Colorado Boulder, where he is working on the linguistic footprints of some of the first speech communities to settle in the Americas.

Don J. Usner was born in 1957 in Embudo, New Mexico, and grew up in Los Alamos and Chimayó, New Mexico. He earned a BA in biology and environmental studies at the University of California, Santa Cruz, and returned to New Mexico in 1988 to complete an MA in geography at the University of New Mexico. He has published several books and numerous articles, most focusing on the cultural and natural history of Northern New Mexico, most notably *Sabino's Map: Life in Chimayó's Old Plaza*, *¡Órale! Lowrider: Custom Made in New Mexico*, and *Valles Caldera: A Vision for New Mexico's National Preserve* (Museum of New Mexico Press); and *Chasing Dichos through Chimayó*. He works as a writer and photographer in Santa Fe.

Index